Deleuze and Futurism

ALSO AVAILABLE FROM BLOOMSBURY

Cinema After Deleuze, Richard Rushton
Between Deleuze and Derrida, John Protevi and Paul Patton
Deleuze and Art, Anne Sauvagnargues, translated by Samantha Bankston
Deleuze and Cinema, Felicity Colman
Deleuze and Film, Teresa Rizzo
Deleuze and Guattari, Fadi Abou-Rihan
Music After Deleuze, Edward Campbell
Philosophy After Deleuze, Joe Hughes
Theology After Deleuze, Kristien Justaert
Deleuze and Guattari, Politics and Education, Matthew Carlin and
　　Jason Wallin

Deleuze and Futurism

A Manifesto for Nonsense

HELEN PALMER

Bloomsbury Academic
An imprint of Bloomsbury Publishing Plc

B L O O M S B U R Y
LONDON • NEW DELHI • NEW YORK • SYDNEY

Bloomsbury Academic
An imprint of Bloomsbury Publishing Plc

50 Bedford Square	1385 Broadway
London	New York
WC1B 3DP	NY 10018
UK	USA

www.bloomsbury.com

BLOOMSBURY and the Diana logo are trademarks of Bloomsbury Publishing Plc

First published 2014
Reprinted by Bloomsbury Academic 2014, 2015

British Library Cataloguing-in-Publication Data
A catalogue record for this book is available from the British Library.

ISBN: HB: 978-1-4725-2189-7
PB: 978-1-4725-3428-6
ePDF: 978-1-4725-2500-0
ePUB: 978-1-4725-2793-6

Library of Congress Cataloging-in-Publication Data
Palmer, Helen.
Deleuze and futurism: a manifesto for nonsense/Helen Palmer.
pages cm
Includes bibliographical references and index.
ISBN 978-1-4725-2189-7 (hardback) – ISBN 978-1-4725-3428-6 (pbk.) –
ISBN 978-1-4725-2793-6 (epub) –
ISBN 978-1-4725-2500-0 (epdf) 1. Deleuze, Gilles, 1925-1995.
2. Future, Th e. I. Title.
B2430.D454P325 2014
194–dc23
2014006829

Typeset by Fakenham Prepress Solutions, Fakenham, Norfolk NR21 8NN
Printed and bound in Great Britain

CONTENTS

ACKNOWLEDGEMENTS

I would like to thank Andreas Kramer and Alberto Toscano for helping me to negotiate multiple simultaneous pathways throughout this project. Thanks to Alberto for consistently challenging and detailed feedback on Deleuze, and thanks to Andreas for introducing me to Russian futurism back in 2007, and for providing motivation, encouragement and friendship ever since. Thanks to my Goldsmiths friends for Monday Club drinks and Twiglets: particularly Jessica Rapson for her friendship and her proofreading eagle-eyes; Eva Aldea for dog walks, talks and stacks of Deleuze books on loan; and my sisters-of-sorts, Vikki Chalklin and Jo Lloyd, for three years of PhD-fuelled hysterical laughter at Malpas Road. Special thanks go to Mum, Dad and Neil, who have encouraged, motivated, counselled and supported in a huge number of ways. I could not have done it without you.

I dedicate this book to Beth, for your inspiration, pragmatism, energy, alliterative flair and eternal bestowal of homebaked treats: thank you for keeping hold of me, even when I made no sense.

INTRODUCTION

A manifesto for nonsense

In the 1960s, Gilles Deleuze presented a case for nonsense as the ultimate being of language. The groundwork is palpable in *Difference and Repetition* (1968), and its fullest expression can be found in *The Logic of Sense* (1969). Decades earlier, the Italian and Russian futurists begin an international and transdisciplinary movement presenting a case for the elimination of linguistic sense as we know it. The movement in both cases consists of the liberation of language from the strictures of preconceived meaning. Deleuze's philosophical extraction and affirmation of difference is in a certain sense analogous to the linguistic experiments of the early European avant-garde. This is again demonstrated by a linguistic model, which is why the futurist manifestos chosen as models for analysis in this book are the principal 'technical' manifestos of Russian and Italian futurism, the ones that outline the metamorphoses to which language should be subjected: F. T. Marinetti's 'Technical Manifesto of Futurist Literature' (1912) and the Russian futurists' collectively written and untitled literary manifesto in the book *A Trap for Judges 2* (1913).

What leads Deleuze to affirm nonsense in this way, and how can one specific movement of the avant-garde help us to understand it? There are several ways in which we could characterize the answer to this. It has its base within language and linguistic theory, and a perception of language as matter. This affirmation of linguistic materiality consists of a shift in focus from the semantic content of the word to its material properties: a word's sound and shape are the most obvious and common examples. The word 'shift' is important. Deleuze and the futurists (both Italian and Russian) share a desire to liberate, radicalize and reconfigure language. The

nature of this manipulation is at once both radically destructive and radically creative; it is based on a critique of reason and an ensuing celebration of language for its own sake. The metamorphoses to which Deleuze and the futurists aim to subject language to reach a point of 'nonsense' are by no means identical, but their linguistic drives tend towards a common dynamic element. This element is outlined below, but this book will argue that it is a concept in the form of a neologism: we might call it a conceptual neologism. The conflation of linguistic and philosophical practices, or the use of linguistic concepts as models to express philosophical ones, is a process we can view in Deleuze's thought. Just as the creation of neologisms is fundamental to a futurist poetics, the creation of conceptual neologisms is fundamental to Deleuze's thought.

The dynamic element

The aim of this book is to identify the dynamic element that constitutes or drives a 'futurist poetics' and examine it in its various guises, both in futurist writing and in the writing of Deleuze. The first two chapters, 'Poetics of futurism' and 'Poetics of Deleuze', set the stage for the aspects of language, space and time under investigation. These chapters introduce some important concepts for the book as a whole. The concept of 'nonsense' and the analogous function of the neologism occurs in Deleuze's discussions as well as futurist manifestos; the element of creativity and disregard for linguistic convention is a trope which can be viewed not only at a lexical but also a conceptual level. This leads us to the idea of the conceptual neologism, which is the ultimate goal of futurist poetics. The first two chapters also introduce the type of thinking which this book argues is present in the poetics of Deleuze and of futurism: an alternative type of reasoning based on a critique of Saussurian arbitrariness, which in this book is called Cratylic reasoning. This involves the motivatedness of links between objects or terms, both linguistic and conceptual, and is fundamental to the link this book draws between Deleuze's linguistic theories and futurist aims. These chapters also introduce the concept of the 'shift', another way of describing the dynamic element that can be seen in both futurism and Deleuze. The shift is a reconfiguration, a radicalization but also

a formalization, which is the peculiar movement of these aspects of avant-garde and Deleuzian thought. Examples of the shift are presented in the following chapters, which demonstrate its various effects on linguistic spatiality and temporality.

The next four chapters examine the dynamic element from various angles, through the dual perspectives of Deleuze and futurism. Chapter 3, 'The materialist manifesto', examines the concept of linguistic materiality and the ways in which this is celebrated within futurist writings and Deleuze's texts. Two 'technical' manifestos – one Russian, one Italian – are examined as models that outline this 'ideal' of language-as-matter, and the sections of Deleuze's writing that outline analogous linguistic drives are critically analysed simultaneously. Chapters 4 and 5 examine two ways in which we can discern the dynamic shift at work, through the development, abstraction or reconfiguration of linguistic norms. Chapter 4, 'Shiftology #1: From performativity to dramatization', analyses the way the celebrated linguistic materiality discussed in Chapter 3 is then set in motion – through its performance, enactment or dramatization – differentiating between the linguistic implications of performativity and the philosophical implications of drama-tization. This distinction is not a clear-cut one, as both aspects constitute the attempt to bypass mediation through acceleration. This acceleration, I argue, is a vital part of futurist poetics. Chapter 5, 'Shiftology #2: From metaphor to metamorphosis', analyses the way this aforementioned linguistic materiality is intensified and made more 'material' through the critique of metaphor which again takes the form of an acceleration. Metamorphosis is a more immediate alternative than metaphor because it eliminates the temporal gap between items in an analogical equation. The distinctions between concepts of space and time within language are significantly problematized under this futurist schema, and this is the subject of Chapter 6, 'The see-sawing frontier: Linguistic spatiotemporalities'. This chapter examines the 'shifts' occurring in linguistic conceptions of space and time, through the philo-sophical developments of Bergson and the creative explorations of Khlebnikov and Marinetti, and Deleuze's own temporal schemas. The book concludes by arguing that within the futurist poetics outlined, temporality and language are linked through geometrical models, the most important being the ambiguous 'frontier line' of futurist advancement articulated by Deleuze.

One part of the argument demonstrated in the chapters that follow is the fact that the linguistic model is a powerful figure that stands metonymically for Deleuze's entire conceptual system. In fact, the synecdoche is the most applicable trope to this type of analogous thinking because it demonstrates a part (language) standing for the whole (language + everything else). Language is only part of Deleuze's philosophy, but in this area of Deleuze's writing he relies on it in multiple ways to express concepts that stand for much broader philosophical concepts. The other part of this argument is that the linguistic models being expressed by Deleuze happen to constitute a dynamic openness and materiality of language envisioned by the futurists. For example, one of the ways in which language can be perceived as radically 'open' is through the grammatical formulation of the infinitive. The futurists' simultaneous celebrations of the verb in the infinitive and the solidity of the linguistic 'object' create a prism through which an entire conceptual map of Deleuze's philosophy can be viewed. The oscillation between the grammatical forms of infinitive and substantive operates as a model or framework for a specific mode of thinking, a dynamic, see-sawing element, which this book seeks to identify and explore.

Theories of futurism

Futurism is a large and international movement within the early European avant-garde, and while it is predominantly understood as being Italian in origin, there are other extremely important locations in which analogous and mutually influenced ideas were being put forward at the beginning of the twentieth century.[1] In terms of the conceptual or theoretical link to Deleuze and language, it may appear that other avant-garde movements contain just as many fruitful points of comparison. It is true that the international dada movement contains much to say in terms of radical materiality, anti-establishment 'nonsense' and dramatic statements that bypass conventional language.[2] It is true that surrealism, too, contains aspects of a revolutionary poetics, particularly in terms of the incongruous placing of lexical or conceptual items and the critique of rational linearity or stasis of thought.[3] It is futurism,

however, which firstly exists at the forefront of the avant-garde, which in itself exists at the forefront of modernism, as the most extreme avant-garde experiment. The reasons for the particular applicability of futurist poetics to Deleuze, however, goes further than the position of futurism at the most extreme 'promontory' of the early twentieth-century European avant-garde.[4] It is the construction of a specific and complex theory of linguistic temporality that is the key to a futurist poetics, and this can be gleaned from a study of Italian and Russian futurism rather than any other avant-garde movement. Neither dada nor surrealism develops a particular theory of linguistic temporality in the same way. Dada is self-confessedly more concerned with questions of spatiality: according to Francis Picabia, dada 'lives in space and not time'.[5] Deleuze, too, is concerned with expressing a theory of linguistic temporality that focuses, like the futurists, on an acceleration of the very process of sense-making. They are united by a desire to make language more immediate, through a critique of the temporality of existing mediating systems. This is why I have described Deleuze's poetics as 'futurist'.

Of course, this book's discussion of both Italian and Russian futurism is restricted by the use of translated material, which requires a disclaimer of sorts. For a technical typology of the precise linguistic operations being performed in both the Italian and the Russian futurist texts, a scholar fluent in both languages would have a considerable advantage through reading them in the original. The aim of this book, however, is not to produce a typology or analysis of the different types of linguistic experimentation taking place; rather, my aim is to capture the motivation and the ideology behind this experimentation, analyse its dissemination in the huge number of manifestos published and distributed, and use it to examine the linguistic practices of Deleuze. The primary subjects of analysis are not the linguistic experiments themselves, but the texts produced, which extol the virtues of experimentation, functioning as a creative call to arms. For the purposes of this book, then, the lively and creative English translations of the Italian and Russian futurist manifestos available have been a sufficient aid to the discussion. Furthermore, the very concept of translation is a vital component of the discussion, as it raises questions about the translation of lexical items that already carry indeterminate meaning. This is discussed further in Chapter 1.

It is clear from the previous paragraph that 'futurism' means many things; it is perhaps more accurate to speak of the term in the plural. There are many futurisms, but it is also important to note that these futurisms are part of still wider international movements of the early twentieth century. Futurism can be classified as part of the larger movement of the European avant-garde, and the avant-garde can be categorized as part of the larger movement of modernism. These are all interrelated and relevant to the present discussion, although the way in which they relate to one another has been a source of debate among critics. There is also the distinction between 'modernity' and 'modernism', which has come to be understood as the distinction between the dynamic state of modern life and all that it ensues: urbanity, technology, capitalism, revolution and war (modernity), and the multiplicity of artistic responses to this dynamic state: fragmentation, abstraction, rebellion, distortion and radical creation (modernism). Some critics have seen the two terms 'avant-garde' and 'modernism' as interchangeable, whereas others see one as part of the other. Martin Travers presented a perspective of the avant-garde as the most radical part of modernism in 1998, but this perspective is not shared by everyone.[6] The following passage from Susan Stanford's article 'Definitional Excursions: The Meanings of Modern/Modernity/Modernism' (2001) is significant, because it contains all three terms.

In the humanities, on the other hand, modernity and modernism are most often associated with the radical *rupture* from rather than the supreme embodiment of post-Renaissance Enlightenment humanism and accompanying formations in the West. Artists and writers, within this view, constitute an avant-garde of change, seeing sooner and more searchingly the profound significance and future effects of epistemological, ontological, political, technological, demographic, cultural, and aesthetic transformations.[7]

While modernity, modernism and the avant-garde are all included in this passage, they are not distinguished apart from one another. Both modernity and modernism are associated with the concept of rupture, but the distinction between modernity as modern life and modernism as its artistic expression is not present. Similarly, the avant-garde is included in the description, but not extracted as a

distinct term with its own meaning. My own project's perspective on these distinctions is close to Travers' mentioned above: the avant-garde is a radical branch of modernism, and should be viewed as its artistic driving force. It is my belief that the principle of *ostranenie* [остранение], estrangement or defamiliarization, shows the avant-garde to be synecdochic of the most extreme version of modernism in terms of artistic fragmentation and revolution.[8] As a general artistic principle it can be viewed throughout the multiple international modernisms, but is theorized and concretized by Russian formalist Viktor Shklovksy.[9]

Theorizing the avant-garde is a difficult task, because it constitutes the attempt to place itself outside of temporal restrictions but ultimately remains tethered by them. There are two aspects to the theoretical problematic of the avant-garde which have been presented and discussed by various critics: a *spatial* problematic, which investigates the avant-garde as that which seeks to transcend its own limits, and a *temporal* problematic, which questions the nature of the avant-garde in terms of the critique of successive temporality. The important idea of the avant-garde as moving, extending or transcending boundaries is theorized by José Ortega y Gasset in his influential essay 'The Dehumanization of Art' (1925): 'Life is a petty thing unless it is moved by the indomitable urge to extend its boundaries'.[10] Renato Poggioli's 1962 book *The Theory of the Avant-Garde* is one of the first attempts to temporalize the notoriously tricky concept of the 'avant-garde', and coins the concept of the transient futurist 'moment'.[11] Whilst Poggioli's theories have been significantly developed by more recent scholars, the concept of the 'moment' remains in currency and is particularly relevant to futurism. The temporal complexities of the futurist movement are discussed in Chapter 6. Poggioli's figure of the 'moment' is used by Marjorie Perloff in her book *The Futurist Moment: Avant-Garde, Avant Guerre, and the Language of Rupture* (1986), an important milestone in isolating futurism from the rest of the avant-garde movements and studying it in its own right.[12] In terms of revising Poggioli's theories of the European avant-garde, by far the most influential monograph to come in the twentieth century was Peter Bürger's *Theory of the Avant-Garde* (1974), a dialectical argument which criticises Poggioli's celebration of the avant-garde and argues for a necessary historicization of the movement. Bürger defends the early avant-garde as a critique of art as an institution; he sees

collusion with capitalism within the neo avant-garde, deriding it as an empty recycling of theories and forms.[13] Bürger's theories have since been developed with a defence of the neo avant-garde with the publication of volumes such as *European Avant-Garde: New Perspectives* (2000).[14]

The ideological and aesthetic differences between Russian and Italian futurism are often vast, and this book attempts to maintain a dividing line between these movements throughout the discussion, without viewing it as a homogenized whole. There is little of the Marinettian glorification of war and celebration of fascism within Russian futurism; there is less of the destructive aesthetic and celebration of technology, and more focus on the crafting of a new language. There is less evidence that the Russian futurists intended to create an actual world-dominating political movement out of their artistic one; they were much more focused on revolutionizing and deconstructing language. This does not mean that the scope of their ambition was smaller; Velimir Khlebnikov in particular viewed his goal as nothing less than the creation of a new language from the fragments and shards of the Russian grammar and lexicon he had at his disposal, in order for this language to become universal. 'Let us hope that one single written language may henceforth accompany the long-term destinies of mankind and prove to be the new vortex that unites us, the new integrator of the human race', he writes in 'To the Artists of the World' (1919).[15] The fact that this one single written language is Russian in origin displays his fervent nationalism, which is a point at which the Russian and Italian futurists converge. Both Russian and Italian futurisms display nationalism, but this is expressed in very different ways. Regardless of these vast differences and similarities, both the Russian and the Italian futurist models are important for identifying the linguistic futurist 'drive', and both are engaged with separately throughout the chapters.

A futurist poetics is in some senses a purification of language – and this concept of linguistic purity requires a keen critical eye, close as it is to the idea of hierarchies, formalisms and fascisms. The relationship between nonsense and formalism will be another aspect of the futurist drive in Deleuze's thought. The simultaneous affirmation of pure form and pure matter within language is another example of the futurist drive going in both directions at the same time. Problems and complexities arise in this, however,

when the concept of a limit or a telos is proposed. Similarly, within futurism we can see a trajectory moving away from regular substantive meaning and towards 'pure' form, which results as formalism. The fact that the radical experimentation of this futurist drive results in such rigid homogenized formulations of uniformity is an interesting and complex situation – one that will be interrogated in the chapters that follow.

Deleuze scholarship

It is important to state that aside from his discussions of Lewis Carroll and Antonin Artaud in *The Logic of Sense*, this book is not primarily concerned with Deleuze's writings about literature. Deleuze wrote numerous texts about Anglo-American as well as French literature, presenting idiosyncratic readings of these texts in order to present his own linguistic theories.[16] Rather than a study of Deleuze's writings on literature or an application of Deleuze's theories to literary texts, this book is concerned with his own linguistic practices, particularly his writings of the late 1960s in which he often employs a linguistic model to outline his ontology. These works precede his collaboration with Félix Guattari, although it is worth noting that the use of linguistic models continues throughout their collaborative period. While a few examples are drawn from the collaborative works *Kafka: Toward A Minor Literature* (1975), *A Thousand Plateaus* (1980) and *What Is Philosophy* (1991), the arguments being presented here do not concern the work of Guattari. While Deleuze and Guattari wrote as a collective, each thinker brought their own vastly different perspectives to the table. The investigation here is into the work of the solo Deleuze, rather than Deleuze and Guattari's work together. Guattari's more overtly political programme lends a pragmatic and substantive dimension to Deleuze's thought, and it is the linguistic dimension of Deleuze's earlier ground-breaking ontological works engaged with here. While I would defend the early Deleuze against accusations of being completely apolitical, it is undeniable that Guattari's activism places him in more of a political light, whereas Deleuze's early philosophical works analysed here are more purely ontological and, according to some

thinkers, empty of worldly content.[17] The aim of this book is not to counter or to affirm this critique of Deleuze, but rather to identify some of his linguistic theories and analyse the ways in which these theories themselves are affected by or enacted through the language that expresses them.

The discussion of Deleuze and language is always inextricably tied up with the rest of his philosophy, which is one of the arguments presented in this book; the consequence of this, however, is that other aspects of his philosophy are inescapably brought into the discussion. One of the propositions around which this book pivots is that Deleuze's linguistic examples operate synecdochically for his entire philosophy. Certain minute linguistic operations or constructions express vital functions in his thought of the late 1960s. These include the phonological opposition, the 'zero' phoneme and the infinitive verb. This statement in itself is not a critique as such; Deleuze's affirmative philosophical gesture legitimates synecdochical or metonymical manoeuvres. The potential for critique begins only when we ask further questions, such as whether a synecdochical point escapes the representation it purports to critique, or whether this entails a discontinuity between the concept and its articulation in a philosophy that supposedly 'requires no medium at all'.[18] This could be a problem for a philosophy that, in keeping with the futurist drive, purports to 'say its own sense'.[19]

There has not been much work produced that presents Deleuze's texts themselves as works of literature, or analysing Deleuze's linguistic theories couched within these texts. Similarly, there are far fewer works discussing Deleuze's texts of the late 1960s than there are of later works. There are also far fewer publications that deal with Deleuze's solo works, particularly *Difference and Repetition* and *The Logic of Sense*.[20] Aside from a few passing comments, furthermore, there has not been any detailed discussion of Deleuze in terms of futurist thought.[21] These are the lacunae that this book seeks to address. Alongside an investigation into the ideals of Russian and Italian futurism, this book is a simultaneous analysis of both Deleuze's perspectives on language and his own language use, in light of the concept of a 'futurist poetics'. This is a specifically linguistic question which is part of a larger question of Deleuze and aesthetics. Jacques Rancière asks this important question, which pertains both to linguistic practices and language

use: 'Existe-t-il une esthétique deleuzienne?'[22] When asked this very question in an interview, Rancière responded that

> I am struck, whether it's a matter of painting, literature or cinema, by the same fundamental approach of Deleuze. It operates in two moments: always, the affirmation of a sort of radical materiality, immanent to pictorial expression, literary language – for the cinema it's a little more complicated – the affirmation then, of a sort of characteristic of the pictorial or literary object; but, in a second moment, he produces a sort of return.[23]

Rancière's argument points towards a paradoxical double movement in Deleuze's thought which I believe warrants further investigation from a specifically linguistic angle. The radical materiality he speaks of is precisely the type of language extolled in futurist poetics, as the following chapters will argue. The 'return', on the other hand, is what Rancière sees as the failure to escape from representation completely. The desire to escape representation, and the necessary failure of this due to the interrelated constraints of language and temporality, affects both Deleuze and futurism in different ways; this is an important theme which is addressed in the chapters that follow.

Some other thinkers have produced partial answers to Rancière's question above regarding a 'Deleuzian' aesthetics by examining one or more aspects of Deleuze's language or style. In an article about 'dryness' and Deleuze, Clément Rosset's remark on Deleuze's style compares it to a cracker with no butter: it's excellent but it's dry.[24] What I find interesting about this comment is not implied critique but rather the material implications, which present Deleuze's philosophy as a solid ingestible object. The comment is returned to in Chapter 3, which discusses materiality in Deleuze's philosophy. It is quoted in a book by one prominent anglophone scholar concerned with Deleuze's writing style already mentioned: Ronald Bogue. Bogue writes more about Deleuze and Guattari's collaborative work than he does about Deleuze's solo work, although he does make the following comment about their book *Kafka: Toward a Minor Literature*, which aligns them with the genre of the avant-garde manifesto.

Ultimately, however, *Kafka: for a Minor Literature* is not so much a work of literary criticism as a manifesto and apologia for a literary/political avant-garde. In their basic approach to modern art and politics, Deleuze and Guattari are not especially eccentric or unorthodox.[25]

Bogue states that the aim of Deleuze and Guattari is ultimately to produce a manifesto for a new literature: 'one in which linguistic experimentation is combined with the invention of a people to come'.[26] As discussed in Chapter 2, Deleuze and Guattari display multiple nods to the avant-garde manifesto in both the *Kafka* book and *A Thousand Plateaus* (1980), but these overt or obvious references to futurism, while important, are not the primary concern of this book. Deleuze's earlier solo texts do something more subtle in expressing some linguistic practices that display more complex and implicit parallels with futurism, and these are this book's focus.

A radical poetics

This book's understanding of the term 'poetics' is developed from structuralist theories of language as a system, but the dynamic nature of both futurist thought and Deleuze's philosophy requires a combination of diverse approaches. *Stylistics*, *poetics* and *linguistics* are all terms interlinked with structuralism, but poetics is the most appropriate term because it is the term preferred by most important figures who helps to bring out and illuminate the dynamic element under discussion. Not only is Roman Jakobson's name synonymous with poetics, but he is also a thinker who views language as a dynamic system in a way that reconfigures and radicalizes the synchronic linguistics developed by Saussure. Jakobson's position as a linguist coupled with his identification as a futurist makes him a unique point of enquiry for the linguistic element under investigation. While I am not suggesting that Saussure's structuralism viewed language as wholly static, the conflation of synchrony and diachrony in linguistic study is what makes the Jakobsonian system an important part of the explanation for his significant role in this book. As this book will demonstrate, however, it is Jakobson's work in phonetics which gives him a particularly important role in what follows.

Aristotle speaks of the poet as an 'imitator', who, 'like a painter or any other artist, must of necessity imitate one of three objects, – things as they were or are, things as they are said or thought to be, or things as they ought to be'.[27] This book's exploration of a 'poetics' of futurism and a 'poetics' of Deleuze departs entirely from the original Aristotelian concept of art as imitation or representation. One of the most important premises which can be found in Deleuze and the futurists is the exploration of a possibility of non-mimetic or non-representational art. This is only one of the aspects being explored here, but its application as a model for thought is important. The areas of futurist thought and Deleuze's thought investigated in this book pertain to the ways they believe language should be created, used, manipulated, reconfigured or destroyed, to varying degrees. Each of these very different subjects, therefore, is examined in terms of a double line of enquiry: the statements they make about language, and the language in which these statements are expressed. The focus is very much on the functioning of language, and the particular contextual problematic of the place from which these linguistic aims are expressed: the text itself.

Prefixes

Earlier in this introduction I highlighted the significance of a dynamic spatiotemporal 'shift' of language. This can be discovered within the functioning of a certain literary construct (the manifesto), the dynamic shape and movement of Deleuze's linguistic model (the surface of sense), and the temporal theories encompassed within both Deleuze's thought and futurism (travelling both forwards and backwards in time simultaneously). All of these permutations of this common element instantly suggest themselves as difficult complexes requiring unconventional modes of thought. There are multiple spatiotemporal metaphors we could employ to describe this element, but for now it will suffice to say that it *goes in both directions at once*. This is the way that Deleuze himself describes his own linguistic system in *Logic of Sense*, introducing it as 'a pure becoming without measure, a veritable becoming-mad, which never rests'.[28] A 'pure becoming' which goes in both directions at

once is a helpful, albeit vague, starting model for thinking about this element. To begin investigating this, we need to ask some questions: *what* exactly is going in both directions at once; *how* is it going in both directions at once, and *which* directions are included in the description of 'both'? The very simple answer to begin answering these questions is that they pertain to language, temporality and the interaction between them. The two main foci of this book are language and temporality. We could therefore surmise that it is language and time that go in both directions at once, although this does not really tell us which directions are being spoken of. We might surmise that this shared element stems from a kind of critique of temporal linearity, but what is suggested as a replacement? To answer this, it is useful to remain with the linguistic model and define the dynamic element, the critique of linguistic temporality, through a series of prefixes. A prefix is a dynamic linguistic operation that affects the rest of the word through its very positioning *before*. My argument is that the futurist dynamic shift functions as a prefix, both in futurism and Deleuze. Some pertinent prefixes may illuminate this hypothesis, before some particular examples of this operation are examined in the succeeding chapters.

Pre-

The placing of *any* prefix before the rest of the word is important and requires a brief comment; it precedes the word in both spatial and temporal terms. The prefix 'pre-' both expresses and performs this, causing the remainder of the word to effectively perform a forward leap in time. Much of avant-garde spatiality and temporality is to do with breaking new ground, but this is specifically important in futurism, which is a movement consumed by the desire for an endless forward propulsion into the future. The 'pre-' is also a vital component of the futurist drive because it presupposes a number of temporal complexities; it is the problematic 'avant' of the avant-garde. The 'pre-' of 'before' presupposes the past, but the desire to be 'before' everything else reaches into the future. The 'pre-' prefix links the future with the past, and is also contained within the present. It therefore presupposes a complex linguistic temporality which requires some detailed analysis.

Bi-

The process of abstraction is ubiquitous in discourse surrounding the avant-garde; it is generally understood as a refusal of preconceived ideas.[29] If we attempt to describe the element being refused from the perspective of art, we might term it meaning, interpretation or the creating subject. If we describe it from a philosophical point of view, it would be something like reason, identity or subjectivity. One consequence of a process of abstraction is a diminution of the role of representation, whether we are discussing art, literature, philosophy or a transdisciplinary mixture. Simultaneous with the diminution of representation, however, is an increase in something else. The examples of art and literature characterize this more easily as *material* than philosophy; it is more difficult, but not impossible by any means, to conceive of philosophical materiality. This is one of the challenges broached by Deleuze of the 1960s. In her important work on futurism *The Futurist Moment*, Marjorie Perloff makes an important point when she says that abstraction is *never* straightforward negation; 'there can hardly be rupture without a compensatory addition; to cut out X inevitably means to make room for Y'.[30] It is a two-way, bi-directional process whereby nothing is actually lost; it merely works according to the laws of energy transfer and changes state. Abstraction under the futurist schema, therefore, is not a negative process; it is rather a simultaneous affirmation and negation. This is a fundamental aspect of the element being identified: the processes of affirmation and negation go in opposite directions at the same time. We will discover this bi-directionality in Deleuze's writing time and time again, at a multiplicity of levels.

Para-

The extent to which we choose to accompany Deleuze along his aleatory and multiple conceptual trajectories depends on the extent to which we are willing to legitimate the affirmation of paradox. Deleuze views paradox as something that we must not only necessarily accept, but also actively use as a dynamic tool in our thinking of all concepts. This is a creative move, and aligns him with poetical thought. The principal role of the prefix

'para-' is described somewhat ambiguously by the *Oxford English Dictionary* as denoting that which is 'analogous or parallel to, but separate from or going beyond, what is denoted by the root word'.[31] There is an element of analogy or equivocation in the 'para-' prefix, but there is also an element of additional difference or separation. Just as with the combination of affirmation and negation, it is the combination of sameness and difference that will be significant. There are several paradoxical formulations discussed in the following chapters which pertain to linguistic temporality. Ultimately, the conceptions of both language and time in Deleuze's futurist poetics require an affirmation of paradox. The very thing that makes them work is the fact that they contain their own opposite, or their own negation, within their overall structure. We will see this in the futurists' paradoxical relationship with the past, and similarly in Deleuze's paradoxical linguistic formulation of 'word' and 'thing'.

Trans-

Another prefix that contains its own dynamism is 'trans-'. It presupposes a metamorphosis, a difference or a spatiotemporal change or relocation. The term 'transreason' pertains to a metamorphotic process to which language is subjected; it is the most common English translation of the Russian futurist word *zaum*. Rather than a negation of reason, it suggests a movement beyond reason to another alternative location. *Zaum* language is a language of neologisms, deliberate errors, misspellings, phonaesthetic effects and glossolalia. It manipulates the existing Russian grammatical and etymological systems in order to produce new and different types of sense. Two other English translations of this word are 'beyond the mind' and 'beyonsense', and the paronomastic link to nonsense is very important when thinking this in relation to Deleuze. 'Beyonsense' is a neologism coined from a blend of 'beyond' and 'sense', but it also rhymes with 'nonsense' and therefore fulfils a paronomastic role that is important for the arguments that follow. As a type of euphonic wordplay, paronomasia is discussed by Jakobson and solidified into a paronomastic 'function'.[32] This function is the proffered linguistic explanation for the sound symbolism present not just in *zaum* writing but in many

diverse genres of poetry. As I will discuss in the following chapters, a paronomastic function is precisely what is magnified in some futurist texts and in Deleuze's logic of sense into a type of alternative reasoning, which in this book I have called Cratylic. The argument of Plato's *Cratylus* states that the relationship between words and things may be motivated rather than arbitrary. In a certain sense, *zaum* is a concrete example of the type of 'nonsense' that Deleuze is celebrating in *The Logic of Sense*.

Neo-

While the concept of the 'new' is fundamental to futurism in the generic sense that it is fundamental to the entirety of the avant-garde and modernism, the particular aspect of the new under discussion here pertains again to the linguistic model. The process of creating new words is what we are concerned with, and the term that illuminates this aspect the best is *neologism*. The radical novelty of a word unrestricted by the strictures of preconceived sense is what makes this concept revolutionary in terms of linguistic innovation and expression. Both Italian and Russian futurism is full of neologisms of various types: Khlebnikov's 'Dostoevskitude' and 'vyum'; Kruchenykh's 'shchyl', 'ryukpl', 'trollolop'; Marinetti's 'zang-tooooomb-toomb-toomb' and 'picpacpam'.[33] These examples demonstrate different methods of construction and exhibit different effects, but the aim here is not to produce a typology of neologisms; it is rather to investigate the point from which the impetus to produce these neologisms bursts forth. When Deleuze talks in *The Logic of Sense* about 'the esoteric word' or the Carrollian 'portmanteau' word, he is discussing neologisms; these words are both other ways of describing what we mistakenly term as 'nonsense'. Again, what is important is the affirmation of a word prefixed with a negative morpheme; there is nothing negative about nonsense in futurist poetics. In terms of the dynamic element of the futurist drive, however, the concept of 'neo-' reaches further than that of merely inventing new words. It is rather to do with thought functioning neologistically. This is Deleuze's futurist drive of the 1960s. Through this type of thinking, 'thought itself must produce movements, bursts of extraordinary speed and slowness'.[34] The dynamic element follows a route that is

completely uncharted; it writes its own theory as it moves. This is the link between the problematic concept of the futurist 'nonsense' word and the significance of Deleuze's 'esoteric' word, functioning for a model of his trajectories of thought. The invention of completely new forms is required – forms sufficient to uphold the proposed substantive material that is so much at the forefront of thought and creation that it may appear inconceivable or impossible. This is why complete affirmation is necessary, so that the form and the substance are given the space to develop simultaneously without mutually inhibiting one another.

Prefixing

What can we take from the multiple prefixes outlined above? While denoting different semantic manoeuvres, each prefix does something comparable in that it works to precede. The grammatical form of the prefix, however, may not be the most appropriate for denoting an action or operation. The operation of *prefixing* is the verb which we will take forward as the continuous action of the dynamic element, which is far more suited to the form of the element than the noun. The importance of the verb and its infinitive form has been hinted at above, and its significance will develop over the next six chapters. The verb 'to prefix' or the gerund 'prefixing' is a helpful encapsulation of the restless and multifarious temporal surge of futurisms, not because they suggest a unilinear forward motion but rather because it suggests a 'before': the 'avant-' of the avant-garde. The desire to be 'before' is what makes futurist temporalities paradoxical; it demonstrates the mutual presupposition and inextricability of the past, present and future. Among other things, Deleuze's aim is to prefix philosophy or the history of philosophy with a comparable kind of dynamic gesture or translative shift. I hope to demonstrate that the grammatical operation of prefixing – its announcement, performance and potential enactment – expresses a particular and complex linguistic temporality, both in the writings of the futurists and in the writings of Deleuze.

CHAPTER ONE

Poetics of futurism: *Zaum,* shiftology, nonsense

Zaum

Russian futurism can be roughly divided into two warring factions: those who welcomed Western influence and actively adopted the theories and terminology of the Italians, and those determined to create an entirely separate and thoroughly Slavic futurism. The latter group eschewed the futurist vocabulary borrowed from Marinetti, preferring to create on their own terms by doing just that: creating their own terms. The Hylaea group of Russian avant-garde thinkers belongs to the latter group, always couching their theories in nationalist terms and denying links with their Italian counterparts. Radical linguistic experimentation within the Hylaea group led to the creation of what became known as *zaum. Zaum* is described by Vladimir Markov as 'the most extreme of all futurist achievements'.[1] It is described thus because it supposedly goes further than other examples of futurist language in terms of breaking away from the preconceived meaning, shape, sound and spelling of words. Anything that would have been described as an 'error' – in the grammar, spelling, or even in the shaping or rendering of a letter or character – was celebrated as part of the linguistic experimentation. Nowhere else within avant-garde movements is there such a comprehensive and self-styled attempt to revolutionize language so completely. The

two main proponents of *zaum*, Velimir Khlebnikov and Alexei Kruchenykh, wanted to break the Russian language apart and put it back together in completely new configurations.[2] Khlebnikov's neologism *budetlyane*, variously translated into English as 'man of the future', 'futurian' or 'futureman', was initially preferred by his consort to the Italian version *futurista* and its Russian equivalent *futurist*. They also had a specific word for a creator of *zaum* language – a *vechar*.[3]

The aim of *zaum* and of Russian futurism in general is more creative and less destructive than that of the Italian futurists. In her book on the subject, Nina Gurianova describes the early, pre-Soviet phase of Russian futurism as '*ontologically* anarchist'.[4] The work of the Russian futurist Hylaea group (of which Khlebnikov and Kruchenykh were members) is anarchic both in terms of its linguistic rule-breaking and its unconventional use of materials, but also in terms of its attempt to create an entirely new type of language. Gurianova focuses on the anarchic potential of the material in a very material sense as well as in the radical reconfigurations of linguistic sense, spatiality and temporality. 'The Russian futurists were anarchists in their art, but anarchists throwing books as if they were bombs.'[5] These self-published, hand-crafted, deliberately irregular and erroneous incendiary objects were abrasive in every sense of the word, and were designed that way to overthrow every single preconception of what 'literature' should look and feel like. It is, however, a different type of destruction being propounded to that of the Italian futurists. While the rhetoric of the Russian futurist manifestos includes typical quasi-violent imperatives such as 'Throw Pushkin, Dostoesvsky, Tolstoy, etc., overboard from the Ship of Modernity',[6] there is no place for the fascism and nihilistic glorification of war extolled by Marinetti. The focus is on innovation rather than destruction, particularly in the early phase of the Russian avant-garde, and *zaum* is the apex of the project. *Zaum* is a linguistic phenomenon first and foremost, and is translated variously as 'transreason', 'beyond-the-mind' or 'beyonsense',[7] depending on which English translation is followed, but it is not 'nonsense' in any negative sense of the word: quite the opposite. Rather than nonsense, *zaum* is described by Marjorie Perloff as 'super-sense'.[8] Its construction is often far from arbitrary; its derivations are based on Russian etymology and grammar, manipulating them for creative ends. It is super-sense

because it *says its own sense*.[9] As we will see, Khlebnikov's *zaum* also demonstrates a kind of intensified, poetic etymological flair. The philosophical implications of etymology are always important for Deleuze, who later defines it as 'a specifically philosophical athleticism'.[10] At the point where ambiguity of meaning appears to have reached its furthest extreme, there is none to be found at all. The *zaum* word means exactly what it says.

Zaum is obviously described as literature, but the fact that its boundaries spill over into those of painting and graphic design is crucial; the Russian verb 'pisat' means both to write and to paint. Roman Jakobson, despite being a theoretician of language and words, described painting as the 'most intense aspect of creative culture'.[11] Most of the Russian futurist poets had trained as artists before turning to writing, and the lithographed booklets containing manifestos and poems were often illustrated by important futurist artists such as Olga Rozanova (who married Kruchenykh). Futurist poets used the terminology of painting when discussing their writing, using words such as *sdvig* (dislocation), *faktura* (texture) and *bespredmetnost'* (nonobjectivism).[12] The 'za' of *zaum* is a shift towards material significance, where the emphasis on the shape of the letters and their sensory potential and the choice of materials employed is at least as significant, perhaps more, than on the words written. In this sense *zaum* is emblematic of the avant-garde celebration of linguistic materiality. Sound is important too, but while the Italians focused on onomatopoeia and auditory effect as their primary 'elsewhere', as in Marinetti's 'Zang Tumb Tumb', the Russians emphasized the visual effect of the word as matter. This obsession with the look of the lettering has been translated into newer versions of *zaum* works; it is fitting that on the last page of a 1985 edition of Khlebnikov's *The King of Time*, there is a detailed description of the typeface used throughout the book with its name, history and 'character'. The typeface, Linotron Galliard, is described as having 'a flair that seems appropriate to Khlebnikov'[13]: it is as if 'character' as person, actor and agent, and 'character' as letter, symbol and graphic device are one and the same for the Russian futurists. This almost supernatural belief in the qualities of the letter or word is exhibited by the *zaum* writers and is summed up by Khlebnikov himself: 'Poetry is not sign but magic spell'.[14]

Worldbackwards

The *za-* prefix of *zaum* means 'beyond', which necessitates a kind of shift. The *-um* denotes 'mind', which is where 'beyond-the-mind' or 'trans-sense' is derived. The idea of the shift to somewhere beyond the mind was explored most concretely by the Russian futurists, for whom *sdvig* ('shift' or 'dislocation') was a key word and became a quasi-discipline in its own right – and the neologism 'shiftology' (*sdvigologiia*) was coined. The shifting process can already be seen in the word *zaum*; whichever English translation is chosen (transrational, transreason, beyonsense, beyond-the-mind), the word displays the shifting movement encapsulated in the '*za*'. The 'trans-' prefix denotes the shift, but it does not simply pertain to temporal shifts. Within *zaum* the spatial as a category is just as important as the temporal in terms of land, ground, location and nationality; the space–time dichotomy is precisely the one that is collapsed by the project and no longer holds relevance, so every shift is at once both spatial and temporal. Later this dynamic shift would become crystallized into one of the cornerstones of Russian formalist theory: estrangement (*ostranenie*). Viktor Shklovsky was the principal theoretician of estrangement, or 'defamiliarization' as it was to become known. 'I personally feel that defamiliarization is found almost everywhere form is found', Shklovksy writes in 'Art as Technique' (1917).[15] An upholding of form, then, presupposes a shift in perception at the same time as it presupposes a negation of substance. This proposition is important for the purposes of this book, which suggests that Deleuze in the late 1960s presents his own version of philosophical 'estrangement', and subsequent philosophical formalism. Deleuze's own 'estrangement' will be discussed further in Chapter 2; for now, it is important to understand the experimental linguistic procedures within *zaum* that prefigure Shklovsky's formalist conceptual manoeuvre.

At its most basic level within *zaum*, this 'shift' is an operation performed upon a word or a part of a word. The first step in the process, therefore, involves liberating a word or part of a word from the stricture of preconceived sense. Russian is a particularly good language for this type of experimentation, as its meaning is dependent on a large amount of moveable prefixes and suffixes. This liberation involves clearing away the surrounding debris of a

syntactical structure so that we are left with the pure unit, which is then under the power of the writer to manipulate at their will. For some Russian futurists, the shift conveyed and expressed a lot more than a basic morphological manoeuvre. For example, Kruchenykh later theorized the shift with a series of broad and grandiose statements that signify its esteemed position in the theory of *zaum*.

Transrational language is always a shift language!
It contains fragments of shattered worlds!!

The shift conveys movement and space.
The shift conveys multiplicity of meanings and images.
The shift is the style of our contemporary life.[16]

The idea of the shift as an overall principle was already in play before 1923, however, as a letter to Kruchenykh from none other than Roman Jakobson, dated 1914, demonstrates. Jakobson writes of the *zaum* text *Worldbackwards* (1912) and talks of the shift in chronology explored therein as a significant temporal principle within itself.[17] Co-authored by Khlebnikov and Kruchenykh, *Worldbackwards* is one of the most materially experimental of the *zaum* publications. Here anarchy resides within the form perhaps more than anywhere else, with letters of varying shapes, sizes and directions, deliberate mistakes, a variety of printing methods as well as handwriting, stencils, collage, rubber stamps and potato cuts. The emphasis is on irregularity and subversion, and in parts the reader has to physically turn the book around or upside down to read the words. Every preconceived notion of how a 'book' should be is challenged in this text. The Russian futurists were revolutionary in the materials they used right from the beginning, however: the early publication *A Trap for Judges* (1910) was printed on the reverse side of patterned wallpaper, and later 'A Slap in the Face of Public Taste' (1913) was printed on sackcloth. This method of using unusual, rough-textured or industrial materials intended for other purposes is vitally linked with their operations on the word because it represents the materiality of language pushed to its furthest extreme. Both the word and its habitat, the book, exist primarily as material objects. Both the books and the words contained within them are shaped and crafted by hand, and the primitive strokes used in the artwork-lettering contrast sharply both with the Italian futurists'

love for the clean lines of machinery and the careful detail of previous Russian symbolist publications. *Worldbackwards* displays an impressive array of printing techniques. Each copy differs slightly from the next, and the bewildering mixture of handwriting and printing combined with letters deliberately printed backwards and upside down immediately confounds and confuses the reader. At some points the positioning of the text demands that the book be physically rotated around. It is not only the aspects of construction, however, that demonstrate the theory and practice of the shift. The book itself is concerned not with the future but with the past: it is clear from the title that the perspective being celebrated involves 'backwardness'. This can be interpreted in different ways. To perform a basic action 'backwards', such as writing or walking, immediately thwarts conventional logic and reason because it goes against the 'forwardness' of regular temporality and movement. It is also anarchic because it refuses to look ahead into the future and adopt new methods, preferring instead to mimic the primitive brushstrokes of the first Stone Age artists. Jakobson, who will be discussed in greater detail below, aligns the book with cinema in his commentary.

> Xhlebnikov offers an example of the realization of a temporal shift, and one, moreover, which is 'laid bare' (*obnazhënnij*), that is to say, not motivated, in his *World in Reverse* ... which has the effect of a motion picture film run backwards.[18]

Significant in this description is the use of the term 'shift' as well as the classification of it as a temporal shift. The Shlovsykian description of 'laying-bare' which becomes so important within Russian formalism is applied to the temporal manoeuvre in *Worldbackwards*; this is something that is deliberately foregrounded. The creators of this book – Khlebnikov, Kruchenykh, and illustrators Goncharova, Larionov, Tatlin and Rogovin – were prepared to go backwards as far as it was possible to go in order to push the notion of literature forwards, and performed this contradictory process openly. The temporal shift within Russian futurism, therefore, is a complex movement. It appears to go in conflicting or opposing directions: back and forth. The precise nature of this movement will be discussed more fully in Chapter 6.

Shiftology

Kruchenykh continued to be an enthusiastic theoretician of the shift within *zaum*, later producing a manifesto in his *Shiftology of Russian Verse: An Offensive and Educational Treatise* (1923) containing the following lines:

> It is impossible to teach all possible artistic effects because the work of art is a live organism. However, shiftology brings them to the fore and gives us a new tool, a new way of reading, a new alphabet.

> When there seemed to be a slip of awareness, one would discover a shift, some hidden creative work which at times betrays many of the author's secrets![19]

For Kruchenykh, *zaum* was 'an aesthetics of complete shift'.[20] His conception of the term appears more conceptual and more overarching than that of Khlebnikov; he views the operation of this shift as something that affects the *entirety* of language and makes the whole language shift, analogous to the process of 'stuttering' which Deleuze suggests as something that affects the entirety of language (discussed in Chapter 4).[21]

Khlebnikov's approach to the shift is not counter to Kruchenykh's, but his methodology is more specific and more technical. Here is an excerpt from Khlebnikov's 'supersaga' *Zangezi* (1922), in which the root 'um' has been treated by a list of dynamic 'shifts' in the form of prefixes, creating a series of neologisms permutating around the suffix *-um*, meaning 'mind':

Proum
Praum
Prium
Nium
Vèum
Roum
Zaum
Vyum
Voum

Boum
Byum
Bom![22]

Obviously the word '*zaum*' itself is included in this example: -*um* is 'mind' and each prefix adds a different dimension to it, with the *za*- prefix discussed above creating 'trans-sense'. Here Khlebnikov shows the reader how language can shift and/or be shifted, through a deliberate and specific act of lexical fragmentation and subsequent multiple affixations. In Gary Kern's 1976 translation, while the resulting neologisms remain in transliterated Russian, Kern adds some speculative explanations as to some of Khlebnikov's constructions of his -*um* neologisms. Here are some examples from Khlebnikov's list, with Kern's additional explanations in parentheses.

> *Goum* – high as those trinkets of the sky, the stars, which are invisible during the day. From fallen lords (*gosudari*) *goum* takes the dropped staff *Go*. (That is, the first two letters of *gosudari*, which Khlebnikov takes to mean 'high'.)

> *Laum* – broad, flowing over the broadest area, knowing no confining shores, like a flooding river. (Khlebnikov has in mind the l-sound of *lit'* – to flow, to pour; *lodka* – boat; *letat'* – to fly; etc.)

> *Oum* – abstract, surveying everything around itself, from the height of one thought. (*Ozirat'* = to survey, look around.)

> *Izum* – a leaping out of the borders of the everyday mind. (*Iz* = out of.)[23]

As these examples demonstrate, Khlebnikov uses affiliated sounds from the language to construct a network of associated and speculative meanings. The intended result is the creation of a new language which is related to conventional Russian, but with a system in which sound and meaning are directly united. What is striking about Khlebnikov's neologisms is the way that even his definitions of them are poetic and imaginative. They are not at all fixed in the sense of a word as closed definition, denotation or

limit; they are not 'terms'. In fact, they represent a radical critique of language as a system of terms. There are perceptible etymological derivations, but it is a poetic and speculative etymology. Rather than looking to the past for a closed derivative meaning, it looks simultaneously to both past and future in order to create something open, unfixed and anti-teleological.

Nonsense

Deleuze's 'poetics' are the subject of the following chapter, and his theorization of nonsense in *The Logic of Sense* will be discussed in detail there. It is helpful at this point, however, to introduce Deleuze's formula for nonsense briefly here before exploring how this theory was explored earlier within futurism. Deleuze differentiates between the conventional linguistic process of synonymy and the more immediate and sense-*donating* process of nonsense.

> We know that the normal law governing all names endowed with sense is precisely that their sense may be denoted only by another name $(n_1 \rightarrow n_2 \rightarrow n_3 \ldots)$. The name saying its own sense can only be *nonsense* (N_n).[24]

This formula almost makes a mockery of synonymy, the conventional sense-making process, for its eternal inaccuracy and certain failure in the attempt to mimetically represent both the referential object and the previous synonym. Nonsense, on the other hand, 'says its own sense'.[25] It manages to be both entirely self-referential and entirely external to itself at the same time, because while it only refers to itself, each time that 'itself' may be something different. A process of meaning and a referential object are not absent but instead have infinite potential to vary, because the nonsense word is created, performed, defined and understood anew at each occasion of its utterance. This will be returned to and explored in more depth in the next chapter; for now, it is important as a general point of comparison to the project of *zaum*. It is worth mentioning here that within the past decade, one scholar has aligned Deleuze's own original exemplary nonsense-maker, Lewis Carroll, with *zaum* nonsense-maker Alexei Kruchenykh in terms

of what he calls a Russian 'alogism'. Nikolai Firtich defines this
alogism as an 'anti-rational, essentially metaphysical development
that was particularly evident in the early days of the Russian avant-
garde'. According to Firtich, the alogism that links Carroll's and
Kruchenykh's nonsense is made up of three aspects, of which the
linguistic experiment of 'nonsense' is but one. Also linking these
figures is the concept of alternative metaphysical realms being
explored, and an artistic *épatage* against the dominant contem-
porary social and cultural institutions.[26] While it is true that there
are elements of all three aspects to be found in both Carroll and
Kruchenykh, it must be accepted that in terms of artistic and
cultural subversion, Carroll's inventions remain within the realms
of conventional logic; his only subversions of linguistic sense are
gentle nods towards certain odd lacunae of meaning within the
English language expressed by substituting a conventional noun
with a portmanteau word. Kruchenykh, on the other hand, is a true
artistic revolutionary in the sense that his desire was to shake the
entire system of expression and presentation. To equate *zaum* with
Carrollian nonsense in this way is to understate *zaum*'s anarchic
potential. The lack of real subversion in Carroll is surely one of the
reasons why Deleuze eventually rejects his work as a 'nonsenspi-
ration' in favour of the radical linguistic materiality of Artaud: 'We
would not give a page of Artaud for all of Carroll.'[27]

Zaum is 'nonsense' in the sense that its meaning is, arguably,
entirely unfixed. Of course, the counter-argument to this is that
every sound, letter or combination of these in a given language
carries with it associations. Even the most extreme of the Russian
formalists, Viktor Shklovsky, was aware of this, stating in his book
Knight's Move that the poetic word 'is not just a word. It draws in
its wake dozens and thousands of associations. It is permeated with
them just as the Petersburg air during a blizzard is permeated with
snow.'[28] It is this which gives the *zaum* 'nonsense' word its creative
potential and power. Although Deleuze's formula N_n constitutes a
'prototype' for nonsense-making, there is nothing in his writing
to show as an example or enactment of this aside from the bare
formula N_n, which according to Deleuze's theory could contain
just as much poetry as any of its infinite permutations. This is
because according to Deleuze's theory of univocity (discussed in
Chapter 2), the formula does not differ from its permutations; in
fact, it contains the potential for any possible permutation within

its structure. 'Nonsense is of a piece with the word "nonsense"', Deleuze says; 'the word "nonsense" is of a piece with words which have no sense, that is, with the conventional words we use to denote it'.[29] It is easy to see why critics of Deleuze's philosophy have problems with this concept. The removal of hierarchies of meaning and therefore the removal of the delineation between sense and nonsense means that everything can make exactly the same amount of sense, which is at once as liberating as it is restricting. At the very apex of creativity and innovation there is absolute openness, but there is also nowhere left to go. This may give us some explanation as to why Deleuze does not venture any examples of 'nonsense' apart from the formula N_n. Put in avant-garde terms, the manifesto that overwrites and encompasses any potential 'manifestation' is both a total success and a total failure, which appears to be what Deleuze is aiming for at times in *The Logic of Sense* when he discusses language. The co-presence of sense and nonsense, the verb in the infinitive and the univocity of language (all discussed further in the following chapters) are all synonyms of this radical linguistic telos about which nothing more can be said or done. Khlebnikov and Kruchenykh talk about a 'universal language' at several points in their manifestos, which has an identical teleological outcome: they are talking about the end of language.[30] Their creative output, however, does not necessarily always signal this end of language; to them, it points towards new beginnings.

'The Simple Names of the Language' (1916)

The shift of meaning encompassed within the 'trans-' of transreason can often be split into two categories based on the new locus of the 'shifted' meaning. These categories are the sound and the shape of the words themselves. It is as though the concept of sense or reason cannot ever disappear; it merely changes state or location. Reading meaning in sound or shape, however, defies Western linguistic systems altogether. To make the language do this constitutes a grand gesture of semantic rebellion. The alternative reasoning preferred by Khlebnikov and Kruchenykh, therefore, is based in sonic or graphic symbolism. While this phenomenon

is perceptible throughout the avant-garde in varying degrees, it is within *zaum* that the phenomenon takes centre-stage, being the object of commentary and theory at the same time as it is creatively explored. Examples of both sound and shape symbolism can be found in lots of Russian futurist poetry, but Khlebnikov in particular often extends the concept in his writings by including simultaneous interpretations with his innovations. At these points, Khlebnikov offers the reader a potential method of interpreting a word based on a combination of Russian grammar and etymology, sonic associations and his own personal speculation. One particularly pertinent example of this etymological transreason can be found in Khlebnikov's text 'The Simple Names of the Language' (1916), which is an example of 'shape' symbolism. In this text Khlebnikov proposes several ways of reading the letters M, V, K and S as 'simple names', rendering each consonant as a world with specific characteristics according to the words he chooses which begin with these letters. Meaning is therefore ascribed according to the very angles of the letters. Khlebnikov first runs through nineteen exemplary words that begin with M and concludes that 'In these 19 words beginning with M, we see one and the same concept straying throughout – the smallest quantitative member of a given category.' The sense of M, however, is then further complicated as Khlebnikov states that 'In its further diminution the member loses the qualitative features of its category', but then after discussing several more groupings of M-commencing words he finally concludes that 'If the *M*-name be reduced to one image, this concept will be the act of division'. M is equated with the process of division; V is equated with subtraction (because of the Russian word [*vychitanie*]); K is described as being linked to both 'disappearance of movement' and 'the act of addition'; and S is linked to 'the abstract image of the act of multiplication'.[31] While some of these links are understandable to a certain extent due to the shape of the letters, others are more difficult to comprehend. The system Khlebnikov creates and uses is not consistent, which makes it harder for the reader to comprehend or take seriously. The overall process, however, is the same: a new conceptual link is created and explained in each instance, linking the shape of the letter to a particular meaning (in this case, mathematical functions). In each example a bridge is created between the letter and a mathematical operator or process, as if Khlebnikov wishes to unite or merge the

two languages. Whether the bridge exists previously or whether it is created in the mind of the reader is not the most relevant question to Khlebnikov. The process of creating the bridge, and the difficulty encountered in making it real, are his concerns. This is *zaum* in action.

Zangezi (1922)

Another example of Khlebnikov's transrational etymological reasoning pertains directly to war, and makes it a concrete reality in the very construction of the letters. The text *Zangezi*, Khlebnikov's self-styled 'supersaga' composed of twenty 'planes', is an important text for several reasons. In the character of Zangezi Khlebnikov creates a semi-autobiographical 'conceptual persona' (to use terminology from Deleuze and Guattari); this will be discussed further in Chapter 4.[32] Even the neologism of the name Zangezi is significant, and some scholars have suggested that it fuses the names of two rivers from separate continents: the Zambezi and the Ganges.[33] The concept of war is unsurprisingly prevalent in the writing of this time, and is obvious within the bellicose etymology of 'avant-garde'. What singles out Khlebnikov and distinguishes him from this trend is not only the fact that war is not celebrated, as it is in earlier Italian futurist manifestos; it is also the connection he makes between war and language, and the fact that this connection is not so much metaphoric as literal. In his writings Khlebnikov talks about the doubling that occurs within language between sound and reason.

> This struggle between two worlds, between two powers, goes on eternally in every word and gives a double life to language: two possible orbits for spinning stars. In one form of creativity, sense turns in a circular path about sound; in the other sound turns about sense.[34]

War and struggle permeate Khlebnikov's work, from the smallest linguistic particle to the largest imaginable concepts. When talking about space and time, for example, Khlebnikov almost sets time at war with space, choosing himself to side with time. 'In place of

the concept of space to introduce everywhere the concept of time, for example, the war between the generations of the terrestrial globe, the war of the trenches of time.'[35] When Khlebnikov writes that 'The alphabet is peopling an alternative universe', this is to be taken literally rather than metaphorically. War is occurring within the language, at times between single letters. This intra-alphabet battling is dramatized in his 'supersaga' *Zangezi.*

> We have heard of L. We know that it is the sudden halt of a falling point upon a broad transverse plane. We know about R; we know it is the point that penetrates, that cuts like a razor through the transverse plane. R rips and resonates, ravages boundaries, forms rivers and ravines.[36]

Just as in 'The Simple Names of the Language', in this passage Khlebnikov mythologizes the physical angles of the letters, endowing the marks on the page with their own characteristics, their own subjectivities. He is equally comfortable with the reverse of this process, as we see from the lines

> O the racing cloud's Dostoevskitude!
> O the melting noon's Pushkinations![37]

While in the previous example letters were 'elevated' to the status of characters endowed with subjectivity, this example demonstrates canonical literary figures being reduced to qualities or traits. This performs multiple functions. First, it enacts one of the aims from the first Russian futurist manifesto, which was to 'Throw Pushkin, Dostoevsky, Tolstoy, etc., overboard from the Ship of Modernity.'[38] It refuses to acknowledge the status of these writers by reducing them to an adjectival modification. It also provides a proto-postmodern metacommentary on the workings of the poem, forcing the reader to consider the ways that we 'read' visual stimulus in such a way that common sights such as a cloud or the sun become figural. We read racing clouds and melting noons in the shadow of Dostoevsky and Pushkin's proper names, and Khlebnikov's lines perform a critique of this type of reading. It is a non-creative type of recognition, rather like Shklovsky's passive 'recognition' as opposed to the active 'seeing'. This distinction will be returned to later in the chapter. Returning to the examples

above, however, it is immediately clear that the letters are at war with one another. The language is splitting apart, differing within itself and warring among its very atoms.

Cratylic reasoning

Let us turn to Deleuze for an example of the other type of transreason – the shift of meaning to a word's sonic rather than its graphic qualities. On the surface, the difference between *zaum* and conventionally understood 'nonsense' is that while nonsense supposedly denotes an absence or negation of sense, transreason denotes a metamorphosis of reason. Another way we could describe this phenomenon is a pre-emptive quest against structuralist arbitrariness – a motivation against the gap between signifier and signified before structuralism has even begun to take hold. This unification of signifier and signified aligns *zaum* with Deleuze's paradoxical Stoic-inspired formulation in *The Logic of Sense*, in which language is both the 'word' and the 'thing' (discussed in Chapter 2). The other text it calls to mind, however, is Plato's *Cratylus*. It is highly significant that *zaum* scholar Gerald Janecek prefaces his book on Russian avant-garde literature with an excerpt from Plato's *Cratylus*. Cratylic thought is linked to avant-garde theory and practice in general, but it is perhaps in *zaum* where this type of thinking finds its most obvious exponent. The reason why *zaum* is a concept that fits the description 'Deleuzian' is that Deleuze's entire linguistic project at the time of *The Logic of Sense* pertains to what I have termed Cratylic thinking. The Stoic paradox that language is both word and thing in a certain sense finds its solution in the *Cratylus*.

In the quote in Janecek's preface, Socrates makes a typically contorted statement concerning the relationship between words and things.

> SOCRATES: I quite agree with you that words should as far a possible resemble things; but I fear that this dragging in of resemblance ... is a kind of hunger, which has to be supplemented by the mechanical aid of convention with a view to correctness; for I believe that if we could always, or almost

always, use expressions which are similar, and therefore appropriate, this would be the most perfect state of language; as the opposite is the most imperfect.[39]

In the perfect state of language, therefore, words would resemble things. It is, however, stated in the *Cratylus* that there is 'no principle of correctness in names other than convention and agreement; any name which you give, in my opinion, is the right one, and you change that and give another, the new name is as correct as the old'.[40] This point is the same as Saussure's; it is only convention and agreement that links the words 'tree' and 'arbre' to the material object in the ground with branches and leaves. *Zaum*, and avant-garde practice in general, exhibits the desire to get beyond the arbitrary conventions of naming and synonymy, and make language resemble its object. This is exhibited through avant-garde visual and aural experimentation in which the language becomes its object, but in Khebnikov's work this phenomenon is explored, documented and theorized more technically than anywhere else within futurism.

In the work of both Khlebnikov and Kruchenykh the emphasis is on the disregarding of preconceived or conventional interpretations of words or sounds, and new creations that operated according to etymological or phonaesthetic reasoning, as opposed to conventional logic or meaning. While the explanations presented so far in this book might suggest to the reader that this intention underpins all avant-garde endeavour, what separates *zaum* from the rest is its overt intention as a linguistic project of reinvention. While the words used to describe or translate *zaum* into English generally pertain to an absence of or movement away from sense, the aim of Khlebnikov and Kruchenykh was to create new types of sense in language, or modify the understanding of what sense can be. This is clearly the type of language creation that Deleuze had in mind when he wrote *The Logic of Sense*, but his references to Russian futurism are limited to the concluding sentence to 'He Stuttered': 'Biely, Mandelstam and Khlebnikov: a Russian trinity thrice the stutterer and thrice crucified.'[41]

Despite the multiple complications that arise through both the transliteration and translation of this highly sonic material (this will be returned to later in the chapter), the extensive use of this type of sound symbolism, especially by Khlebnikov, has been

commented on by a few English-speaking critics. In his famous study on Russian formalism, Victor Erlich describes Khlebnikov's idiom as 'bizarre', simultaneously praising his innovation and deriding the 'distinctly amateurish quality' of his philological generalizations.[42] Futurist scholar Marjorie Perloff believes that Khlebnikov's explanatory mechanisms make etymological or philological cases that philologists might see as dubious, and could easily be refuted. Perloff believes that Khlebnikov's metonymic and metaphoric associations are his own inventions, pointing out that his imaginative linguistic accounts are 'by no means scientific'.[43] Perloff draws attention to the wind–stone analogy which Khlebnikov and Kruchenykh discuss in the text *The Word as Such* (1913):

> Which is more valuable: wind or stone?
> Both are invaluable![44]

In a theoretical move that affirms the imaginative logic of the *zaum*ists, Perloff states that both the wind and the stone mentioned in the text are equally invaluable because 'there is really no opposition between the two principles in question'.[45] The two disparate objects are mutually affirmed and harmonized in a move that is both conceptually hard to swallow and deceptively facile. As we will see in the next chapter, this is analogous to the way in which Deleuze's system of nonsense presents no difference between terms. At the point of absolute difference, there is no discernible difference whatsoever.

The unashamed celebration of creativity in its purest form is another link between Khlebnikov and Deleuze. Creation is everything to Khlebnikov; he defines it as 'the greatest declination of the string of thought from the life axis of its creator and as a flight from oneself'.[46] Khlebnikov's project could be described as the application of pure creativity (if such a thing exists) to linguistic sense-making operations. Because of the way we make sense through language, every sound contains scores of possible contextual associations, which makes this an adventure through etymology and phonaesthesia rather than complete 'nonsense'.

As we will see later in the book, Deleuze theorizes this idea, but does he enact it himself at any point? In fact, Deleuze does allow himself a rare moment of comparable etymological creativity in

The Logic of Sense when he attempts precisely this type of sound-symbolic reasoning. The moment comes when Deleuze is explaining the difference between Chronos and Aion, the two forms of time in the temporal schema he sets out via Lewis Carroll's famous nonsense text 'Jabberwocky'. The distinction itself will be discussed further in Chapter 6; for now, let us focus on Deleuze's moment of contrived 'nonsensical' explanation. The word he employs is Carroll's word 'wabe', from the first two lines of 'Jabberwocky', to describe the precise nature of the distinction between Chronos and Aion.[46] Through quasi-etymological, phonaesthetic word-association rather than conventional signification, Deleuze interprets Carroll's coinage 'wabe' as both the cycle of Chronos and the straight line of Aion. He links it to the English verbs 'swab' and 'soak', seemingly purely through sibilance, and because of the association with water links the word to 'the rain-drenched lawn surrounding a sundial; it is the physical and cyclical Chronos of the living present'. He also presents it in opposition as a blend of 'way' and 'be': 'it is the lane extending far ahead and far behind, "way-be", "a long way before, a long way behind." It is the incorporeal Aion which has been unfolded.'[48] Critics might describe this interpretation as not particularly illuminating in any frame of reference outside of itself, as it is a 'poetic' and therefore singular etymologization of a nonsense word with no concrete referent. This Cratylic literary exegesis, however, is exactly the process he would have us follow. It is Cratylic because it makes the sonic properties of the word link up with its newly created singular meaning, but in addition to this there is a singular creative leap (from 'swab' and 'soak' to a rain-drenched garden and a sundial; from 'way' and 'be' to a lane). It is also singularly 'nonsensical' because it only exists within its particular utterance. This is Deleuze unwittingly producing his own version of *zaum*, which is a blend of simultaneous creation and analysis – an example of an interpretative and yet aleatory line being put to work. Through a manipulation of the motivatedness of the link between sound and meaning, Deleuze turns the word 'wabe' a portal into his entire dual and coexistent temporal vision. This is exactly the type of poetic or 'nonsensical' reasoning by which some avant-garde writers desired to have their neologisms interpreted. The most pertinent example of a futurist writer who produced analogous creations and interpretations is none other than Khlebnikov.

Jakobson and the formalization of *zaum*

Not all Russian formalists were sympathetic to the futurist movement in their country; neither were all Russian political revolutionaries – far from it. In addition to the common post-1917 Soviet criticism of futurism's lack of commitment, Victor Erlich's indictment of the Russian futurists in his important book on Russian formalism strikes a similar tone to Leon Trotsky's earlier critique (discussed later in this chapter). Erlich's criticism is significant because it is an accusation of style over substance, or perhaps volume and hyperbole over anything else.

> The Futurist artistic credo never developed into a full-blown esthetics. This was due both to the meagreness and to the light-weight quality of its theoretical output. Slogans shouted at the top of one's lungs could not serve as a substitute for a coherent system of intellectual concepts. Flamboyant declarations, often intended to baffle the audience rather than clarify the issues at stake, were productive of more heat than light.[49]

Erlich is keen to separate futurism and formalism, lest anyone think of Russian formalism as a predictable theoretical segue stemming from futurism. As has already been discussed, however, Khlebnikov's output consists of far more than slogans shouted at high volume. Some linguists were more sympathetic towards futurism, however, and no one was in a better position to comment upon the link between futurism and formalism than the linguist Roman Jakobson, who bridged the gap between them.

Jakobson's unique combination of linguistic technicality and poetic sensibility, as well as his position in the group of Russian futurists at the time, makes him an extremely significant figure in the development of *zaum* and its theorization. His idiosyncratic mixture of technicality and quasi-mystical reverence for language's creative potential links his linguistic theories with those of Deleuze at the time of *The Logic of Sense*. Jakobson the scientific linguist, however, was in fact heavily involved with the Russian avant-garde. He was friends with Khlebnikov and Kruchenykh, he wrote some futurist writing himself, and he considered himself a futurist for a time. Aged 18, Jakobson the futurist was known as Aliagrov

and this pseudonym can be seen on texts such as Kruchenykh and Jakobson's *Transrational Boog*.[49] In Khlebnikov Jakobson saw the possibilities of new worlds through linguistic innovation. 'The thematics of time and space, so mysterious and head-spinning, opened up. For us there was no borderline between Xlebnikov the poet and Xlebnikov the mathematical mystic', Jakobson writes in an early essay on his friend Khlebnikov.[51] While Jakobson discussed *zaum* directly in many texts and in particular wrote texts about Khlebnikov, his linguistic writings often read as theoretical counterparts to *zaum*, even when *zaum* is not mentioned and the topic under discussion is something else entirely. These theoretical texts often work retroactively. For example, in 'Linguistics and Poetics' (1960) Jakobson introduces his concept of the 'poetic function' of language. 'The set (*Einstellung*) toward the message as such, focus on the message for its own sake, is the POETIC function of language.'[52] The 'focus on the message for its own sake' is the type of language propounded in futurist thought (and Deleuzian nonsense, as we will see in the next chapter). Rather than empty of meaning, however, it is charged with its own unique sense which is derived from its material properties. This poetic function is at the base of the Cratylic writing mentioned above, in which lexical items are linked through paronomasia rather than syntax: 'In a sequence in which similarity is superimposed onto contiguity, two similar phonemic sequences near to each other are prone to assume a paronomastic function.'[53] This 'paronomastic function' is the proffered linguistic explanation for the sound symbolism present not just in *zaum* writing but in many diverse genres of poetry.

> In referential language the connection between *signans* and *signatum* is overwhelmingly based on their codified contiguity, which is often confusingly labeled 'arbitrariness of the verbal sign'. The relevance of the sound-meaning nexus is simply a corollary of the superposition of similarity upon contiguity.[54]

In identifying this 'paronomastic' function, Jakobson solidifies and clarifies the mechanism that goes against sense in favour of 'nonsense', or rather takes its sense from its sound rather than any preconceived meaning. While the formula at this stage can be applied to poetry of all kinds, Jakobson does give examples

of Khlebnikov's particular use of this function in his essay 'The Newest Russian Poetry: Velimir Xlebnikov' (1921). Unfortunately, the editors of the volume *My Futurist Years* choose to omit this section and only mention it in passing, describing it as 'a brief section in which Jakobson deals with Xlebnikov's tendency to select epithets for euphonic rather than semantic reasons: for example, "strange fear" – *strannij strax*; "full flame" – *polnyj plamen'*.[55]

Jakobson's discussion of paronomasia is comparable to Deleuze's formula for nonsense, in that both theories engage in the arguably paradoxical attempt to theorize and universalize an alternative and highly singular method of reasoning from within conventionally rational channels. Moreover, both Jakobson and Deleuze choose to elaborate their theories regarding unconventional sense-making in highly technical language. There is nothing speculative about Jakobson's poetic function; it is scientific in its mapping onto the syntagmatic and paradigmatic poles. Jakobson believes that *zaum* has the power to widen and multiply language's scope in multiple ways simultaneously. It achieves this by taking the word out of its 'dormant and petrified' form, forcing it into a new innovation and definition. This is through the use of neologism, another interlinking feature of *zaum*. 'The meaning of a word at any given moment is more or less static, but the meaning of a neologism is to a significant extent defined by its context, while at the same time it may oblige the reader to a certain etymological celebration.'[56] The potential 'etymological celebration' is the Cratylic interpretation discussed above – linked associations based on material properties of the word that occur in the mind of the reader as the word is processed. This works in contrary motion to the process of differentiation of binary oppositions at the heart of structuralist theory, which is particularly interesting for Jakobson, the budding structuralist for whom the phonological opposition would become so important.

Jakobson's linguistic theories have their root in phonology, which provides an interesting link to Deleuze's own use of it in his theorization of nonsense. Jakobson's prioritization of the phonological opposition is fundamental to Deleuze's early work on structuralism, 'How Do We Recognize Structuralism?' (written 1967; published 1972), discussed in the next chapter. According to Jakobson, an exemplary pivotal moment in the development

of these emergent linguistic theories can be seen in the termin-
ology of the Prague Linguistic Circle's proceedings of 1931. In an
'architectonic hierarchy' of fundamental notions centring around
phonology, the phonological *unit* is stated as secondary whereas
the phonological *opposition* is primary.[57] What is most important
to the study of phonology at this stage in its development is not
the smallest phonological unit but the difference between these
units: the opposition, based on presence or absence of a particular
sound. This seemingly humble development in phonology is very
significant for succeeding philosophies, not least Deleuze's work
on difference in both *Difference and Repetition* and *The Logic
of Sense*. The Deleuzian process of differentiation and its variant
differenciation will be discussed in the next chapter, 'Poetics of
Deleuze', but for now it is sufficient to focus on the phonological
shift.

The new emphasis on the differentiation of phonemes forms
the basis of the beginnings of linguistics as a science because it
also highlights one of the most important shifts in linguistic study
foregrounded by Saussure: the shift from diachronic analysis,
which studies how a language changes over time, to synchronic
analysis, which studies language at one particular time.[58] Saussure's
Course in General Linguistics (1916) is the instrumental text
first for delineating between synchronic (static) and diachronic
(dynamic) perspectives of language, and secondly for presenting
the synchronic perspective as the preferred one.[59] This is significant
in its own right, because it develops linguistic study from older
historically bound systems of philology and etymology into more
scientific, structuralist methods concentrating on language as
a system. Saussure's linguistic shift, then, is a temporal one.
Jakobson refuses to acknowledge this distinction, however, stating
instead that from the outset he has been interested in the simul-
taneous dynamic study of both horizontal and vertical linguistic
trajectories:

> Since my earliest report of 1927 to the newborn Prague
> Linguistic Circle I have pleaded for the removal of the alleged
> antinomy synchrony/diachrony and have propounded instead
> the idea of permanently dynamic synchrony, at the same time
> underscoring the presence of static invariants in the diachronic
> cut of language.[60]

In refusing to separate out synchrony and diachrony, Jakobson enacts and perhaps even goes one step further than his own 'poetic function'. He famously defines the poetic function as projecting *'the principle of equivalence from the axis of selection into the axis of combination'*.[61] This formula uses the opposition of 'selection' and 'combination' and maps them onto poetry and prose. Selection for Jakobson is differentiation; it is the way that language operates syntactically, with different word classes working together to produce prose. This is the way that sense operates conventionally. Combination, on the other hand, operates paradigmatically, forming at its most basic level a kind of list. To use Saussurian terminology, words organized by combination are grouped together according to 'similarity' rather than 'contiguity'; there is no differentiation. This brings us right back to Cratylic paronomasia, as discussed above. The poetic function, therefore, is also a kind of shift.

The fact that Jakobson presents the poetic function as an actual dynamic *function*, however, operating between one axis and another, is significant. Rather than describe the poetic function as operating according to the principle of combination, the function itself is the dynamic act of projection from one (selection) to the other (combination). It shifts the perspective to the 'in-between', just as with the phonological opposition. In all three examples – phonology, synchrony/diachrony and the poetic function – Jakobson's aim appears to be to operate in between two seemingly opposing temporal modes, thereby conflating them. Both 'static' and 'dynamic' systems operate statically *and* dynamically. As can be seen in the quote above, he presents synchrony as permanently dynamic while diachrony contains static invariants. This eliminates the difference between these through the acceptance that dynamism and stasis can coexist simultaneously.

The conflation of *differentiation* and *combination* is therefore Jakobson's most significant theoretical manoeuvre for the purposes of the present discussion. Its significance is derived from the simultaneous presentation of two conflicting modes of temporality. This is instrumental to both his theories on the way language should be studied (both synchronically *and* diachronically) and the ways in which he presents poetry as functioning (both selection *and* combination). This has extremely important implications if we think about the way Deleuze uses and develops structuralism.

These complex, paradoxical linguistic temporalities find particular and problematic expressions in Deleuze's thought, which will be explored in the following chapters.

The 'za' of translation

Various types of 'shift' have been discussed so far in this chapter. One particular example of a linguistic shift is translation: the transmittance of the semantic content from the vessel of one language to that of another. This is an important factor in a discussion of *zaum*, which deals with neologisms which have been transliterated and then translated, so that multiple shifts have already occurred just to make the material available for the non-Russian-speaking reader. In light of Jakobson's theories of simultaneous dynamism and stasis, which we have just discussed, it is unsurprising that he presents translation as a conflation of the opposition 'equivalence/difference'; he finds one within the other in translation. For Jakobson, equivalence in difference is 'the cardinal problem of language and the pivotal concern of linguistics'.[62] Equivalence in difference is a necessary condition for the possibility of translation because if there is no equivalence between different languages or modes there can be no common point from which to differ. The concept of equivalence in difference will be very important when thinking about Deleuzian sense in the next chapter.

In his essay 'On the Translation of Verse' (1930) Jakobson distinguishes between the iambs in Russian, Czech and Polish. They are structurally different and therefore semantically different. 'I think that we must approximate the art of the original when, to echo a foreign poetic work, a form is chosen which, in the sphere of forms of the given poetic language, corresponds *functionally*, not merely externally, to the form of the original.'[63] Jakobson is using multiple languages to further prove the point that form determines function, and the gap between languages renders translation a necessarily inaccurate act, and consequently a creative one at every turn. When the writing under scrutiny is *zaum* language, however, the creative aspect increases exponentially. As Kruchenykh points out in 'New Ways of the Word' (1913): 'it is IMPOSSIBLE to translate from one language into another; one can only transliterate

and provide a word-for-word translation'.[64] The attempt to unite two disparate languages is the same as the attempt to unite signifier and signified within one language. As poet, futurist and linguist, Jakobson defines poetry as completely untranslatable:

> The pun, or to use a more erudite, and perhaps more precise term – paronomasia, reigns over poetic art, and whether its rule is absolute or limited, poetry by definition is untranslatable. Only creative transposition is possible: either intralingual transposition – from one poetic shape into another, or interlingual transposition – from one language into another, or finally intersemiotic transposition – from one system of signs into another, e.g., from verbal art into music, dance, cinema, or painting.[65]

Jakobson's concept of 'creative transposition' is important for *zaum* and futurist poetics in general, as a principle of language as a multiplicity within itself. Jakobson distinguishes further between three different types of translation in his later essay on the topic, which he expresses thus:

1 Intralingual translation or *rewording* is an interpretation of verbal signs by means of other signs of the same language.

2 Interlingual translation or *translation proper* is an interpretation of verbal signs by means of some other language.

3 Intersemiotic translation or *transmutation* is an interpretation of verbal signs by means of signs of nonverbal sign systems.[66]

The problems of non-equivalence at three levels are discussed in this essay. In terms of the first one, Jakobson points out that synonymy within one language is not complete equivalence. A *rewording* does not carry identical meaning; a synonym is a substitution or surrogate, but it is not completely equivalent. In terms of the second level, there is no full equivalence between code-units in different languages – it is only ever an appropriation; it is something akin to the original meaning but not an identical replicate. Languages are not exact equivalents of one another; lexical items cannot be swapped one-by-one because grammatical structures and concepts operate differently. In terms of the third

level, the sign systems are of a completely different type, so there is no chance of equivalence, only analogical comparison.

All three types of Jakobson's translation are relevant to this study of Deleuze and futurism because they deal with translation as a kind of dynamic 'shift' from one type of system to another, but it is the first one that is the most pertinent to the current questions being addressed. Here Jakobson's intralingual translation places the concept of translation, and therefore the concept of difference, within one supposedly unified language. The result of this is a further multiplication and internalization of difference. This will become even more significant when we take Deleuze's concept of difference into account. If like Jakobson we view synonymy as a type of translation, then the movement of language is a consistently translative movement. How then does this work with neologisms? How do we translate a newly created piece of language? The only way we can begin to answer this question is by asking it first of poetry in general, which is less radically 'creative' than pure neologism but still relies on different relationships between sound, shape and sense to create its meaning. As previously discussed and according to Jakobson's poetic function, the fact that the poetic function projects similarity into contiguity means that phonemic similarity is sensed as a semantic relationship. Two important things must be stated as a result of this. First, poetry can be said to be working against the fundamental tenets of Saussurian structuralism. The sound and shape of language is not arbitrary in poetry. Secondly, translation of poetry is technically impossible. It is impossible because at its base is paronomasia rather than any discrete semantic value, and to translate this requires an entirely new poem, or as Jakobson calls it, 'creative transposition'. Now, if we push Jakobson's description of poetry as paronomasia to its furthest extreme (he focuses on sonic rather than graphic aspects, which also contain possibilities), this would be pure neologism, gaining its only symbolism from phonemic aspects. This does not just require 'creative transposition': with a neologism there is no semantic context whatsoever from which to hang even a transposition. An entirely new neologism is required.

In the above three types of translation, Jakobson is setting out a blueprint for avant-garde theory and practice. Translation of all kinds is vitally linked to the avant-garde, and especially to the project of *zaum*. The 'za', the 'beyond', is immediately a type of

translation before the concept of translation is even introduced. It differs within itself; it performs an internal interlingual transposition every time it is spoken or written. Interlingual transposition of *zaum* enhances the belief, held by Jakobson and Kruchenykh, that every translation of poetry is in fact not translation but an entirely new poetic act. This is why translators of *zaum* poetry are necessarily poets in their own right. Intersemiotic transposition is also a vitally important facet of avant-garde art in the form of the transition from one disciplinary boundary to another. It might come in the form of the transposition of writing to painting in concrete poetry, or the transposition of writing to music in the form of sound poetry (to give two linguistic examples), but the transposition – the discovery of the limit and then the stretching and breaking of this limit – is a fundamental aspect of futurist poetics.

Nonsense: Formalizing, transposing, deviating

If we continue to think of translation as one type of dynamic shift, how would we characterize the translation of newly coined words? There is obviously an additional level of complication within the field of translation when the original language incorporates words that do not have an established meaning. *Zaum* is one type of 'nonsense' which requires creative transposition. Another example of the exploitation and perhaps explosion of this limit of linguistic sense can be found in Antonin Artaud's partial and critical attempt at translating Lewis Carroll's 'Jabberwocky'. Deleuze seizes upon this fragment in *The Logic of Sense* and uses it to promote his two typologies of nonsense, one of which is more predictable and regular than the other. As with much Victorian literary nonsense, Lewis Carroll's portmanteau words rely on the strict rules of grammar to uphold their meaning. The division within between standardized, formalized nonsense and the later, more radical Artaudian 'schizophrenic' nonsense is extremely important, as its reliance on paradox is symptomatic of much of Deleuze's concepts. He appears to approve of the instability or inconsistency of nonsense to a certain extent, so long as it is consistent in its

inconsistency. This is the static or perhaps substantive paradox of Lewis Carroll's nonsense. We can oppose this to a more dynamic, performative type of nonsense, equally perceptible in form and content because the two are inextricable. Mathematician Roger Penrose, credited with the impossible 'tribar' or Penrose triangle, differentiates between 'pure' and 'impure' impossible objects. Pure impossible objects are consistent in their inconsistency: the impossibility they display is the same everywhere in the picture. Impure impossible objects display variations of consistency and inconsistency.[67] The idea of a static inconsistency fits neatly with Carrollian paradoxes in their specific blend of adherence to and deviation from rules of grammar and sense. Dynamic or variable inconsistency, however, is more destabilizing and less predictable. We can see the latter type of inconsistency in Deleuze's discussion of the Carroll's nonsense follows strict formal guidelines. Through an analysis of these inventions Deleuze distinguishes three types of esoteric word: *contracting* words in which the sense is squeezed from several lexemes into one; *circulating* words in which two heterogeneous propositions or dimensions of propositions are conjoined; and *disjunctive* or *portmanteau* words which only occur when two heterogeneous series are conjoined with a disjunction between them.[68] According to Deleuze, Carroll's 'frumious' is a true portmanteau word not just because it consists of two heterogeneous components, but also because there is a disjunction between these components: simultaneous convergence and ramification. At this point it is as though Deleuze is positing this bi-directional type of nonsensical typology as more radical than total linguistic anarchy; simultaneous convergence and ramification as akin to Penrose's 'consistent inconsistency' mentioned above.

The distinctions above belong to Carroll's playful nonsense of the 'surface' rather than Antonin Artaud's more extreme and terrifying nonsense of 'bodies'. In one letter written from the asylum in Rodez where he ended his days, Artaud's own preference for vital, visceral language is clear:

> I don't like surface poems or surface languages, works which speak of happy leisure hours and felicities of the intellect, the intellect in question was based on the anus, but without putting any soul or heart into it. The anus is always terror, and I cannot accept the idea of someone losing a bit of excrement without

coming painfully close to losing his soul, and there is no soul in 'Jabberwocky'.[69]

The mention of the 'surface' in relation to Artaudian or schizophrenic language *is* matter to such an extent that it can affect the body. This type of nonsense is not a convergence of signifier and signified: these two series no longer exist. It is closer to futurism than it is to Carroll's logical-linguistic conundrums, because of the foregrounding of materiality and the radical manipulation of a linguistic surface. The difference between Carrollian and Artaudian nonsense lies in the location of the nonsense: if language is located exactly on this surface which is the boundary between propositions and things, Deleuze sees Artaud's language as having crossed the boundary into the 'depths' of schizophrenia, where language *is* material first and foremost. It is so material it has the power to wound and maim. While there is more detailed discussion of Deleuze in Chapter 2 and of Artaud in Chapter 4, what concerns us in this chapter is the moment when the nonsense of Artaud confronts the nonsense of Carroll, in the vein of a partial translation or creative transposition.

The place where Artaud confronts Carroll is of particular interest here, as it represents a double kind of linguistic indeterminism: it is the metamorphosis of nonsense from one language to another. The place of confrontation is Artaud's 'translation' of the first verse of Carroll's 'Jabberwocky':

'Twas brillig, and the slithy toves
Did gyre and gimble in the wabe:
All mimsy were the borogoves,
And the mome raths outgrabe.[70]

Il était Roparant, et les Vliqueux tarands
Allaient en gibroyant et en brimbulkdriquant
Jusque là lò la rourghe est à rouarghe a rangmbde et rangmbde
 a rouarghambde:
Tous les falomitards étaient les chats-huants
Et les Ghoré Uk'hatis dans le Grabugeument.[71]

It is immediately apparent that there is a considerable diversion from Carroll's verse. Language here tends towards becoming wholly

tonic or wholly consonantal, with vowels and consonants becoming fused together to create tonal or fricative sounds. The groups of vowels and consonants are described by Deleuze as 'passion' and 'action' words. Passion-words have all their phonetic elements removed; action-words have all their tonic elements removed. The addition of these tendencies to the text of 'Jabberwocky' can be seen in Artaud's fragment, where an increasing number of vowels and consonants are placed next to one another in the portmanteau words. The word 'rangmbde' contains five consonants placed next to one another, which is a cluster that does not exist in 'regular' French or English. It is particularly significant that in the English translation of *The Logic of Sense*, Mark Lester translates the third line of Artaud's translation back into English as 'Until rourghe is to rouarghe has rangmbde and rangmbde has rouarghhambde'.[72] Rather than attempt to invent more anglicized versions of these portmanteau words, he leaves each of Artaud's 'nouns' untouched.

What is interesting in Artaud's rendering of Carroll's nonsense is the deviation. Artaud departs considerably from whatever ambiguous sense is promulgated in Carroll's lines, and moves towards a radical linguistic materiality. There is an element of this radical materiality that can be found both in futurist poetics (Russian and Italian futurism exhibiting this in different ways) and in the writings of the 1960s Deleuze, and will be returned to in Chapter 3.

From futurism to formalism

The link or transition between Russian futurism and Russian formalism bridges the gap between the futurists' artistic output and Jakobson's structuralist theories. Just as 'futurism' was originally a derogatory term and was only later adopted by participants in the movement, the same occurred for 'formalism', which was for the Russian formalists a pejorative label used by their opponents.[73] According to Victor Erlich, another point of comparison between Russian futurism and formalism is that they both grew out of a reaction against the symbolist movement and all that it stood for. The unity of formalism and futurism in this regard is also outlined in Boris Eichenbaum's 'Theory of the Formal Method' (1926), an

important document that aimed to solidify some tenets of formalist theory.[74] While symbolist poetics constituted the first attempt to get rid of the dichotomy between form and content and the futurists shared this attempt, the difference was that the futurists treated the word as a thing in and of itself rather than a symbol standing for something else. Erlich does however stress that Russian formalism cannot be described merely as a reflection of futurist poetics.[75] There is therefore a distance or separation between the writings that inspire Russian formalism and the writings that are used to demonstrate it, but this separation between theory and practice is common of the avant-garde and can also be seen in the philosophical literary 'practice' of Deleuze. As we will discover, his writing is also temporally bound despite its greatest attempts to eschew temporality.

In terms of spatiality versus temporality in language, for Shklovsky the spatial understanding of language is the insufficient one, whereby in the 'shift' or 'estrangement' of poetic speech the language is digested 'in its temporal continuity'. This for Shklovsky is successful artistic practice and appreciation. Shklovsky's description of art is in fact very useful as a theorization of the futurists' 'shift' described at the beginning of this chapter: to him it is a process that 'removes objects from the automatism of perception'.[76] The remove he describes is the dynamic prefix, the za- of zaum. There is, however, one important distinction. The Russian formalists were linguists and theorists; the Russian futurists were poets and artistic practitioners. Obviously figures such as Jakobson constitute an overlap, but in general, the vastly differing approaches are important to remember. While the formalists viewed defamiliarization as one mode of cognition among others, the futurists believed that it showed the world as it really was. Despite this difference, the futurists and formalists were linked through a shared desire to revolutionize linguistic perception. One important reason why the Russian futurists wanted to reconfigure the word is to avoid the involuntary cognitive processing of objects as they are known, and instead to perceive them anew each time. This idea is fundamental to both formalist and futurist thought. The distinction between 'recognition' and 'seeing' is described by Shklovsky in 'Art as Technique':

By this 'algebraic' method of thought we apprehend objects only as shapes with imprecise extensions; we do not see them in

their entirety but rather recognize them by their main character-
istics. We see the object as though it were enveloped in a sack.
We know what it is by its configuration, but we see only its
silhouette.[77]

If we think about this idea verbally and linguistically, it is the word
itself that is enveloped in a 'sack' of a preconceived configuration.
This is the normal procedure of the standardization of words,
and the language of *zaum* works against precisely this standardi-
zation. Shklovsky states the significance of the futurists' work for
this project in his important text 'The Resurrection of the Word'
(1914). This is a manifesto that seeks to echo the sentiment of
the futurist manifestos written the year before bridges the gap
between futurist and formalist poetics through a shared celebration
of new forms. In this text Shklovsky defines the aim of futurism
as 'the resurrection of things – the return to man of sensation of
the world'.[78] It is clear that the formalists were working on what
they saw as a theory of general perception. Familiarity is to be
avoided in favour of experiencing every word as if for the first
time, and *zaum* language allowed for the actualization of this
idea owing to the fact that each time the word would actually
be different, making novelty and innovation an eternal part of
the linguistic process. The texture of language is palpable in both
futurist and formalist writings; it is clear even in English transla-
tions how much language was perceived in terms of sensation.
Shklovsky's analogies are often to do with verbal texture; he warns
in 'The Resurrection of the Word' (1914) that epithets have 'worn
smooth', which is to say that they no longer have the sensory
resonance they once did.[79] This 'smooth' language is presented
as prosaic and unfelt, which is contrasted against the language
of poetry in 'Art as Technique', described as 'a difficult, rough,
impeded language'.[80] This perception of language is foreshadowed
one year previously in the writings of Khlebnikov and Kruchenykh:
they describe their work as 'plenty of knotted ties and buttonholes
and patches, a splintery texture, very rough'.[81] The implications of
this linguistic materiality will be discussed further in Chapter 3, but
for now it is enough to note that a heightened awareness of verbal
texture is a fundamental aspect of the 'liberation' or 'resurrection'
of the word from its supposed strictures of standardization.
One of Kruchenykh's three more 'theoretical' books from 1923

(alongside *Shiftology* and *Apocalypse in Russian Literature*) was in fact entitled *Verbal Texture*.[82] The sonic and visual properties of language are obviously explored multifariously within avant-garde writing, but the texture of it – requiring extra dimensions and methods of perception, presentation and description – is something that the Russian futurists took further than most.[83]

The purpose of art, Shklovsky goes on to declare, is 'to make a stone feel stony'; it is to reunite an object with its sensation. This extract shows perhaps more clearly than many formalist writings the link between the futurist practice and the formalist theory. Examples used by Shklovsky and others do not come from the futurists themselves; less controversial figures such as Russian literary stalwarts Tolstoy, Pushkin and Dostoevsky are analysed. As previously discussed, the Russian futurists are hostile towards such figures, commanding in their manifesto 'A Slap in the Face of Public Taste' (1912): 'Throw Pushkin, Dostoevsky, Tolstoy, etc., overboard from the Ship of Modernity.'[84] They are employed by the formalists, however, because if a science of literature is being established, then it is necessary to start at least with some predictable theorems that can only later be problematized or challenged. The futurists' output would be no good as a starting point for the formalization of literature, but they are its inspiration. The fact that the telos of the avant-garde project is formalism might seem surprising, but it is no more surprising than the fact that the telos of nonsense is formalism. The removal of particularities in the dynamic shift of 'abstraction' or estrangement moves the language closer towards formalism. Despite this upholding of forms, both futurism and formalism here can be characterized through a critique of their own temporal forms.

A critique of time

While Russian formalism is linked historically and thematically to futurism, the general concept of a preoccupation with form in all its guises is inherent to the futurist reconstitution of expression and perception. Whether we are talking about Russian formalism or formalism in general, and whether we are talking about Italian or Russian futurism, there is within this concept an inbuilt manoeuvre

away from temporal constriction. Both the preoccupation with form and the critique of time find their apex in futurism, which exhibits this much more strongly than any other avant-garde movement. This manoeuvre of temporal critique is another version of the 'shift' which has been discussed in various ways throughout this chapter. The shift in this case is a movement away from, and refusal of, chronological time. Modernist novels are often used as examples to demonstrate the idea that form, or structure, contends against time. High modernists such as Joyce and Woolf engender a complex temporal relay of succession, eternity and the instant through the manipulation of their own form. In fairly recent literary theories of modernist temporality, form is defined as a 'momentary refusal of sequential integration'.[85] The failure of this refusal, however, becomes clear in the attempt to convey the atemporal modernist or futurist 'moment' in real time, from within the confines of the temporally bound narrative format of the novel. This failure itself often then becomes the subject of the narrative.

Form, then, is a central concern of not just the avant-garde but modernism as a movement. The definitions of 'new', 'modern' or 'avant-garde' are such that they defy chronology, but any attempt to defy chronology emerges for historical reasons and is subject to its own historicization. The problematic nature of this has not gone unnoticed. There is a clear division within temporal theories of the avant-garde, between dialectical Hegelian theories such as Bürger's *Theory of the Avant-Garde* (1974) and Kantian expositions such as Lyotard's 'The Sublime and the Avant-Garde' (1984). The debate centres round whether the avant-garde as a critique of time manages to escape its own historicization. As already stated, however, these arguments do not distinguish between the various movements of the avant-garde and do not relate specifically to futurism.

'We stand on the last promontory of the centuries!', declares a defiant Marinetti in his first manifesto.[86] As an intensified temporal 'promontory' both linked to and separate from modernism, futurism is concerned with the category of the new – perhaps futurism more than any other avant-garde element. Critics of varying positions have discussed the role of the new within the avant-garde, placing themselves somewhere along a spectrum of perceptions of the category of the new. The relationship between Russian futurism and formalism, and the subsequent retraction of

Russian formalism at the hand of the Soviet government, happens to be one particularly stark example of this process of historicization in action. Shklovsky himself is aware of the temporal nature of these problems. At the end of 'Art as Technique', in a description of the systematization of rhythm in prose, he makes this comment:

> We have good reasons to suppose that this systematization will not succeed. This is so because we are dealing here not so much with a more complex rhythm as with a disruption of rhythm itself, a violation, we may add, that can never be predicted. If this violation enters the canon, then it loses its power as a complicating device.[87]

The idea of the 'violation' entering the canon is precisely what happens to the avant-garde, which is its problem. Once it enters the canon it has been subjected to the same temporal constraints as all the other movements, thereby demonstrating that its premise – to thwart the entirety of what has gone before it – is false. Herein lies the paradox: the concept of the avant-garde can only ever be historically determined, but historical determination is exactly the opposite of the concerns of the avant-garde. The differentiation between a development and an entire break is a key question of this book. Bürger does not contest Adorno's claim that the conception of the new within modernism is an entire break rather than a development, but the important problem he finds with Adorno here is the fact that Adorno views this as a general principle, whereas for Bürger it must be historically determined. Bürger always maintains that aesthetic theories must themselves be historicized, which is an extremely important point.[88] Bürger characterizes the avant-garde as the period in which art as an institution enters self-criticism. Bürger uses this category of self-criticism by drawing from Marx's critique of religion and Marcuse's critique of art. Marx finds religion duplicitous just as Marcuse finds art duplicitous; from these examples Bürger describes what he calls the 'twofold nature of ideology'.[89] As Richard Murphy points out in *Theorizing the Avant-Garde: Modernism, Expression, and the Problem of Postmodernity* (1999), the avant-garde of the early twentieth century marks a point where this self-criticism itself becomes institutionalized.[90] Murphy criticizes Bürger's theories for several reasons. First, Bürger does not discuss expressionism,

which is the focus of Murphy's book in detail. Murphy believes that Bürger does not provide a sufficient distinction between avant-garde movements, although the particular examples of artworks he discusses are drawn from dada and surrealism. While Murphy argues that expressionism needs to be included and mentioned as an important part of the avant-garde, I would argue that futurism, which Bürger barely mentions, is even more important. In terms of an extreme temporal 'promontory', I believe that the futurist movement eclipses all other avant-garde movements in its attempt to be at the front – to be at the furthest point *ahead* of its time it is possible to reach. Studies such as Bürger's fail to recognize this competitive drive within futurism to be the newest and most extreme. It appears to me that as one of the earlier movements beginning right at the beginning of the twentieth century with Marinetti's first futurist manifesto published in 1909, the radical novelty of the futurist aesthetic should be viewed as emblematic or synecdochic of much of what the avant-garde stands for as a whole.

Formalism's retrenchment

It is clear that futurism and formalism are related. Alongside the preoccupation with form and subsequent reformulation of temporality there is also the necessary accompanying critique of mimesis or representation. None of these aspects can exist without the other happening as a result: a preoccupation with form leads to a reformulation of temporality, which in turn produces a critique of representation. Philosophically speaking, a critique of representation is precisely Deleuze's project, as we will see in the next chapter. A critique of representation is implied in the Russian term *bespredmetnost'* (nonobjectivism), which is just one of the terms used for both painting and writing within Russian futurism.

With regard to futurism and formalism there are two fundamental temporal problems. First, formalism heralds the 'death knell' of the avant-garde in that it constitutes an attempt to extract and solidify the very thing which resists this attempt: the eternally forward-charging dynamo of artistic revolution. Its rules, which purport to inhabit an extra-temporal space, are of course instantly

historicized. Secondly, owing to this historicization it is also possible to see with hindsight that formalism, once it became viewed as an enemy of Soviet culture, came to represent utter Kantian artistic autonomy which required colossal ideological retractions. The conflicting analogies of mirror and hammer were of paramount importance in Russia at the time of the Revolution, as they encapsulated the debate between autonomy and commitment. Trotsky has something to say on this:

> Art, it is said, is not a mirror, but a hammer: it does not reflect, it shapes. But at present even the handling of a hammer is taught with the help of a mirror, a sensitive film that records all the movements.[91]

Trotsky's plea that art remain content-based is typical of the pressures exerted by the government after the Revolution. At the other end of the spectrum, Shklovsky's famous declaration in 1918 that 'Art has always been free of life; its flag has never reflected the color of the flag flying over the city fortress', presents him at his most purely formalist position.[92] To Shklovsky just as much as the futurists, the word itself is everything. He understands the word itself as carrying a different function in art and in life: in life he describes the role of the word as 'a bead on an abacus', whereas in art the word is 'a texture'.[93] Shklovsky's later works demonstrate an extremely difficult ideological retraction – a desperate attempt to maintain his artistic principles and yet appease the government enough so that he could continue working. In his ambiguous and tortured piece of writing from 1923, *Zoo, or Letters Not about Love*, Shklovsky expresses two views of art, which display one perspective on his measured retraction from earlier formalist statements. He describes art first as a 'window on the world', and secondly as a 'world of independently existing things'. The window analogy, however, is later modified, and Shklovsky concludes that 'Art, if it can be compared to a window at all, is only a sketched window.'[94] Shklovsky is in the difficult position of trying to effect a complete theoretical about-turn so that he can continue to work while maintaining his artistic integrity, and he attempts this in these books from the 1920s by shrouding his statements in ambiguity. Shkolvsky's *Zoo* was severely censored in 1964 with a lot of the bitter irony taken out.

For example, Shklovsky follows the moment of his 'surrender' in the text with a pointed and contradictory anecdote detailing the ways in which Turkish soldiers who surrendered to the Russians at the battle of Erzurum were massacred on the spot, insinuating that this is what might happen to him if he returns. This contradictory section is removed.[95]

Shklovsky's book *Knight's Move* (1923) is titled thus because the specific L-shaped move made by the knight in a game of chess is for him emblematic of the limited and contorted way he was forced to express himself in the wake of the Revolution:

> There are many reasons for the strangeness of the knight's move, the main one being the conventionality of art, about which I am writing.
> The second reason lies in the fact that the knight is not free – it moves in an L-shaped manner because it is forbidden to take the straight road.[96]

It appears at this point that Shklovsky objects to the general fact that artistic production is restricted, rather than any more specific ideological directions. The fact is, however, that the very decision to restrict art is an ideological one.

> The greatest misfortune of Russian art is that it is not allowed to move organically, as the heart moves in a man's chest: it is being regulated like the movement of trains.[97]

Interestingly, this analogy is decidedly anti-futurist in its stance; the relatively modern phenomenon of the train is the 'bad' clockwork mechanism. Russian formalism came under heavy attack from the government after the October Revolution, and was directly aligned with bourgeois thinking by influential figures such as Anatoly Lunacharsky, the first Soviet Commissar of Enlightenment for culture and education. 'Complete absence of content has been very characteristic of bourgeois art of recent times', he asserted in 1920.[98] Formalism would slowly become inextricably linked with bourgeois thinking, with leading scholars forced to rethink their positions or flee the country. The project of Russian formalism's critique is continued in Fredric Jameson's *The Prison-House of Language: A Critical Account of Structuralism*

and Russian Formalism (1972). Jameson's critique of Russian formalist Vladimir Propp's famous functions of the folk tale is important when thinking about a possible critique of Deleuze's own 'formalism':

> This is what the rather Hegelian analysis we have given of Propp aims at doing – reducing the individual events to various manifestations of some basic idea, such as that of otherness, or of work, and ultimately reducing those ideas to some central notion on which they are all partial articulations, so that what at first seemed a series of events in time at length turns out to be a single timeless concept in the process of self-articulation.[99]

Jameson's critique of the formalists' conception of narrative, therefore, is based on temporality. While the formalists were concerned with omitting temporality from the equation, Jameson inserts it back in. According to Jameson, the models proposed, such as Propp's formula for the folk tale mentioned above, purport to work according to a synchronic and not a diachronic perspective. They constitute the attempt to abstract themselves from particularities, but Jameson maintains that these texts are ultimately tethered to their own synchronic temporalities nevertheless. This temporal critique of the supposed narrative paradigms is important because it demonstrates the important point that all types of narrative – folk tale, short story or novel – are subject to their own temporal movements and are therefore unable to live up to their own paradigmatic projections. This critique can be applied to Deleuze's own self-styled 'narrative' and his pronouncements on the 'empty form' of both language and time, which will be discussed in the following chapters.

CHAPTER TWO

Poetics of Deleuze: Structure, stoicism, univocity

Introduction: Deleuze's conceptual shift

Deleuze does not discuss futurism at length, although his oeuvre is peppered with references to the avant-garde. For example, in *What Is Philosophy?* (1991) Deleuze and Guattari describe philosophy as a 'constructivism', defining the practice of philosophy as the creation of concepts.[1] In *Negotiations* (1990) Deleuze half-jokingly describes his philosophy as a kind of '*art brut*'.[2] As already mentioned, Deleuze concludes his essay on performative language, 'He Stuttered' (1993), with the briefest of nods to the Russian avant-garde.[3] In his book *Deleuze and Language* (2002) Jean-Jacques Lecercle goes as far as to describe Deleuze as exhibiting a 'modernist' or 'avant-garde' aesthetics.[4] In terms of futurism itself, some critics have presented certain aspects of Deleuze's philosophy as pertaining to 'the future' or 'the new', although this has not been discussed so far in terms of his linguistic drives or his language use.[5]

From the side of avant-garde theory, in his *Five Faces of Modernity* (1987) Matei Calinescu describes Deleuze and Guattari as belonging to the 'fashionable intellectual avant-garde'.[6] More fundamental than these transdisciplinary cross-references, however, are some common structural elements

– encapsulated thus far in dynamic element, the 'shift' of a prefix. The previous chapter discussed the multifarious nature of 'shiftology', invention of Russian futurism. If it were possible to view this dynamic element discussed in the previous chapter in a philosophical sense, then Deleuze would be a prime exponent of this manoeuvre. The shift, championed by Khlebnikov and Kruchenykh and encapsulated by the dynamic prefixes *'za-'* in *zaum* or 'trans-' in transreason, denotes precisely the type of nonlinear creative and conceptual movement that is required to make Deleuze's philosophy work. It is possible to view the 'shift' in a number of different ways, which again makes it particularly appropriate for Deleuze's philosophy. In terms of dynamic conceptual systems, *zaum* provides a helpful analogical model for the movement of Deleuze's thought. Among other things, Deleuze's aim is to prefix philosophy or the history of philosophy with a comparable kind of dynamic element or gesture. The desire to bypass any established or conventional system of both language and thought is just one of many aspects that link Deleuze's theories to the avant-garde. It is important to remember, however, that in both futurist thought and Deleuze's thought the shift is at once both linguistic and conceptual. It is precisely this inseparability between the linguistic and the conceptual that links up Deleuze and futurism. At the heart of this link is a preoccupation with the form of language; form is the thing that is identified and deconstructed in order to be infinitely reinvented. Deleuze does this in various ways with both language and time, and these will be discussed in the following chapters.

Deleuze's concepts are structured in such a way that the constraints of narrative linearity make it difficult to render them fully. Often a neologism, a diagram or a formula is required rather than merely conventional words and sentences, which is significant when we think about the attitude towards linguistic conventions that Deleuze himself is presenting. This makes one language a multiplicity of languages, and calls to mind Jakobson's multiple types of translation discussed above. Deleuze's deployment of complex and intensive spatiotemporal formulations such as paradox, interdependence, simultaneity, topology, series and differential equations renders conventional syntactically arranged explanatory sentences woefully inadequate. Scholars work hard to avoid the trap of

reproducing Deleuze's work, but this is often difficult because, as will be explained in this chapter, a kind of reduplicative synonymy is one of the benchmarks of his style. He outlines his terms in a deliberately circuitous manner in which a number of related terms are employed to describe one concept. This performs or enacts the movement of language itself: a merry dance around the central fire of a concept but never quite touching it, or, in the words of Lewis Carroll, the hunting of the Snark. Deleuze often enacts his own concepts through language in this way. This chapter will demonstrate that the linguistic practices Deleuze proposes, not only incorporating his ontological proposition of univocity but also underpinning his affirmation of nonsense and paradox, operate synecdochically for his entire philosophy.

Style

Style in philosophy is the movement of concepts.[7]

Deleuze's aesthetic objectives inform his whole ontology. To get a clearer idea of how this works, it is necessary to look at his most overt attempt at outlining these objectives to see how closely it relates to the rest of his writings. While Deleuze and Guattari's essay 'Rhizome' (1976) comes from a later period of Deleuze's career, it is an exemplary philosophical work in the guise of an avant-garde manifesto. The ideas about writing propounded in this text are equally applicable to thinking and being. While 'Rhizome' forms the introduction to *A Thousand Plateaus* (1980), the second part of their two-volume work *Capitalism and Schizophrenia*, it was first published as a stand-alone pamphlet in 1976. This is Deleuze's most obvious attempt at utilizing the format of a manifesto, creating a sympathetic parody of the manifesto style.

> The multiple *must be made*, not by always adding a higher dimension, but rather in the simplest of ways, by dint of sobriety, with the number of dimensions one already has available – always $n - 1$... Subtract the unique from the multiplicity to be constituted; write at $n - 1$ dimensions.[8]

The language of 'Rhizome' contains elements that are immediately recognizable as traits of futurist manifestos: the conflation of algebraic and geometric terminology with literary imperatives in the excerpt above is one example. The reference to writing 'n-1' is reminiscent of Deleuze's formula for nonsense in *The Logic of Sense* mentioned in the previous chapter, although with a '-1' added it is as though the linguistic abstraction or estrangement is pushed even further. The objectives found in 'Rhizome', however, can be discerned in Deleuze's writing long before this publication emerged, and it is the emergence of the linguistic and poetic practices discerned in Deleuze of the late 1960s rather than the overt and deliberate use of the artistic manifesto found in 'Rhizome' that concern us here. They are significant because they start as a 'poetics' and become a model for Deleuze's philosophy. One of the ways to describe these practices is as a critique of representation. Because the linguistic and the conceptual are inseparable in Deleuze's work, this critique of representation is both a philosophical and a linguistic one. We often see in Deleuze's writing a prioritization of expression over representation, to the point that expression is the locus of meaning over and above anything else. 'The expressed is *meaning*: deeper than the relation of causality; deeper than the relation of representation.'[9] The logic of expression is at the heart of his philosophy, and finds its literary expression in 'Rhizome' in the statement that 'There is no difference between what a book talks about and how it is made.'[10] This interrelation describes the performative style of writing typical of modernism and the avant-garde, and is summed up in Beckett's famous comment about Joyce: 'His writing is not *about* something. It is that something itself.'[11] As well as celebrating linguistic immediacy, immanence and performativity, making *all* language operate as if it were a speech act, this description also allows language to become its own object and bypass the medium of signification and sense. The avant-garde demands that there be no discernible difference between content and form in writing: it should demonstrate what it elucidates and create its own meaning just as it creates its own form. Deleuze's poetics dictate the same thing, but there are more specific temporal aspects to this general avant-garde conflation to be found in Deleuze's thought, as we will see, which make his poetics specifically futurist.

One part of the paradox that holds *The Logic of Sense* together relies on linguistic materiality, as will be explained later. At the

simplest level, Deleuze's own literary style has been described in material terms. As mentioned in the introduction, Clément Rosset's remark on Deleuze's style compares it to a cracker with no butter: excellent but dry.[12] For readers of the polyphonic and virtuoso performance of *A Thousand Plateaus*, however, this claim may seem surprising. Furthermore, any of Deleuze's technical or 'dry' sections in *The Logic of Sense* and *Difference and Repetition* are counterbalanced by lyrical impressionistic passages which sometimes make his writing appear like a prose poem. These passages are just as important in outlining Deleuze's thought because they are often polysemous and performative, performing more than one function simultaneously through their very expression. For example, Deleuze's 'homage' to delirium and psychedelia in *The Logic of Sense* ends in a love note that directly addresses its topic in a tone which reads like exultant poetry. Extolling the revelatory effects of drugs and alcohol minus the actual ingestion of these substances, Deleuze exclaims:

A strafing of the surface in order to transmute the stabbing of bodies, oh psychedelia.[13]

This sentence is by no means 'dry'; it is a lyrical and poetic outpouring of intense and ambivalent sensation. Arresting imagery is used to outline a process by which the surface of language becomes perforated and its materiality becomes more perceptible, through the loosening of the constraints of sense. The first thing to note within the sentence is the use of apostrophe, conventionally more typical of the language of Romantic poetry than philosophy.[14] Rather than a person, however, Deleuze uses apostrophe to address an abstract phenomenon. This anthropomorphization of phenomena is one of Deleuze's stylistic traits and will be discussed at various points in the following chapters. In this case psychedelia is endowed with subjectivity and becomes a character in the book. The process of personifying concepts and forms is one that Deleuze explicitly identifies in his own writing later on. 'Philosophy's like a novel', he says. 'You have to ask "What's going to happen?" "What's happened?" Except the characters are concepts, and the settings, the scenes, are space-times.'[15] There is a 'shift' taking place here, which we could describe as a process of estrangement or depersonalization, in which the roles conventionally assigned

to human beings are assigned to abstract concepts. Linked to this process is the passage in *What Is Philosophy?* in which Deleuze and Guattari describe some proper names used by particular philosophers to denote particular concepts as *'conceptual personae'*.[16] The examples they give – 'the Socrates of Plato, the Dionysus of Nietzsche, the Idiot of Nicholas of Cusa'[17] – are already characters in their own right, but Deleuze and Guattari insist that this does not mean the same as the author's name, which they call a 'pseudonym'. A literary heteronym carries its own personality and style rather than functioning merely as another name for the philosopher. 'In philosophical enunciations we do not do something by saying it but produce movement by thinking it, through the intermediary of a conceptual persona.'[18] The preference for *moving* through *thinking* rather than *doing* through *saying* demonstrates the desire to bypass linguistic mediation, and places philosophical enunciations above even the performative speech act *'quand dire, c'est faire'* discussed in Deleuze's essay 'He Stuttered'.[19] In using the conceptual personae, the writing or utterance takes on a particular performative significance; it does something rather than merely saying it. The proper name itself carries a different function than conventionally understood; in both *Anti-Oedipus* and *A Thousand Plateaus* it is described in terms of its force and effect as potential multiplicity rather than as a singular brand or tag.

> The theory of proper names should not be conceived of in terms of representation; it refers instead to the class of 'effects' ... This can be clearly seen in physics, where proper names designate such effects within fields of potentials: the Joule effect, the Seebeck effect, the Kelvin effect. History is like physics: a Joan of Arc effect, a Heliogabalus effect – all the *names* of history, and not the name of the father.[20]

> The proper name (*nom propre*) does not designate an individual: it is on the contrary when the individual opens up to the multiplicities pervading him or her, at the outcome of the most severe operation of depersonalization, that he or she acquires his or her true proper name.[21]

Clearly the proper name loses its propriety in Deleuze and Guattari's thought. The argument here is that this particular

function of both the proper name and the conceptual personae is just as perceptible in Deleuze's own earlier work; in fact, the 'depersonalization' of the proper name described at various points in *Capitalism and Schizophrenia* can be perceived at work in both *Difference and Repetition* and *The Logic of Sense*. In these works we can see concepts such as Chronos and Aion given the status of proper names: as the two orders of time, time itself is named. In a typically contrary double movement, depersonalization as a process ends up personalizing the most abstract of concepts.

Let us return to the sentence above from *The Logic of Sense*, this time in the French: '*Mitraillage de la surface pour transmuter le poignardement des corps, ô psychédélie.*'[22] As well as the romantic tone and form of the language, the second stylistic thing to note about this sentence is the aggressively invasive, bellicose nature of the imagery. Words like *mitraillage* [strafing] and *poignardement* [stabbing] result in the love note doubling up as a battle-plan. There is definitely a futurist aesthetic at work here; the sentence is travelling towards both the love and the destruction of language. The reader cannot help but think of the amorous violence of Marinetti's paeans to speed and destruction, for example the early poem 'To my Pegasus' (written by Marinetti in French in 1905, then translated by Marinetti to '*Ode all'automobile da corsa*':

Veemente dio d'una razza d'acciaio,
Automobile ebbra di spazio,
che scalpiti e fremi d'angoscia
rodendo il morso con striduli denti ...

Vehement god of a race of steel,
space-intoxicated Automobile,
stamping with anguish, champing at the bit![23]

The intensity of these lines and the focus on violence and speed is also something that is explored in Deleuze's language; this will be discussed more fully in Chapter 3. For now, though, the third stylistic thing to note both in Deleuze's sentence and in Marinetti's poem is the apparent use of the gerund or present participles for 'strafing', 'stabbing', 'stamping' and 'champing'. While Marinetti's poem exhibits this grammatical form without a doubt, Deleuze's are in fact nouns – it is 'a strafing' and 'a stabbing' taking place.

This usage renders the reader unsure whether Deleuze is describing a desired state of being or a state that already exists. This is the same problem encountered when looking at Deleuze's description of the process of language. Is this something he wants to happen, something that is happening and he is lamenting, or something that he is celebrating? There is a degree of ambivalence palpable in Deleuze's writing at times, linked to implacable temporal 'moments' signalled precisely by ambivalent grammatical constructions. The complex temporality of the linguistic events Deleuze describes requires a closer analysis.

The philosophical novel

As already stated in this chapter, Deleuze believes that his philosophy should be read like a novel.[24] Deleuze often prefaces his works with instructions on the mode of reading required, not only implying a level of metacommentary unusual for works of philosophy but also suggesting that his work requires a special kind of active and mindful reading. This is just as true for his earlier books as it is for his later collaborations with Guattari. He prefaces *Difference and Repetition* with a note stating that 'A book of philosophy should be in part a very particular species of detective novel, in part a kind of science fiction.'[25] He also prefaces *The Logic of Sense* with a description of the book as 'an attempt at a logical and psychoanalytical novel'.[26] More obviously 'literary' than *Difference and Repetition* due to the recurring motif of Alice in Wonderland and yet no less creative in its ontological presuppositions, *The Logic of Sense* takes language as its primary subject. As well as functioning as a discussion about literature, the book itself reads like a work of literature and contains literary features such as narrative and characterization. If *The Logic of Sense* is a novel, however, it is not written in the chronological style of the nineteenth-century realist novel, which is still used as a benchmark for conventional literary temporality. In Deleuze's own words, *The Logic of Sense* is written in a series of series. Series are variations that work both to connect and to individuate elements – they are bi-directional processes. As Deleuze states, for each series in *The Logic of Sense* there correspond figures that are

not only historical, but logical and topological.[27] In the placing together within his series of these three contrasting systems and arrangements of thought, Deleuze instructs the reader to sustain multiple temporal perspectives while reading – and of course reading dictates its own temporality. At one level there is a quasi-'historical' reading of the Stoics, Plato, Nietzsche and other figures – although typically this tradition or genealogy is a very singular and nonlinear one, and determined by no one but Deleuze himself. At another level there is a work of literary criticism, formulating retroactive theories on Carroll, Artaud, Mallarmé and others, at times developing Lewis Carroll's own ludic anthropomorphizations of philosophical anomalies, at others drawing from the dry lexical fields of analytic philosophy. At yet another level there is the building of Deleuze's own ontological foundations, continuing the work done in *Difference and Repetition* but tinged further with psychedelic colours. Rather than a linear novel, *The Logic of Sense* is arranged according to complex spatiotemporal patterns. The idea of series resonates throughout the book: not only is each chapter of the book a 'series' but Deleuze's reading of *Alice in Wonderland* reduces Carroll's narrative syntax down to the level of series, demonstrating the universal applicability of these structures whether technical, formal or living human categories are being outlined.

The reduction of a plot trajectory to a positive/negative opposition is used in traditional structuralist readings, for example Tzvetan Todorov's outline 'Bergamin is rich, then poor, then rich again: the important thing is to see there are not two autonomous predicates here but two forms of the same predicate, positive and negative.'[28] In the same vein, Carroll's Alice is small, then large, then small again. Both examples, 'rich' and 'poor', 'small' and 'large', are relative values, part of the same continuum and impossible to quantify. Deleuze's qualities, however, find their inspiration in Stoic thought. Deleuze's example 'the tree greens' is drawn from the Stoics and relates to a happening, an intensification, which does not occur in actual time but is rather what Deleuze calls an 'incorporeal event'.[29] The greening of the tree demonstrates the shift from an actual description of a state of affairs, whether qualitative or quantitative, such as 'green', to a verb, 'to green'. There are two shifting operations at work here. First, there is the shift from substantive to infinitive, which is a procedure at

work in Deleuze's philosophy on a much broader level than mere word class. Secondly, the quality of 'greenness' in theory becomes divorced from its positive or negative level of intensity so that it is no longer even relevant whether the tree is 'more' or 'less' green. The 'ideal' state of the tree in Deleuze's world is a constantly fluctuating 'greening'. What Deleuze does with this tree, however, is to add further spatiotemporal incongruities.

Deleuze's placing of the Stoic tree within Carroll's Wonderland is a typical manoeuvre of his which displaces conventional temporality at a multiplicity of levels. 'It is in front of the trees that Alice loses her name. It is a tree that Humpty Dumpty addresses without looking at Alice.'[30] This is interesting for a number of reasons. There is no reason why a tree in particular should be linked to the events of *Alice in Wonderland* or the events that occur therein; the example is simply the one that the Stoics choose to elucidate the infinite event of the tree's 'greening'. Deleuze, however, takes the incorporeal tree and places it in Carroll's text in an audacious leap across centuries of philosophical development. This is an example of a series at work, and the singular nature of it is reminiscent of, but not identical to, the Cratylic reasoning outlined in the previous chapter. Rather than creating a system of reason dictated by a coincidence of signifier and signified, Deleuze places a Stoic tree within Carroll's fictive world and manipulates the boundaries between literature and philosophy. We might even say that Marianne Moore's definition of poetry in her poem 'Poetry' (1935) of 'imaginary gardens with real toads in them' operates as here a philosophical concept.[31]

Wonderland is the imaginary garden, and the Stoic tree is the toad. What links the two operations – Deleuze's Cratylic reasoning on the word 'wabe' as discussed in the previous chapter and his discovery of a Stoic greening tree in Carroll's Wonderland – is the use of literary and poetic devices to produce sincere ontological statements. A type of radical creative audacity is required to create and uphold the premises of such statements – a methodology that accepts neologisms at a conceptual level instantaneously. This requires extreme brevity of thought; mental acceleration to the point of instantaneity. Conventionally within language, figural speech only becomes part of a collective conceptual framework once its metaphoricity is 'dead'.[32] Deleuze's thought requires the reader to perform this process instantly.

Paradox and nonsense: From the *lekton* to the Snark

As well as conceptualizing at speed, Deleuze's thought also requires the reader to accept and affirm processes and movements that are inherently paradoxical. Deleuze's dynamic 'shift' can be usefully described as that of a paradoxical movement; paradox is the *élan vital* of his thought. As mentioned in the introduction, Deleuze defines paradox as 'the affirmation of both senses or directions at the same time'.[33] The affirmation of paradox is a process that Deleuze has in common with the avant-garde. Paradoxes proliferate at every turn, from the linguistic contradictions of the dadaist manifestos to the 'impossible' object of the futurist book, which purports to capture precisely that which the movement decrees can never be captured.[34] Turning momentarily away from futurism, the self-reflexive, self-negating aphorisms of Tristan Tzara's 'Dada Manifesto 1918' are helpful as a model here, performing each linguistic contradiction for the reader in real time:

> I am writing a manifesto and there's nothing I want, and yet I'm saying certain things, and in principle I am against manifestos, as I am against principles … I'm writing this manifesto to show that you can perform contrary actions at the same time, in one single, fresh breath; I am against action; as for continual contradiction, and affirmation too, I am neither for them nor against them, and I won't explain myself because I hate common sense.[35]

Even the title of the manifesto in the *Dada Almanac* is presented with a disclaimer in the form of an asterisked editor's note which reads: 'The editor stresses that as a Dadaist, he is unable to identify with any of the opinions expressed here.' While the ludic element of *zaum* wordplay was highlighted in the previous chapter, there is evidence of this ludic element of the avant-garde being exploited to much greater lengths within the dada movement. Logically speaking, Tzara's clauses lead him towards impossible stalemates at every turn. Each item is called up within the language only to be negated in a movement that is almost instantaneous, but not quite.[36] This manifesto clearly operates according to alternative

systems of reason or logic, another type of 'transreason', but while *zaum* language operates according to language's sensory, grammatical or etymological properties, it is much more difficult to identify an alternative method in the dada extract above. Dada in general can be defined as a refusal of method, which always presupposes the counter-argument that the refusal of method is a method within itself. Deleuze's philosophy relies on the possibility that such a method can exist and does work.

An important thing to note about paradoxes in general is that they require more than one term. They are a particular expression of an opposition in which the condition that makes them possible is the same as the condition that makes them impossible. Not only do paradoxes require impossibility, then; they require the doubling of possibility and impossibility. Rather than 'simple' doubleness, therefore, Deleuze's doubleness is complex in multiple ways. In terms of the bridge between structuralism and poststructuralism, the complication of the binary opposition problematizes the concept of 'simple' doubleness. Paradox is one version of this problematization of the binary.

Deleuze's *Difference and Repetition* lays the foundations for an ontology which is then developed further in *The Logic of Sense*. Deleuze suggests that what may be at the heart of every idea is in fact difference rather than sameness or unity, and he reworks the concept of difference so that it is no longer a negation of sameness: it is 'pure' difference; the celebrated form of difference. Pure difference for Deleuze is intensive rather than extensive.[37] He explains this in *Difference and Repetition* by means of a differentiation itself: a minimal pair, 'differentiation/differenciation'. It is significant that this is demonstrated by means of what is above all a *phonological* opposition, highlighting again the importance of the linguistic model in framing Deleuze's thought. In the previous chapter, the shift in focus from the phonological unit to the phonological opposition was highlighted by Jakobson as a pivotal point in Prague structuralism. The common elements between Jakobson's and Deleuze's linguistics often come down to phonetics, and nowhere is this more obvious than in Deleuze's definition of differentiation. Only differing by one letter, the minimal pair differentiation/differenciation represents the split between the actual and the virtual spheres in Deleuze's ontology. The virtual content of an Idea is 'differentiation', which is an intensive element. The

actualization of this virtual content is 'differenciation', which is extensive. This distinction is a good example of how we might call Deleuze's philosophy performative, because he outlines the process of differenciation by producing an example of it, in the minimal pair 'differen*t*iation/differen*c*iation' itself. This creates a split at the heart of the concept but also performs it within the language, demonstrating that these opposing processes are simultaneously convergent and divergent. The paradox lies in the necessary and yet impossible coexistence of the minimal pair. This is an example of a linguistic function being endowed with synecdochic power, which is a trope Deleuze uses in many places. The minimal pair represents the actual/virtual distinction and is expressed not just *in* language but through the expression of a particular linguistic function.

Another example of Deleuze's futurist synecdochic manoeuvre can be found in *The Logic of Sense*, this time illustrative of the function of nonsense. Deleuze here makes a rare and brief reference to Jakobson himself. Deleuze highlights the fact that Jakobson defines a 'phoneme zero' by its opposition to the absence of the phoneme rather than to the phoneme itself. This is a small note made in Jakobson's essay on French phonology, in which the 'ə' phoneme (the 'schwa' vowel, unstressed and toneless, which has the same function in English such as the 'a' in 'about' or the 'io' in 'station') is defined in opposition to the absence of a phoneme altogether, which consequently affirms it and grants it a positive existence. Despite the fact that this phoneme has neither distinctive features nor a constant sound characteristic, it is still the opposite of no phoneme rather than being the opposite of a defined phoneme.[38] This zero phoneme is one of Deleuze's sources of inspiration for his 'empty square' of nonsense. It has no phonetically determined value but its quality of indeterminacy is its potentiality. Deleuze's use of nonsense is another example of his multifarious shift from substantive to infinitive; nonsense in its purest form is empty of substantive meaning but absolutely saturated with infinite potential meanings. Of course, the fact that language contains its own materiality is fundamental to the futurist drive, so we can never say that nonsense is entirely lacking in substantive meaning; merely the meaning is of a different type. Deleuze begins with the premise that that which does not have meaning can give meaning, presenting nonsense as a linguistic 'precursor' that makes or motivates sense. 'Whence the following paradoxical situation: the linguistic

precursor belongs to a kind of metalanguage and can be incarnated only within a word devoid of sense from the point of view of the series of first-degree verbal representations.'[39] There is much to be drawn from this statement which can be discerned within the poetics of futurism, especially *zaum*. In order for language to really say something, Deleuze states, it must express itself without the safety net of an established meaning or interpretation. In order for language to simultaneously create and self-theorize, it must depart from representation.

The paradox of sense and nonsense is at the heart of both *Difference and Repetition* and *The Logic of Sense*. We can say that for Deleuze, paradox *is* nonsense in so far as nonsense and sense are produced at the surface of language and co exist in an originary paradoxical relationship. 'The logic of sense is necessarily determined to posit between sense and nonsense an original type of intrinsic relation, a mode of co-presence.'[40] Rather than a celebration of structuralist arbitrariness, this framework is a critique of structuralism. The element of critique is palpable in the upholding of Cratylic thought, which we introduced in the previous chapter; the affirmation of a sonic motivation within language. Saussure would have agreed not with Cratylus but with Hermogenes, as François Dosse points out in his *History of Structuralism* (1997).[41] Deleuze makes it clear that he believes the paradoxical element as nonsense should be at the heart of the structuralist system as he sees it. 'Structuralism', he says, 'whether consciously or not, celebrates new findings of a Stoic and Carrollian inspiration'.[42] Deleuze blends structuralism and Stoicism in an innovative temporal leap, just as he does when he places the Stoic greening tree in Carroll's Wonderland. Both require some analysis, but we will deal with structuralism first.

Deleuze's structuralism

'There is good reason to ascribe the origin of structuralism to linguistics,' Deleuze writes in 'How Do We Recognise Structuralism?' (written in 1967), 'not only Saussure, but the Moscow and Prague schools'.[43] This important reference to the domain of Jakobsonian linguistics demonstrates Deleuze's awareness of his debt to thinkers

such as Jakobson in the thinking of language and difference. He goes on: 'In this case again, everything began with linguistics: beyond the word in its reality and its resonant parts, beyond images and concepts associated with words, the structuralist linguist discovers an element of quite another nature, a structural object.'[44] In this essay Deleuze defines structure through negation, stating that it is not a form, or a figure, or an essence: it does not have extrinsic designation or intrinsic signification. This structural object in Deleuze's eyes is an element that carries the same function as a paradoxical element; he describes it as a 'combinatory formula'.[45] Deleuze's structural element, however, is more than a two-sided or double-headed figure (as can be seen in descriptions of the nonsensical 'paradoxical element' in *The Logic of Sense*). He places it within the realm of the Lacanian symbolic rather than the imaginary or the real.[46] While the real tends towards unification and the imaginary towards doubleness, structure is described as 'at least triadic, without which it would not "circulate" – a third at once unreal, and yet not imaginable'.[47] Deleuze describes these as ordinal rather than cardinal, which is significant: the real is 'first', the imaginary is 'second' and the symbolic is 'third'. While the identification of the structural element as symbolic appears at odds with other pronouncements in *The Logic of Sense* which describe the *uni*vocity of language and the '*double*-headed thing', which identify language with the 'first' of the real and the 'second' of the imaginary respectively, this is not actually the case. The univocity of language *is* the real; it is the telos of the linguistic object.[48] The double-headed paradoxical element is unstable because its halves are not equal, which presupposes an indeterminate third term and gives Deleuze's system momentum. He describes it as a *perpetuum mobile*; its dynamism is at the very heart of Deleuze's philosophy of language.

> It is both word = x and thing = x. Since it belongs simultaneously to both series, it has two sides. But the sides are never balanced, joined together, or paired off, because the paradoxical element is always in disequilibrium in relation to itself.[49]

The figure of the paradoxical element is perhaps the most helpful elucidation by Deleuze of the dynamic element or 'shifter' already discussed. Its internal instability means that it cannot

be expressed in an entire positive value, which is why Deleuze turns to the differential equation. His route into this area of calculus is again the path of linguistics, and the concept of the minimal pair. The phoneme, he explains, is the smallest linguistic unit capable of differentiating two words of diverse meanings. What is important about phonemes is that they do not exist independently of the relations into which they enter, but they reciprocally determine each other.[50] Citing Raymond Roussel here and drawing on the minimal pair (*b*illard/*p*illard), this aspect is described in *Difference and Repetition* as 'the quasi-homonym which functions only by becoming indistinguishable from the differential character which separates two words (*b* and *p*)'.[51] The entirety of Deleuze's characterization of a structural element is encapsulated in the differentiation between two aspects of a minimal pair. This renders the element both dynamic and unstable, perched as it is between two aspects. It also displays a typical manoeuvre of Deleuze: he makes one minute linguistic element stand for an entire world of thought. He makes his differential structural element operate as a synecdoche for his philosophy of difference.[52]

Why is only differential calculus sufficiently emblematic of the symbolic order of structure for Deleuze, rather than other mathematical sources? The answer lies in the relation between the terms in a differential equation. The relation of difference can be seen in the differential equation dy/dx, which Deleuze deals with both in this essay and in *Difference and Repetition*.

> Dy is totally undetermined in relation to y, and dx is totally undetermined in relation to x: each one has neither existence, nor value, nor signification. And yet the relation dy/dx is totally determined, the two elements determining each other reciprocally in the relation.[53]

It is important to understand the link between these differing types of determination and their linguistic manifestations in *The Logic of Sense*. Reciprocal determination leaves the object completely undetermined; complete determination contains every possible determination of the object. Reciprocal determination is the way Deleuze defines the relation between the actual and virtual, with the minimal pair differen*t*iation/differen*c*iation as discussed early

in the chapter. The actual/virtual distinction is vital for Deleuze's definition of structure in this essay.

Of the structure as virtuality, we must say that it is still undifferenciated (c), even though it is totally and completely differential (t). Of structures which are embodied in a particular actual form (present or past), we must say that they are differentiated, and that for them to be actualized is precisely to be differentiated.[54]

Structure for Deleuze is therefore a multiplicity which consists of both reciprocal determination (of differential relations) and complete determination (of singular points). In terms of the actual/virtual relation, however, structure itself remains in the domain of the virtual. Again Deleuze cites Jakobson in his essay, using Jakobson's phoneme as an exemplary virtual object in that it is not an actual object in the vein of a letter or a word. Every single potential actualization of a phoneme inheres within its virtual structure. This is why the infinitive, linked to Deleuze's concept of univocity and discussed in the next section, is also an exemplary virtual object. Both a phoneme and a verb in the infinitive are incomplete as actualized linguistic objects, but contain every potential determination within their structure. The coexistence of reciprocal and complete determination is what makes structure for Deleuze not only a multiplicity but completely and affirmatively paradoxical. When it is actualized it becomes particular: *langue* becomes *parole*, whereas structure itself is not actualized. It is differential but undifferentiated. The fact that differen*t*iation is actualization for Deleuze, as outlined in the quote above, is the reason why paradox is so central to his thought. Deleuze says that structure 'envelops a wholly paradoxical object or element'.[55] We have already ascertained that the minimal pair differentiation/ differenciation represents the split between the actual and the virtual spheres in Deleuze's ontology. The virtual content of an Idea is 'differentia*t*ion', which is an intensive element. The actualization of this virtual content is 'differen*c*iation', which is extensive. Deleuze's concept of structure is dependent upon his characterization of the paradoxical element. This is why his structuralism is actually a blend of Stoicism and structuralism, and it is to Stoicism we now turn.

Deleuze's Stoicism

It is common to hear experimental modernist texts such as *Finnegans Wake* (1939) described as 'nonsensical'. Joyce's words operate in a paronomastic, sound-symbolic fashion:

> Phall if you but will, rise you must: and nont so soon aither shall the pharce for the nunce come to a setdown secular phoenish.[56]

While there are varying types of complex wordplay at work here, much of it relies on a thorough knowledge of the Irish vernacular, much like *zaum* requires knowledge of the Russian language. Whether the reader chooses to view Joyce's work as nonsense, however, depends very much on which definition of nonsense is being used. Deleuze calls the world of *Finnegans Wake* a 'chaos-cosmos', the entirety of which is a series powered by a 'letter'.[57] In his typical hyperbolic style, Deleuze does reduce Joyce's work down to one single function, but it is a function that can operate in an infinite number of ways. It is what Deleuze calls the 'paradoxical element', and it is significant that *Finnegans Wake* is the text he chooses to illuminate his definition. This text is an exemplary expression of the linguistic system Deleuze is arguing for. The words in Joyce's phonaesthetic masterpiece operate in a similar fashion to some of the *zaum* language discussed in the previous chapter in that they convey a sense using etymological and grammatical manipulations, but are constructed in a singularly different way which has generally involved the denaturing of a pre-existing lexeme. The 'nonsense' words used in *Finnegans Wake*, just like the *zaum* words used by Khlebnikov and Kruchenykh, are examples of the paradoxical element at work. This element is defined by Deleuze as a two-sided entity, equally present in the signifying and the signified series.

> It is the mirror. Thus, it is at once word and thing, name and object, sense and *denotatum*, expression and designation, etc.[58]

The combination of the word/thing duality is drawn from the philosophy of the Stoics and their concept of the *lekton*, which is also a paradoxical formulation of both word and thing. The

fundamental Stoic linguistic paradox is vital for Deleuze in *The Logic of Sense*: this paradox describes language as simultaneously both 'word' and 'thing'. This paradox underpins much of Deleuze's philosophy of language. One of the most infamous Stoic paradoxical thinkers was Chrysippus, who proposed statements such as the following:

> There is a certain head, and that head you have not. Now this being so, there is a head which you have not, therefore you are without a head.

> If you say something, it passes through your lips: now you say wagon, consequently a wagon passes through your lips.

> If you never lost something, you have it still; but you never lost horns, *ergo* you have horns.[59]

In these syllogisms Chrysippus manipulates the logic of language to create 'impossible' or ridiculous conclusions, exploiting the gap between the particular and the generic, or the literal and the figurative, which are always co-present in an utterance. The ambiguous situations that emerge as a result of these pronouncements require impossible feats of mental contortion, which is required for the harnessing of the multiple-horned paradox in general. In the first example, the head of the first sentence could be viewed as a particular head, whereas the head of the second sentence could be viewed as a generic head, which would render the subject of the sentence headless. The wagon of the second example could be invisible and composed purely of breath and voice, or it could be full-sized, made of solid matter and be expelled or vomited from the mouth in a grotesque and improbable fashion. Of all the virtual 'things' that the 'something' of the third example could possibly signify, horns are one example in an infinite number of possible words denoting an infinite number of possible worlds. In one of these possible worlds you possess the horns because you never lost them. Before this 'something' is actualized, it is easy to comprehend its universal applicability – its role as a vessel for the entirety of language. It is precisely this lack of specificity that gives the statement its infinite potential for variation. After the horns have been introduced into the equation, something changes shape;

it becomes honed to a singular point which simultaneously denotes the shape of a pair of horns. The word becomes a thing.

In *The Logic of Sense* Deleuze creates a whole system that operates between, through and around this paradox. The philosophy of the Stoics was both materialist and cosmological, in which God as a material force permeates the entire world.[60] The linguistic system of the Stoa consists of the *phonē*, the noise or cry; when articulated this becomes *lexis*, speech.[61] Signifier and signified, word and thing, are both physical entities. What is left in the middle is the *lekton*, the sense or 'sayable', which only has subsistence (rather than *ex*istence). Using his method of reduplicative synonymy in which a multiplicity of terms are used to construct a concept, Deleuze calls this *lekton* many things. One definition he uses many times in the book, however, is the 'paradoxical element'. It is possible to see how futurist language – operating according to the logic of Cratylus, as outlined above – is a manifestation of Deleuze's paradoxical element. It manifests itself through the word *as* thing, in foregrounding the 'thingly' elements of language such as texture, sound and shape. It also manifests itself through the unification of these thingly elements with the sense of the word. It is important to note that Deleuze uses his paradoxical element as a kind of force, a combination of origin and telos, which is at the heart of his poetics. It forms a dynamic system because the two sides of the double-headed element are constantly chasing one another:

> In fact, there is no stranger element than this double-headed thing with two unequal or uneven 'halves'. As in a game, we participate in the combination of the empty place and the perpetual displacement of a piece.[62]

This game of chase is how Deleuze sees language as moving. He describe the paradoxical element as the 'ideal' and yet unreachable linguistic telos; a Cratylic coincidence of signifier and signified. Not only does he describe this, but he also performs it. The paradoxical element is described deliberately using a number of different terms: 'esoteric word', 'differentiator', 'empty square', 'magic word', *'perpetuum mobile'*, 'void', 'quasi-cause' and importantly 'nonsense'. It is even described poetically in *Difference and Repetition* as the 'dark precursor' – as that which motivates the entirety of the language, and also by the nonsense terms

'portmanteau word' and 'esoteric word'.[63] The dark precursor is described by Žižek as 'the mediator between two different series, the point of suture between them'.[64] Reduplicative synonymy, then, powered by the 'suture' in between the two dissymmetrical halves of signifier and signified, is therefore the way that Deleuze both describes and performs his logic of nonsense. This is the real paradox at the heart of Deleuze's poetics: the very thing he holds up as the motivator of language is the very thing he cannot (and does not want to) name definitively.

Deleuze likens language to the paradoxical hunting of the Snark because it is powered by a question we do not even know how to frame.

> It belongs to this element which is always absent from its proper place, proper resemblance, and proper identity to be the object of a fundamental question which is displaced along with it: what is the Snark? what is the Phlizz? what is It *(Ça)*?[65]

The reason why Deleuze's linguistics must be paradoxical, therefore, is because he believes that paradox is language's propulsory mechanism. Every act within this mechanism stems from both repulsion and desire; every act is one of both creation and destruction. Paradox forms the basis of a deconstructive act because it reveals interpenetrating contraries, but we would not have deconstruction without structuralism. Paradox can be traced throughout these movements if we search retroactively. Fredric Jameson maintains that both formalism and structuralism are also founded on paradox: formalism because it deals with the paradox of literature being about nothing but itself;[66] structuralism because its concept of the sign 'forbids any research into the reality beyond it, at the same that it keeps alive the notion of such a reality by considering the signified as a concept of something'.[67] To progress, it is necessary to use the tools of language to attack it from the inside. It becomes difficult to discern which linguistic exploits exhibit repulsion for language and which ones display reverence, as these are the same functions. Deleuze exhibits a notable ambivalence when he describes certain linguistic procedures, as we will see in Chapter 3 and the discussions of linguistic materiality.

Lecercle describes the two fundamental paradoxes of language

in Deleuze's thought as the simultaneity of materiality and immateriality and of singularity and universality.[68] These paradoxes are fundamental to the questions concerning Deleuze and futurism. It is specifically important when examining this area that the link between Deleuze's attitude towards paradox and the ways in which paradox works in his own writing is highlighted. James Williams highlights this point in his book on *The Logic of Sense* when he describes Deleuze's thought as proceeding through paradox. As Williams points out, paradox works for Deleuze because it generates 'forks' of difference in thought by revealing systemic inconsistencies. Thought, for Deleuze, is 'perverse': 'it must be capable of a flexibility denying proper meanings and functions and recreating others that lay dormant within apparent propriety and blameless convention'.[69] Thoughts must be created anew rather than donned like familiar clothes; paradox denatures the form of thought so that it is unstable and undetermined in the same way as the *zaum* word encountered in the previous chapter. This is why Deleuze has to use the figure of the word to demonstrate the effect of his paradox-generated system on thought: language is the original model for his ontology. This linguistic synecdoche can be seen time and time again throughout Deleuze's work; it is the reason why his philosophy is truly performative. He sets the linguistic concept of the paradoxical element to work by making it stand synecdochically for his own thought.

The inclusive disjunction as poetic function

In addition to the elements of reasoning already discussed – the minimal pair and the paradoxical structure of nonsense – Deleuze uses another linguistic feature as a synecdoche for his philosophy: that of the conjunction. It is telling that Deleuze has described his philosophy of language in terms of linguistic connectors. The affirmative 'logic of the AND' is stated outright in the concluding paragraph to 'Rhizome', but its significance extends far beyond this reference; it is palpable in Deleuze's thought from much earlier.[70] Lecercle describes Deleuze's logic of AND as both anti-representational and anti-essentialist: 'Neither the INSTEAD OF of

representation nor the IS of essence can deal with the intensive multiplicities that make up language.'[71] Much of Deleuze's philosophy involves the active championing of the conjunction over the copula, but he states this explicitly in *Dialogues* (1977), in which he aligns the AND with empiricism. Philosophy has been too 'encumbered with the problem of being, IS', he writes.

> The whole of grammar, the whole of syllogism, is a way of maintaining the subordination of conjunctions to the verb to be, of making them gravitate around the verb to be ...
> Substitute the AND for IS. A *and* B ... Thinking *with* AND, instead of thinking IS, instead of thinking *for* IS: empiricism has never had another secret. Try it, it is quite an extraordinary thought, and yet it is life.[72]

The manifesto-like imperative mood can be seen here again, as well as in the more obvious places such as 'Rhizome'. The AND, therefore, is what allows Deleuze to think of the multiplicity in the way that he does – as a noun rather than as an adjective. It is what allows his thought to proliferate in the mode of reduplicative synonymy outlined above. Rather than merely substituting the AND for IS, however, we might say that the AND and the IS are conflated.[73] There are several ways to express this. John Mullarkey describes Deleuze's philosophy in terms of the 'both/and' – the inclusive disjunction.[74] Another formulation that works alongside the inclusive disjunction is the schizophrenic 'disjunctive synthesis' of Deleuze and Guattari's *Anti-Oedipus*, in which the same principle is outlined with different terminology:

> A disjunction that remains disjunctive, and that still affirms the disjointed terms, and that affirms them throughout their entire distance, *without restricting one by the other or excluding the other from the one*, is perhaps the greatest paradox. 'Either ... or ... or,' instead of 'either/or'.[75]

The option of the 'either ... or ... or' works in the same way to the AND; each disparate element is affirmed alongside the next. The inclusive disjunction is a combination of inclusion and disjunction, which renders it paradoxical. It describes a particularly affirmative type of thinking which requires conceptual work or energy to make

it work. A disjunction requires two divergent and unconnected parts, but an inclusive disjunction requires us to force these into convergence or view them as one.

The term 'inclusive disjunction', then, is a paradoxical formulation which again brings us back to Jakobson's poetic function, as discussed in the previous chapter. Another important point of convergence for Jakobson and Deleuze is the structural similarity between Jakobson's poetic function and Deleuze's inclusive disjunction. I believe that the inclusive disjunction operates as a poetic function in Deleuze's thought. The term 'poetic function' means something very specific in Jakobsonian poetics, which have their root in futurist poetics. Jakobson's poetic function is an exemplary dynamic element. In Jakobsonian linguistics the poetic function '*projects the principle of equivalence from the axis of selection into the axis of combination*'.[76] These two modes of linguistic arrangement, selection and combination, are important from multiple perspectives and carry implications for linguistic spatiality and temporality. In Jakobson's example of the word 'child' as the topic of the message, the *selection* involves choosing from a group of synonyms, 'more or less similar nouns like child, kid, youngster, tot, all of them equivalent in a certain respect, and then, to comment upon this topic, he may select one of the semantically cognate verbs – sleeps, dozes, nods, naps'. The groups of nouns and verbs share semantic equivalence. The *combination* involves the syntactic sequence of different word classes; they are contiguous rather than similar. In the poetic function, according to Jakobson, 'equivalence is promoted to the constitutive device of the sequence'. Why and how is this the case with the poetic function? The answer lies with the temporal and material aspects of language; it is these that display equivalence. The dynamics of language that it shares with music – rhythm, metre, stress, length and others – are the elements that display equivalence in poetry, rather than their semantic content. This is Cratylic reasoning expressed through linguistic categories, and the projection that Jakobson outlines here is the dynamic shift par excellence. It is the same as saying that *word = x and thing = x*, which is one of the ways Deleuze describes nonsense. To make language work according to Jakobson's axis of combination, we use an inclusive disjunction. Whether we choose to process this in terms of Jakobson's proto-poststructuralism or Deleuze's retroactive Jakobsonian 'structuralism' is irrelevant;

these structures function as seemingly impossible systematizations of infinitely dynamic matter. An inclusion operates according to the principle of combination, whereas a disjunction operates according to the principle of selection; Deleuze's thought requires these two opposing operations to work not only simultaneously but in total co-dependence. His thought is not simply 'non-linear'; it requires both linearity and non-linearity. It seeks to combine two opposing terms within one term which is deemed the 'preferable' one, and this hierarchization of a previously 'equal' dyad or dualism is one of the aspects that have led to criticism. This is referred to below, and some examples of Deleuze's hierarchized dyads will be discussed in the following chapters.

Dualisms and correlations

The actual/virtual distinction is one example of a dualism in Deleuze's thought. The way that Deleuze uses dualisms is again as a complex; it is a paradoxical blend of the prefixes 'uni-' and 'co-', discussed in the Introduction. This is expressed very clearly by Deleuze and Guattari in 'Rhizome':

> We employ a dualism of models only in order to arrive at a process that challenges all models. Each time, mental correctives are necessary to undo the dualisms we had no wish to construct but through which we pass. Arrive at the magic formula we all seek – PLURALISM = MONISM – via all the dualisms that are the enemy, an entirely necessary enemy, the furniture we are forever rearranging.[77]

The fact that pluralism is equable with monism is what allows Deleuze to affirm paradox. Dualisms are intended to be bypassed altogether in favour of a principle of univocity (discussed in the next section) – what Deleuze describes in *Difference and Repetition* as the 'One-All'.[78] This construction, however, has provoked criticism in some quarters. One of the main problems that Deleuze critics have found with the structure of Deleuze's thought is the discontinuity between his critique of dualisms and reliance on them. Fredric Jameson expresses his suspicion for the structure of

the dualism in Deleuze's thought: 'Dualism is, I believe, the strong form of ideology as such … it always tempts us to reinsert the good/evil axis into conceptual areas supposed to be free of it.'[79] The moral or ethical hierarchy that a dualism promulgates, according to Jameson, is problematic because this is precisely what Deleuze purports to eliminate in his thought. Alain Badiou and Peter Hallward differ on several points in their critiques of Deleuze, but one place where their critiques converge is in their discussion of the asymmetry in Deleuze's dualisms. For both of them, Deleuze's dualisms do not escape hierarchical ordering. For Badiou, it is always the case with Deleuze's oppositions that to go 'beyond a static (quantitative) opposition always turns out to involve the *qualitative* raising up of one of its terms'.[80] Hallward similarly points out that each time Deleuze presents an interrelated binary relation he then proves that it is only determined or upheld by one of its terms.[81] Žižek echoes this criticism in his book on *Organs Without Bodies* (2004), stating that:

> One should problematize the very basic *duality* of Deleuze's thought, that of Becoming versus Being, which appears in different versions (the Nomadic versus the State, the molecular versus the molar, the schizo versus the paranoiac, etc.) This duality is ultimately overdetermined as 'the Good versus the Bad': the aim of Deleuze is to liberate the immanent force of Becoming from its self-enslavement to the order of Being.[82]

Some more examples of Deleuze's hierarchized dualisms can be found in the form of a table in the Lecercle's *Deleuze and Language*. Lecercle's focus on Deleuze is a rare one in that he approaches Deleuze through the lens of nonsense. The ways in which nonsense can be theorized are clearly important for Lecercle, who has published several monographs on the subject of nonsense, Lewis Carroll, and language-as-matter.[83] What is particularly significant about Lecercle's description of Deleuze's unequal dualisms is that he renders them performative by presenting them in the form that he is describing. He does this by using the model of the 'correlation'.

Lecercle's term 'correlation' is presented as encapsulating Deleuze's use of the dualism, and is presented alongside its 'opposing' term of the dialectic. As Lecercle points out, this is not

a term Deleuze uses; this is Lecercle's own term for Deleuze's words 'series', 'synthesis' or 'line'. Rather than explaining the function of the Deleuzian correlation in words, seemingly the only way he can outline the concept is by reproducing or performing it – a 'correlation of the correlation', as he terms it. Nine 'dialectical' terms are listed with the Deleuzian 'correlation' as their opposite:

	1	2	3	4	5
A	Correlation	multiple	anarchic	open-ended	relational
B	Dialectic	single	fixed origin	teleological	essential

	6	7	8	9
A	line	rhizome	map	rhythm
B	spiral	tree of Porphyry	triangulation	closure [84]

Lecercle describes the structure of a correlation as

> two antithetical series, or rows, a series of columns structured through disjunction ('x, not y'), each member of a row thus having an opposite number on the other row. The cohesion of each row is not causal ('x, therefore x'), but obtained through connective synthesis ('x and x').[85]

The result of this construction is supposedly neither a unified concept nor an opposition. All of these pairs, however, point towards a preference for the 'A' rather than the 'B' series. It is clear that for Lecercle, the Deleuzian correlation and the type of thinking that it presupposes is intended to be understood as preferable over the Hegelian dialectic. From the above table, it is not immediately apparent how to distinguish a correlation from a dualism; each of the nine dual terms appear very much as oppositions.

What is noteworthy for the present discussion about Lecercle's conception of the correlation is the other figure he names as exhibiting this type of thinking. 'The best example of a correlation I know outside the works of Deleuze is the correlation that structures Jakobson's essay on aphasia', he states.[86] Lecercle refers to Jakobson's famous essay 'Two Aspects of Language and Two Types of Aphasic Disturbances' (1965), in which Jakobson maps the tropes of metaphor and metonymy onto the paradigmatic and syntagmatic linguistic axes as well as a number of other aspects.[87]

This is discussed in more detail later on in this book, but what is important for this chapter is the link that Lecercle draws between Deleuze and Jakobson, and his reaction to their common type of thinking: 'one hesitates between indignation at the flippant facility of the connection and admiration for the inventiveness of the critic's imagination'.[88] Such bald innovation – theories that 'say their own sense' without recourse to a meta-epistemological framework – is precisely what is exhibited in the construction of a neologism. We can view Lecercle's correlation in terms of the Cratylic thinking discussed in the previous chapter, although importantly in this case the reasoning deals with concepts rather than words. Rather than two unrelated lexical items being united through sensory symbolism, or two parts of words being fused together to make one entity, Lecercle is outlining a motivated, trans-logical synthesis of disparate conceptual or theoretical elements. This is a practice he discusses under several guises, but it has not been given enough critical attention. He calls a producer of such thought a 'logophile' in his 1993 article about one such thinker – Abraham Ettleson, who creates a link between *Alice in Wonderland* and the Talmud – and a year later in his book *Philosophy of Nonsense* he also describes them as 'fous littéraires'.[89] Lecercle rightly stops short of describing Deleuze himself as a thinker such as this, and of course Deleuze's philosophy encompasses so many networks and areas of knowledge that to describe him solely in this way would be a colossal disservice, but it is my belief that occasionally his writings display a playful streak of this wilful disavowal of reason. It is the very structure of an inclusive disjunction.

The celebration of univocity

One suggestion that this book makes is that in his 'futurist' drive, Deleuze is simultaneously something of a philosophical formalist at the time of *The Logic of Sense*. In terms of a philosophical 'formalism', then, the construction of an ontology is perhaps the most 'formal' of any possible metaphysical activity. To a critic of formalism, the idea that Being itself can be isolated and studied suggests a metaphysical hierarchization over and above any of the declensions or examples of this 'being'. This does depend, of

course, on the nature of the ontological construction. In the case of Deleuze, this charge of formalism with regard to ontology does hold true. What, then, would ontological formalism look like? The concept of univocity in Deleuze's thought helps to illuminate this. 'There has only ever been one ontological proposition: Being is univocal', Deleuze states in *Difference and Repetition*.[90] Deleuze's ontology draws from Duns Scotus, saying that regardless of all the things that can be, being itself is said in one single voice.[91] All beings share the same form, regardless of distinct qualities. What Scotus calls 'formal distinction', and then is traced in Spinoza as 'real distinction', allows for attributes to be distinct and yet in their essence, or substance (to use the Spinozist term), there is *no division of being*. The substance is the same for all attributes of being, and yet allows for a plurality of these attributes.[92] This is explored fully in Deleuze's book on Spinoza, but for now let us concentrate on how Deleuze takes this ontological concept and makes it linguistic.

Univocity and its application to language is the concept required to further understand the link between paradox and nonsense in Deleuze. He writes in *The Logic of Sense*: 'Univocity means that it is the same thing which occurs and is said: the attributable to all bodies or states of affairs and the expressible of every proposition.'[93] It is in this sense that univocity is nonsensical, because it lies outside signification: it says or performs its own sense. The need for univocity comes from the ultimate insufficiency of structure to uphold the thought of itself producing nonsense. Badiou has some helpful commentary on this:

> Only a thesis of univocity can shed light on this point for, if being is said in a single sense of all which it is said, then, from the viewpoint of the multiple universe of the senses produced by the structural machines, *this* (single) sense is inevitably determined as nonsense. No structural machine is capable of producing this sense, which, on the contrary, is what supports (under the stamp of the paradoxical entity) the possibility of production of the former as such.[94]

Univocity is aligned with nonsense because the *word* and the *meaning* are identical; as we have stated, nonsense says its own sense. The difference between the French and the English

grammatical construction here is significant; as Ray Brassier has pointed out, the accusative '*se*' in '*L'être se dit*' means that rather than being being said, it *says itself*.[95] It therefore explains how Deleuze can say sincerely that being is nonsense, because in his system, both nonsense and being say their own sense: 'From the fact that there is no sense of sense, it is necessary to conclude that the sense of Being can perfectly well be said to be nonsense – provided that we add that sense comes from nonsense, nonsense being precisely the univocal donation of (ontological) sense to all beings.'[96] This demonstrates how important nonsense is to Deleuze's ontology. If he were a philosopher concerned with origins and endings, it would be both genesis and telos.

The fact that Deleuze talks about the univocity of being in *Difference and Repetition* and the univocity of language in *The Logic of Sense* does not mean that he is necessarily talking about different things; Deleuze's univocity of being is always ineluctably linguistic. The univocity he talks about in *Difference and Repetition* is already described in terms of 'the ontological proposition'.[97] Being is said 'in one sense'; the concept already pertains irrevocably to language. A univocal word is used in the same way in different senses, as opposed to an equivocal word which is used in different senses in different contexts. This might appear at odds with the discussion of polysemy and semantic instability in the previous chapter on the avant-garde. Why does a philosopher such as Deleuze, with a preference for multiplicities, see being itself as always being said in the same sense?

> The essence of univocal being is to include individuating differences, while these differences do not have the same essence and do not change the essence of being – just as white includes various intensities, while remaining essentially the same white … being is said in a single and same sense of everything which is said, but that of which it is said differs: it is said of difference itself.[98]

Thinking back to Deleuze's Stoic tree which 'greens', both examples function as a unified verb of being, 'to green' and 'to white', which include all possible permutations, determinations and intensities of greenness or whiteness. There is no need to affix something wholly substantive to these celebrated forms in Deleuze's thought,

because what he is interested in are the forms themselves. Univocity therefore pertains to form and must be given the same treatment as the structural element discussed above. Univocity would reside in the realm of the virtual and would remain unchanged in any possible circumstance or permutation. In terms of grammatical forms, it is clearly not substantive: it is rather a verb in the infinitive. This is something Deleuze is very keen to highlight; it is key to an understanding of his poetics. Just as the structural element outlined above, a verb in the infinitive is both undetermined and completely determined. It contains linguistic *puissance* because it contains every conjugation within its structure. It is this force that leads Deleuze to describe it in the celebratory terms he does:

> The Verb is the univocity of language, in the form of an undetermined infinitive, without person, without present, without any diversity of voice. It is poetry itself. As it expresses in all language all events in one, the infinitive verb expresses the event of language – language being a unique event which merges now with that which renders it possible.[99]

It appears from this description that the unique event of univocal language is its limit – its telos. In the form of the verb in the infinitive, all possible linguistic openings are as wide open as they can be, so that what is left is the pure and empty form of language. Deleuze's most celebratory descriptions in *Difference and Repetition* involve the phrase 'the pure and empty form'. This is his philosophical formalism of the late 1960s; he sees potential and power in the form that is at once both empty and completely saturated. What exactly is the nature of this univocity of language, and can it exist outside of its own self-proclamation? Is it a desirable state to achieve? Is it even possible to achieve? Having set up the system, does Deleuze give us any examples or suggestions of this univocity? The section of *The Logic of Sense* on the univocal Verb reads almost like an excerpt from a futurist manifesto, prognosticating an 'ideal' state of language which is simultaneously its annihilation. It is vital that this state is not actually reached within Deleuze's writing itself, whereas in some examples of avant-garde writing the attempt is made to mirror the sentiment in the form. As we will see in Chapter 3, futurist manifestos have been described as exhibiting more of the aesthetic and linguistic objectives than

any non-manifesto artistic attempt to follow or utilize them; they nullify any further statement because they already operate at the limit or frontier they are apprehending. Deleuze's linguistic utopia of univocity is an example of this at work. Writing that exhibited the univocity of language would perhaps be impossible, invisible or transcended to an entirely different realm; in Jameson's words,

> the forcible eradication of literary 'signs' from the work itself or, in other words, the practice of a kind of 'white writing', the access to a kind of 'zero degree' of literary language in which neither author nor public could be felt present, in which an austere neutrality and stylistic asceticism would be charged with the absolution of guilt inherent in the practice of literature.[100]

If there is then a schism between writing that is about the univocity of language and writing that *is* the univocity of language, this means that there is a gap between the concept and its articulation. The univocity of language reaches beyond the limits of the language Deleuze uses to articulate it. This is a problem that can only be solved through the utilization of another system altogether, which is why the celebration of univocity is in effect the ultimate critique of a 'state' of language.

CHAPTER THREE

The materialist manifesto

Poetics of the manifesto

One of the foremost tasks of art has always been the creation of a demand which could be fully satisfied only later.[1]

What does a manifesto do? It proclaims; it justifies; it declares a set of beliefs. The fact that there is a need for a manifesto within any sphere of politics or culture, however, suggests that these beliefs are set apart from those generally held in a particular milieu. The manifesto generally makes a set of demands; it calls for change. While its language can include proclamations, exclamations and declarations, the general format of the manifesto is that of an imperative. It demands something; there is a specific pre-existing ideological programme to be broken down or modified. This programme often encompasses both political and aesthetic issues, and it is the framing of aesthetic ideals within a political medium, and the subsequent overlapping of these areas, that makes the avant-garde manifesto so interesting. The shift from the political to the aesthetic within the genre of the manifesto is not a particularly surprising or drastic one. Both types of manifesto work on manipulating and persuading the receiver of a certain point of view. We can see in the *Communist Manifesto* (1848) various typical components that signal to the reader that this text is a manifesto; these components typify it as belonging to the manifesto. These components include: rhetorical questions; emotive language; repetition;

exclamation; the use of an inclusive first person plural pronoun; speed, urgency and dynamism of delivery.[2] These are rhetorical literary devices common to texts that aim to capture attention and persuade. They are as common to the language of advertising as they are to politics. What is significant about this is that all types of manifesto, both political and artistic (and sometimes it is not possible to separate these), use euphonic or graphological effects in their language. Sensation and emotion, important aspects to artistic language, are just as important to a wholly 'political' manifesto.

The 'literariness' of the *Communist Manifesto* has been noted by various critics.[3] If rhetorical devices are to be found within political tracts, however, there is the possibility that they could deviate from rather than fortify the 'message' of the text. This is what Marshall Berman believes happens in the *Communist Manifesto*; its rhetorical or literary quality ends up unwittingly celebrating the dynamism of capital it seeks to escape. The way this linguistic process is described by Berman suggests something of the Italian futurist urgency:

> Marx's prose suddenly becomes luminous, incandescent; brilliant images succeed and blend into one another; we are hurtled along with a reckless momentum, a breathless intensity. Marx is not only describing but evoking and enacting the desperate pace and frantic rhythm that capitalism imparts to every facet of modern life. He makes us feel as though we are part of the action, drawn into the stream, hurtled along, out of control, at once dazzled and menaced by the onward rush. After a few pages of this, we are exhilarated but we are perplexed; we find that the solid social formations around us have melted away.[4]

The effect of this reading of the *Manifesto* is that there is a degree of ambivalence perceived; there is a discontinuity between the ideals outlined and the language used to describe their antithesis. Berman distinguishes between the didactic message of the *Manifesto*, which instructs the reader that capitalism is bad, and the mode of delivery, which appears to gain a certain linguistic enjoyment from the thrill of describing the market. This is interesting when we turn our thoughts back to Deleuze, futurism and linguistic materiality. Certain linguistic or aesthetic practices that Deleuze presents are discussed with a degree of ambivalence so that it is almost impossible

to tell whether this is something he condones or not. The becoming-material of language is a complex process that Deleuze and the futurists explore in many ways, but it is unclear at times whether the reader is supposed to welcome this process or resist it. The two dynamic material aspects of violence and speed within language are explored by Deleuze and the futurists, with varying degrees of ambivalence. These aspects are returned to later in the chapter.

It is clear that the delineation of 'political' and 'literary' or 'artistic' is in some ways a false one, because it is impossible to find any examples of manifestos that inhabit solely one of either extreme. Every manifesto is couched in language that has been deliberately chosen to have a particular effect which is at once both aesthetic and political: it affects the senses at the same time as it aims to persuade. Peter Osborne's foregrounding of the pronoun 'we' in the *Communist Manifesto* is significant, in that the analogy he draws is with the first of the Russian futurist manifestos, 'A Slap in the Face of Public Taste' (1912), in which the Hylaea group defend their right to 'stand on the rock of the word "we" amongst the sea of boos and outrage'.[5] Osborne finds the Russians' 'we' problematic from a contemporary perspective; this rock, he says is 'only rarely inhabited these days; people fear the colonizing impulses it arouses'.[6] Osborne finds Marx's 'we' more inclusive rather than elitist or exclusive. Where the avant-garde artistic manifesto is concerned there is almost always a varying degree of squabbling between different factions of one movement, and a portion of the manifesto will often be taken up with setting this faction apart from the rest and asserting its superiority and origi-nality over the rest. The pronoun 'we', of course, is not limited to the genre of the manifesto. It is used as a powerful device in many genres and types of writing, not least philosophical writing. Of course, petty differences between groups seemingly 'on the same side' affect political groups as well, which makes the degrees of exclusivity and inclusivity nestled in this pronoun difficult to measure. The pronoun 'we' is no stranger to philosophical discourse either. Deleuze's use of 'we' becomes completely different once he begins to write with Guattari, because then they form a 'we' together. He is already using 'we', however, in *The Logic of Sense*, although in the French this is a much more common mode of academic expression. Deleuze's particular use of this pronoun will be discussed later in the chapter.

The problematic of the avant-garde
hic et hunc

There is a network of reasons why the avant-garde is a particular artistic moment which required and produced – or perhaps *created the demand*, to echo Benjamin's words – for manifestos. The types of art being produced required instruction; they needed prefaces and disclaimers which were just as much a part of the artwork.[7] This performed a pedagogic as well as a polemical role; radical changes in the form of artworks at this time sometimes required operating instructions. In terms of literature, a preface framed in this way is both didactic and reasserts authorial power.

It is interesting that Deleuze's texts are also often prefaced with instructions to the reader, as we saw in the previous chapter. When a text blurs or confuses generic boundaries, such as a literary-philosophical 'novel', the author may feel the need to guide the reader towards a particular mode of reception. As well as providing explanations for hitherto unknown types of artistic production, however, avant-garde manifestos also operate within a strange temporal framework. Benjamin's description of art as the creation of a demand is extremely interesting in terms of the temporality of a manifesto. It suggests that art somehow pre-empts itself; that there is something outside of conventional temporality that announces itself as a lack. The manifesto genre has its own strange temporality, perched between the state of things either as they are or as they have been, but necessarily addressing and attempting to shape the future from within its structure. The time of a manifesto's creation, its consumption and the time to which it refers are all different temporal loci, leading to difficult questions regarding the nature of 'nowness', 'newness', the 'present moment' and 'avant-garde' itself. In this way we could say it is one of the most 'present' of literary forms as well as one of the most contextually dependent: its immediacy is palpable in the use of present-tense markers such as 'now' and also formal features such as short, exclamatory imperatives, demands and lists. There are avant-garde movements specifically concerned with 'nowness'; both the nowism or 'nunism' of Pierre Albert-Birot and the presentism of Blaise Cendrars and Henri Barzun present the 'now' as something that reaches beyond itself.[8] The reason why these movements are often

grouped together with simultaneism is because the 'now' of these movements is presented as simultaneously both the 'now' at the time of writing and the 'now' at the time of reading, whenever that may be.[9] We can see this attitude of the multiple nature of 'now' very clearly in Albert-Birot's manifesto for nunism, which states: 'All the great philosophers, the great artists, the great poets, the great scientists, all the flamebearers, the creators of all ages have been, are, will be nunists.'[10] The word 'nunist', derived from the latin *nunc* for 'now', is perhaps more reminiscent of the definition of 'modern' rather than 'avant-garde'. To be modern means to be of the present – of the 'now'. Though it might appear as a simple temporal construct, this is always already wholly bound to its context. To be avant-garde, however, means to be at the forefront of a movement and also contains the word *before*, which is more multi-layered than 'modern' in temporal terms. These issues are highlighted in the manifesto format, which operates from a very specific location in order to state its demands.

The 'now' expressed in any manifesto is problematic as soon as we begin to unpick its contextual particularities. As readers we assume that the 'now' referred to only connects with the 'now' usually connected with the present at the instant of its creation; every moment after that is separated from the manifesto's 'now' by a temporal and contextual gap. The 'now' at its creation is different from the 'now' of publication, dissemination, and every single 'now' of reading or performance that happens thereafter. This is significant when considered alongside the avant-garde project of constant renewal or invention. For the Italian futurists, the manifesto does not just demand invention or renewal – it also demands destruction. For these reasons, then, the temporality of the language in which these manifestos are expressed requires careful attention. If the manifesto exists in a temporal no-man's land between 'before' and 'after'; if it expresses the impossible 'now' of change, there are certain aspects of its temporality as a piece of writing that problematize its position. First, as a piece of written language to be understood and to effect change, it is expected to be written in a linear fashion. Avant-garde movements are of course the sources of some of the greatest challenges to this premise; nevertheless, for the demands and challenges to be understood it is necessary that the avant-garde writer uses the grammatical chronology of the time. The manifesto suffers from

instantaneous historicization. The futurist writer is often aware of this, and manipulates it for creative ends; these can appear nihilistic or messianic depending on which figure is speaking, but always with a degree of self-mythologization. This is only one layer of the temporal problematic of the manifesto. Another is the fact that it exists as an actualized linguistic interface. The manifesto in its linearity (and, necessarily, its extensive spatiality and materiality) *takes up* or occupies a certain amount of linear time. It therefore cannot remain true to its structural premise of instantaneity. Between the beginning and the end of its composition, the temporal location from which anyone perceives the manifesto's 'now' has irrevocably shifted. Furthermore, if we take a reader from any point in history after the manifesto's creation, between the reading of the first word and the reading of the last word the temporal location from which the 'now' is expressed has shifted. The 'now' of the manifesto is impossible to capture, which is problematic when we consider its specific urgency or immediacy of purpose.

The word as matter

The Italian futurists' 'Technical Manifesto of Futurist Literature' (1912) and the Russian futurists' similar untitled 'technical manifesto' from the book *A Trap for Judges 2* (1913) both supplement the Italian and Russian movements' main manifestos with specific details outlining the necessary operations to be performed on language.[11] These technical manifestos are again both didactic and polemical, instructing the reader how to create and how to receive the new forms of language and literature. It is important to note at this point that the Italian and Russian futurist projects differ considerably. There is an element of linguistic destruction in both in terms of the fragmentation of old forms, but this element is far more violent in the Italian example. For example, both the Russian and the Italian futurists outline in their technical manifestos the need to rid language of syntax, but while Marinetti describes this as the destruction of syntax with the subsequent abolition of punctuation and ultimately the dissolution of the 'I' altogether, the Russians are typically less violent, describing only a 'loosening' of syntax. While it is true to a certain degree that for the

Russian and the Italian futurists their aesthetic objectives are tied up with their political objectives, these political objectives differ a great deal. While nationalism plays an important part for both the Italian and the Russian futurists, this is expressed in ways that almost appear diametrically opposite. In linguistic terms, however, it is interesting to examine the ways in which a common linguistic process can be introduced and developed under two contrasting political ideals. The relation between fervent nationalism and the concept of linguistic materiality can be understood in terms of viewing language as the fundamental substance of the country itself, and is shared by both the Italian and Russian the futurists.[12] In Italy this stance develops into the fascism of Marinetti, but in the hands of Khlebnikov and Kruchenykh in the years leading up to 1917 this develops into some truly revolutionary visions of a new Russian language. The consequences for the Russian futurist invention of linguistic matter with unstable semantic content after the Revolution, however, were fatal. Although *zaum* continued to be produced into the twenties, it did not match the radical innovation of the pre-revolutionary Hylaea group. Ultimately, what unites the opposing factions of Russian and Italian futurism is the way in which language's materiality is viewed not as static but dynamic. This concept of dynamic linguistic materiality is problematic for both factions of futurism, and is an important part of the reason why language is problematic for Deleuze.

The magnification of language's material properties is highlighted in both the Italian and the Russian futurist 'technical' manifestos. In both manifestos we see the formal or sensory elements of the literature foregrounded: the 'sound', 'weight' and 'smell' of the words in the Italian manifesto, and in the Russian manifesto vowels are 'time' and 'space' whereas consonants are 'colour', 'sound' and 'smell'.[13] It is important to note that within language, the seemingly opposing qualities of 'formal' and 'sensory' amount to the same thing: the focus on physical, material aspects. The foregrounding of materiality is a foregrounding of language's form, without recourse to semantic content. Andrei Bely's early text 'The Magic of Words' (1909) points towards this, in terms of a dichotomy between the 'word-flesh' [*slovo-plot'*] and the 'word-term' [*slovo-termin*].[14] Rather than the 'term', the materiality of the word is its 'flesh'. Bely's text prefigures Khlebnikov and Kruchenykh's manifestos detailing the same liberation of the word from pre-established

meaning such as *The Word as Such* (1913), *Explodity* (1913), 'New Ways of the Word' (1913), 'Declaration of the Word as Such' (1913) and others. The Burliuk brothers' text 'Poetic Principles' (1914) describes the poetic word as '*sensible*', a '*living organism*', and explains the significance of materiality over and above the meaning: '*the word is able to convey an object only insofar as it represents at least part of the object's qualities*. Otherwise, the word is only a *verbal mass* and serves the poet independently of its meaning'.[15] Marinetti, however, goes even further than this and suggests replacing the subject in literature with matter itself.

> **Destroy the 'I' in literature:** that is, all psychology. The sort of man who has been damaged by libraries and museums, subjected to a logic and wisdom of fear, is of absolutely no interest any more. We must abolish him in literature and replace him once and for all with matter ... capture the breadth, the sensibility, the instincts of metals, stones, woods, and so on, through the medium of free objects and capricious motors. Substitute, for human psychology now exhausted, **the lyrical obsession with matter.**[16]

The Italian futurists' obsession with matter and its potential for dynamism and speed can be seen in numerous Italian futurist manifestos such as Severini's 'Plastic Analogies of Dynamism: Futurist Manifesto' (1913), Marinetti's 'Geometrical and Mechanical Splendour and the Numerical Sensibility' (1914), Boccioni's 'Absolute Motion and Relative Motion = Dynamism' (1914), Marinetti's 'The New Religion-Morality of Speed' (1916) and others.[17] There is a palpable distinction between the Russian and Italian perspectives on materiality here: while the focus in the Russian manifestos is on the word *as* matter, the Italian manifestos focus on materiality of a more all-encompassing type. While language is still perceived as a material object, this is only one part of the Italian futurist view of the entire world as a force field of sensible matter.

One aspect of Marinetti's futurist poetics that shares some common points but also some significant differences with Khlebnikov and Kruchenykh's *zaum* is his concept of *parole in libertà*, 'words-in-freedom', outlined in the manifesto 'Destruction of Syntax – Radio Imagination – Words-in-Freedom' (1913). In

this manifesto Marinetti writes that 'the imagination of the poet must weave together distant things *without connecting wires, by means of essential words in freedom.*' The 'connecting wires' are syntactical wires, so in this sense Marinetti sees himself as a liberating force, freeing the word from the strictures of syntax. Again, this process is not merely a linguistic one but an overall mode of thought. The type of thinking that Marinetti wants us to perform is what he calls *l'immaginazione senza fili*: imagination without strings or 'wireless' imagination. 'By wireless imagination, I mean the absolute freedom of images or analogies, expressed with disconnected words, and without the connecting syntactical wires and without punctuation.' The examples of words-in-freedom which he gives in this text do exactly this:

Condensed Metaphors. – Telegraphic images. – Sums of vibrations. – Knots of thought. – Closed or open fans of movement. – Foreshortened analogies. – Color Balances.[18]

While arguably 'freed' from syntax to a certain extent, the words in this example are all clearly established words which would be found in a dictionary. The 'freedom' that Marinetti talks about does not extend to a freedom from preconceived meaning at this stage. While Marinetti's sound poetry, such as his famous battle poem 'Zang Tumb Tumb', does demonstrate more lexical liberation, this is generally a recourse to an onomatopoeic logic rather than a neologism which refuses to locate itself in any particular alternative semantic explanation. This is the freedom of words that the Russian futurists aim for; theirs is a freedom that absconds from syntax but, in addition, creates neologisms to express new and unique words that mean nothing but themselves. '... what sets us apart from our predecessors and our contemporaries by an unbridgeable gap is the exclusive emphasis that we place on the creative word, free for the first time, freed by us', Benedikt Livshits writes in his text 'The Liberation of the Word' (1913).[19] *Zaum* words are not to be found in conventional dictionaries and cannot always be mapped onto sonic symbolism, which heralds a semantic freedom as well as a syntactical one.

As stated above, the perception of the word as a material object is a belief that unites Italian and Russian futurism despite the differences in their treatment of this perception. In keeping

with the Italian futurist aesthetic, this is a dynamic rather than a static materiality. In describing the sound, weight and smell of literature, these aspects are given idiosyncratic definitions in the Italian manifesto which are not the conventional ways of understanding the words. 'Sound' is described as the 'manifestation of the dynamism of objects'; 'weight' is described as 'objects' faculty of flight'; and 'smell' is described as 'objects' faculty of dispersing themselves'. Each aspect is given a definition that specifically relates it to its dynamic potential. This is vital for the futurist aesthetic: language is an object, but it is always a dynamic object moving through space and time. In the Russian manifesto, a similar idea is outlined in which letters are viewed as *vectors of speech*. There are several aspects of futurist linguistic materiality and dynamism which will be discussed here in relation to Deleuze's thought. At a fundamental level, couched within the descriptions above is the perspective of language itself as a spatiotemporal dynamism. This perspective combined with the overarching glorification of spatiotemporal dynamisms *as such* is the apex of Deleuze's futurist poetics. This will be discussed further in Chapter 4.

Materiality in Deleuze's Stoic paradox

Materiality makes up an important part of Deleuze's sense, which has a complex and asymmetrical relation to incorporeality. As discussed in the previous chapter on Deleuze's poetics, language for Deleuze is encapsulated by the paradoxical relationship between things and propositions; between language's materiality and immateriality. The word he uses for this relation is 'sense'.

> Things and propositions are less in a situation of radical duality and more on the two sides of a frontier represented by sense.[20]

It is significant that Deleuze describes the surface of sense as a 'frontier'. The 'frontier' of the avant-garde is the line that is constantly being displaced, eroded and pushed forward in the name of artistic revolution, renewal and reform. It is also the word Deleuze uses to describe his temporal figure of the Aion. The significance of the term 'frontier' will be discussed fully in Chapter 6; for

now, let us focus on sense. Deleuze's sense is what is left of language when the particularities of time, space and speaking subject have been removed. We could view the 'sense' of a text or an utterance as something analogous to the 'gist' – its general semantic core. This, then, appears to place it completely at odds with the materiality of language. In other words, what is the material nature of 'sense' that Deleuze subtly and yet programmatically argues for in *The Logic of Sense*? He places corporeality within a framework of incorporeality, and in doing so seemingly betrays a preference for the latter. At times, however, Deleuze pushes materiality to the forefront even of incorporeality: 'qualities are also bodies, breaths and souls are bodies, actions and passions themselves are bodies'.[21] The foregrounding of linguistic materiality is an archetypal 'avant-garde' function; it is part of the general artistic problematization or critique of mimesis analogous to Deleuze's philosophical critique of identity and representation. Deleuze's work discusses linguistic materiality with a degree of ambivalence, while the concept of *philosophical* materiality is implicit throughout. How and why, then, is Deleuze ambivalent about linguistic materiality? The answer is linked to what he sees as the lack of dissymmetry between the two sides that make up Deleuze's theory of sense.

If we start with the Stoic paradox as outlined in Chapter 2, we could attempt to understand linguistic materiality as the conception of language as denoted 'thing', rather than as idea or signifying 'word'. Rather than stopping at the conception of language being the 'thing' that it denotes, however, we can view the language itself as matter. The material aspects are those apprehended by the senses. It is interesting that before Mark Lester's 1990 translation of Deleuze's *Logique du sens* standardized the English version of the title as *The Logic of Sense*, some critics were calling it *The Logic of Meaning*.[22] The multiple senses of the word *le sens* in French cause difficulties for translators, precisely because of the delicate balance that Deleuze manipulates between sense, meaning, feeling and direction. All of these definitions are pertinent to Deleuze's use of the word.

When language tends towards the sum of its material properties, this sum is made up of various components. The simplest way of distinguishing these components is by separating them into phonetic and graphic categories: into sound and shape. If these material components are measured, is the relation between 'word'

and 'thing' as simple as one of inverse proportion? Does the level of meaning decrease as the materiality increases, or can we look at it another way? There is a dual reason why the technical manifestos mentioned above are particularly important for this question of linguistic materiality. First, it is possible to analyse the ways in which they argue the case for language and literature which exhibits a high level of this materiality, and secondly, it is possible to analyse the ways in which they exhibit this materiality themselves. We can see from the Technical Manifestos of both the Italian and the Russian futurists that the sound and the shape of language are highlighted and intensified. The end results of these trajectories are sound poetry (sonic materiality) and concrete poetry (visual materiality), both of which at their furthest extreme enact the quality of nonsense suggested by Deleuze in *The Logic of Sense*, as 'that which says its own sense'.[23] Sound poetry approaches its own pure musical signified, whereas concrete poetry approaches either a picture representing its sense or its own pure ideogrammatic signified. This complex relationship in the language of the artistic manifesto between what is desired and what is enacted is precisely the relationship that needs to be analysed in the writing of Deleuze.

The infinitive verb

Marinetti's stance in his 'Technical Manifesto' on the importance of the infinitive is very clear:

> It is imperative to use verbs in the infinitive, so that the verb can be elastically adapted to the noun and not be subordinated to the *I* of the writer who observes or imagines. Only the infinitive can give a sense of the continuity of life and the elasticity of intuition that perceives it.[24]

The prioritization of the verb is just one of the many examples in this manifesto which foreground language as matter. There is nothing that dictates the subject matter of this proposed futurist literature; the focus is completely on the form of the language. The double use of 'elasticity', as well as 'intuition', is reminiscent

of Bergson's philosophy, despite the fact that Marinetti is reported to have vehemently denied any Bergsonian influence on his own thought, both in his addendum to the Technical Manifesto and in his conversations with the Russian futurists during his 1914 visit as reported by Livshits.[25] The elimination of the writer, and the elimination of the 'I' in general, is important for the same reasons as the elimination of conjugation and the elimination of any subject matter. Particularities of any kind are omitted in Marinetti's vision, in favour of the generic infinitive. This also gives some additional reason to the destruction of syntax. As we discussed in Chapter 2, Jakobson's poetic function can be seen in one sense as a shift *away* from syntactical arrangement, from the syntagmatic axis to the paradigmatic. Words are to be strung next to one another without syntactical connectors, which again echoes the theory behind Deleuze's logic of AND. The conjunction 'and' makes no grammatical demands upon the words that precede or succeed it; it simply allows disparate items to be placed alongside one another.

Marinetti follows his addendum to the Technical Manifesto with a piece of writing, 'Battle: Weight + Smell', which goes a certain way to exhibiting these aspects:

Billy-goat couscous-moldy aromas saffron tar egg-soaked dog-drenched jasmine opopnanax sandal carnation to ripen intensity boiling to ferment tuberose To rot to scatter rage to die to dissolve pieces crumbs dust heroism **tatata** rifle-fire **pic pac pun pan pan** orange wool-fulvous machine-gun rattle leper-shelter sores forward meat-soaked dirty smoothness hetarae Tinkling backpacks rifles cartridge-boxes wheels gasoline tobacco incense anise village ruins burnt amber jasmine houses guttings abandonment terracotta-jar **boom-boom**[26]

It is clear from this extract Marinetti enacts his own linguistic ideals fairly accurately, punctuating the free flow of words with onomatopoeic war sounds. As he outlines in the manifesto, nouns are attached to one another without recourse to analogy, and many words are in the infinitive. If the two principal material aspects of language are sound and shape, Italian futurist writing often demonstrates more use of the sound, whereas Russian futurist writing sometimes places more emphasis on the shape. Khlebnikov's *Zangezi*, for example, discussed in Chapter 1, places semantic

weight on the physical angles of letters as well as being composed not of chronological sections but rather geometrical 'planes'. Other *zaum* language, however, relies on neither sound nor shape as an alternative logic of meaning; this makes it more radical as an overall new linguistic system.

To what extent does Deleuze enact his own linguistic practices when discussing the materiality of language? There is a moment in *Dialogues* when Deleuze enacts his own futurist drive. In a passage that echoes Marinetti's style, Deleuze adopts the infinitive and places nouns next to one another. The nouns are self-referential, pertaining to theoretical strands occurring in Deleuze's previous texts which then operate as motifs or conceptual personae.

HE – TO WALK – TOWARDS, THE NOMADS – TO ARRIVE, THE – YOUNG – SOLDIER – TO FLEE, THE SCHIZOPHRENIC STUDENT – OF – LANGUAGES – TO STOP – EARS, WASP – TO ENCOUNTER – ORCHID.[27]

The Deleuze scholar will know that 'nomads' refers to a whole section of Deleuze's later thought championing 'nomadology', just as 'the schizophrenic student of languages' pertains to Louis Wolfson (discussed later in this chapter) but stands for an entire theory of linguistic materiality and 'schizoanalysis' which goes back to his discussion of Carroll and Artaud in *The Logic of Sense*. These figures problematize the very concept of 'the figure', because they operate at both a figural or metaphorical level and a literal one. This will be addressed further in Chapters 4 and 5, in the discussions on performativity and metaphor respectively.

Going back to the infinitive, if we look at Deleuze's discussion of the infinitive in *The Logic of Sense* it is immediately apparent that there is a striking similarity in the desire to see the verb freed from the constraints of conjugation.

The Verb is the univocity of language, in the form of an undetermined infinitive, without person, without present, without any diversity of voice. It is poetry itself. As it expresses in language all events in one, the infinitive verb expresses the event of language – language being a unique event which merges now with that which renders it possible.[28]

How exactly is the infinitive linked to poetry, and why is it so vehemently championed by both Marinetti and Deleuze in this way? The univocity of language and its link to nonsense was discussed in Chapter 2. To reduce a verb down to one particular conjugation is to actualize it and therefore reduce its creative virtuality. Creative virtuality is what Deleuze means when he says that the infinitive is 'poetry itself': it is the ultimate aim of both thinkers here. Instead of the actualization and determination that necessarily takes place when a verb is tied to a tense or mood, the infinitive both refuses and accepts all possibilities. Whether this results in a creative Nirvana or problematic stalemate is a question that will be addressed in each of the following chapters. The celebration of the verb in the infinitive is a linguistic expression of what Žižek calls Deleuze's 'basic Hegelian motif' of reversing the relationship between a problem and its solution.[29] Žižek here uses DeLanda's argument, which states that in Deleuze's approach, 'the relation between well-posed explanatory problems and their true or false solutions is the epistemological counterpart of the ontological relation between the virtual and the actual'.[30] In the linguistic model, the infinitive is the undetermined problem, while the conjugation is a solution. Even if we accept this premise of the infinitive as it is offered, however, there is a colossal difference between stating the fact that the infinitive is poetry itself and proving this statement through poetry itself. There remains the possibility that this theoretical statement in the form of a manifesto about language contains more poetry than any poetry that would attempt to enact it. This is the stance of Marjorie Perloff when talking about futurist manifestos, as discussed above.

An example of a poetic attempt of this kind, however, can be found in Velimir Khlebnikov's poem 'Incantation by Laughter'. Rather than the pure infinitive, however, the verb is coloured by an entire spectrum of different grammatical manipulations. The text in Russian:

ЗАКЛЯТИЕ СМЕХОМ
О, рассмейтесь, смехачи!
О, засмейтесь, смехачи!
Что смеются смехами, что смеянствуют смеяльно,
О, засмейтесь усмеяльно!
О, рассмешищ надсмеяльных – смех усмейных смехачей!

О, иссмейся рассмеяльно, смех надсмейных смеячей!
Смейево, смейево!
Усмей, осмей, смешики, смешики!
Смеюнчики, смеюнчики.
О, рассмейтесь, смехачи!
О, засмейтесь, смехачи!

ZAKLYATIE SMEKHOM
 O, rassmeites', smekhachi!
 O, zasmeitse', smekhachi!
Chto smeyutsya smekhami, chto smeyanstvuyut smeyal'no.
 O, zasmeites' usmeyal'no!
O, rassmeshishch nadsmeyal'nykh-smekh usmeinykh
 smekhachei!
O, issmeisya rassmeyal'no, mekh nadsmeinyk smeyachei
 Smeievo, smeievo,
 Usmei, osmei, smeshiki, smeshiki,
 Smeyunchiki, smeyunchiki,
 O, rassmeites', smekhachi!
 O, zasmeites', smekhachi!

Incantation by Laughter

O laugh it out, you laughsters!
O laugh it up, you laughsters!
So they laugh with laughters, so they laugherize delaughly.
O laugh it up belaughably!
O the laughingstock of the laughed-upon –
the laugh of belaughed laughsters!
O laugh it out roundlaghingly, the laugh of laughed-at
 laughians!
Laugherino, laugherino,
Laughify, laughicate, laugholets, laugholets,
Laughikins, laughikins,
O laugh it out, you laughsters!
O laugh it out, you laughsters![31]

In this poem, the verb fragment *'sme-'*, meaning 'to laugh', is affixed
to a number of word endings creating a fantail of laughing-related
grammatical permutations. It almost reads like an idiosyncratic or

nonsensical list of declensions, which is significant when we consider Jakobson's poetic function discussed in the previous chapters. Here we can actually see the principle of equivalence being projected from the axis of selection into the axis of combination happening at a structural level within the poem. Rather than a conventional sentence, for example 'I laugh at you', based on selection of different contiguous word classes and therefore prosaic producing sense, we have one word class – the verb – and a combination of verbs grouped together forming a list of variations. Jakobson's formula does not usually find such an obvious exponent, but this poem is a textbook example of his poetic function. It is difficult to see how this idea could be extended further, which is why *zaum* was seen as a 'limit' of language or poetry, or for some (Trotsky, for example), as existing outside poetry altogether.[32]

The lines of this poem have been translated in many different ways, but in this one the prefixes and suffixes used are derived from recognizable grammatical constructions: '-sters', '-ians', '-ikins', '-ify', '-olets', '-erize', '-erino', '-icate', 'de-' and 'be-' could all be grouped and classified as various types of lexical adjunctives extracted from a range of vernaculars, the primary function being one of humour and play. In this translation by Gary Kern, some of the suffixes contain shades of other languages although they are still recognizable in their function: '-ino' is more like a Spanish or Italian word- or name-ending, while '-olets' could be a Latin or French construction. The poetry comes from the deliberately erroneous application of pre-established grammatical rules. No words are incomprehensible; each morpheme can be identified and recognized. The ludic element in this type of verbal manipulation is vital, and this example is particularly pertinent because of the chosen verb. To laugh is to produce sound and movement as a result of amusement. The dynamism of laughing is enacted by manipulating the root of the verb and creating a string of laughing-related neologisms, which both are and are not words in themselves. The poem is not *about* laughter: through the repetition of the stem of the verb and the refusal to settle to one particular tense, mood or agreement, the poem remains open and contains within it the dynamic potential to laugh itself. It achieves this, however, not through use of the infinitive but almost the opposite; specific, unconventional, 'alternative' conjugations are offered rather than any examples of the verb in the infinitive.

The stuff of nonsense

Artaud says that Being, which is nonsense, has teeth.[33]

If we view nonsense as the enactment of dynamic linguistic materiality, the two types of nonsense proposed by Deleuze and represented by Lewis Carroll and Antonin Artaud exhibit varying degrees of this materiality. Artaud's partial translation of Carroll's 'Jabberwocky' and Deleuze's interpretation of Carroll's word 'wabe' in *The Logic of Sense* have already been discussed as examples of 'nonsensical' translation. Deleuze's attempt at analysing Artaud's translation is another example of the Cratylic logic already discussed. He fragments Artaud's nonsense words and analyses the morphemes according to their sound symbolism, just as he does with Carroll's word 'wabe'. He does this, however, to demonstrate the difference between Artaud's nonsense words and Carroll's. First of all, the translation does not render any equable sense at all. Artaud is doing something different with the language, which points towards a more radical type of materiality. Nonsensical translation always requires creativity, as we have seen with the English translations of *zaum*. In the case of Artaud's nonsensical translation, however, something else happens entirely. As previously discussed, Deleuze's 'translation' of Carroll's 'wabe' uses a type of reasoning that sources meaning in sound, but it is entirely Deleuze's invention. Similarly, Artaud's line *'Et les Ghoré Uk'hatis dans le Grabugeument'* creates new neologisms that are entirely his own. Just as Deleuze departs from Carroll, so Artaud departs from Carroll. Here Deleuze attempts to 'reason' Artaud's deviation:

> Artaud's *'Ghoré Uk'hatis'* are not equivalent to the lost pigs, to Carroll's 'mome raths', or to Parisot's *'verchons fourgus'*. They do not compete with them on the same plane. They do not secure a ramification of series on the basis of sense. On the contrary, they enact a chain of associations between tonic and consonantal elements, in a region of infra-sense, according to a fluid and burning principle which absorbs and reabsorbs effectively the sense as soon as it is produced: *Uk'hatis* (or the lost pigs of the moon) is K'H (*cahot = jolt*), 'KT (nocturnal), and H'KT (Hecate).[34]

Deleuze's apparent criticism of the 'inaccuracy' of Artaud's translation is where the ambivalence begins. He continues with the unification of sound and sense as he himself performed with Carroll's 'wabe', although clearly due to the nature of Artaud's words the associations are looser. If we were to view Carroll and Artaud on a spectrum ranging from transparent mimetic representation to materiality and opacity, Artaud's would clearly be closer to materiality. What this process also demonstrates, however, is precisely the 'ever greater gradation of analogies' which Marinetti argues for in his Technical Manifesto.

> Until now writers have been restricted to immediate analogies. For example, they have compared an animal to man or another animal, which is more or less the same thing as taking a photograph. (They've compared, for example, a fox terrier to a tiny thoroughbred. A more advanced writer might compare it to gurgling water. In this there is **an ever greater gradation of analogies,** affinities ever deeper and more solid, however remote.)[35]

The important thing to note about this point is the fact that however remote these 'affinities' might have become, they are still affinities. The point at which Deleuze displays ambivalence is the lack of clarity over whether Artaud's language displays a type of remote 'affinity' to Carroll's text, or whether he achieves complete severance from its referent. The question we have to ask is whether the difference Deleuze presents between Carroll and Artaud is intended as a difference in degree or a difference in kind. Are they presented as two different types of nonsense, or the same type at slightly different stages? The lack of clarity as to whether we are dealing with a difference in degree or a difference in kind is the point at which a critique of Deleuze becomes possible. This distinction will be returned to in the following chapters. Deleuze's 'wabe' interpretation discussed in the previous chapter is singularly his own, although it uses the letters and sounds available in the original to invent a new meaning. Artaud's words above do not pertain to anything that occurs in the original at all. There is a definite shift that has happened; it is as though the balance has tipped too far over from 'wordness' to 'thingness'. Opacity takes over in a very material sense, with consonant clusters so dense it

is virtually impossible to enunciate them. This is exactly the point Artaud wants to make. This, for Deleuze, is 'infra-sense' or schizophrenic language. Like the more 'regular' sense, it is composed of two sides, but now it is both sides that are material. The simultaneous excitement and fear with which Deleuze explains this cannot quite be suppressed. The difference between Carrollian and Artaudian nonsense lies in the location of the nonsense: if language is located exactly on this surface which is the boundary between propositions and things, Deleuze sees Artaud's language as having crossed the boundary into the 'depths' of schizophrenia, where language *is* material first and foremost. It is so material it has the power to wound and maim. Deleuze is fascinated by the concept of language physically affecting the body, which is discussed in the section 'Violent matter' below.

There are some important differences between Carrollian nonsense and Artaudian infra-sense that go further than their location underneath or on the surface. While they share the apparent rejection of identity, they perform this in different ways. Infra-sense does this by way of what Deleuze calls 'infinite identity', which 'makes each term at once the moment and the whole; the part, the relation, and the whole; the self, world, and God; the subject, the copula, and the predicate'.[36] This reads like the univocity of language more than any other description he provides. In the 'regular', non-infra-sense schema which he calls 'surface' nonsense, Deleuze states that of the four components of the proposition that comprise the stages of language – manifestation, denotation, signification and sense – surface nonsense renders the first three obsolete. Thus the self as manifestation is rejected, as is the world as manifestation and God as signification. Only the 'pure sign' of sense, expressed as an event and emanating from paradox, remains. An example of this would be the event of the 'greening' Stoic tree. This type of (non)sense forms the basis of the book, despite Deleuze's clear preference for the ingenuity of Artaud. Ultimately, it appears that the celebration of univocity fits more with Artaudian infra-sense than it does with Carrollian surface nonsense. Deleuze's attitude to infra-sense in *The Logic of Sense* does, however, appear a little ambivalent. Infra-sense would appear to be providing a more extreme critique of identity and representation than surface nonsense, but it represents an abyss which

Deleuze is not willing to fully engage with. In constructing a 'logic' of 'sense' with surface nonsense he has created something affirmatively paradoxical which manages to occupy a position incorporating the simultaneously abstract and concrete nature of language, synthesizing content and expression. The difficulty of concretizing anything from the Artaudian schemata of radical materiality, however, is encapsulated in Deleuze's presentation of Artaud's partial translation of Carroll's nonsense verse.

The importance of the minimal pair for Deleuze was discussed in the previous chapter. Another 'nonsensical' writer who Deleuze discusses with a particularly creative use of the minimal pair is Raymond Roussel. In his essay on Wolfson and Roussel, 'Louis Wolfson; or, The Procedure' (1993), Deleuze discusses the process, or *procédé* as Roussel called it, to which these writers subjected language. [37] Wolfson and Roussel both treat language as a material object to which metamorphoses can (or must, dependent on the psychosis) be subjected. Roussel's example comes from his story 'Among the Blacks', which begins with the line (in English): 'The white letters on the bands of the old pooltable …' and ends with 'The white letters on the bands of the old booltable'.[38] Roussel manipulates one letter of a regular French sentence so that the sound is the same but the meaning is completely distorted: it is a metagram. The two sentences, *'les lettres du blanc sur les bandes du vieux billard'* and *'les lettres du blanc sur les bandes du vieux pillard'* display the minimal pair. Each term in these sentences is given some significance in the plot, so there is a sense that the story has gone almost full circle, but has produced nothing in the way of conventional sense. Roussel's procedure, which can be seen at several points in his writing, is to fuse the two entirely disparate meanings together and create an entirely new object. It happens at the level of plot in the example discussed by Deleuze, but happens at a lexical level in other examples. It is significant that, just as with Deleuze's texts and the various manifestos under discussion in this book, a guide or instruction to the reader detailing Roussel's methodology is necessary. It is necessary because it is the method-ology, or the procedure, that is the focus, rather than the result. Roussel's text *How I Wrote Certain of My Books* (1935) performs this very function. In this text he explains how he chooses a word with multiple potential meanings, links it to another poten-tially polysemous word with the preposition *à*, then fuses these

together to produce something entirely new. This is a type of lexical-conceptual neologism. For example:

> Taking the word *palmier* I decided to consider it in two senses: as a *pastry* and as a *tree*. Considering it as a *pastry*, I searched for another word, itself having two meanings which could be linked to it by the preposition *à*; thus I obtained (and it was, I repeat, a long and arduous task) *palmier* (a kind of pastry) *à restauration* (restaurant which serves pastries); the other part gave me *palmier* (palmtree) *à restauration* (restoration of a dynasty). Which yielded the palmtree in Trophies Square commemorating the restoration of the Talou dynasty.[39]

Roussel gives numerous examples of these creations over several pages. Through a deliberate 'mis-reading' of certain terms, his methodology fuses together two double meanings to create ridiculous or improbable situations. His comment on this method is that it is 'essentially a poetic method' because it is related to rhyme. Obviously this type of thinking also belongs in the Cratylic category discussed in the previous two chapters. Rather than rendering two disparate terms as having a motivated link through a common paronomastic function, however, this example deliberately refuses to alight on one semantic direction and instead affirms multiple trajectories at the same time.

Speed

The Italian futurist preoccupation with speed has many sources. The early twentieth-century acceleration of travel, technology and telecommunications which characterize modernity resulted in a faster world. The attempt to create anew and retain a position at the forefront requires speed: futurism requires this because it must always be looking 'ahead' of its time. Like the pioneering avant-garde of which is it a part, futurism's concepts must be constantly disposed of and reformed. Furthermore, the importance of speed can be seen clearly in the 'impatience' of the manifesto as a genre, which must make its demand loudly and urgently so as to be heard and followed. While the rapidity of the communication of ideas

or demands is palpable throughout most avant-garde manifestos, the conceptual glorification of speed reaches its apex in Italian futurism. Marinetti's glorification of velocity is one of the most striking things in the first futurist manifesto, declaring: 'Time and space died yesterday. We already live in the absolute, because we have created velocity which is eternal and omnipresent.'[40] In a movement concerned with eternal forward propulsion into the future, the beauty of speed is of the utmost importance. Speed too is linked to materiality, and Italian futurism celebrates a particular type of dynamic matter. It is significant that a fast-moving object (the racing car) is preferred to a piece of classical art (the *Victory of Samothrace*). It is important to remember, however, that speed for the Italian futurists is never far away from destruction; the two are linked. The two come together in an ecstatic description of a car crash at the beginning of Marinetti's first manifesto: 'When I climbed out, a filthy and stinking rag, from underneath the capsized car, I felt my heart – deliciously – being slashed with the red-hot iron of joy!'[41] Further celebration of dynamism and speed is evident from the distinction between literature before and after the futurist movement. While literature before is described in terms of 'contemplative stillness, ecstasy and sleep', a triad of stasis, their future literature is described in terms of 'movement and aggression, feverish insomnia, the racer's stride, the mortal leap, the slap and the punch'.[42] Futurist speed is competitive: everything is a race. The literature of 'now' is just as much to do with aggression as it is with speed. Its materiality makes itself felt in multiple ways: language as material, as nonsense, but also as an object that can cause harm.

The Russian futurists make less explicit points regarding speed, but the insufficiency of language and thought for the speed of 'inspiration' is still referred to in what is now thought of as one of the founding manifestos of *zaum*, 'Declaration of the Word as Such' (1913). Kruchenykh begins his manifesto:

(4) THOUGHT AND SPEECH CANNOT KEEP UP WITH THE EMOTIONS OF SOMEONE IN A STATE OF INSPIRATION, therefore the artist is free to express himself not only in the common language (concepts), but also in a personal one (the creator is an individual), as well as in a language which does not have any definite meaning (not frozen), a transrational language.[43]

The difference between the Russian and the Italian futurist attitudes towards the speed of language in these manifestos is again sourced in the different temporal placing of the speakers. While Marinetti believes that they have achieved their 'absolute speed', Kruchenykh believes that the current language is not fast enough and an entirely new type of language is necessary. It is not only *zaum* language that is required, but multiple types of simultaneous language. The issue of temporality is vital and will be returned to in Chapter 6; for now, though, both versions of futurism are united in the belief that language is too slow and requires acceleration.

What is Deleuze's perspective on speed? His own celebration of 'absolute' speed is explicitly addressed in later works such as *A Thousand Plateaus* and *What Is Philosophy?* In these texts, 'absolute' or 'infinite' speed is linked to the speed of thought.[44] Before this becomes concretized in Deleuze's thought, however, there is a more complex, subtle interaction with speed and language. It is necessarily more complex because of Deleuze's paradoxical double-vectored linguistic procedure, simultaneously towards both 'wordness' and 'thingness'. Every step within language is both ideal and material; this is its bi-directionality in Deleuze's thought. There is some interesting commentary in *The Logic of Sense* on the rapidity of the progression of language, but it is never clear whether Deleuze views this process as too fast or not fast enough. An example of this occurs when Deleuze discusses Alice's dissolution of identity and the loss of her proper name. There is a degree of enacted velocity within Deleuze's language while he discusses his own linguistic procedure, which makes it difficult for the reader not to be whisked along on a high-speed journey much in the same way that Berman describes Marx's quasi-exultant description of capitalism's velocity. When Deleuze takes the reader through the steps of denotation, manifestation and signification in the proposition before rejecting them in favour of sense, each step is insufficient for the same reason. It fails in its aspiration to ideality, always hurtling back towards matter. This is the 'overturning' or reversal of Platonism with which Deleuze accredits himself, and it appears that it must happen *at speed*.

> It is therefore easy to ask Plato to follow down the path which he claimed to have made us climb. Each time we are asked about a signification, we respond with a designation and a pure

'monstration'. And, in order to persuade the spectator that it is not a question of a simple 'example', that Plato's example was poorly posed, we are going to imitate what is designated, we are going to eat what is mimicked, we will shatter what is shown.[45]

Critics have noted that the very nature of Deleuze's two-pronged thought procedure results in any subversion of Plato being equal to an absolute fortification or upholding of Platonic thought.[46] This adds to the sense of ambivalence that occurs with the discussion of speed. According to the above description, language's demand for a Platonic idea always results in the production of some instantaneous and arbitrary object. The speed under discussion applies to a simultaneous ascent and descent: an ascent towards the phantom of the referent and a descent towards the materiality of the language. In the desperate attempt to get closer to the thing itself we grab onto something else entirely. It doesn't matter what we hold onto. One word will do as well or as ill as another. But who is this 'we'? Recalling Osborne's critique of the exclusivity in the term 'we' in the Russian futurists' first manifesto mentioned earlier, the same critique could be applied to Deleuze here. While the 'we' of Deleuze and Guattari's 'Rhizome' is explicitly addressed at the beginning of the text, Deleuze's solo use of 'we' in books such as *The Logic of Sense* is more problematic.[47] It suggests a definite process of bordering; of inclusion or exclusion. It is never clear exactly who is included in the 'we', but the reader is drawn in and made to feel as though they are in accord – almost outside their own volition.

Why does Deleuze describe his process in *The Logic of Sense* in this particular way, as a collective statement of intent? At this point he is describing a process, but he is far from the position of impartial observer: the inclusive pronoun 'we', common to the manifesto, implicates everyone involved in this process from author to reader. He goes on to enumerate the specific way in which this process must be carried out, which is where speed is introduced (italics are my own):

The important thing is to *do it quickly*: to find quickly something to designate, to eat, to break, which would replace the signification (the Idea) that you have been invited to look for. All the faster and better since there is no resemblance (nor

should there be one) between what one points out and what one
has been asked.[48]

The collective statement of intent has shifted to an instruction
or command: this passage is built around the imperative 'do it
quickly'. This is odd when considering the fact that Deleuze is
supposedly outlining the way in which language *already* works.
What effect is intended or gained by describing this detail of
speed in the form of an imperative? The assumption is surely that
this process is always already at work everywhere in language.
How performative, then, is the above passage? How quickly do
we read it? The listing of 'to designate, to eat, to break' and
the separation of these items by commas produces the effect
of acceleration: the list bypasses syntax, following exactly the
programme outlined by Marinetti in his 'Technical Manifesto'.
The repetition of 'quickly' also accentuates the sense of urgency,
as does the placing of the comparatives 'faster' and 'better' next
to one another. There are other examples of lists in the same
paragraph, all describing the various ways in which language
moves away from the ideal into the material, 'substituting desig-
nations, monstrations, consumptions, and pure destructions for
significations'.[49]

It would appear that Deleuze's attitude towards the system he
is outlining is highly ambivalent at this point. One minute it seems
as though he is urging that 'we' enact the process of signification
or denotation as quickly as possible. The next step, however, is to
reject the process of the material 'descent' altogether. If the end
result of denotation is the depths of sub-sense or Artaudian infra-
sense, this is not the location where Deleuze's system can operate to
produce sense. The descent must be simultaneously an ascent; we
are taken from the depths back up to the surface where the 'right'
kind of nonsense resides. 'Once again,' Deleuze says, 'what matters
here is to act quickly, what matters is speed.'[50] There is little
explanation as to why speed is the thing that matters here, except
that it is absolute to the point of instantaneity, and does not have
to involve a change of position. This is encapsulated in Deleuze's
discussion of Alice and the Red Queen who run very fast to stay
in the same place.[51] In order to get to the surface where sense and
nonsense reside, then, the reader is subjected to a bi-directional
breakneck hurtling that is simultaneously a stasis: Deleuze takes us

by the hand and pulls us in opposite directions at the same time. This is the very process of an immanentization of language, but in fact it is the process that is celebrated in the book rather than any end point. Deleuze's futurist celebration of radical linguistic velocity can only go so far before it becomes instantaneity. Before this stalemate of the surface is introduced, however, there is the potential for linguistic matter travelling at speed to cause injury. To this we will now turn.

Violent matter

The manifesto genre exemplifies language of a particularly aggressive nature, as does the nature of the avant-garde with its military connotations. The first manifesto of the Hylaea group of Russian futurists is called 'A Slap in the Face of Public Taste' (1912) and describes throwing Russia's established literary heroes overboard from 'the Ship of Modernity'.[52] It should be noted, however, that there is much more of a violent imperative to be found in the manifestos of the Italian futurists. Vladimir Markov notes in his *History* of Russian futurism that while their manifestos worked as polemical texts, this was of a tactical kind and did not contain real anger.[53] Marinetti's first manifesto is full of aggressive imperatives, which move from literary examples to examples drawn from life in general with almost instantaneous speed, but it is literature itself that is described as 'the slap and the punch', and poetry as 'attack'.[54] Khlebnikov and Kruchenykh's description of the way in which their futurist literature should be written and read is not so violent, but does involve pain and discomfort in a material sense: they stress 'that it be written tightly and read tightly, more uncomfortable than blacked boots or a truck in the living room'.[55] After this description again is a list in parentheses also pertaining to this material nature of both their painting and poetry: '(plenty of knotted ties and buttonholes and patches, a splintery texture, very rough ...)'.[56] The reference to knots, holes and patches give a sense of their writing as a craft: the 'material' in question is one that can be knotted, stitched or sewn. It also adds extra textures and dimension to language so that a two-dimensional medium is nowhere near sufficient; it must stand up from the page and be

'read' in all directions. The desire to move away from a smooth linguistic surface is palpable in other areas, not least in Shklovsky's 'Resurrection of the Word' (1914):

> The writers of past times wrote too smoothly, too sweetly. Their things were reminiscent of that polished surface of which Korolenko spoke: 'across it runs the place of thought, touching nothing'. The creation of a new, 'tight' language is necessary, directed at seeing, and not recognition.[57]

The surface of language is not a smooth and polished one; its dimensionality is complex and multiple. This multidimensionality of language is something that both the futurists and Deleuze write about. It is part of the reason why Deleuze chooses Carroll above any other writer to elucidate his theory of sense. He writes in the preface to the Italian edition of *The Logic of Sense*: 'The fact is that Carroll has a gift for renewing himself according to spatial dimensions, topological axes … For the first time literature thus declares itself an art of surfaces, a measurement of planes.'[58] In this description Deleuze promotes Carroll as a kind of proto-avant-garde writer. The spatiality and multidimensionality of language are avant-garde considerations, which would indeed render the nineteenth-century Carroll as a literary pioneer. Even Carroll's innocuous pronoun wordplay with terms such as 'it' and 'nobody' foregrounds linguistic materiality because those incorporeal grammatical words become material rather than abstract entities. Not only that; they become sentient.[59] As soon as Alice begins to question the validity of these linguistic beings, anger ensues: the Mouse is cross; the King is fretful. There is an element of danger and instability within Wonderland which hints at the depths of linguistic materiality and is highlighted more so by Deleuze. There is an abrasive quality to the Wonderland characters, which is only escaped once Alice takes the reins of reality once again by declaring that the Red Queen, who is threatening to chop off her head, is nothing but a playing card. It is interesting that her exclamation, 'You're nothing but a pack of cards!'[60] has a material effect, albeit a negative one. The function of this utterance is that of a speech act; its purpose is to *de*-materialize the Wonderland characters and save Alice from the abyss.

The injurious potential of linguistic matter is a point of fasci-
nation for Deleuze, and makes up an important part of his
discussion of schizophrenic language, as we will see in his case
of Louis Wolfson discussed below. The potential for corporeal
injury or damage from within language is also palpable in both
futurisms. As already mentioned, some manifestos were published
on rough sackcloth or sandpaper, physically abrasive to the hands
of the reader and pushing the boundaries of the linguistic object.
While the 'rough' and 'splintery' texture of Russian futurist art
could pertain to the primitivism the Russian futurists sought to
uphold, the potentially injurious nature of these qualities is also
significant. The effect of splintering the language into smaller
fragments leaves potentially sharp edges or shards of words. This
destructive quality of linguistic matter manifests itself at several
points in *The Logic of Sense*. Language becomes damaging when
meaning is lost altogether; when words become pure objects
devoid of signification. This is the 'infra-sense' of Artaud. As we
saw in the Russian manifesto above, the splitting of language into
vowels and consonants results in an intensification of the material
properties of each. In the Artaudian abyss of nonsense as schizo-
phrenic language, this intensification is felt to such an extent that
these material properties have the power to inflict damage and
pain. When comparing the nonsense of Carroll to the nonsense
of Artaud, Deleuze describes the former as being 'emitted at the
surface' and the latter as 'carved into the depth of bodies'.[61] The
surface of language, which is the location where language takes
place in Deleuze's system, is described as no longer present for
the schizophrenic, for whom all is depth and bodies. Deleuze is
therefore well aware of the dangers of schizophrenic language: not
only does sense disappear at this extreme, but language as mass
or matter is no longer distinguishable from any other substance
entering or leaving the body.

The other example Deleuze proposes of the link between linguistic
materiality and schizophrenia is Louis Wolfson, the American linguist
who feared his mother tongue. Deleuze states in his essay on Louis
Wolfson that 'Psychosis is inseparable from a variable linguistic
procedure.'[62] In his preface to Wolfson's 1970 book *Le schizo et les
langues* Deleuze describes how Wolfson creates a system of instan-
taneous translation so as to avoid his mother tongue. Each word is
translated into another language similar in sound and meaning, and

again Deleuze highlights the importance of speed: 'The operation must be done as quickly as possible, given the urgency of the situation.'[63] The reason for the speed here is because for Wolfson the schizo-linguist, the mother tongue has injurious potential of a very material nature. To fend off the damaging word-things Wolfson produces esoteric words – inclusive disjunctions such as Carroll's 'frumious', although made up of various different languages. Wolfson's linguistic armour is a comparable attempt to Alice's *de*-materializing utterance discussed above – 'You're nothing but a pack of cards!' – the difference being that Alice retains her place on the surface, while Wolfson truly believes that he will be injured by certain word particles. While Wolfson, along with the other radical linguistic 'materialists' discussed in the essay, Jean-Pierre Brisset and Raymond Roussel, all hold a certain fascination for Deleuze, he is keen to point out that these psychotic, translative 'procedures' are not particularly helpful or productive.[64] Rather than the infinite, potential of the infinitive as discussed above, the schizophrenic form of the verb according to Deleuze is the conditional. This contains all of the potential for action contained within the infinitive, but is thwarted by its own construction.

Strafing the surface

It appears that the Artaudian linguistic materiality of the depths is appealing to Deleuze, but always in moderation and always with a surface in place, albeit a perforated one. His rapturous exultation of psychedelia, discussed in the previous chapter – 'a strafing of the surface in order to transmute the stabbing of bodies, oh psychedelia' – details the ways in which the surface of language is penetrated and violated. It also appears, therefore, that a degree of violence is necessary in order to make progress along whatever trajectory of literary and linguistic development the writer is mapping out, but it is easy to see how this can soon become problematic. These linguistic operations are violent acts, but they are acts of love. Beckett's oft-quoted remark in his 1937 letter to Axel Kaun points towards the same destructive impulse, with the same imagery used by both Deleuze and the futurists in terms of language as a surface to perforate:

To bore one hole after another in it, until what lurks behind it – be it something or nothing – begins to seep through; I cannot imagine a higher goal for a writer today.[65]

Beckett's verb 'to bore', along with a similar description earlier in the letter of language as 'a veil that must be torn apart', demonstrates a similar violent impulse to Deleuze's 'strafing' and 'stabbing'. It is noteworthy that Beckett's 'to bore' is left in the infinitive, opening the action up to anyone at any time.

The point at which Deleuze's theory of language can be criticized is the ambiguity with which he presents the opposition of surface and depth within language; there is an ambivalence of approach in relation to this opposition which is deliberately not resolved. The way that he seeks to escape the hierarchization of either term over the other in *The Logic of Sense* is by characterizing the surface as a topological, multidimensional surface that includes depth within itself.

It is by following the border, by skirting the surface, that one passes from bodies to the incorporeal. Paul Valéry had a profound idea: what is most deep is the skin.[66]

The depths of materiality, however, the 'abyss' he speaks of in relation to Artaud, is upheld as something to be feared and allowed in small doses. The ambivalence that appears at times is a kind of gap or schism between admiration of and repulsion towards the linguistic materiality being discussed. Deleuze concludes his essay on Louis Wolfson by saying that his procedure remains, 'in a certain manner', unproductive.[67] Again, there is ambivalence in his perspective, a hesitancy borne out of simultaneous repulsion and attraction. Of course, ambivalence is a necessary part of Deleuze's method, which is why his description of Wolfson's procedure as 'unproductive' is surprising. Productivity is not generally understood as one of Deleuze's priorities.

This is why Wolfson keeps saying 'paradoxically' that it is sometimes more difficult to remain slumped in one's chair, immobilized, than it is to get up and move farther on ...[68]

This closing image presents an idea that is recurrent in Deleuze's writing, but his attitude towards it does not remain consistent. He creates a link between language and a simultaneous movement and stasis, which is sometimes celebrated and sometimes presented in this halfway point between celebration and caution. It is celebrated in 'Literature and Life' (1993) in the dictum that the writer must be an 'athlete in bed';[69] it is presented more ambivalently in *The Logic of Sense* and the example of Alice and the Red Queen running very fast in order to stay in the same place. The energy transference taking place, the work being done, is of an intensive nature: psychological or psychedelic movement. Deleuze is championing Michaux, who details the adeptness with which he can skate when he closes his eyes and thinks of skating: 'At bottom I am an athlete, an athlete abed. You must realize that I no sooner shut my eyes than I get into action.'[70] He is clearly fascinated by the concept of a wholly ineffectual and yet wholly absorbing linguistic procedure – a machine that produces nothing and yet which is infinitely working. It is as though this is his ultimate perspective, not of 'schizophrenic' language but of an entire linguistic system. This is but one variation of his general aim, which is always to make the limit of the system the rule for the entire system – which is precisely why we can call him both a paradoxical and a futurist thinker.

CHAPTER FOUR

Shiftology #1: From performativity to dramatization

Futurist performativity

The previous chapter identified a focus on dynamic linguistic materiality within futurist poetics, and furthermore identified an ambivalence in Deleuze's thought towards its potentially destructive nature. This chapter develops these ideas further, as the first of two examples of the 'shiftology' already outlined. The shift from 'performativity' to 'dramatization' in this chapter, then, is an exemplary conceptual 'shift', as discussed in the previous chapter. Performative language is already a two-pronged simultaneous process; it does at the same time as it says. Both Deleuze and the futurists use the concept of performativity in their objectives and in their writing style, but in both it is possible to see a desire to get beyond this radical linguistic event, heralding a process that is yet more radical, more immediate and more intensive. Dramatization widens the scope of the process, from the linguistic to the conceptual and the spatiotemporal. To trace this shift within futurism and Deleuze, then, we need first to analyse the role of performativity, and then the role of dramatization.

The concept of performative language enacts the Stoic paradox of 'word' and 'thing' by performing an action that has material

effects through its very expression. The manifesto includes prescriptions that are intended to have material effects in terms of effecting change, but this is different in a temporal sense from the potential the language might have to effect something in real time, like a speech act. This is particularly relevant for manifestos that deal with linguistic or literary aspects, such as the technical manifestos discussed in the previous chapter. In order to progress from the performativity model to that of dramatization, however, the process has to become more immediate. There exists the potential for the dynamic materiality celebrated in futurism and discussed by Deleuze to be set in motion or dramatized in a more immediate manner, without any recourse to linguistic mediation whatsoever. This type of conceptual or philosophical dramatization should be viewed as separate from performativity, because while the former uses language in order to express and enact simultaneously, in the latter philosophical concepts are 'dramatized' in the sense that they are endowed with subjectivity, agency and movement, and are subsequently put to work. As we will see in this chapter, Deleuze's philosophy, both performative and dramatic, can be characterized in terms of a kind of formalism due to the formal nature of his conceptual 'characters'. The linguistic model becomes the conceptual one, and from the 'nonsense' of 'word' + 'thing' comes the potential for neologistic thought.

The manifesto: Theatrical, performative, contradictory?

The previous chapter discussed the function of the avant-garde manifesto as a hyperbolic and potentially performative piece of text. Performativity and materiality work together in interesting ways in the avant-garde manifesto. Linguistic materiality is one of the phenomena being presented and argued for within futurist manifestos, but it also makes itself 'manifest' in more direct ways, so that a 'manifesto' is in fact a simultaneous manifesto *and* manifestation. J. L. Austin's famous work on the concept of the speech act is useful here. Austin distinguishes between perlocutionary and illocutionary speech acts: while illocutionary acts do

what they say in the moment of saying, perlocutionary acts merely produce certain consequences that follow on.[1] Could we describe manifestos as perlocutionary or illocutionary speech acts? They are perlocutionary in the sense that their objectives are intended to be carried out by others at a later date, but they are only illocutionary if they enact these objectives within their own frameworks. Of course, Austin's formulations have since been challenged, and the aim here is not to apply these categories unquestioningly. There is clearly a potential within performative language for ambiguity, exploitation and contradiction.[2]

The example in the previous chapter of the *Communist Manifesto*'s 'enjoyment' of its own description of the rapidity of burgeoning capitalism suggests exactly the opposite of a manifesto performing or enacting its own ideals. One way of interpreting this in terms of performativity is by what Habermas and others have called a performative contradiction. 'A performative contradiction occurs when a constative speech act $k(p)$ rests on noncontingent presuppositions whose propositional content contradicts the asserted proposition p.'[3] This model is worth bearing in mind when we think about Deleuze's ambivalence towards speed, which we saw in Chapter 3. Does Deleuze's attitude towards linguistic materiality, encapsulated by his mixed fear and reverence for Artaud, express a performative contradiction? 'Performative contradiction occurs in concrete existential contexts of contemporary philosophy whenever one shifts from being engaged in discourse into evading one's own stance, when what I say is undermined by my saying it.'[4] This type of criticism can manifest itself in different ways when applied to Deleuze. For example, a common criticism of Deleuze is that while he says at various points in his books that he dislikes and distrusts metaphor, ultimately his application of models or frameworks is inherently metaphorical.[5] It forms part of an accusation aimed at many continental philosophers in what has been termed the 'science wars', and has spawned many books in which Deleuze, Foucault and other French continental philosophers have been attacked by thinkers who view themselves as scientists or simply objective realists. Deleuze is a prime target for this type of criticism because of the way he employs concepts and vocabulary from such a vast number of spheres of knowledge. There is a chapter dedicated to Deleuze and Guattari in Sokal and Bricmont's now famous book *Intellectual Impostures: Postmodern Philosophers' Abuse of*

Science. While the debate itself is not relevant here, what *is* relevant here is clearly one of Sokal and Bricmont's prime bugbears: what they see as the 'metaphorical' usage of scientific analogies.[6] The aim here is not to add to this debate over the relative depth or superficiality of engagement in scientific or mathematical models; such an undertaking would require a thorough knowledge of each of the fields involved. The question it leads us to here is rather one of the performative contradiction. Does a critique of metaphor that relies on metaphorical language amount to a performative contradiction, or does Deleuze's paradox-driven thought sidestep or overturn the concept of performative contradiction altogether? The following paragraphs constitute an attempt to think through this question.

Martin Puchner's work on the theatrical aspects of philosophy, and simultaneously the philosophical aspects of theatre, is an important theoretical source for a discussion of the performativity of manifestos. As discussed in the previous chapter, Puchner's aim is often to place a high level of emphasis on the theatrical elements of texts or areas of cultural production that do not explicitly call themselves theatrical. In addition to performativity as the enactment of an ideal, the writing style of the manifesto has led to descriptions of it as 'theatrical'. This suggests something more than performativity; it suggests exaggeration, embellishment, hyperbole, all to create a particular effect. Puchner distinguishes between *performativity* in the political manifesto and *theatricality* in the avant-garde manifesto: while the former does things with words, the latter are pronounced in cabaret clubs and theatres and often enjoyed for the sake of spectacle. However, as he points out, performativity and theatricality are often co-present in all types of manifesto.[7] Puchner draws out the theatrical elements of Italian futurist manifestos so that theatricality appears like the backbone or driving force of the movement. This angle contains an obvious importance in a discussion of movements such as Italian futurism, because not only does futurism discuss the theatre explicitly, but all the other elements of the movement contain obvious signs of performativity.

Puchner's application of the 'performativity' argument to philosophy is more subtle, but still extremely resonant. In his book *The Drama of Ideas* (2010), while dealing with the apparent 'overturning' of Platonism (which he argues is often

nothing more than a masked Platonism), Puchner guides the reader through a discussion of the 'dramatic' philosophies of Kierkegaard and Nietzsche to Deleuze himself. Puchner describes Nietzsche's *Thus Spake Zarathustra* (1883–5) as 'the emergence of a new philosophical protagonist'.[8] This introduction of the philosophical 'protagonist' precedes Puchner's discussion of Deleuze's later work with Guattari in *What Is Philosophy?*, and their discussion of the 'conceptual personae', which will be explored later on in the chapter. Puchner discusses Deleuze's comments on drama in *Difference and Repetition*, focusing on Deleuze's rejection of the 'theatre of representation'. Puchner cites Artaud as Deleuze's main theatrical or dramatic influence, although his comments on Artaud's lack of concrete dramatic methodology are significant when considering Deleuze's own method because in both areas the 'performativity' does not quite do what it purports to do.

> To be sure, Artaud did not supply Deleuze with a thriving theatre practice; Artaud himself was more of a visionary, articulating his conception of a theatre of repetition in manifestos and letters and only occasionally on an actual stage.[9]

The lack of concrete practical instruction is a critique that has also been levelled at Deleuze in this area; James Williams's words describing the section of *Difference and Repetition* that deal with Kierkegaard and Nietzsche's dramatic philosophies could be interpreted as critical, if Deleuze's level of performativity is not taken into account.

> Many of the pages that follow the statements on movement read like empty posturing and prevarication in the light of this question. However, this rather heavy literary style is designed to dramatize Deleuze's point in line with his views on the necessity of dramatization, as developed later in the book.[10]

Here Williams discusses Deleuze's own 'dramatization' of the process of dramatization. It is clear that Williams detects a level of performativity in Deleuze's own discussion of the 'performative' philosophies of Kierkegaard and Nietzsche, but feels that Deleuze's method at this point is not clear. He describes Deleuze's efforts

at making us 'sense' the necessity of dramatization as 'rather inelegant'.[11] In these arguments for philosophical dramatization, we encounter the same problem identified in previous chapters when analysing the linguistic discussions within both Deleuze's writing and the avant-garde: the problem of what happens when a concept under discussion is 'doubled' by being enacted in its own discussion, in a manner that cannot help but perform itself. This is always the problem when language turns in on itself; the biggest proponent of this problem is of course Derrida, who not only exploits the problem but trademarks it. This might be one way that paradox works against Deleuze, rather than for him. It leads him into the territory of the potential performative contradiction. Having already ascertained that Deleuze's philosophy affirms paradox, however, this may present the 'performative contradiction' argument as somewhat irrelevant. One of the most famous paradoxes is that of the Cretan Liar, credited to the Cretan Epimenides, who states that Cretans are always liars.[12] The defining property of Cretans is that they are liars, but the declaration 'I am a liar' nullifies the truth value of the statement, so the speaker is in a paradoxical no-man's land between truth and falsehood. One strand of criticism that develops this type of thinking is the more recent work that sees Deleuze in light of his use of Nietzsche's 'power of the false'; attributing a kind of 'fabulation of philosophy'.[13] This does arguably turn the 'performative contradiction' argument on its head, but also simultaneously problematizes the distinction between philosophy and fiction. Deleuze actively encourages this perspective of his philosophy, which is why, as discussed in Chapter 2, he describes his texts at various points as a novel.

Deleuze's phrase 'quand dire, c'est faire' at the beginning of his most overt discussion of performative language, the essay 'He Stuttered' (1993), is a nod to Austin's classic text *How to Do Things with Words* (translated into French as *Quand dire, c'est faire* by Oswald Ducrot) and is highlighted by his English translators.[14] This essay will be discussed in this chapter together with Deleuze's earlier discussion of the relationship between drama and philosophy in the 1967 paper 'Method of Dramatization', his critique of the 'theatre of representation' in *Difference and Repetition*, and his work with Guattari on conceptual personae in *What is Philosophy?*.

Language bleeding outwards

The most important reference point on the subject of performativity within Deleuze's own writing is 'He Stuttered' (1993). This essay begins with a discussion of performativity, but then zooms out to encompass a shift towards what we are calling here 'dramatization'.

Deleuze sets up a distinction in the first paragraph between varying levels of performativity in the reported speech of 'bad novelists'.[15] Deleuze presents the performative function of language as a third option presented to the writer of reported speech. The first two linguistic options are *to do it* and *to say it without doing it*, and the third option is *when saying is doing*. The pattern he uses here is one we see time and time again in Deleuze's work, the disjunctive synthesis: the combination of two opposing elements to create a paradoxical third term. Within the above three-part example of reported speech – *doing*, *saying without doing* and *when saying is doing* – Deleuze sets out his formula for performativity. The first example, the 'doing', is set apart from the second example, the 'saying without the doing', in the same way that oppositional binary pairs are set out in structuralist phonetics or linguistics – namely, by way of differentiation of minimal pairs. For his third synthesis, the flourish of 'when saying is doing', Deleuze merely places these two oppositions together so that the conjunction functions as a copula and the *addition* of the saying to the doing is what makes the performative perform. One initial problem with this three-part schema is that it is not clear what the difference is in speech between doing and when saying is doing. The example Deleuze centres his argument around is that of stuttering, which he believes is both action and word. He says that in a stutter, the words no longer exist independently of the stutterer, who unites them through the act of enunciation. Deleuze affirms this linguistic pathology as a creative motivation with this sentence, in which he turns the focus away from speech and towards writing; away from *parole* and towards *langue*. Deleuze is in fact not talking about stuttering at all; he is using what we might call the 'speech act' of stuttering to further elucidate his theories about structuralism and a poetic comprehension of language. It is noted in the English translation of '*Begaya-t-il*' that Deleuze's examples of *le faire, le*

dire sans le faire and most explicitly *quand dire c'est faire* are delib-
erate references to Austin's *How to Do Things with Words*, a text
that was hugely influential on Derrida's theory and practice.[16] If
we take Derrida as an exemplary theorist of performativity whose
writing enacts the theories he promulgates, this question could just
as easily be asked of Deleuze's writing, not just in this essay but in
varying degrees in everything he writes. To ask this question, we
need to identify the exact procedure he outlines here when he talks
about stuttering.

The performative example of stuttering is not merely appro-
priate because of its simultaneous 'saying' and 'doing'; Deleuze
stresses that it is in both the form of expression and the form of
content that stuttering occurs. While the form of expression in
speech, i.e. 'he stuttered', is easily signposted and comprehended,
what is important to note is the way Deleuze describes the form
of content: 'an atmospheric quality, a milieu that acts as the
conductor of words – that brings together within itself the quiver,
the murmur, the stutter, the tremolo, and makes the indicated effect
reverberate through the words'.[17] The words used here, which
describe the precise dynamism of stuttering, are one key aspect
to understanding why Deleuze has chosen this example. Deleuze
shifts the locus of the stuttering outwards from the particular to
the general, from the individual speaker of *parole* to the general
instance of *langue*. This is manifested on a grander scale when he
describes some literary instances of stuttering that are *doubled* in
the speakers' affective environments. The murmuring and foreign
intonations of Melville's Isabelle are enacted through 'the hum of
the forests and caves, the silence of the house, and the presence
of the guitar'; the squeaking of Kafka's Gregor Samsa is indicated
by 'the trembling of his feet and the oscillations of his body'; and
the stammering of Masoch's characters is palpable in 'the heavy
suspense of the boudoir, the hum of the village, or the vibrations
of the steppe'.[18] What happens in each case is the dynamism of
linguistic distortion bleeds outwards, linking up speaker and
external environment so that the entire fictive world is nothing but
a stuttering, a stammering, a linguistic tremor or twitch. In what
is again a highly rhetorical or metaphorical manoeuvre, Deleuze is
setting up a kind of linguistic pathetic fallacy with these examples,
in which the fictional surroundings mirror the linguistic opera-
tions, or action-words, of the characters. The link between this

phenomenon and the removal of the boundaries of sense in the Carroll-Artaud schema already discussed is clear to see. In both Melville's and Kafka's examples, the 'sensible' line dividing word and thing, actual and virtual, or the stuttering subject and his/her environment is dissolved.

But why stuttering? What happens in the performance of stuttering? Stuttering and stammering are linguistic pathologies in which the normal temporal flow is interrupted and speech gives way to repetition. In Deleuze's model, it is the precise motion of repeated vibration that becomes emblematic of the motion of the entire language. Deleuze presents a linguistic practice reliant on a system in a state of perpetual disequilibrium, or bifurcation. This is achieved if every term within the system passes through a zone of 'continuous variation' and as a result the whole language stutters. Deleuze defines a poetic comprehension of language itself thus: 'it is as if the language itself were stretched along an abstract and infinitely varied line'.[19] This line could easily be mistaken for a description of the temporal figure of the Aion, which Deleuze describes at several points in *The Logic of Sense* as a straight line traced by an aleatory point, or the 'pure and empty' form of the infinitive.[20] This will be returned to in the remaining chapters.

As discussed in the previous chapter, the concept of a Deleuzian 'poetic function' is never far away. Furthermore, Deleuze's 'poetic' function is directly influenced by Jakobson's. When discussing the doubleness of language in 'He Stuttered', Deleuze makes this comment:

> Language is subject to a double process, that of choices to be made and that of sequences to be established: disjunction or the selection of similars, connection or the consecution of combinables.[21]

The above description is Deleuze at his most Jakobsonian, and is extremely reminiscent of Jakobson's famous statement that the 'poetic function' projects the principle of equivalence from the axis of selection into the selection of combination.[22] It is helpful at this point to source this remarkable statement in Jakobson's thought by breaking it down into its constituent parts and looking more closely at the axes of *selection* and *combination*. In Jakobson's essay on aphasia he introduces the concept of the 'twofold

character of language'.[23] In this passage Jakobson first presents
two aspects of language as the *concurrence* of simultaneous entities
and the *concatenation* of successive entities, but these are only one
part of the two principal aspects of selection and combination.
Concurrence and concatenation are both part of the combination,
although – and this is one significant point where Jakobson
departs from Saussure – he notes that Saussure only recognized the
temporal sequence of concatenation and failed to take concurrence
into account. Using selection and combination, then, Jakobson
identifies two types of aphasia: the similarity disorder, which
exhibits a deficiency in selection; and the contiguity disorder, which
exhibits a deficiency in combination. His conclusion, then, maps
these disorders onto the opposing linguistic tropes of metaphor
and metonymy: 'Metaphor is alien to the similarity disorder, and
metonymy to the contiguity disorder.'[24] We therefore have a string
of related oppositional terms within Jakobson's 'bipolar structure':
one pole consists of selection, similarity and metaphor, whereas
the other consists of combination, contiguity and metonymy. We
can add to the list the axes of paradigm and syntagm, in which the
former maps onto selection and the latter maps onto combination.
It is important to point out, however, that again showing his proto-
Deleuzian colours, Jakobson never loses a sense of fluidity of these
oppositions under the schema of his poetic function. He maintains
that in poetry, 'where similarity is superinduced upon contiguity,
any metonymy is slightly metaphoric and any metaphor has a
metonymic tint'.[25]

In Deleuze's account of creative stuttering, both linguistic
axes are affected: the 'disjunction of similars', outlined above,
as normal linguistic practice becomes a combination, and the
'connection of combinables' is divided. The stuttering is therefore
a double stuttering. 'Every word is divided, but into itself (*pas-rats*,
passions-rations); and every word is combined, but with itself
(*pas-passe-passion*).'[26] The syntactic line that this type of language
follows is described as a 'syntax in the process of becoming'. It is
not wholly outside of language, but *the* outside of language. This
is the linguistic limit that links up Deleuze's earlier term 'sense',
discarded by this point in his career. This limit heralds a point
where language transcends itself and tends towards another mode
of expression altogether, and Deleuze is aware of this: 'Words
paint and sing, but only at the limit of the path they trace through

their divisions and combinations.'[27] It is this manipulation of spatiotemporal boundaries, the creation of new, impossible syntactic lines in order to transmute language, that Deleuze shares with the futurists.

Futurist theatre and philosophical dramatization

In the same way that the linguistic performance of stuttering becomes emblematic of an entire linguistic process under Deleuze's intended schema, we can turn to the avant-garde for analogous descriptions of performance that are synecdochic of an overall method of thinking or being. The overall celebration of movement palpable in futurist theatre is just one reason why theatre and performance are such important elements for the avant-garde as a whole. As far as the avant-garde is concerned, theatre in general is a fitting model because it is to do with setting concepts in motion. Ezra Pound famously stated in *ABC of Reading* (1934) that 'whereas the medium of poetry is words, the medium of drama is people moving about on a stage and using words'.[28] Before this was written, however, the Italian futurists had already extended this idea further so that the statements are no longer merely about theatre but are about the movement itself. Above all else, futurism is a movement of movement.

While manifestos of futurist theatre treat performance as their primary topic, they represent much more than purely theatrical objectives. The method of dealing with the performance can be seen as an extension of these artists' general aesthetic and/or political objectives; they operate synecdochically as dramatic models. For example, Marinetti's manifesto 'The Variety Theatre' (1913) not only employs the model of the variety theatre as a metaphor for futurist theatre but also extends it outwards towards all futurist endeavours.[29] Marinetti and the Italian futurists deliberately flit between the literal and the metaphorical in their discussions of athleticism and gymnastics. The variety theatre is a particularly appropriate model for futurism for various reasons; its focus on speed, force, shock and abstract feats of physical agility rather than the emotion-led narrative frameworks found in conventional

theatre is one of its principal features. The competitive nature of performers and the combination of physical and mental dexterity found in variety performance is noted by Marinetti in the manifesto: he champions the 'fierce competition of mind and muscle to beat all records for agility, speed, and strength, for complexity and elegance'.[30] There is an emphasis on health, vitality and movement for its own sake rather than as a representation or depiction of a human situation or emotion.

> The Variety Theater offers the healthiest of all kinds of entertainment, by virtue of the dynamism of its form and color (simultaneous movement of jugglers, ballerinas, gymnasts, multicolored riding troupes, dancers en point, whirling around like spinning tops). With the rhythm of its quick exhilarating dances, the Variety Theater inevitably drags the most sluggish souls out of their torpor and forces them to run and leap.[31]

Movement is vital in and of itself; it is separated from its referent just as language is separated from its referent in futurist language. Gymnastic movements in the variety theatre are 'pure' forms of movement celebrated for their own sake. This is linked to the futurist deification of speed; movement creates speed, but it is a specific type of movement being celebrated which is in keeping with the celebration of the verb in the infinitive discussed in the previous chapter. The movement itself is abstracted, separated from any substantive content surrounding it. It is movement in the infinitive.

One avant-garde figure who would have supported the concept of dramatization as more radically conceptual *and* more radically material than performativity is Artaud. Artaud wrote several manifestos detailing his version of avant-garde theatre. Nowhere else do we get such a detailed outline of how a truly avant-garde theatre should operate in terms of the modifications of the dynamic between actor, playwright, director, audience and set. Artaud was never a futurist, and his relations with the surrealists were fraught and ended badly due to his reluctance to wholeheartedly join the revolution.[32] His preoccupation with the violent materiality of language, however, is more of a futurist endeavour than a surrealist one. Breton's 'Manifesto of Surrealism' (1924) talks of 'madness', 'freedom' and 'psychic automatism',[33] and in this sense can definitely be described as continuing the project of a critique

of reason, but does not concern itself with the materiality of the voice in the same way as Artaud. Undeterred by his decaying link with surrealism, Artaud endeavoured to create his own non-representational theatre with the Theatre of Cruelty. His first text of this kind, *The Theatre of Cruelty* (1932) declares that we need to end the subjugation of theatre to text and favours a 'kind of unique language halfway between gesture and thought'.[34] The prioritization of spatial over verbal expression will be important for the discussions that follow. While the 'show rather than tell' ethos runs through much artistic theory of the twentieth century, like many other currents it can be seen within modernist writing but finds its most extreme examples in writing of the avant-garde.[35]

> I maintain that the stage is a tangible, physical place that needs to be filled and it ought to be allowed to speak its own concrete language.

> I maintain that this physical language, aimed at the senses and independent of speech, must first satisfy the senses.[36]

Artaud's new language here purports to use the possibilities of expression in space rather than linguistic expression through dialogue; he later refers to this as 'spatial poetry'. This description is an interesting development or reconfiguration of the theories expounded by Jakobson and explored by the futurists in terms of the spatial arrangement of poetry.[37] Artaud's use of the term is a literalization of spatiality so that the language has transcended its boundaries altogether. The poetry is an expression *in* the space, rather than lexical objects arranged according to spatial terms. It is dynamic expression without recourse to any linguistic system at all. The boundaries are stretched so far that the linguistic element disappears altogether and pure materiality is left, but this pure materiality is a language of its own.

It is important to note that while movement and gesture is a language in itself for Artaud, he does not disregard the vocal faculties; far from it. 'The atrophied windpipe is not even an organ but a monstrous abstraction that talks: actors in France can no longer do anything but talk.'[38] Another subversion of expectations is clear here; the discursive articulatory mechanism is 'atrophied' and is not performing, for him, its most important function. He

prefers the voice to be used for inarticulate and amorphous noise, which is another form of language 'in itself', just like movement in space, rather than being used for discourse. Talking is pointless in Artaud's theatre because it is confined by logic and reason; for him, the pure materiality of the voice must be unfettered by any mimetic or representational motivations. Artaud's distrust of conventional reason again links him with the surrealists, but his championing of the voice's primal waste products pushes his theatre into a territory all of its own. In the comparison of the 'nonsense' of Carroll and Artaud considered in Chapter 3, Deleuze reaches the conclusion that the nonsense of Artaud at its most poignant goes 'further' and is 'more' nonsensical than Carroll's, because Carroll's still upholds its grammatical form whereas in Artaud's screams and cries it appears that coherent form has disintegrated altogether. It is not the case, however, that Artaud discounts the voice as the site of production. Far from it; in Artaud's work the voice becomes (in Deleuze's words) even purer. The adjective 'pure' might appear odd for a philosopher such as Deleuze, for whom difference and multiplicity are central. The futurist drive towards a kind of formal purity, however, helps us to understand this further. Futurism shows us that an attempt to revolutionize form requires a preoccupation with form, which in turn requires the elimination of substantive detail, which in turn requires a kind of purism.

Artaud's inflections; Deleuze's intensities

Artaud is an important source of inspiration for Deleuze, and therefore the type of theatre Artaud proposes in his writings sounds unsurprisingly like the theatre of repetition Deleuze proposes in *Difference and Repetition*. Here Deleuze describes the skeletal framework of how such a theatre should operate:

> In the theatre of repetition, we experience pure forces, dynamic lines in space which act without intermediary upon the spirit, and link it directly with nature and history, with a language which speaks before words, with gestures which develop before organized bodies, with masks before faces, with spectres and

phantoms before characters – the whole apparatus of repetition as a 'terrible power'.[39]

The 'pure forces', 'dynamic lines', 'language which speaks before words', 'gestures', the replacement of faces with masks and of characters with spectres and phantoms are all concepts reminiscent of Artaud's own theatrical vocabulary. Deleuze is using the concepts from Artaud's theatre of cruelty to describe his own 'theatre' of repetition. The difference between these characterizations of materiality is that Deleuze is using the theatrical model to present a conception of non-representational thought, whereas Artaud's discussions, while still non-representational, are based on theatrical praxis.[40] Despite this difference, some of Artaud's texts are more theoretical than others. Two of Artaud's earlier manifestos, 'Manifesto in Clear Language' (1925) and 'Situation of the Flesh' (1925), demonstrate a more general theoretical or philosophical perspective rather than a literal statement about theatre. Both pieces read almost like manifestos for materialism, seeking to replace reason with matter. Similar ground is covered in Marinetti's 'Technical Manifesto of Futurist Literature', as discussed in the previous chapter. Artaud sounds more like a futurist than a surrealist when he writes 'My mind, exhausted by discursive reason, wants to be caught up in the wheels of a new, an absolute gravitation' and that 'The truth of life lies in the impulsiveness of matter.'[41] This celebration of materiality is more extreme, more 'pure', than merely celebrating language's material aspects in terms of 'sound', 'weight', even 'colour' or 'smell', as outlined in the futurist technical manifestos discussed in the previous chapter. It is no longer merely a case of willing synaesthesia or even radical translation; Artaud's materiality eschews language altogether. The difference lies in the distinction between a critique and subsequent reconfiguration of an existing linguistic system, and the attempt to leap out of this system entirely. Inserting materiality *into* language at the expense of reason is certainly something that can be detected within futurism, but creating an entirely new substance through exploring the limits of the voice goes a step further in a critique of representation. This is a radical type of dramatization which goes much further in abstracting human corporeality and force than mere performativity. Artaud's move towards this radical materiality of the voice is extremely important for Deleuze's thought.

It can be seen in his first manifesto of 'The Theatre of Cruelty', which describes 'an altogether Oriental sense of expression'. This 'concrete' language turns words into 'incantations' and 'utilizes vibrations and qualities of the voice'.[42] As described in 'An Emotional Athleticism' (1925), the focus is on the voice box as an instrument of pure sound, capable of producing a spectrum of intensities.

Both Artaud and Deleuze are interested in the intensive qualities of their chosen material, whether it is a scream, a gesture or a concept being discussed. An example of this focus on the 'intensive' is discernible in Artaud's 'An Emotional Athleticism'. In this text we can see a 'twofold' nature of movement emerging, analogous to Deleuze's 'twofold' nature of language, previously discussed: 'The muscular movements of physical effort are like the effigy of another identical effort, which in the movements of dramatic performance is localized at the same points.'[43] Artaud's preoccupation with the figure of the double is palpable throughout 'An Emotional Athleticism', which details the doubling of physical and emotional musculature. The doubling would have to be internal and would require interpenetration, because from Artaud's words here it appears that these twin processes of muscular effort do not require double the extension in space.

> The man who lifts weights lifts them with his loins, it is with a movement of the lower back that he supports and reinforces the strength of his arms; and it is rather curious to observe that inversely in every feminine and hollowing feeling – sobbing, desolation, spasmodic panting, fear – it is in the small of the back that the vacuum is physically expressed, in the very place where Chinese acupuncture relieves congestion of the kidneys.[44]

> The point of heroism and sublimity is also the seat of guilt. The place where one beats one's breast. The place where anger boils, anger that rages and does not advance.
>
> But where anger advances, guilt retreats; this is the secret of the empty and the full.[45]

> A high-pitched anger which is taken apart begins with a loud neuter and is localized in the plexus by means of a sudden, feminine void; then, obstructed at the shoulder blades, it bounces back like

a boomerang and gives off male sparks which are consumed without advancing. In order to lose their biting tone, they retain the correlation of the male breath: they exhale violently.[46]

In the examples above, Artaud begins mapping the body in terms of the dynamic interrelated forces of the muscles and the emotions. While muscular extension occupies actual space, emotional concentration is intensive. This is reminiscent of Bergson, who in *Time and Free Will* (1889) presents intensive muscular effort as an example of how a purely psychic state, which does not occupy space, can nevertheless possess magnitude. 'When a paralytic strives to raise his useless limb', says Bergson, 'he certainly does not execute this movement, but, with or without his will, he executes another.'[47] This enigmatic description is significant for a number of reasons: it highlights muscular effort without localizable output as a *sensibility*, thus providing an inspiration for both Artaud's and Deleuze's thoughts on the matter; it also describes an 'elsewhere' which again is reminiscent of Deleuze's small but vitally important reflection in *The Logic of Sense* on Alice and the Red Queen running very fast in order to stay in the same place.[48] This is an intensive type of exercise; it is the same type of exertion that occurs in creativity. As previously discussed, Deleuze aligns this concept of 'intensive' athleticism with creative literary output in his essay 'Literature and Life' when he echoes Henri Michaux in describing the writer as an 'athlete in bed'.[49] Intensity is vital for Deleuze; it is the 'form' of difference for him.[50]

> The expression 'difference of intensity' is a tautology. Intensity is the form of difference in so far as this is the reason of the sensible. Every intensity is differential, by itself a difference. Every intensity is E-E', where E itself refers to an e-e', and e to ε-ε' etc.: each intensity is already a coupling (in which each element of the couple refers in turn to couples of elements of another order), thereby revealing the properly qualitative content of quantity. We call this state of infinitely doubled difference which resonates to infinity *disparity*.[51]

Deleuze's foregrounding of intensity in *Difference and Repetition* operates as an 'intensification' of Kant's discussion of intuition in the *Critique of Pure Reason*, in which Kant's spatiotemporal

extensions are turned into 'intensions'. Kant states in the *Critique* that 'all intuitions are extensive quantities'.[52] The place where Deleuze departs from Kant is clear, as can be seen from this passage:

> All objections [to his upholding of the transcendental principle of the mathematics of appearances and the belief that the objects of sense conform to the rules of construction in space] are but the chicaneries of an ill-instructed reason, which erroneously thinks to liberate the objects of sense from the formal conditions of our sensibility, and represents these, although mere appearances, as things in themselves, presented as such to our understanding.[53]

The idea of liberating the objects of sense from the formal conditions of sensibility, however, is exactly what Deleuze does; in *Difference and Repetition* Deleuze defines a 'pure spatium' as an intensive quantity and endows intensity with transcendental status.[54] Extensity is insufficient for Deleuze's purposes because it fails to take into account the individuations that occur within it. Deleuze calls the 'depth' of intensity the '*implex*',[55] which subjects spatial extensities such as length and size to relative variations. Here we can see a thread running through *Difference and Repetition* and *The Logic of Sense*. As discussed in Chapter 2, Deleuze talks about the indifference within pure becoming to the distinctions of 'bigger' and 'smaller'. These are rendered as intensive rather than extensive magnitudes, due to the relative position of the observer.

If we compare the intensities of Artaud and Deleuze from an etymological perspective, it is clear that Artaud's 'inflection' is derived from *inflectĕre*, which means to curve or bend, whereas Deleuze's 'implex' is derived from the Latin *implectĕre*, meaning to entwine, twist or plait. The Latin derivations form another quasi-minimal pair *inflectĕre* / *implectĕre*, and denote slightly different types of dynamic intensive force. Artaud treats the voice as an instrument capable of producing variations and spectra of tones and breaths; these variations are his inflections, whereas Deleuze's 'implex' pertains to difference, which for him precedes identity. Both figures, however, point towards a materiality of thought, or what Artaud describes as 'a fluid materiality of the soul'. This is far harder to conceptualize than performative language, precisely because the language to express it does not yet exist.

The dance of thought

The discussion of dramatization at the beginning of *Difference and Repetition* is introduced within the framework of a critique of Hegel, who Deleuze believes remains within the realm of representation and 'simple' generality.

> The theatre of repetition is opposed to the theatre of representation, just as movement is opposed to the concept and to representation which refers it back to the concept.[56]

What is significant here is Deleuze's extended use of the term 'theatre'. Deleuze discovers a new type of theatre *within* philosophy in the figures of Kierkegaard and Nietzsche – a dramatic philosophy which disregards representation altogether. He draws a direct link between metaphysics and movement, which is a desire discernible within the avant-garde, not least within Italian futurism and of course Artaud's dynamic materialism, as discussed above.

> They [Kierkegaard and Nietzsche] want to put metaphysics in motion, in action … It is not enough, therefore, for them to propose a new representation of movement; representation is already mediation. Rather, it is a question of producing within the work a movement capable of affecting the mind outside of all representation; it is a question of making movement itself a work, without interposition; of substituting direct signs for mediate representations; of inventing vibrations, rotations, whirlings, gravitations, dances or leaps which directly touch the mind.[57]

It is important to note the avant-garde nature of the philosophical 'director': Deleuze could be mistaken for Marinetti when he describes a 'man of the theatre' and 'ahead of his time' – and there is no reference to a female here, despite the fact that he is writing in 1968, several decades on from the misogyny of Marinetti and the other Italian futurists. The listing of 'vibrations, rotations, whirlings, gravitations, dances or leaps' is a collection of abstract movements for their own sake which is reminiscent both of Marinetti's and Artaud's theatre. Deleuze uses the futurist

theatrical synecdoche, which he clearly admires, and applies it to the non-representational thinkers he admires. It is important to note, however, that there is a difference between the specific types of movement that Deleuze ascribes to these thinkers. One goes further than the other down the path of non-representational thinking. This soon becomes a distinction between Kierkegaard's theatre of 'faith' and Nietzsche's theatre of 'unbelief', which Deleuze then describes as 'already a theatre of cruelty'.[58] The reference to Artaud is telling. To equate Nietzsche's theatricality with that of Artaud is to bestow high praise indeed, for throughout his work Deleuze reserves the highest praise for Artaud. This is because Deleuze believes that both Nietzsche and Artaud tend towards the dissolution of the self, which is one part of his aim in *Difference and Repetition* under the guise of the critique of identity. Deleuze, of course, spends more time discussing this aspect of Nietzsche's philosophy in his earlier *Nietzsche and Philosophy* (1962). In this book Deleuze states explicitly that it is Nietzsche who transforms thought into a 'thought-movement', and he is at pains to point out that this is not merely linking manoeuvre between abstract thought and concrete movement. It is, rather, he says, 'that thought itself must produce movements, bursts of extraordinary speed and slowness'.[59] As with his discussion of the nonsense of Carroll and Artaud, it is clear whose philosophy of movement Deleuze prefers. He describes Kierkegaard's movement as 'leaping', whereas Nietzsche's is 'dancing'. This distinction is reminiscent of Paul Valéry's distinction between poetry and prose, which likens prose to walking and poetry to dancing. Poetry is like dancing because it is non-representational; it is an end unto itself.[60] We see further arguments to this end in Jakobson's poetic function, which is the linguistic message for its own sake.[61] At the level of the word, the Russian futurists expressed this idea most clearly in the very titles of their manifestos such as 'The Word *as Such*' (1913) and 'The Letter *as Such*' (1913).[62]

While these poetic movements of language and thought are comparable, they are not identical. The difference between non-representational dancing-writing and non-representational dancing-thinking could be expressed in terms of the extent of their non-representability. While language in the poetic function does not seek to represent anything, it is generally couched within the invariants of a system of signs. These signs are problematized and

stretched in avant-garde writing, but they are still signs. Dancing-thinking, however, would appear to be even more radically empty of signification in Deleuze's system. He expresses this philosophical practice in *Difference and Repetition*:

> The transcendental form of a faculty is indistinguishable from its disjointed, superior or transcendent exercise. Transcendent in no way means that the faculty addresses itself to objects outside the world but, on the contrary, that it grasps that in the world which concerns it exclusively and brings it into the world.[63]

This passage celebrates form as its transcendental exercise or deployment, and is one of Deleuze's many descriptions of the ways in which a faculty locates itself within the world through the unification of form and movement. This unification describes the movement of his thought, and is vital for futurist poetics.

Spatiotemporal dynamisms

What is it that motivates the dynamic intensities that make up Deleuze's thought? The relationship between philosophy and performance in Deleuze's theory of individuation begins with the idea of spatiotemporal dynamisms motivating or pre-empting the concept. There is a palpable urge in Deleuze's thought to recon-figure language so that it bypasses or short-circuits all mediating systems, and the spatiotemporal dynamisms are the source of this urge. It is introduced in the discussion 'Method of Dramatization', included in the collection *Desert Islands and Other Texts*. Deleuze distinguishes concepts and Ideas in this text, and relates how each term is motivated by dynamisms: 'pure spatio-temporal dynamisms have the power to dramatize *concepts*, because first they actualize, incarnate *Ideas*'.[64] The Idea is defined here, again through the double, as a multiplicity traversed in two directions simultane-ously. It is traversed from the point of view of the variation of differential relations, as well as from the point of view of the distri-bution of singularities corresponding to particular values of those relations: the idea is therefore differentiated through qualification and partition. As discussed in previous chapters, differentiation

and actualization for Deleuze are the same thing, but the pure and virtual Deleuzian Idea is both completely differentiated and completely undifferenciated.

> Dynamisms, and all that exists simultaneously with them, are at work in every form and every qualified extension of representation; they constitute not so much a picture as a group of abstract lines coming from the unextended and formless depth. This is a strange theatre comprised of pure determinations, agitating time and space, directly affecting the soul, whose actors are larva – Artaud's name for this theatre was 'cruelty'.[65]

The prioritization of the spatiotemporal dynamism is immediately palpable in many Italian futurist postulations regarding '*dinamismo*'. Both Marinetti and Boccioni extol the virtues of dynamism, Marinetti declaring in 'The Futurist Synthetic Theatre' (1915) that 'WE ACHIEVE AN ABSOLUTE DYNAMISM THROUGH THE INTERPENETRATION OF DIFFERENT ATMOSPHERES AND TIMES',[66] while Boccioni's manifesto 'Plastic Dynamism' (1913) defines the word as 'the simultaneous action of the motion characteristic of an object (its absolute motion), mixed with the transformation which the object undergoes in relation to its mobile and immobile environment (its relative motion)'.[67] The concept is celebrated at a multiplicity of levels, which include the dynamism of language and thought in futurist writing. 'Only Futurist free verse, a perpetual dynamism of thought, an uninterrupted flow of images and sounds, can express the unstable and symphonic universe that is forging itself in us and with us.'[68] *Dinamismo* and the French *dynamisme* derive from the Greek δύναμις, which means power or force. It is dynamisms that precede identity in Deleuze's thought, and which are celebrated at the expense of the human; the stomp of the Dionysian dance in which the particularities of the human intellect are completely dissolved.

> Given any concept, we can always discover its drama, and *the concept would never be divided or specified* in the world of representation *without the dramatic dynamisms* that thus determine it in a material system beneath all possible representation.[69]

The philosophical subject as abstract movement, or, the dancer and the dance

The futurist (and Deleuzian) drive towards the separation of a particular movement from its referent is reminiscent of Yeats' famous lines which capture this event at the very moment when the dance becomes independent of the dancer:

> O body swayed to music, O brightening glance,
> How can we know the dancer from the dance?[70]

The philosophical critique of both representation and subjectivity finds a powerful argument in the avant-garde use of puppets, masks and marionettes, all which 'double' the face or body in some way as well as eliminating explicit human input. Prostheses and doubles, it seems, make better actors and movers – not just because they can perform infinitely perfect and identical actions without deviating or tiring, but also because of their lack of self-awareness or self-consciousness. As critiques of humanity, they themselves are superhuman. Marinetti expounds more of the anti-human rhetoric in his manifesto 'Futurist Dance' (1920), in which he encourages us to 'go beyond what muscles are capable of and, in the dance, strive towards the idea of the *body extended* into machine, something we have envisaged for a long time'.[71] The idea of extending the body, or transcending its limits, is a concept Deleuze develops from Nietzsche and Spinoza. It demonstrates the body's potential to *become*, and the preference of 'becoming' over 'being' forms the basis of Deleuze's thoughts about Nietzsche. His description of becoming in *Nietzsche and Philosophy* demonstrates evidence of another doubling:

> A working thought which affirms becoming and a contemplative thought which affirms the being of becoming. These two ways of thinking are inseparable, they are the thought of a single element, as Fire and Dike, as Physis and Logos.[72]

The concept of becoming is extremely important because as well as being translated into the linguistic sphere, it is precisely what allows language to become something other than itself. Linguistic

becoming unites Deleuze's thought with futurism, and will form the basis of the next chapter.

Linked to this idea is the use of objects such as puppets, because they are not constrained by the limitations of the human psyche. The valorization of the marionette as a critique of human subjectivity can be traced as far back as Heinrich von Kleist and his famous essay 'On the Marionette Theatre' (1810), which describes the advantages a dancing puppet would have over a dancing human as a lack of 'affectation' and therefore an increase in graceful movement. The conclusion to Kleist's argument is worth quoting here:

> We see that in the organic world, as thought grows dimmer and weaker, grace emerges more brilliantly and decisively. But just as a section drawn through two lines suddenly reappears on the other side after passing through infinity, or as the image in a concave mirror turns up again right in front of us after dwindling into the distance, so grace itself returns when knowledge has as it were gone through an infinity. Grace appears most purely in that human form which either has no consciousness or an infinite consciousness. That is, in the puppet or in the god.[73]

The elimination of the messy human consciousness here suggested by Kleist ends up like another kind of Platonism: the 'ideal' form of human is the human with all of its humanity missing, or completely saturated with infinite knowledge and therefore omniscient and deified. The complete overturning of Platonism would end up with Platonism itself; as Deleuze has commented, the beginning of the project of overturning Platonism began at the beginning with Plato himself.[74] Rather than this eschewing of human consciousness in favour of the pure and empty form of movement, however, Deleuze and Guattari return to the concept of a *philosophical*-dramatic figure in *What Is Philosophy?* with their dramatization of the 'conceptual persona'. The necessity for a subject or persona to effect, enact, practise or perform the concept or thought of some kind that has been created seems to be felt by them at this point: in their words, 'Even Bergsonian duration has need of a runner.'[75] This shows a development in Deleuze's thought from the highlighting of spatiotemporal dynamisms, or difference, which is presented as occurring prior to identity in *Difference and Repetition*.

The conceptual persona is defined as the 'becoming' or the 'subject' of the philosophy, linking the person who expresses the philosophical concept with the concept itself. The act of enunciation lifts the utterance out of its particular circumstance of uttering and formalizes it, making it universal. The function of the speech act, therefore, is to change *parole* into *langue*, which is an operation Deleuze is very familiar with at every level of his writing. The speech act changes the speaker from a singular human being uttering a particular string of sounds into a formalized, collectively understood agent fulfilling a role and uttering a pre-decided, pre-interpreted string of sounds that have a specific and predictable material effect on the world. But in Deleuze's thought, every utterance is at once both *langue* and *parole*. This is in fact quite a grandiose statement to make about philosophy: first because it mentions a philosopher's 'destiny' to become 'his' conceptual persona (note the 'his') which places the philosopher in an esteemed, hierarchical position which appears at odds with Deleuze's supposed disregard for hierarchies; and secondly because it renders each particular philosophical enunciation as something universally applicable.

> In everyday life speech-acts refer back to psychosocial types who actually attest to a subjacent third person: 'I decree mobilization as President of the Republic,' 'I speak to you as father,' and so on. In the same way, the philosophical shifter is a speech-act in the third person where it is always a conceptual persona who says 'I': 'I think as Idiot,' 'I will as Zarathustra,' 'I dance as Dionysus,' 'I claim as Lover'.[76]

Rather than a mere double being posited, this 'third person' presupposes a trebling: speaker, interlocutor, and this 'subjacent third person'. The third person lifts the enunciation out of a particular circumstance and makes it collectively significant, but it is not quite as simple as turning *parole* into *langue*. The point of Deleuze and Guattari's articulatory mechanism is that every utterance is at once utterly singular and utterly collective. But this is only setting out the scheme for the main part of their framework for philosophical enunciation, which appears to depart from 'saying' altogether. Here it is possible to see why their philosophical ideal is presented as 'dramatic' or 'theatrical'. Philosophy becomes utterly direct; it

effects a dynamism without recourse to mimetic language. Rather than an image of thought, which Deleuze is always keen to write against, the thought itself produces its own movements and images.

> In philosophical enunciations we do not do something by saying it but produce movement by thinking it, through the intermediary of a conceptual persona. Conceptual personae are the true agents of enunciation. 'Who is "I"?' It is always a third person.[77]

In the above sentence Deleuze and Guattari differentiate between the speech act as it is understood in linguistic theory and their reworking of it at the level of philosophical thought. With speech acts the conflation is between saying and doing; with philosophical enunciation Deleuze and Guattari are positing here the conflation is between thinking and moving. In Deleuze's thought, the doubling of the persona and the process links up the linguistic speech act and the performative thought. The doubling of the philosophical protagonist of Zarathustra is itself the dramatization of the form of the speech act. Zarathustra is the dramatization of the idea of the speech act: he is both word and thing; word and deed. The progression from the discussion of reported speech in novels in 'Method of Dramatization' to the discussion of thought and movement can be traced through the work done in *The Logic of Sense* when Deleuze states that philosophy is like a novel. Deleuze's own 'conceptual personae' are abounding, but they are different to the examples of other philosophers' personae that Deleuze and Guattari suggest. They discuss Nietzsche's Dionysus and Zarathustra and Plato's Socrates as 'characters' which become not synonymous but in their own terminology 'heteronymous' with the figures Nietzsche and Plato, which are merely 'simple pseudonyms'. It is clear from these terms that the virtual personae are favoured over the actual philosophers, and when we actually begin to consider Deleuze's own conceptual personae (which he refrains from using as examples in *What Is Philosophy?*) the level of virtuality or abstraction increases even more.

As discussed in Chapter 2, Deleuze links philosophy with the novel form in both *The Logic of Sense* and *Negotiations*. In *Negotiations* he says that in this type of philosophical novel, the characters are concepts and the settings are space-times.[78] This is

his most explicit statement about his own conceptual personae, but still he does not name them. They are, however, littered throughout all of his writing; concepts as characters endowed with proper names. This is especially evident in his earlier books: in *Difference and Repetition* he introduces Habit and Mnemosyne, in *The Logic of Sense*, Chronos and Aion. The difference between Deleuze's conceptual personae and the examples of Nietzsche's and Plato's is that Deleuze's are abstract concepts rather than characters. This is his philosophical advancement: he removes the human speaker of the concept and makes the concept itself become the subject. In this way his philosophy is 'dramatic', not so much in a linguistic or literary sense but in a conceptual one. His critique of subjectivity is enacted at the level of his theories on time and consciousness, because it is the philosophical subject that has become an empty form. The only 'subjects' applicable for a philosophical critique of subjectivity like Deleuze's are those such as Aion, 'the pure and empty form of time'.[79] This argument will be developed in the following chapters. Pure forms behave themselves in a way that a speaking, writing, erring human subject may not. It is here that a kind of Platonism does become perceptible within its apparent overturning. This strange purism of form is the crux of the link between Deleuze's philosophy and the futurist drive.

CHAPTER FIVE

Shiftology #2: From metaphor to metamorphosis

Analogy and metaphor

The previous chapter introduced the concept of philosophical dramatization, or the potential for a direct link between thought and movement without recourse to representation. The shift from performativity to dramatization was presented as an exemplary dynamic 'shift'. This can be seen in both Deleuze and futurism, and is provoked by a problematic desire for an increase in the velocity of language, potentially at the expense of the speaking subject. This desire stems from a focus on language's material properties, as we have already discussed. Before the total bypassing of language can occur, however, an increasing amount of linguistic elision must happen; a certain acceleration of linguistic analogical procedures must occur. This is behind Deleuze and the futurists' preoccupation with speed, which importantly occurs at both a literal and a metaphorical level as well as both a linguistic and a conceptual one. Interestingly, it is precisely the elimination of the distinction between the literal and the metaphorical, and between the linguistic and the conceptual, that is brought about by the intensification of linguistic analogical manoeuvres. It is analogy itself that is being speeded up; the acceleration of analogy is framed, in both language and thought, as a critique of metaphor. The first section of this chapter looks at the *linguistic* critique of metaphor within futurism

and its development into what Deleuze would call 'metamorphosis'; the second section looks at the *philosophical* critique of analogy in Deleuze and its ensuing affirmation of becoming. This separation, however, is to some degree a false one in terms of Deleuze's futurist poetics. These processes, while not identical, both utilize a dynamic shift in order to develop, through acceleration, alternative and more immediate modes of being. The ways in which they inter-relate are explored in the third section.

There are multiple things to determine here, which will involve some analysis of the philosophical function of analogy within Deleuze, some analysis of the linguistic function of analogy within futurism, and then some analysis of the intersection between these. As we have already discussed in previous chapters, it is impossible to separate the linguistic and the philosophical in Deleuze's writing. Philosophical analogy and linguistic metaphor are discussed at different points in his work, but they work according to the same principles. The critique of analogy in *Difference and Repetition* is produced from within the history of philosophy and framed around the concept of univocity. It finds its linguistic expression later in his work in the explicit critique of metaphor. But through an exploration of both of these functions – analogy and metaphor – within futurism, it is possible to see how the levels of language and philosophy operate in tandem, or rather, the linguistic is synecdochic of the philosophical. We must ascertain what role metaphor conventionally plays within philosophical writing, and how Deleuze alters this. We must ascertain the ways in which a successful critique of metaphor can be produced within language; what speedier or more direct linguistic alternatives are available, and how these are explored within both futurist writing and Deleuzian thought. At this stage it is important to point out that in both Deleuze and futurism, 'metaphor' and 'analogy' are not discrete entities; one bleeds into another. It is as though metaphor stands metonymically or synecdochically for the broader term of analogy. In a similar way, we can say that 'metamorphosis' stands synecdochically for the broader term of 'becoming'. Both of these dual concepts are discussed in this chapter.

There are a lot of theoretical twists and turns that must have occurred before metaphor has been accepted in philosophical discourse enough to then be criticized by the same figures respon-sible for affirming it. As we will see, Deleuze is a Nietzschean

thinker in the sense that his thought relies on the affirmation of multiple metaphorical truths; nevertheless, he writes strong words against metaphor. Why does he hold this perspective, and why do the futurists display a similar stance? To answer this, it is helpful to consider futurism in the context of its reaction against symbolism, because metaphor and symbol are undeniably intertwined. It is also important to document the ways in which metaphor is treated within philosophical and linguistic discourse, specifically its acceptance and affirmation as a deeply entrenched cognitive function, and then the move to its critique.

Symbolism: Metaphor as deferral

Before futurism there was symbolism, and it is easy to see how metaphor is a necessary part of this movement whereas futurism declares that it is seeking to eliminate it. The language of symbolism can be characterized by a repeated deferral of meaning, substitution and replacement of a concept with something that stands in its place. The very nature of a symbol, and in fact the nature of language, is something that represents or stands for something else.

> Inimical to pedantry, to declamation, to false sensitivity, to objective description, Symbolist poetry tries to house the Idea in a meaningful form not its own end, but subject to the Idea. The latter in its turn will never appear without the sumptuous clothing of analogy; for the essential character of Symbolist art consists in never going so far as to conceive of the Idea in itself.[1]

This excerpt from the Symbolist Manifesto encapsulates the symbolist view of artistic representation: the Platonic Idea exists, but must always be cloaked in the 'sumptuous clothing of analogy', which functions as a mediating veil between word and thing. The clothing is, of course, another metaphor for the vessel that carries a content of meaning. When we replace the word 'heart' with the word 'ocean' in the metaphorical expression 'Her heart was an ocean', the ocean becomes symbolic of the heart due to whichever particularly ocean-like quality of the heart the writer is trying to

convey: depth, vastness, blueness, wetness or any other quality. Max Black calls the conventional perspective on metaphor the 'substitution view', in which in metaphor is used

> to communicate a meaning that might have been expressed literally ... The author substitutes M for L; it is the reader's task to invert the substitution, by using the literal meaning of M as a clue to the intended literal meaning of L. Understanding a metaphor is like deciphering a code or unravelling a riddle.[2]

Symbolism and metaphor are linked due to their shared movement of substitution or replacement of the original concept with something else which represents it. Mallarmé highlights this substitution process as fundamental to the process of language.

> I say: a flower! and outside the oblivion to which my voice relegates my shape, insofar as it is something other than the calyx, there arises musically, as the very idea and delicate, the one absent from every bouquet.[3]

What is highlighted in this passage is the *absence* of a flower which is then called forth; when the word 'flower' is uttered, what actually takes place is not a materialization of a flower but a metaphorical substitution. We can therefore see in Mallarmé's sentence a type of metaphorical manoeuvre which is nothing other than the fundamental act of naming: the word 'flower' functions as a metaphor or a symbol of the flower itself. The outcome of this is a position arguing for the metaphorical nature of language itself. There is, of course, a difference between metaphor and allegory in this regard, expressed succinctly by Paul de Man in his discussion of Proust. He points out that in a metaphor, the figural substitution engenders a meaning that does have the power to remain implicit because it is constituted by the figure itself. In the case of allegory, on the other hand, there is less faith in the figural application because it bears no relation to the literal meaning.[4] This then maps onto the multiple Jakobsonian distinctions already discussed, one of which was the opposition between metaphor and metonymy, which Jakobson of course collapses within his poetic function. What is interesting is the potential for instability between the literal and the figurative – the potential for one to overcome or usurp the other's meaning.

While the symbolists may have apprehended the process of significative substitution or deferral as corroboration of their position, the futurists saw this as a fundamental problem. The separation of vessel and content within symbolism is precisely what futurism and Russian formalism react against; the 'clothing' is deemed an unnecessary distraction. As we have seen in previous chapters, a process of 'materialization' can be seen as more complex if it is understood as happening at the level of the language itself rather than at the level of the concept. This causes problems for a metaphorical substitution, because the hierarchical structure that would place the Idea over Language is then turned upside down. The battle between 'wordness' and 'thingness' would be won by 'thingness'. This is the desire of Blanchot, who champions the materiality of language above anything it is supposed to represent.

The fault of simple metaphor is less in its simplicity, which makes its deciphering easy, than in its stability, its plastic stability; it is as weighty and present as what it represents.[5]

Blanchot distrusts metaphor because of its 'stability', which may appear a strange word to use for a figure of speech. He views metaphor as 'as weighty and present as what it represents'. By eliminating the – 're-' from 'represent' and leaving only 'present' remaining, Blanchot sheds an analogical layer and accredits the figure of metaphor with just as much material existence as the thing itself. In positing materiality in the metaphor he is granting legitimate material existence to poetic language: the metaphor becomes the real thing. In this he marks the difference between materialism and materiality, in that materiality retains both sides and therefore immanentizes language. The immanentization of both language and thought is a project Deleuze remains keen to promote from his early to his late work.

The futurist critique

The insufficiency of metaphor for Marinetti can clearly be seen in his 'Technical Manifesto': the 'narrow nets of metaphor' used by futurist poets before him are 'too weighted down by the plumb

lines of logic'.[6] It may appear to be an argument against the use of metaphor, but the remainder of the manifesto instead argues for a type of figurative language unrestricted by the infrastructure of reason. This would be a different type of metaphor, one in which the 'strict nets' have been loosened and analogies between source and target are wider and more arbitrary. His alternative to the strict nets of metaphor is therefore not an entirely new theory or practice; it is an extension of the pre-existing one. The ways he sets out for this concept to be transformed are expressed in his various and detailed discussions of the functioning of analogy.

The term 'analogy' receives a lot of attention from Marinetti in the 'Technical Manifesto'. His attitude towards this word is typically ambivalent; analogies should be used, but only in the specific way that he decrees. Marinetti outlines in the 'Technical Manifesto' his desire to stretch or intensify the notion of analogy into something more immediate. If for now we uphold a (metaphorical) view of the avant-garde as the projection along a continuum of representation from a 'transparent', entirely mimetic representation of an object to complete severance of analogy from its referent, Marinetti's desire is to take the concept of analogy and metaphor a step further towards severance. This step would be where reason no longer holds relevance and the materiality of language takes on a more 'weighty' significance. There is of course no assurance that this continuum follows a linear pattern; if anything, it is cyclical in shape. As symbol or substitution process, metaphor here represents the mediating channel of signification through which meaning must pass – a dividing screen that separates word and thing. Marinetti desires to remove this mechanism of separation, making word and thing into one being. If metaphor is either eschewed in favour of something more immediate or granted a material existence itself, then it is no longer simply a way of seeing a particular thing: it has the power to make that thing become something else entirely.

There are several instances in the 'Technical Manifesto' in which the word 'analogy' is mentioned, four of which are quoted below:

1 Every noun should have its double; that is, the noun should
 be followed, with no conjunction. By the noun to which
 it is related by analogy. Example: man-torpedo-boat,
 woman-gulf, crowd-surf, piazza-funnel, door-faucet.

2 Just as aerial speed has multiplied our knowledge of the

world, the perception of analogy becomes ever more natural for man. One must suppress the *like*, the *as*, the *so*, the *similar to*.

3 Up to now writers have been restricted to immediate analogies. For instance, they have compared an animal to a man or to another animal, which is almost the same as a kind of photography. They have compared, for example, a fox terrier to a very small thoroughbred. Others, more advanced, might compare that same trembling fox terrier to a little Morse Code machine. I, on the other hand, compare it to gurgling water. In this there is *an ever-vaster gradation of analogies*, there are ever-deeper and more solid affinities, however remote.

4 Analogy is nothing more than the deep love that assembles distant, seemingly diverse and hostile things. An orchestral style, at once polychromatic, polyphonic, and polymorphous, can embrace the life of matter only by means of the most extensive analogies.[7]

Taking the first two examples from Marinetti (1 and 2), what is common between them is a desire to be rid of any conjunction separating tenor and vehicle; the two items should be placed next to one another with no mediating term in between them. It is as if the concept of analogy is accelerated to the point of immediacy, with the end result being the simultaneity or co-presence of tenor and vehicle. Here we witness the aesthetic of speed so important to the Italian futurists entering the very form and grammar of the language: elision and abbreviation speeds up the process of conceptual linking so much that it becomes total blending. In the first example, the words are separated only by hyphens so that they are no longer even discrete lexical items.[8] Analogy itself has been accelerated from the veiling and obscurantism of the symbolists' 'sumptuous clothing' into something instantaneous and direct. It is so direct it evades language itself, preferring diagrammatic, mathematical or non-linguistic symbols. There are many examples of this type of ideogrammatic experimentation to be found within futurist writing. What is significant here is that this type of extreme linguistic reduction is in fact applicable to the 'analogies' that are to be found in Deleuze; these will be discussed later in this chapter. The second

two examples of 'analogy' in Marinetti's 'Technical Manifesto' (3 and 4), involve a closer examination of the relative notions of proximity and distance with regard to analogical relations. As we have seen, the way rhetorical or figurative language works is by substitution or symbol; one item replaces another and stands for it. To replace this process there are two directions that would appear to oppose one another. First, the analogy can become closer and more immediate, bypassing the substitution process which would appear to stand in the way of approaching or apprehending the source of the description. This may make it appear closer to the supposed transparency of realism because the mediating process of symbol or sign has been removed.[9]

The second option, which appears to oppose the first, is that the analogy can become more divergent, more arbitrary, or further away from its source, so that it becomes more difficult or even impossible to chart the chain of cognitive associations that has led from source to target. The interplay between the two options outlined above is a vital tension within the avant-garde attitude towards representation. 'In discovering new analogies between distant and apparently opposite things, we will evaluate them ever more intimately', Marinetti declares in 'Wireless Imagination' (1913); just as in the 'Technical Manifesto' he declares that in an *ever-vaster gradation of analogies* there are ever-deeper and more solid affinities'.[10] The opposing trajectories of becoming-wider and becoming-narrower are brought together as one. Again we are reminded of Deleuze's description in *The Logic of Sense* of the removal of the distinction between 'smaller' and 'larger' for Alice in Wonderland. This contradictory logic encapsulates the nature of the abstraction or 'defamiliarization' process; it is presented as a manoeuvre that moves further away in order to get closer. The avant-garde continuum from realist representation to total materiality and nonsense therefore cannot be understood in linear terms: it is paradoxical in its bi-directionality. If we think about the difference traditionally understood within figurative language between simile and metaphor, metaphor can first be viewed as more immediate than simile because prepositions such as 'like' and 'as' are omitted. The gesture of comparison or analogy shifts to one of definition or being itself: instead of A being *like* B, A *is* B. Obviously a comparison between metaphor and simile in English would result in the elimination of the 'like', and therefore

could be viewed as an 'acceleration' or a shortening of the distance between tenor and vehicle. Because of this distinction, metaphor is seen as stronger than simile. Structurally, though, they carry the same function; their ultimate goal is to create a link between two disparate entities.

It was and was not: Metaphor as catachresis

Catachresis is defined as an 'improper' use of metaphor.[11] Max Black, however, describes metaphor in its entirety as catachresis in *Models and Metaphors* (1962).[12] Rather than imbuing metaphor with a sense of error or wrongness, this allows us to think of it as an opening of potential meaning; making meaning multiple. Rather than creating erroneous 'mixed' metaphors, catachresis allows for the proliferation of polysemy and creates new ways of perceiving. Jakobson, who talks of Majorcan storytellers who mark their tales with '*Aixo era y no era*' ('It was and was not'),[13] is aware of the importance of affirming the 'error' of metaphor. In his significant 1975 study of the trope, Paul Ricoeur says of the Majorcan phrase that it 'contains *in nuce* all that can be said about metaphorical truth'.[14] From this statement, we can begin to understand the relationship between metaphor and paradox, or perhaps, the paradoxical structure of metaphor. The dynamic shift of defamiliarization already discussed is an example of this catachresis; to defamiliarize an established concept we create new ways of perceiving it, placing a new sense onto the established one.[15] It is an affirmation of error that allows for the proliferation of multiple meanings, which is precisely what is celebrated within modern thought.

The relationship between metaphor and philosophy charts a similar path to that of paradox and philosophy. As with paradox, metaphor in philosophical writing can be either affirmed or explained away; it can either be separated from the content or it can be treated as the content itself. Further complications arise when the philosopher's own metaphors are taken into account at the same time as their perspective on metaphor, whether affirmative or negative, is being investigated.

To draw attention to a philosopher's metaphors is to belittle him – like praising a logician for his beautiful handwriting. Addiction to metaphor is held to be illicit, on the principle that whereof one can only speak metaphorically, one should not speak at all.[16]

Black's aim in *Models and Metaphors*, following Nietzsche before him, is to refute the above claim by demonstrating that metaphor is far more fundamental to thought than this supposed anti-metaphorical philosophical stance would allow. The formulation of Black's description above, with its tongue-in-cheek reference to Wittgenstein's ambiguous remark in the *Tractatus Logico-Philosophicus* (1921) concerning the attempt to say the unsayable, shares with Wittgenstein's comment a perspective on philosophy and language not necessarily held by the author but understood as accepted within Anglo-American philosophy: metaphor and rhetoric belong to literature rather than philosophy.[17] The fact is, however, that Nietzsche's thoughts on metaphor pave the way for an entirely different perspective, quickly to become widespread among continental philosophy; the role of metaphor has shifted from an unnecessary rhetorical or literary embellishment of an idea to a fundamental catalyst for cognition.[18]

Philosophers cannot write anything without employing layers of metaphor, and Nietzsche proves this by calling to attention his own metaphorical usage. Nietzsche defines a word in 'On Truth and Lying in an Extra-Moral Sense' (1873) as 'the expression of a nerve stimulus in sounds'. Immediately after he has stated this definition, Nietzsche very famously and deliberately calls to attention his own metaphor; he says: 'A nerve stimulus, first transformed into an image! First metaphor! The image again copied into a sound! Second metaphor!'[19] Nietzsche's point is clear: we cannot discuss metaphor without using it. Ricoeur's comprehensive study *The Rule of Metaphor* (1975) presents the argument for the utter metaphoricity of metaphor, arguing ultimately for a metaphorical notion of truth and echoing Heidegger's statement that 'The metaphorical exists only within the metaphysical.'[20] It is particularly noteworthy that Ricoeur presents this metaphoricity of metaphor as paradoxical.

The paradox is this: there is no discourse on metaphor that is not stated within a metaphorically engendered conceptual

network. There is no non-metaphorical standpoint from which to perceive the order and the demarcation of the metaphorical field. Metaphor is metaphorically stated.[21]

This formulation is potentially problematic if the philosopher in question is writing against metaphor itself. When discussing language, the fact that only language can speak to negate itself leads to paradox. By the same token, when discussing metaphor, the same paradoxical situation arises. Whether this problem is celebrated or lamented depends on the stance of the thinker or writer in question. It is what leads Lecercle to begin his book *Deleuze and Language* with the statement that language is a 'problem' for Deleuze.[22] The discussion of 'dramatization' in the previous chapter was a move to eschew language altogether, but this impulse is of course couched in the very medium it seeks to escape.

From analogy to univocity

Marinetti's acceleration of analogy is an attempt to eliminate the time-consuming process of mediation within an analogical process. A critique of mediation is a position we can also see in Deleuze. Deleuze lists the four 'shackles' of mediation in *Difference and Repetition* as identity, opposition, analogy and resemblance.[23] How much is Deleuze's work a critique of analogy, and how much does he employ the very thing he aims to critique? The type of analogy he aims to critique here is derived from Aristotle's metaphysics. While Deleuze presents Being as univocal, Aristotle, he claims, presents Being as equivocal. Deleuze's characterization of Aristotle's equivocity of being and analogy is made up of two functions: 'distribution, which it ensures by the *partition* of concepts; and hierarchization, which it ensures by the *measuring* of concepts'.[24] These analogical functions constitute measure or justice as a value of judgement. This model, which Deleuze sees in every philosophy of 'categories' from Kant to Hegel, is insufficient for Deleuze's own theorization of pure difference.

Deleuze shifts from Aristotelian analogy to Spinozist univocity, which is discussed more fully in *Expressionism in Philosophy:*

Spinoza (1968). Deleuze takes on Spinoza's characterization of the attribute, which contains forms common to God. 'Analogy cannot do without equivocation or eminence, and hence contains a subtle anthropomorphism, just as dangerous as the naïve variety.'[25] Analogy is therefore linked with equivocity and opposed to Spinozist univocity. Spinoza insists on an identity of form between creatures and God. Creatures in Spinoza's philosophy are formally identical to God, and it is this 'community of form' that makes it univocal rather than equivocal. If every being shares the same formal characteristics, no equivocity is required; everything is 'said' in the same way.

The structure of mimetic representation, to varying degrees, requires the analogical equation of one thing with another. In both *Difference and Repetition* and *The Logic of Sense* Deleuze presents univocity as the preferred term to analogy or equivocity. In the previous discussion of Deleuze's univocity in Chapter 2, we ascertained that Deleuze presents Being as that which is said, or says itself, in one voice. It is aligned with Deleuze's nonsense because it says its own sense rather than denoting, connoting or signifying anything else.

Deleuze presents univocity in *Difference and Repetition* as developing through three key figures and points, all centring around the process of individuation: Duns Scotus, Spinoza and Nietzsche. While the univocity of Duns Scotus presents itself as indifference to the distinction of the universal and the singular, it distinguishes between two types of distinction: formal (a 'real' distinction, grounded in being) and modal (between being/attributes and the intensive variations they are capable of). Deleuze's Spinoza makes univocity 'affirmative' and divides it into substance, attributes and modes. He does this by rendering 'real' distinctions as 'formal', and 'numerical' distinctions as 'modal'. Univocal being is said in one unique substance, distinguished formally by way of attributes and modally by way of intrinsic modes. Nietzsche's development of this is to nullify the remaining difference between the substance and the modes. This moment, described below by Deleuze, is the real critique of identity and representation.

> That identity not be first, that it exist as a principle but as a second principle, as a principle *become*; that it revolve around the Different: such would be the nature of a Copernican revolution

which opens up the possibility of difference having its own concept, rather than being maintained under the domination of a concept in general already understood as identical.[26]

Difference having its own concept would for Deleuze supplant the equivocity of analogy. While being is always said in the same sense, this sense is infinitely variable and affirms difference more radically than anything that differs *from* something else. Again, it is the preoccupation with the form of the concept (difference) that is emphasized. Analogy is insufficient for Deleuze's purposes because it retains an unhelpful chasm between the universal and the particular. Deleuze's univocity is a difficult concept to think, because it requires a simultaneous eschewing of categorization and affirming of pure difference. The way distinction can occur, inspired by both Spinoza and Nietzsche, is through degrees of intensity. This is the example of 'whiteness' that Deleuze gives in *Difference and Repetition*, which we discussed in Chapter 2.

The futurist vehicle: Metaphor as conduit

It has already been suggested that the division between these linguistic and philosophical critiques is a false one. The operations performed on language, thought and being within futurism and Deleuze are not so much analogous as univocal themselves, in that they are said in the same sense. Philosophical or religious analogy and linguistic or rhetorical metaphor work in the same way. As already discussed, Marinetti declares in his 'Technical Manifesto' that the metaphors used by futurist poets preceding him are insufficient for the futurist project: their 'strict nets' are 'too weighted down by the plumb lines of logic'.[27] It is immediately clear that despite his protestation, Marinetti's own sentence contains a typical metaphor in which thought itself is concretized: 'logic' is described as flowing through 'plumb lines'. The imagery of this particular metaphor is noteworthy in light of more recent work on metaphor within linguistics; the 'conduit' metaphor is discussed below. Marinetti's description is also significant because it highlights the potential problems encountered when we try to

talk about metaphor without using metaphor itself. Derrida and de Man are concerned with this problem, which, as we have seen, is a concern for Nietzsche. Returning to Nietzsche's description of a word as 'the expression of a nerve stimulus in sounds', there is a further point to be made about this: this is Nietzsche's use of the preposition 'in'. The use of 'in' in this description is important because it suggests that the word requires a dual perspective: an inside and an outside, a vessel and a content. The sound is presented as a vessel that carries the nerve stimulus; metaphor is split into two.

The image of language as a vessel transporting a meaning has been used to describe the movement of language ever since Aristotle's *Poetics*, when he says 'The *vehicle* of expression is language – either current terms, or, it may be, rare words or metaphors'[28] (my italicization). This particular metaphor for language's movement has been developed by various linguists and philosophers; the terms most commonly used are those of the 'vehicle' or 'conduit' in which the metaphor functions by transferring or translating meaning from one locus to another. The terms 'tenor' and 'vehicle' are drawn from theories on metaphor voiced by I. A. Richards in his famous lecture on metaphor in *The Philosophy of Rhetoric* (1936), which first separates out the dual components of a metaphor, with the tenor referring to the concept, object, or person meant, and the vehicle being the image that carries the weight of the comparison.[29] The 'conduit' metaphor was introduced by linguist Michael Reddy in 1979, who presented a huge appendix of different instances in the English language where words are presented as containers for ideas. The expression is a pipe or a vein carrying the flow of ideas.[30] Marinetti's plumb lines enact precisely this cognitive infrastructure, which is tricky considering that he uses them to express his apparent dissatisfaction with metaphor. This problematic and potentially paradoxical situation wherein metaphor is utilized only to negate itself is a situation that can also be found in Deleuze. Before we analyse this further, however, it is important to understand how Nietzsche's concept of using metaphor to discuss itself has been used to affirm rather than to discredit.

We can see examples within certain areas of philosophy where the ideas behind both the conduit metaphor and the concept of tenor and vehicle are manipulated and extended. As Derrida points out, the word *metaphorikos* means 'mode of transportation' in

modern Greek; he uses this fact to create his own metaphorical description of its function.

> *Metaphora* circulates in the city, it conveys us like its inhabitants, along all sorts of routes, with intersections, red lights, one-way streets, no-exits, crossroads or crossings, and speed limits. We are in a certain way – metaphorically, of course, and as concerns the mode of habitation – the content and tenor of this vehicle: passengers, comprehended and displaced by metaphor.[31]

There are several things to note about this passage. First, Derrida is very deliberately using an obvious and extended metaphor here, describing metaphor itself in terms of a city's public transportation system and infrastructure. Secondly, it is interesting that he describes the human, the speaking subject, as the 'passenger', which is suggestive of a strong undercurrent of linguistic determinism which powers deconstruction. Derrida's use of 'vehicle' in his description of the structure of metaphor is in a sense a different kind of metaphor than his first metaphor of the city's transportation. The 'vehicle' is both material and immaterial. Derrida manipulates the space between the abstract metaphor and the concrete vehicle, but of course this vehicle is simultaneously a linguistic abstraction. This is confusing, but we still hang onto the concept of metaphor as something dynamic, something that moves or translates. If we turn to Paul de Man, however, we can see in 'The Epistemology of Metaphor' (1978) two attributes of metaphor that contradict one another even further.

Paradoxical metaphoricity: Metaphor as battle

> It is no mere play of words that 'translate' is translated in German as '*übersetzen*' which itself translates the Greek '*meta phorein*' or metaphor. Metaphor gives itself the totality which it then claims to define, but it is in fact the tautology of its own position. [32]

De Man first presents metaphor in terms of transport and movement just as Derrida does, demonstrating through translation itself the

link between metaphor and translation. Metaphor is still presented as a dynamic shift, which reminds us of the important 'trans-' prefix discussed in the Introduction. He then, however, describes it as 'the tautology of its own position'. By using translation itself to demonstrate that metaphor is a kind of translation, he has in fact gone 'nowhere', highlighting the fact that metaphor as a trope is simultaneously both static and dynamic. Its movement is intensive; like Alice and the Red Queen, it runs in order to stay in the same place. It moves from one location to another, but all it achieves is what de Man calls 'the fallacious illusion of definition'. Both Derrida and de Man position themselves as if to describe metaphor itself as 'the fallacious illusion of definition', and the paradox therein, is something that contains infinite potential. If we say 'Her heart was an ocean', the heart is both a heart and not a heart as well as being both a heart, an ocean, and both a heart and an ocean at the same time. This is precisely what makes metaphor paradoxical; it manages to be both a contradiction and a tautology at the same time. The tautology is composed of the structure and the content of philosophical discourse on metaphor: the tenor and the vehicle. What necessitates the discourse on metaphor is metaphor itself, so in the discussions of metaphor both the tenor *and* the vehicle are metaphor. The potential for unhelpful infinite repetitions of a paradoxical statement from this situation is rather high. What, then, is Deleuze's perspective of this situation? He subscribes to the weightiness of the metaphor that Blanchot alludes to earlier in the chapter. While Blanchot says that metaphor is 'just as weighty and present as what is represents', implicit within this statement is the suggestion that it is in fact *more* weighty. Language under this schema is not just attempting to usurp its object, which would still presuppose representational thinking; rather there is an immediacy being suggested that is even more direct than the 'thing' usurping the 'word'. Again, however, Deleuze's attitude towards this is ambivalent; while he describes the event of language as a battle in *The Logic of Sense*, it is not quite clear who he wants to be the winner.[33] Metaphor for Deleuze is an event of battle between tenor and vehicle; the asymmetry is displayed in terms of a power imbalance wherein the metaphoricity of the language itself struggles against the metaphors that form the discussion. The vehicle's structure has the potential to usurp its content; it is not so much that 'word' overcomes 'thing' but that 'word' encompasses

'thing' within its structure and in doing this collapses the dualism altogether. The foregrounding of language's materiality, vital in both futurism and Deleuze, works towards precisely this end.

'Kill metaphor'

The fact that it is difficult or potentially even impossible to talk about metaphor without using it is described not as a problem by Derrida and de Man but as a fortification of the argument that *all* language is rhetorical. As well as in Nietzsche, this argument is fundamental to the avant-garde and forms an important part of the shift away from realism. Jakobson gives some examples of this from the Russian avant-garde in 'On Realism in Art' (1921):

> Consider Gogol's pronouncement about the poetic qualities of an inventory of the Muscovite crown jewels, Novalis's observation about the poetic nature of the alphabet, the statement of the Futurist Kručenyx about the poetic sound of the laundry list, or that of the poet Xlebnikov claiming that a misprint can be an artistically valid distortion of a word.[34]

The particular spatiotemporal implications of perceiving a list as a poetic work are highly significant in conjunction with Deleuze and futurism, and will be covered in the next chapter, but the championing of prosaic, pragmatic linguistic occurrences as artistic events is very clear. Metaphor, it appears, is everywhere. The inventory, the alphabet, the laundry list and the misprint are not metaphors, but a world view that renders truth as inherently metaphorical makes them become so.

Deleuze's position on metaphor appears to be different, but the degree to which he manages to detach himself from metaphoricity is questionable. A prescriptive attitude towards the reader's consumption of his philosophy has been part of Deleuze's project ever since *Difference and Repetition* and *The Logic of Sense*. The fact that he deems this necessary is an important aspect of the radical element that he shares with the futurists, who wrote scores of manifestos with prescriptions of this kind. As we have seen, at the beginning of both books Deleuze instructs the reader on exactly

how the book should be read. Rather than the mere shift from 'work of philosophy' to 'novel', Deleuze places his works across several literary and non-literary genres. *Difference and Repetition* should be viewed 'in part a very particular species of detective novel, in part a science fiction'; *The Logic of Sense* should be read as 'an attempt to develop a logical and psychological novel'.[35] Even when describing the writing of someone else, such as in *Kafka: Toward a Minor Literature*, the aim of Deleuze and Guattari is to present a particular programme or perspective of both literature and language. The question remains whether this typology is developed any further than the writers they discuss. The 'minor literature' described in *Kafka* and *A Thousand Plateaus* is their most overt aesthetic and political literary programme. The way in which they appropriate Kafka's work to promote their own project has been criticized by Ronald Bogue, one critic of Deleuze's aesthetic objectives, who importantly describes him in terms of the avant-garde:

> *Kafka: for a Minor Literature* is not so much a work of literary criticism as a manifesto and apologia for a literary/political avant-garde. In their basic approach to modern art and politics, Deleuze and Guattari are not especially eccentric or unorthodox.[36]

Almost every reference to metaphor in both *A Thousand Plateaus* and *Kafka: Toward a Minor Literature* is a repudiation; metaphor is rejected in favour of something more immediate. Rather than overtly alter metaphor itself, however, Deleuze and Guattari coin two interrelated alternatives of metamorphosis and becoming.

> Metamorphosis is the contrary of metaphor. There is no longer any proper sense or figurative sense, but only a distribution of states that is part of the range of the word. The thing and other things are no longer anything but intensities overrun by deterritorialized sound or words that are following their line of escape.[37]

A desire to eliminate the analogical conjunction that is implicit in Deleuze's earlier philosophical works becomes concretized in these later ones. Rather than place words next to one another, Deleuze

and Guattari appear to want to remove the analogical shift from the linguistic sphere entirely. How is this possible if the medium being used is still a linguistic one? What viable options are there for the philosopher-writer with a hatred of metaphor? Deleuze and Guattari's rejection of metaphor here consists of abstracting the mediating process of metaphor from the linguistic sphere and making it material or actual. This is often expressed in a dismissal of the subordinating conjunction 'like' in favour of dynamic events in which the source object is supposed to behave in a way that allows it to 'become' its desired state. Metaphor for Deleuze and Guattari is encapsulated in the subordinating conjunction. While in English this would conventionally be used to express simile rather than metaphor, Deleuze and Guattari appear to view it as *functioning* metaphorically. The use of 'like' or 'as' is perceived as emblematic of a metaphorical structure, even when the more immediate copula is used. They reject the conjunction when describing the trajectory of their own thought. The following comment can be read as an instruction to the reader, outlining the way in which their analogies must be digested:

> There is no 'like' here, we are not saying 'like an electron,' 'like an interaction,' etc. The plane of consistency is the abolition of all metaphor; all that consists is Real.[38]

The emphasis is on a literal appropriation of the analogies. Deleuze and Guattari's insistence on the solidity and literality of the 'electrons' and 'interactions' in the analogy is where they would purport to diverge or 'go further' than other writers. But how exactly do they carry this out? As well as eliminating the conjunction entirely, Deleuze and Guattari also offer a different interpretation of it that points towards becoming rather than metaphor.

> If we interpret the word 'like' as a metaphor, or propose a structural analogy of relations (man-iron = dog-bone), we understand nothing of becoming. The word 'like' is one of those words that change drastically in meaning and function when they are used in conjunction with haecceities, when they are made into expression of becomings instead of signified states or signifying relations.[39]

While Marinetti in his 'Technical Manifesto' argues for a suppression of the 'like', the 'as', the 'similar to', Deleuze and Guattari here argue for a different, more intense usage of 'like'. The 'structural analogy of relations' which they present as insufficient is reminiscent of Marinetti's analogies; the 'man-iron = dog-bone' is similar in structure to the 'man-torpedo-boat, woman-gulf, crowd-surf, piazza-funnel, door-faucet' presented as extreme examples of analogies in the 'Technical Manifesto'.[40] While Marinetti is quite happy with this mode of presenting analogies, the replacement of conjunctions with symbols is still seemingly not immediate enough for Deleuze and Guattari. While both the hyphens and the equals signs function as conjunctions, it is significant that they are not identical in their meaning: a hyphen joins two items together making them into a blend, whereas an equals sign merely equates one discrete thing with another.[41] A true similarity between Marinetti's analogy and Deleuze and Guattari's would occur if the tenor of 'man' and the vehicle of 'dog' in Deleuze and Guattari's example were separated by a hyphen and not by an equals sign.

It is important to note, as some scholars of Deleuze have done, the potentially performative nature of both grammatical terms and symbols that he uses: John Mullarkey describes Deleuze's use of hyphens as performative,[42] while James Williams describes his use of the conjunction 'or' as performative.[43] In the case of symbols such as the hyphen, its performativity is evident not just in the work of Deleuze but in general. A hyphen functions as a joining tool without recourse to letters or words. This is helpful for understanding what both Deleuze and Marinetti are arguing for at this point: a type of metalinguistic system that functions to create a new entity out of a fusion, distortion or metamorphosis of an existing one. Whether this is truly removed from the realm of metaphor will be discussed in the following sections.

The grotesque body

Only the extreme forms return – those which, large or small, are deployed within the limit of their power, transforming themselves and changing into one another. Only the extreme,

the excessive, returns; that which passes into something else and becomes identical.[44]

The 'return' mentioned above pertains to Nietzsche's eternal return, and how it relates to theatricality and metamorphosis.[45] We have seen examples of how language can be stretched to a limit or an 'extreme', how its forms can be denatured and fragmented. For a true critique of metaphor or analogy to have taken place, however, language should not be the form that we are focusing on. How exactly does metamorphosis or becoming leave the linguistic sphere and become something more actual? Interestingly, in 1965, a few years before *The Logic of Sense* was first published, Bakhtin would talk about 'the grotesque world of becoming'.[46] We have already discussed how Deleuze's becoming is bi-directional. The first image Deleuze presents us with is that of Alice becoming smaller and becoming larger. The distortion of Alice's body is thus a grotesque image; the further complication that these processes of becoming-smaller and becoming-larger are interchangeable only furthers the grotesquerie. 'It pertains to the essence of becoming to move and pull in both directions at once: Alice does not grow without shrinking, and vice versa.'[47]

Bakhtin's descriptions in *Rabelais and his World* (1965) of the grotesque image of the body describe the ways in which the grotesque is linked with metamorphosis and becoming. Bakhtin's grotesque body is 'a body in the act of becoming. It is never finished, never completed; it is continually built, created, and builds and creates another body ... This is why the essential role belongs to those parts of the grotesque body in which it outgrows its own self, transgressing its own body, in which it conceives a new, second body.'[48] The grotesque body is significant because it offers a physical, corporeal example of how real processes of change are effected at its boundaries or edges. The grotesque model is in fact nothing but boundaries or edges. The surface of this body and Deleuze's surface of sense operate in an analogous way, but the fact that a literalization or actualization is in fact another type of analogical manoeuvre suggests that it may be more difficult to produce a successful critique of metaphor without resorting to another metaphorical framework.

According to Bakhtin, the areas of the body considered grotesque – orifices and protuberances – are considered so because they are

the loci of metamorphosis, swellings and contractions, ingestion or excretion. They are what make the body into something other than itself because at these areas, parts of the body *become* the external world and vice versa. In the normal scheme of things, language is the incorporeal (or metaphorical) example of this, with the mouth as the organ of expulsion. Deleuze makes much of this analogy in *The Logic of Sense*; he asks us, playfully: 'What is more serious: to speak of food or to eat words?', giving examples from *Alice in Wonderland* of both possible outcomes – anthropomorphizations of food, and materializations (and rendering-edible) of words.[49] The suggestion would remain wholly innocuous if this bi-directional process was in equilibrium, but in *The Logic of Sense* equilibrium is the furthest thing from anyone's mind. The esoteric word unites things and propositions, but its substance, dimensions and properties are nothing but a question mark. Bakhtin's grotesque example is different: instead of the Deleuzian eating–speaking duality, he describes giving birth to a word. Instead of speaking-as-defecating, which is the Artaudian view of the grotesque nature of language, we have speaking-as-procreating. Words are embryos, and each utterance is a little birth. The materialist schema is the same: in both the alimentary/expressive and the ejaculatory/expressive dualities are broken down and words are eaten, regurgitated or excreted instead of spoken.

While the embodiment of this idea is presented in *The Logic of Sense* in the form of the growing and shrinking Alice, the grotesque style as characterized by Bakhtin brings the concept back to the linguistic model of a futurist poetics. 'Exaggeration, hyperbolism, excessiveness are generally considered fundamental attributes of the grotesque style.'[50] It is the *hyperbole* of the grotesque body that renders it a literalization, or embodiment, of the futurist poetics under discussion. They are both extreme forms that seek to transcend their limits and become something else. Aside from being an extreme materialization or embodiment, this concept of the grotesque body is fundamental to futurist poetics in the sense that it is the distortion (or defamiliarization) of regular forms. This is perceptible in the lexical and grammatical distortions the futurists performed on language; they render it grotesque to the point of being unrecognizable.

Considering Deleuze's suspicion of metaphor, to say that Bakhtin's grotesque body is analogous to Deleuze's surface of sense

may be problematic at this point, but only through the description of corporeal becoming do we understand more the potential for linguistic 'becoming'. It is at the boundaries of language as well as at the boundaries of the body where the potential for holes, cracks, leakages and metamorphoses exists. It is as though the manifestos of the avant-garde and Deleuze demand that language itself be made into a grotesque body. As already discussed, the desire for language's corporeality is a common goal in the language manifestos of Deleuze and the futurists, but for language to escape what they see as the limiting constraints of metaphor this language-body must become denatured, perforated and contorted; it must become grotesque. Beckett is well aware of this process; his own description of the process of 'boring holes' in language was discussed in Chapter 3. Deleuze and Guattari discuss the importance of Beckett's linguistic project in *Kafka*: Beckett is presented as approaching a limit, but doing so with sobriety and 'dryness' in comparison with the deconstructive, polysemic excesses of Joyce.[51] Through its multifarious bi-directionality, futurist poetics oscillates between these two linguistic extremes.

Opening up the vehicle

Deleuze and Guattari's concept of metamorphosis is presented as a radical literalization of the change that takes place in a metaphorical progression; the idea that 'one does not think without becoming something else, something that does not think – an animal, a molecule, a particle – and that comes back to thought and revives it'.[52] This can be understood as a progression or development of Nietzsche's thoughts on metaphors introduced at the beginning of the chapter. Nietzsche goes out of his way to prove that thought *is* metaphor, by demonstrating that the supposedly rhetorical manoeuvre can be found everywhere and is in fact fundamental to philosophy.[53] The process of thinking consists of the 'hardening', or wearing-out, of a metaphor. When Nietzsche states that 'Every idea originates through equating the unequal', he is describing the process that occurs in language wherein a new thought is spawned.[54] It occurs through analogy; equating two disproportionate things and making them the same requires a flash

of creative energy which to him is the beginning of thought. A flash of creative energy is also what is required to affirm paradox rather than to view it as a problem which needs to be solved. Deleuze and Guattari use the same reasoning when they equate philosophy with becoming, which they do in *What Is Philosophy?*.[55] To understand this further we might turn back to the concept of the conduit metaphor, the pipes that carry the meaning. Deleuze and Guattari's development of Nietzsche's 'thought-as-metaphor' formulation expresses a desire to either partially or completely remove the walls of the vehicle or conduit, making the inside and the outside join up and become one entity. The strafing of the surface, or the boring of holes in the surface of language, is a metaphorical enactment of this removal. If the walls are perforated or removed, there is nothing stopping actual metamorphosis from taking place. Instead of philosophy working by metaphor, it works according to the more literalized, radicalized alternatives of metamorphosis and becoming, so that, according to Deleuze and Guattari, actual, material changes can take place. This therefore requires alternative forms of logic, reason and spatiotemporal understanding. In this description they are not heralding a progression from metaphor to something more radical like metamorphosis; rather they are talking about the potential already inherent and in fact vital within metaphor to both be *and* become something other than itself. The very fact that metaphor already contains within itself the potential to *be* and not be *like* something renders metaphor much closer to metamorphosis than Deleuze and Guattari choose to present it. Metaphor already carries the potential for metamorphosis within its structure. Furthermore, despite the need for alternative temporalities, philosophy-as-becoming is a concept that Deleuze and Guattari necessarily still introduce and discuss in linear, syntactically arranged prose. The temporal incongruence between the concept and its deployment in language, and the various potential alternatives to this presented within futurist writing, will form part of the discussion in the next chapter.

While it is important to remember that in both futurist writing and Deleuze's philosophy, generic distinctions such as that of 'poetry' and 'prose' do not hold the same significance as they would in a conventional framework, it is nevertheless significant that the axes of poetry and prose are highlighted by Jakobson in relation to metaphor. This is important if we think about

philosophers' uses of metaphor, and what it might mean if we tried to think about a philosopher's work in terms of the metaphor/ metonymy divide. Traditionally speaking, philosophy is written in prose and would seemingly work by way of contiguity rather than similarity; it progresses by logical, syntactical formations. What would be the implications for the divide between 'literature' and 'philosophy' if a philosopher's thought moved by way of metaphor rather than metonymy, regardless of the syntactical arrangement of its prose? We have already discussed the performative nature of Deleuze's philosophy in the previous chapter – the ways in which his concepts are expressed within the very fabric of his language. How might an evolved form of (or complete alternative to) analogy present itself in his philosophy in this way, without recourse to a non-linguistic system? Deleuze's discussion of Artaud in *Difference and Repetition* suggests that Artaud affirms the existence of such a type of thought.

> He [Artaud] knows that the problem is not to direct or methodologically apply a thought which pre-exists in principle and in nature, but to bring into being that which does not yet exist (there is no other work, all the rest is arbitrary, mere decoration). To think is to create – there is no other creation – but to create is first of all to engender 'thinking' in thought.[56]

This would be the true movement of non-representational thinking. Deleuze does not quite perform this type of thinking himself, neither does he wants to; he rather presents it as a desired goal. The holes being bored into the surface of language represent the work being done to allow for this type of thought to take place, but the fractured linguistic layer still exists.

CHAPTER SIX

The see-sawing frontier: Linguistic spatiotemporalities

The temporal structure of pure becoming

This chapter will address the spatiotemporal implications of Deleuze's futurist poetics. Deleuze discusses time in terms of three syntheses in *Difference and Repetition*, and in terms of the Chronos/Aion distinction in *The Logic of Sense*. In very simplified terms, the first synthesis concerns the present, the second concerns the past and the third concerns the future while enveloping all presents and pasts within it. Similarly, while Chronos designates the present, Aion encapsulates all pasts, presents and futures. Deleuze presents opposing or multiple terms in each definition, but then makes one term contain both itself and all other possibilities. These distinctions complement and develop rather than opposing or contradicting one another; they too operate according to Deleuze's logic of 'and'. Not only is it possible that several multiple theories and forms of time can coexist, it is actively necessary. Its necessity is clear from the beginning of *The Logic of Sense* and the fact that 'pure becoming', expressed as the infinitive verb, does not specify between two opposing directions, trajectories or intensities.

Why does Deleuze require a complex and radically unconventional form of time? The previous chapter discussed the way in

which Deleuze's development of metaphor equates being with becoming, forming what I have termed a 'conjunction-copula'. The interpenetration of conjunction and copula requires a specific conception of nonlinear temporality. The acceleration of a linguistic analogical procedure such as metaphor is what is argued for in both futurism and Deleuze. So if we think about what happens when we use a metaphor, if we say 'His brain was a sieve', something *becomes* something else. What the futurists share with Deleuze is a desire for the speed of the 'becoming' to become so intense that we no longer have any need of a conjunction separating tenor and vehicle; the two items should be placed next to one another with no mediating term in between. The brain and the sieve interpenetrate. It is as if the very concept of analogy is accelerated to the point of immediacy, with the end result being the simultaneity or co-presence of tenor and vehicle. The aesthetic of speed so important to the futurists can be detected at a structural level; elision and abbreviation speed up the process of conceptual linking so much that it becomes total blending. Pure becoming is both instantaneous and simultaneous.

> But it is at the same moment that one becomes larger than one was and smaller than one becomes. This is the simultaneity of a becoming whose characteristic is to elude the present. Insofar as it eludes the present, becoming does not tolerate the separation or the distinction of before and after, or of past and future.[1]

I believe that we can see in Deleuze's championing of 'pure becoming' an identical desire for a linguistic speed so absolute that it cannot be upheld by a regular temporal form. As discussed in the previous chapter, metamorphosis or becoming, *devenir*, is presented as Deleuze's alternative to metaphor with its own temporality. The equation of one thing with another already found within 'regular' metaphor already requires a type of complex temporal shift, but the joining of conjunction with copula adds a further level of temporal complexity. There are several aspects to consider here in addition to metaphor and becoming. The previous chapter has demonstrated that if we follow Deleuze's thought, the blending of equation (*est*) with addition (*et*) is in fact the basis of both metaphor *and* metamorphosis, because the transition from

metaphor to metamorphosis or becoming is merely an intensification of the same concept rather than a completely separate alternative. The reason why this is problematic for Deleuze's thought is that he presents becoming as a concept that differs in kind from analogy, when in fact it merely differs in degree. As we saw in the previous chapter, he later presents metamorphosis as a concept that differs in kind from metaphor, when in fact it too differs only in degree. Cloaked as an entire transversal shift, this intensifying manoeuvre is typical of Deleuze, whose particular use of extremes, intensities and superlatives is another trait he shares with the manifestos of the avant-garde. In temporal terms, the closest analogy to the shift from metaphor to metamorphosis would be of a temporal shortening of the gap between tenor and vehicle – an acceleration to the point of instantaneity and ensuing simultaneity.

The image of the 'surface' which Deleuze draws on in the preface to *The Logic of Sense* is helpful, not so much for clarification but for necessary complexification; it is an image drawn from the system he is about to present, the system of series, sense and surface. 'As on a pure surface, certain points of one figure in a series refer to the points of another figure: an entire galaxy of problems with their corresponding dicethrows, stories, and places, a complex place; a "convoluted story".'[2] Deleuze's description here – *histoire embrouillé* in French – must surely be referring to Carroll's *A Tangled Tale* (1885), which is discussed directly later in the book. It is confusing why Mark Lester has chosen to translate the words in the preface differently as 'convoluted story', when the similarities between the two books are so clear. The format of Carroll's book of children's logical puzzles clearly inspired Deleuze in the writing of *The Logic of Sense*, not least in the anthropomorphization of philosophical concepts or logical-mathematical formulae, a game Deleuze dubs 'recreational mathematics'.[3] The assigning of proper names to abstract structures is also an important process for Deleuze, and one we have already discussed. It is important because it displays how the elimination of subjectivity in favour of form or structure is another bi-directional process. In presenting an abstract structure such as the differential equation, Deleuze then endows it with subjectivity. This process is later addressed and concretized in *What Is Philosophy?* in the conceptual persona. Deleuze even echoes Carroll's preface with his structuring of the

book in series, only Carroll's 'series' are originally described as 'knots':

> The writer's intention was to embody in each Knot (like the medicine so dexterously, but ineffectually, concealed in the jam of our early childhood) one or more mathematical questions – in Arithmetic, Algebra, or Geometry, as the case might be, for the amusement, and possible edification, of the fair readers ... [4]

Rather than travelling in one direction, *The Logic of Sense* unfolds by allowing a number of interpenetrating conceptual figures to unfold. One of these figures is the duality of Chronos and Aion. Paradox is again central to the thinking of these forms of time. At the very beginning of *The Logic of Sense* Deleuze defines paradox as the affirmation of both senses or directions at the same time. The notion of simultaneous bi-directionality is vital for Deleuze's philosophy of time, and in a very Carrollian move he uses Carroll's Alice as a figure to vivify this process for the reader.

> She is larger now; she was smaller before. But it is at the same moment that one becomes larger than one was and smaller than one becomes. This is the simultaneity of a becoming whose characteristic is to elude the present.[5]

Deleuze wants to persuade the reader that Alice is always becoming larger *and* becoming smaller at the same time in order to present various temporal theories. The way the reader has to swallow this statement is to accept that there will always be a simultaneous before and an after; a Heraclitean constancy of movement. The fictive nature of the present instant is just one of these theories, however. The infinitive form of the *devenir*, the becoming, is vital for an understanding of how this temporality is necessary for Deleuze's sense, which he describes as 'neutral'. As well as eluding the present, pure becoming does not uphold the distinction of past and future. Deleuze's forms of time necessarily express all pasts and all futures. His preferred form of temporality eschews linear succession altogether, and is perhaps best expressed using the grammatical model we have already discussed: the verb in the infinitive. If we recall Chapter 2, Deleuze's infinitive verb contains every possible temporal configuration within its structure. It is both

'without person' and 'without present'. Furthermore, the infinitive expresses the entire event of language, described by Deleuze as 'that which merges now with that which renders it possible'.[6] The conflation of 'now' with 'that which renders it possible' requires an interesting trajectory of movement, which is why Deleuze's temporal figures always traverse complex and dynamic trajectories. There is an important thinker of time who links up Deleuze with the futurists in this regard and requires some attention at this point: Henri Bergson.

Bergson: Uprooter of time

Bergson's philosophy opens up some extremely important temporal problems, some of which Deleuze uses and develops in his futurist drive through a linguistic lens. One of the most important of these is a fundamental shift in our perception of time. One of the reasons for the futurist manipulation of temporal boundaries was the revolution in philosophies of time and space that was going on while futurism was flourishing in both Italy and Russia.[7] The influence of Bergson on Italian futurism is palpable in many places, particularly his concept of intuition and his distinctions of motion. Boccioni's manifesto 'Absolute Motion + Relative Motion = Plastic Dynamism' (1914) makes use of Bergson's 'Introduction to Metaphysics' (1903) and its discussion of intuition as well as his distinctions between absolute and relative motion.[8] In Russia, in addition to the theories of Bergson there was much discussion of the 'fourth dimension' in writings such as those of the popular Russian 'hyperspace' philosopher P. D. Ouspensky.[9] Ouspensky's *Tertium Organum* was first published in St Petersburg in 1912. His statement 'All art is just one entire illogicality' displays his affinity with avant-garde thought, and both Khlebnikov and Kruchenykh were influenced by the speculations of this book.[10] At times Ouspensky sounds positively Bergsonian. 'That which we manage to catch is *always already past*', he states, echoing Bergson's (and subsequently Deleuze's) paradox of the present.[11] Quoting poet Nicolas Boileau-Despréaux, who first uttered the lines not in the twentieth century but in 1701, Bergson states his problem with the material

and determined present in *Matter and Memory* (1896): 'the moment in which I am speaking is already far from me'.[12] This concept is far from 'modern' or new – even the lines from Boileau are echoing those from a satire from Persius.[13] Deleuze echoes this in *Difference and Repetition*: 'To constitute time while passing in the time constituted. We cannot avoid the necessary conclusion – *that there must be another time in which the first synthesis of time can occur.*'[14] This evasion of the present is precisely what is encountered in Deleuze's becoming and was discussed at the beginning of the chapter. The connections between Bergson and Deleuze, however, are more multifarious than the paradox of the present.[15] To understand further the nature of the relationship between futurist and Deleuzian temporalities, we must look to Bergson's groundwork in *Time and Free Will* (1889) and *Matter and Memory* (1896).

Conventional linear clock time is insufficient for Bergson; he defines it as 'nothing but the ghost of space haunting the reflective consciousness'.[16] The reason why this perception of time is insufficient for Bergson is because for him time is an example of an intensity that differs in kind rather than degree. Bergson asks why an intensity should be assimilated to a magnitude, when this is not necessarily the case; a magnitude suggests homogeneity rather than heterogeneity.[17] The distinction between these differences, as DeLanda has pointed out, expresses a temporal conflict within physics between the laws of relativity and the laws of thermodynamics. The difference is encapsulated in the variance or invariance of laws under a time-reversal transformation. The laws of classical and relativistic physics remain invariant; the laws of thermodynamics do not.[18] The fact that thermodynamic laws change under a time-reversal transformation renders them irreversible and aligns them with Bergson's difference in kind.

The distinction between a difference in degree and a difference in kind underpins Deleuze's conception of difference as outlined in *Difference and Repetition*. Put simply, Deleuze's difference *is* time. This differs within itself, and its particular type of difference is a difference in kind rather than a difference in degree. The expression of differences in kind rather than differences in degree could be seen as a problem for Deleuze's philosophy. For example, in the previous chapter, a critical question we could ask of Deleuze is whether the distinction between analogy and becoming, or more

linguistically, between metaphor and metamorphosis as outlined in *Kafka: Toward a Minor Literature*, is a difference in degree or a difference in kind. 'Metamorphosis is the contrary of metaphor', Deleuze and Guattari state in their book on Kafka.[19] Whether the 'contrary' is a difference in degree or a difference in kind is in part a temporal question and depends on Bergson's earlier formulations on intensity and irreversibility. If we apply this to the analogy/ becoming or metaphor/metamorphosis distinction, it appears that Deleuze is presenting the transition between these as an irreversible process – a difference in kind. Bergson's concern in terms of temporality is to present time as something that differs in kind and is therefore irreversible. Deleuze tellingly describes Bergson's *durée* as a 'becoming', which takes us back to the previous chapter's discussion of becoming and metamorphosis. Deleuze writes in *Bergsonism* (1966): 'it is a case of a "transition", of a "change", a *becoming*, but it is a becoming that endures, a change that is substance itself'.[20]

Bergson's concept of 'pure' duration is something distinct from space altogether.[21] The total separation of time and space is, according to Deleuze, the principal Bergsonian distinction. Time and space are divided, according to *Bergsonism*: between differences in kind and differences in degree.[22] Duration takes on differences in kind because it differs qualitatively within itself, whereas space takes on differences in degree because it is a quantitative homogeneity. Put more simply, time is intensive whereas space is extensive. Bergson's first example of a type of intensity in *Time and Free Will* is one of violent emotions, which he explains thus: 'The intensity of these violent emotions is thus likely to be nothing but the muscular tension which accompanies them.'[23] This transference from extensive to intensive again calls to mind Alice and the Red Queen running very fast to stay in the same place.[24] Rather than energy being exerted and becoming kinetic, it piles up on itself in layers. Pure duration is 'succession without distinction, and think of it as a mutual penetration, an interconnexion and organization of elements, each one of which represents the whole, and cannot be distinguished or isolated from it except by abstract thought'.[25] Bergson compares it to a tune which is composed of notes which do not exist discretely; rather all parts permeate one another to form an organic whole. Pure duration without recourse to spatial terms would be heterogeneous rather than homogeneous.

Without space, time is pure heterogeneity; it is pure difference. The differential nature of time is one strand of an argument that renders Bergson's *durée* reminiscent in some ways of Deleuze's temporal form of the Aion, which is discussed in the next section. These two, however, are by no means the same thing. While *durée* relies on a total separation from space, Deleuze deliberately uses spatial terminology to express the Aion, which is expressed at numerous points as a straight line.

The battle between spatiality and temporality within language is one of the fundamental problems of structuralist linguistics. Like many disciplines, linguistic study in the first half of the twentieth century was dominated by a series of overlapping binaries. The axes of syntagmatic and paradigmatic arrangements of language set out by Saussure form one of the most fundamental of these binaries, placing language within a framework corresponding to two potentially opposing spatiotemporal perspectives.[26] The fundamental difference between these axes in temporal terms is that syntagmatic relations consist of combining or sequencing different linguistic units in a unilinear chronological string, whereas paradigmatic relations consist of selecting units according to a similarity in kind, which renders them more atemporal or nonlinear. It is important that the syntagmatic/paradigmatic dualism mentioned above applies not only to language itself but also to approaches in linguistic study. This goes further than describing two opposing approaches as 'syntagmatic' and 'paradigmatic' approaches; instead, we can map the distinction onto the established distinction within linguistics of synchrony and diachrony. Saussure is responsible for introducing the idea of synchronic linguistics, which looks at the entirety of a language at one particular point in time, whereas diachronic linguistics looks at how a language changes over time. Synchronic linguistics is necessary for the development of Saussurian structuralism because it looks at language as a closed system. It is also the point from which Jakobson departs from Saussure, because his project consists of looking at language as an open and dynamic system. Jakobson's critique of Saussure occurs at exactly this point, because according to him, pure synchronism is an illusion. Jakobson places synchrony and diachrony together, stating that 'every system necessarily exists as an evolution, whereas, on the other hand, evolution is necessarily of a systemic nature'.[27] For Jakobson, to define synchrony as purely static and

diachrony as purely dynamic is to miss the point; his project is always for a synchrony that contains dynamism at the same time as a diachrony that contains stasis.

> Since my earliest report of 1927 to the newborn Prague Linguistic Circle I have pleaded for the removal of the alleged antinomy synchrony/diachrony and have propounded instead the idea of permanently dynamic synchrony, at the same time underscoring the presence of static invariants in the diachronic cut of language.[28]

Jakobson is always interested in synchrony and diachrony; they are for him the Bergsonian simultaneity of two dynamisms rather than of two stases. Bergson distinguishes in *Duration and Simultaneity* (1922) between the simultaneity of the instant and simultaneity of the flow; the latter is important for thinking about language in the radically dynamic futurist drive:

> It is therefore the simultaneity between two instants of two motions outside of us that enables us to measure time; but it is the simultaneity of these moments with moments pricked by them along our inner duration that makes this measurement one of time.[29]

Jakobson's argument regarding the dual dynamism of linguistic axes, which he first outlines in the 1920s, is framed very deliberately in the genre of a manifesto. The text in question, 'Problems in the Study of Literature and Language' (1928), co-authored with Jurij Tynjanov, is described by Jakobson himself as a manifesto and was originally published as such in *New Left Front*. The manifesto suggests that synchrony and diachrony be studied not as separate entities but together. His basis for this argument is a placing of systematicity in dynamism and vice versa; as he says of synchrony and diachrony, 'the history of a system is in turn a system'.[30] According to Jakobson and Tynjanov, pure synchrony or pure diachrony is an illusion, and the opposition of these is equal to the opposition between the concept of system and the concept of evolution. For them, systems evolve just as evolution is systemic. Jakobson uses this argument throughout his career; he restates much later in his 'Dialogue on Time in Language and Literature'

(1980) the need for 'the overcoming of statics'.[31] For Jakobson, the most important area of linguistic temporality requiring study is the interrelation between simultaneity and succession, which is the linguistic expression of what Bergson discusses in *Duration and Simultaneity*. The primacy of the dynamism of an invariant perceptible in Jakobson's thought, as can be seen from the quote above, is precisely what Deleuze enthusiastically elucidates in his essay on structuralism. It is important to note, as Alberto Toscano has done, that for Deleuze a structure is never merely a static form. As Toscano notes,

> The uniqueness of Deleuze's reconstruction of structuralism lies precisely in this consideration of structures as neither immaterial essences nor formal invariants, but rather as the preindividual grounds of individuation ... structures as internal multiplicities are at once static (or atemporal) and dynamic (or genetic).[32]

As we will see later in the chapter, his combination of stasis and dynamism has repercussions for Deleuze's theories of time expounded in *The Logic of Sense*, wherein the 'form' of time expressed is not merely a line but is also a dynamic line, and does not merely move but moves according to an aleatory fashion.

Marinetti: Murderer of time

The problematic nature of the manifesto's 'present' was discussed in Chapter 3. The potential impossibility of the present is a problem for any text referring to a 'now', but is intensified when the text is attempting to create a future 'now', as in a manifesto. The speed at which this 'nowness' must be expressed is never quite enough. The manifesto suffers from instantaneous historicization; the arguments (presented earlier) of Peter Bürger's *Theory of the Avant-Garde* still hold in the sense that any attempt to eschew historicization, from theory to practice and back again, is doomed to fail because it is necessarily historically determined.

Marinetti's 'The Founding and Manifesto of Futurism' (1909) begins with a 'narrative' section which contains many conventions of narrative fiction: it recounts a story in the past tense from

a first-person perspective, presenting events in a chronological fashion. 'We had stayed up all night – my friends and I ...'[33] The narrative, however, is used as a preface to the manifesto itself, and at this point the tense, pronoun and mood of the piece changes: from past to present; from individual to collective; from past to future. 'We intend to sing ...'[34] The principal tense of the manifesto section is aptly the future tense, and the only real past tense marker is the problematic declaration that 'Time and space died yesterday.'[35] As we have already seen, however, the manifesto genre both describes the state of things in the past and outlines intentions for the future; it positions itself on a boundary between the way literature has been and the way the futurists want it to be. The problems inherent in Marinetti's statement above are immediately clear: he uses a temporal marker to announce the precise *time* of the death of time. Another example from an avant-garde manifesto mentioned earlier, Raoul Hausmann's 'Manifesto of PREsentism' (1920), contains some interesting comments and instructions regarding time:

> Eternity is nothing, it is neither older or better than the Middle Ages, it comes from yesterday ... Let's get rid of the old prejudices, the prejudice that yesterday something was good or that tomorrow it will be better still. No! Let's seize each second today! Time is an onion: under its first skin there appears, in the light, another and still another. But we want the light![36]

What is noteworthy in many avant-garde manifestos that deal with the 'death' of time as we know it is their reliance on temporal language to express their aims. The excerpt above is full of temporal reference points, and not all of them are brought forth purely for dismissal. The reason why manifestos that treat the 'end' of time as their subject end up running into difficulties is because they presuppose a 'before', a 'now' and an 'after' as soon as they begin to refer to the way time *was* expressed 'in the past' and the way it should be expressed 'in the future'. It is also important to note the continued and problematic relationship between temporality and spatiality within futurism. Time is characterized above as an 'onion'. A spherical, multi-layered material and digestible object is extremely different from the conventional spatial rendering of time as a line, but is still an object measurable in extensive space.

Khlebnikov: King of time

The implications of a reliance of temporal markers for futurism as a movement are clear: in totally rejecting the past, it clearly presupposes it. The past is therefore implicated in the future; it is part of it. This is something that distinguishes Russian from Italian futurism; the coexistence of past and future is something to be welcomed. The temporal difference between Italian and Russian futurism is immediately apparent if we compare two extracts from their manifestos, the first from the Italian and the second from the Russian:

> Why should we look back over our shoulders, when we intend to breach the mysterious doors of the Impossible? Time and Space died yesterday. We already live in the absolute, because we have already created velocity which is eternal and omnipresent.[37]

> *We* alone are the *face of our Time*. The horn of time blows through us in the art of words. The past constricts.[38]

The Russian futurists are not dismissing time or the past; far from it. Time blows through them, propelling them into the future as they face the past, much like Benjamin's description of Klee's *Angelus Novus*.[39] The significance of time for Khlebnikov in particular is clear in his self-styled alias 'King of Time'. Rather than destroy time, Khlebnikov wanted to conquer it. The conquering of time necessarily involves prediction of the future, and this is precisely what mathematician Khlebnikov set out to do. Khlebnikov's *The Tables of Destiny* (1922) is an attempt at a mathematical account for significant global events such as the Russo-Japanese war in 1905. 'I wanted to find a key to the timepiece of humanity, to become humanity's watchmaker, and to map out a basis for predicting the future ... I wanted to find a reason for all those deaths.'[40] An example of Khlebnikov's calculations is included below:

> If we let $n = 10$, we get x equal to the time between Yermack's expedition and the retreat of Kurpatkin: these points represent the beginning and the end of Russian penetration of the East. If we let $n = 18$, we get the time between the Tertiary age and our

own. And, finally, if $n = 23$, then $x = 369, 697, 770$ years, or the interval between the earth's Devonian age when reptiles were lords of creation and the present day, when the Earth is a book with the shrieking title 'Man'.[41]

It is clear that Khlebnikov perceived himself as a visionary or prophet, and the scope of his ambition can only be marvelled at. While this type of speculative mathematics may seem outlandish, characterizing Khlebnikov as kind of a *fou mathématique* in the same vein as Lecercle's *fous littéraires*, there are a few important factors to take into account over and above any opinions on the work's accuracy or validity. First, he sees the past and the present not only as informing the future, but determining it. This again separates him from Marinetti's attitudes towards history. Secondly, his faith in mathematical temporality seems to stem from his apparent distrust of linguistic temporality. As editor Charlotte Douglas states in his collection *The King of Time*, 'the presence of Time in poetic rhythm eventually forced him to look for rhythms beneath the conventional ones, to seek meaning in the cyclical patterns of the universe'.[42] *Zaum* language eschews linear temporality at a linguistic level, but Khlebnikov's preoccupation with time is far more all-encompassing than a mere syntactic line.

The differences between Italian and Russian futurism are vast, but they are particularly magnified in terms of their attitudes to history and temporality. As previously suggested, nationalism is an important aspect of both the Italian and the Russian futurist movements, despite the fact that their methods, aims and politics begin and end in opposition to one another. While some Russian futurists and movements, such as Igor Severyanin's Ego-Futurism, used Marinetti's Italian model to shape themselves, Khlebnikov, Kruchenykh and the Hylaea group were extremely keen to distance themselves as much as possible from the West.[43] Similarly, Marinetti declared that the Russians were not true futurists, using none other than a grammatical model to express this. According to Marinetti, the Russians were only pseudo-futurists and lived in a *'plusquamperfectum'* rather than a *'futurum'*.[44] Russian futurism championed the use of an almost prehistoric Russian primitivism and faith in natural materials. The Hylaea group did not print their publications and manifestos; they hand-wrote them and used primitive methods such as the *lubok* (originally

a traditional peasant woodcut; later done by lithograph), rough stencils, rubber-stamps, even potato-cuttings.[45] Even their name, Hylaea, is derived from an ancient Greek term borrowed from the *Histories* of Herodotus, where it described the lands occupied by the Taurii, a Scythian tribe.[46] All of this resulted in a multifaceted, further-reaching project than that of the Italians, reaching further back and further forward simultaneously. For example, Mikhail Larionov succeeded in simultaneously developing two temporally contrasting artistic methods: backwards-looking neo-primitivism and forwards-looking rayism. Larionov's neo-primitivism has been explained as a rejection of Western modernism in favour of Russian prehistorical traditions, but it is important to remember that the modernist trend for primitivist art cannot solely be attributed to Russia.[47]

The attempt to reach into both the past and the future is a common trope within both modernism and the avant-garde, and is not confined to futurism. One movement of the Russian avant-garde is particularly exemplary in its attempts to encompass all possible temporalities within one. Everythingism, as expressed in its manifesto, acknowledges 'all styles as suitable for the expression of our creativity, those existing both yesterday and today such as cubism, futurism, Orphism, and their synthesis rayism'.[48] Preceding this is Andrei Bely's Russian symbolist manifesto, which also claims: 'At the moment we are experiencing all ages and nations in art; the past rushes before us. This is because we are standing before a great future.'[49] Past, present and future are not completely indistinguishable but are definitely conjoined. It is clear that the futurism that developed in Russia concerns much more than the future tense; it welcomes all temporal dimensions and places them together.

Temporal geometries #1: The plane

One of the most basic cognitively entrenched metaphorical concepts is the spatial rendering of time. A particularly important and pervasive example of this spatializing of time is the geometric rendering of linguistic temporality. This is palpable in both Italian and Russian futurism, although it is expressed in different ways.

Marinetti writes in 'Destruction of Syntax – Radio Imagination – Words-in-Freedom' (1913):

> I maintain, however, that the verb in the infinitive is indispensable to a violent and dynamic lyricism, for the infinitive is round like a wheel, and like a wheel it is adaptable to all the railroad cars that make up the train of analogies, so constituting the very speed of style ... While the **verb in the infinitive is round** and mobile as a wheel, the other moods and tenses of the verb are triangular, square, or oval.[50]

Here Marinetti is quite specific about his own usage of a geometric model, again expressing the importance of the infinitive. Khlebnikov expresses his own broader version of a linguistic geometry eloquently in *Zangezi*, which tellingly is organized according to a series of 'planes' rather than in chapters or stanzas.

> Planes, the lines defining an area, the impact of points, the godlike circle, the angle of incidence, the fascicule of rays proceeding from a point or penetrating it – these are the secret building blocks of language. Scrape the surface of language, and you will behold interstellar space and the skin that encloses it.[51]

This description renders language in deliberately spatial terms, rather than temporal ones. The figure of the surface is one which we have already seen in Deleuze's characterization of language in *The Logic of Sense*. It is precisely this translative gesture of linguistic 'geometricizing' that Deleuze shares with the futurists, particularly Khlebnikov. Turning to Deleuze, we have already discussed the organization of *The Logic of Sense* and his description of the book as 'topological', as well as its use of series rather than linear chapters. Mirroring the geometrical structure of the book is Deleuze's own geometrical characterization of language:

> Thus the entire organization of language presents three figures: the metaphysical or transcendental *surface*, the incorporeal or abstract *line,* and the decentred *point*. These figures correspond to surface effects or events; at the surface, the line of sense immanent to the event; and on the line, the point of nonsense, surface nonsense, being co-present with sense.[52]

Deleuze's system of point, line and surface links up his inter-relation of sense and nonsense with his temporal form of the Aion. He describes the point of nonsense as the 'zero point of thought', the line as the 'Aion or empty form and pure Infinitive', and the metaphysical surface as the place where the univocity of the infinitive is distributed in 'the two series of amplitude' that constitute the Stoic paradox of word and thing.[53]

The common thread of these geometrical renderings of language is that they are inextricably bound up with temporality. Neither Khlebnikov nor Deleuze is interested in presenting language as a static object; the linguistic geometries they propose both include a vital dynamic element of time. Deleuze's formal definitions of language and time are inextricably tied up with one another, and they are linked by the straight line of the Aion. They are the same concept expressed differently, using Deleuze's logic of 'and', as previously discussed. It is clear from this definition that the Aion is synonymous with the infinitive verb, thereby demonstrating the inextricability of language and time in Deleuze's thought. The Aion is returned to in the next section.

Interestingly, the use of the plane as an alternative temporal figure as outlined by Khlebnikov above is returned to by Deleuze and Guattari in *What Is Philosophy?* as a model for schematizing philosophical time. 'Philosophy is becoming, not history; it is the coexistence of planes, not the succession of systems.'[54] Here Deleuze and Guattari describe the time of philosophy as 'stratigraphic', in which 'before' and 'after' indicate only an order of super-impositions.[55] Rather than a completely non-spatial perception of time, they prefer to view it as that which can be layered, piled up and superimposed onto itself. Rather than view space and time separately, Deleuze always favours the two together, always considering them as a combined and dynamic entity. It is the combination of these that forms his futurist signature, the 'empty form' of the spatiotemporal dynamism.

Temporal geometries #2: The line

The opposition of Chronos and Aion is at the centre of Deleuze's treatment of time in *The Logic of Sense*. The distinction between

these aspects is complex, although it is always clear which one Deleuze prefers. It is not, however, a simple case of simple linearity versus complex nonlinearity. Both Chronos and Aion are linked to Nietzsche's eternal return, but only Chronos retains the figure of the cycle with regard to the eternal return. Chronos is described as the time of the present; it is infinite, but it is limited. Aion, on the other hand, is the subsistence of both pasts and futures; 'each present is divided into past and future, ad infinitum'.[56] The shape of Chronos is cyclical; it is described as infinite because it goes back on itself. The more radical nature of the Aion means that its shape is a straight line. Aion, however, is 'eternally Infinitive and eternally neutral'.[57] It is only the linguistic form of the infinite, the infinitive, that is associated with the Aion. The Aion is *devenir*; it is the verb in the infinitive because it is unconjugated. This also means that in terms of the corporeal/incorporeal and actual/virtual distinctions which Deleuze often returns to, it is Chronos that deals with matter, bodies and actualities, whereas Aion is incorporeal and virtual. Deleuze describes the Aion as the 'empty form' of time.[58] This is telling when we bring the discussion back to language; the infinitive is the 'empty form' of language. These forms are completely devoid of matter. It is due to the fact that events themselves are incorporeal that they can exist everywhere along the line; they can all coexist, communicate with one another and form a unified whole.

Deleuze's specific use of the figure of the line has an interesting heritage. Deleuze's cherry-picking of philosophical conceptions of temporality has been described as 'distaff', an adjective that is illustrative of his philosophy of time within itself.[59] The distaff lineage is a particularly appropriate because it is a discontinuous, marginal and paradoxically non-linear line. This will of course be the type of line that Deleuze chooses to employ as his model. How, then, does Deleuze build on other characterizations of philosophical or temporal 'lines' to shape the line of Aion? Bergson again is helpful here, specifically in his essay on Félix Ravaisson. Bergson describes how Ravaisson uses Leonardo da Vinci's *Treatise on Painting* when describing how a certain type of line illuminates his philosophy. The description in da Vinci's *Treatise* is 'the one where the author says that the living being is characterized by the undulous or serpentine line, that each being has its own way of undulating, and that the object of art is to make this distinction'.[60] The most important

aspect of this undulating line is that it does not have to be an actual line that is present within the drawing. It constitutes the entirety of the living being; it is a singular, mobile and aleatory core. 'It is not in one place any more than in another, but it gives key to the whole. It is less perceived through the eye than thought by the mind.' For da Vinci this means the soul; for Bergson it is closer to his concept of *élan vital* as outlined in *Creative Evolution.*[61] For an understanding of the way Deleuze relates to this line, it is again helpful to turn to Kleist's marionettes as discussed at the end of Chapter 4.

> The line the centre of gravity has to follow is indeed very simple, and in most cases, he believed, straight. When it is curved, the law of its curvature seems to be at the least of the first and at the most of the second order. Even in the latter case the line is only elliptical, a form of movement natural to the human body because of the joints, so this hardly demands any great skill from the operator. But, seen from another point of view, this line could be something very mysterious.[62]

Kleist's story details the way that human subjectivity obscures the perfect or ideal trajectory of movement in a dance, which for Kleist expresses pure grace. While Kleist's and Ravaisson's lines are not identical by any means, what they do share is a complete unification of movement and subject. Deleuze's line of Aion celebrates both of these lines, but develops the 'undulating' and 'serpentine' nature of Ravaisson's line to its furthest possible extreme: 'The Aion is the straight line traced by the aleatory point.'[63] Deleuze's line is straight, and yet encompasses an entire spectrum of potential undulations. The affirmation of paradox is the legitimating mechanism that allows it to be a straight line that traces an aleatory point, so it completely fills up and saturates the idea of randomness and chance. As well as going in both directions at the same time and so encompassing both past and future, it also encompasses every possible probability of outcomes.

> Everything changes, including movement. We move from one labyrinth to another. The labyrinth is no longer a circle, or a spiral which would translate its complications, but a thread, a straight line, all the more mysterious for being simple,

inexorable as Borges says, 'the labyrinth which is composed of a single straight line, and which is indivisible, incessant'.[64]

Temporal geometries #3: The hinge

Deleuze begins his 1963 book on Kant's philosophy with a discussion of the temporal hinge. 'The hinges are the axis around which the door turns. *Cardo*, in Latin, designates the subordination of time to the cardinal points through which the periodical movements that it measures pass ... It is now movement which is subordinate to time.'[65] In a typically poetic turn, Deleuze summarizes Kant's philosophy with four famous literary dictums. This is another example of the Cratylic reasoning in previous chapters. While the examples presented earlier were single words that Deleuze interpreted using sound symbolism, the use of poetic lines or even whole poems remains a type of poetic or etymological exegesis favoured by thinkers such as Heidegger, Derrida and de Man. It is a line of approach that is deliberately and necessarily creative, and an example of the line itself being put into play. The line is from *Hamlet*: 'The time is out of joint'.[66] Deleuze interprets this line as time being 'unhinged', and uses it to describe the reversal that he believes takes place in Kantian thought within the relationship between time and movement. It is Kant, he believes, who makes movement subordinate to time rather than time being subordinate to movement.

The word that Deleuze uses the Latin *cardo* to illuminate is *gond*; this means both 'joint' and 'hinge'. This is an important word for Deleuze's philosophy of time, and is described in more detail his discussions of time in *Difference and Repetition*:

The joint, *cardo*, is what ensures the subordination of time to those properly cardinal points through which pass the periodic movements which it measures ... By contrast, time out of joint means demented time or time outside the curve which gave it a god, liberated from its overly simple circular figure, freed from the events which made up its content, its relation to movement overturned; in short, time presenting itself as an empty and pure form. Time itself unfolds (that is, apparently ceases to be a

circle) instead of things unfolding within it (following the overly simple circular figure). It ceases to be cardinal and becomes ordinal, a pure *order* of time.[67]

As discussed in Chapter 3, a manifesto positions itself exactly on a moveable joint or borderline between the state of things preceding it and the state of things to come once its demands have been met. In this way we can say that Deleuze's three syntheses of time in *Difference and Repetition* and his Aion in *The Logic of Sense* are useful temporal models for the genre of the futurist manifesto. Both the Aion of *The Logic of Sense* and the third synthesis of *Difference and Repetition* are described as 'the pure and empty form of time'. It is the fact that a fracture, caesura, joint, line, hinge *can also* be a pure and empty form that makes it so well-placed as a temporal form for a futurist poetics. The third synthesis deals with the category of the future as well as containing all presents and all pasts.[68] It is true that the terms in which Deleuze outlines the third synthesis differ from his characterization of the others, but this is due to its placing within the future. While the first synthesis draws on the human experience of habit and the second draws on the experience of memory, the third synthesis is not based on human experience: it concerns itself with the new. It is different from the first and second syntheses in that it is presented as a formal, albeit speculative, category.[69] In the third synthesis, both present and past are dimensions of the future.[70] The third synthesis is a non-representational view of time.

Advance and retrenchment

There is another word that is key to Deleuze's interlinking theories of language and time. We have stated several times already that language for Deleuze is simultaneously word and thing, a paradox he draws from Stoic philosophy. He emphasizes that sense is never just one of these two terms; rather, it is 'the frontier, the cutting edge, or the articulation of difference between the two'.[71] Now if we think about the connotations of those words – the 'frontier', the 'cutting edge', or the 'articulation of difference' – we are back to theories of the avant-garde. The Aion is a useful model for the

futurist frontier in multiple senses which reach further than the
military connotations of the word. Deleuze uses the word 'frontier'
to describe sense at numerous points in the books, but also uses it
to describe the Aion. 'It therefore rests with the Aion, as the milieu
of surface effects or events, to trace a frontier between things and
propositions; and the Aion traces it with its entire straight line.'[72]
The Aion is a straight line, but it is also the site of an event of battle.
'Frontier' resides within the same semantic field as 'avant-garde'; in
fact, in a military sense both 'avant-garde' and 'frontier' designate
the front line or foremost part of an advancing army. Deleuze's
entire system of sense is based on the interplay between definitions
of 'frontier'. A frontier is a boundary separating countries and is
often the locus of battle between each side that touches it, because
the specific nature of a frontier is that it is a boundary that moves,
or that aims or intends to move forward. It is the site of a battle
because each opposing side considers it the 'front' and is deter-
mined to push forward to gain more territory. The most forward
promontory of a futurist movement, as we have seen, concerns
itself with pure forms – albeit paradoxical pure 'material' forms.
The transition from Russian futurism into formalism demonstrates
this clearly. The Aion itself is described by Deleuze as the pure and
empty form of time.

> Always already passed and eternally yet to come, Aion is the
> eternal truth of time: *pure empty form of time*, which has freed
> itself of its present corporeal content and has thereby unwound
> its own circle, stretching itself out in a straight line.[73]

It is not that we can describe the Aion as *the* temporal form of the
avant-garde; rather, Deleuze presents a model for linguistic tempo-
rality that encompasses futurist aims. In one passage of *The Logic
of Sense* Deleuze describes the potentialities for art and thought
encompassed in this temporal frontier.

> The question is less that of attaining the immediate than of
> determining the site where the immediate is 'immediately' as
> not-to-be-attained (*comme non-à-atteindre*): the surface where
> the void and every event along with it are made; the frontier as
> the cutting edge of a sword or the stretched string of a bow. To
> paint without painting, non-thought, shooting which becomes

non-shooting, to speak without speaking: this is not at all the ineffable up above or down below, but rather the frontier and the surface where language becomes possible and, by becoming possible, inspires only a silent and immediate communication, since it could only be spoken in the resuscitation of all the mediate and abolished significations or denotations.[74]

The immediacy of thought is a fundamental aspect of Deleuze's futurist drive. There is the suggestion of a limit in the passage above that is a futurist aspiration: to reach a point of abstraction wherein the form of expression must become something else entirely if it is to communicate itself without recourse to mediation or representation. Because it is only a line and in some sense does not contain substance itself, the line of Aion is incorporeal and structural, or Deleuze would say virtual. But owing to the type of thinking that Deleuze forces us to do when reading him, this incorporeal frontier-line also contains unlimited capacity in the same way as Deleuze's surface of sense is actually a multidimensional entity.

The frontier, therefore, designates language just as much as it designates time. Deleuze's sense is the empty form of language just as the Aion is the empty form of time. Because they are empty forms they do not exist outside of their own announcement. But both forms are completely bound by language and can only be expressed in those terms. Deleuze says sense is always double sense; it is supposedly indifferent to affirmation and negation.[75] But even with regard to the opposition of affirmation and negation, we can always select one of the two opposing terms as the 'preferred' option for Deleuze. The way in which Deleuze attempts to circumvent this problem is by presenting one term as containing both itself and its opposite, which manages to uphold both the binary structure and its dissolution simultaneously. Aion encompasses both Chronos and itself; and in the same way, sense contains both incorporeal 'wordness' and corporeal 'thingness' despite being presented as the virtual, incorporeal event of language. The coexistence of both parts of a dualism within one term is precisely what the temporal frontier of the Aion and the linguistic frontier of sense share in Deleuze's thought. The Aion is constituted as the frontier, but it is also the form of the pure infinitive. It is both a straight line and a hinge; or, as we have stated, a straight line traced by an aleatory

point. Its structure is therefore paradoxical. It designates both the form of the infinitive, which encompasses all linguistic variations, as well as the absolute limit of language. The fact that the sharp edge of the frontier *is also* the empty form of the infinitive is vital for thinking about the futurist drive in Deleuze's poetics. The futurist drive tends towards the point at which nonsense becomes formalism, which is precisely encompassed in this multidimensional characterization of the Aion.

As discussed in the introduction, some scholars in the field of modernism define it as the setting of boundaries, whereas the avant-garde is described as constituting their disruption.[76] In presenting the radical line of the Aion, is Deleuze setting a boundary or disrupting one? According to Peter Osborne, modernity is paradoxical because of its double movement; it designates contemporaneity at the same time as it makes a new temporality which distances the present even from the most recent past. This results in a dialectical movement in which the logical structure of the process of change is abstracted from its concrete historical determinants.[77] Change becomes change for itself, for its own sake; it is a differential temporality, working between 'chronological' and 'historical' time. The nature of modernity is such that it must define itself in relation to a past that is not static but growing. Modernism is concerned with the new, which is a paradoxical concept itself. Osborne cites Adorno's description of the new as 'longing for the new, not the new itself: that is what everything new suffers from'.[78] The new is an invariant, and Deleuze's project consists of reworking the very concept of the invariant; of setting the invariant in motion. We might describe Deleuze's Aion as the temporal branch of his wider project of philosophical and aesthetic formalism. For the expression of this form to take place, however, certain temporal constraints must be in place. The fact is that the Aion does not exist within our communicative channels, because for every utterance brought forth and delivered in language, for every sentence or demand in a manifesto written, printed and read, multiple pockets of actual time open up. To glorify the infinitive is to disregard the human, but it is only to humans that these pronouncements are being made. This is why the gap between the concept and its articulation is in fact is a temporal retrenchment. Not only are these impossible teleological states, but their linguistic actualization occurs somewhere further

back than the frontier that they herald. The fact is, however, that it relies on an artistic medium for its expression. What are the implications of this linguistic actualization-retrenchment manoeuvre; is it not problematic that the very expression of an ideal – its actualization in language – restricts it from its own achievement? Deleuze's answer to this would no doubt involve a reference to his numerous examples of bi-directional processes; it is in fact the precise movement of pure becoming that goes in both directions at the same time.

I have described Deleuze's presentation of the Aion at times as a characterization.[79] In what ways can we see the Aion as a character? Deleuze's concepts can be listed as names or characters; they are easy to spot because they are given the status of proper nouns and capitalized: Habitus, Mnémosyne and Aion are but three examples. The way we are instructed to put these concepts/ characters to work is the same way in which Deleuze puts actual philosophers to work: they are arranged in a way that certainly does not conform to linear chronology and in terms of space would only work topologically, as each concept works as a point to connect them. As we saw in *What Is Philosophy?*, the way Deleuze wants us to treat philosophical figures is the same way he wants us to treat his concepts: as points determined by conceptual linkages which require topological space–time in which to interpenetrate.

> The life of philosophers, and what is most external to their work, conforms to the ordinary laws of succession; but their proper names coexist and shine either as luminous points that take us through the components of a concept once more or as the cardinal points of a stratum or layer that continually come back to us, like dead stars whose lights is brighter than ever.[80]

Nowhere is this more important than in Deleuze's figuration or paradoxical characterization of the Aion. It is a paradoxical characterization because he endows an empty form with a proper name; it is only itself through its lack of particularities. Deleuze's main definition of the Aion is 'the pure and empty form of time'.[81] If we take Deleuze at his word and attempt to view the Aion as an important character in his 'novel', even the structure of this character would be inherently paradoxical because it is defined

through its total lack of characteristics. The Aion is therefore an example of how Deleuze's set of 'characters' are defined through their very lack of characteristics, almost reminiscent of Russell's set paradox in which the membership of a set depends on its members' non-membership.[82] If the paradox is expressed as 'the set of all sets that are not members of themselves' and each member of the set has 'characteristics' that define them as discrete members of the set, then the Aion as character is defined solely through its lack of characteristics. If this really is the case, and the Aion is nothing but a pure and empty temporal form, then it would not pertain to one side of a binary opposition. This is the crux of Deleuze's conceptual linkage of paradox and form; a pure and empty form is both empty and full. It is empty because it is full; it contains both everything and nothing. This would suggest that the Aion evades all oppositional distinctions, even the universal and the singular, the generic and the particular. The problem is that owing to the nature of certain oppositions (such as that of the particular and the generic), it is clear that the Aion prioritizes one side over the other.

In attempting to answer the question of whether the Aion is an opening or a closing of boundaries, the mistake would be to read this temporal form as anything outside its own linguistic superpositioning. The nature of an avant-garde movement is to announce itself as being at the forefront, and it must do this by distinguishing itself against rivalling factions through the use of hyperbole, so it has to articulate its own difference. In order to push itself forward and keep itself at the front, it has to make a difference in degree look like a difference in kind. Deleuze's Aion is not just the expression of any infinitive verb: it is *the* ontological infinitive – he wants to make it the infinitive of being itself. It is the infinitive of an infinitive, which is why it is a differential temporality. Being is an infinitive in its own right, but in Deleuze's thought, becoming precludes this. It is the same intensifying, hyperbolic or superlative manoeuvre he expresses when he distinguishes metamorphosis from metaphor, or when he distinguishes dramatization from performativity. This is the operation Deleuze performs with concepts; he cloaks an intensifying manoeuvre or a futurist hyperbolic shriek in the semblance of a complete transversal shift, in order to keep himself at the forefront.

CHAPTER SEVEN

Conclusion: Suffixing, prefixing

Defining: The dynamic element

Throughout these chapters it has been demonstrated that Deleuze and a number of key futurist thinkers manipulate certain linguistic spatiotemporal preconceptions, in order to present their own radically new reconfigurations of the space–time in which language operates. Bridging 'Deleuzian' and 'futurist' thought, together these figures constitute a paradoxical manifesto for nonsense. Under this schema, the syntagmatic and paradigmatic poles are problematized; semantic stability is challenged; temporal linearity is rejected; mediation is accelerated and immediacy is celebrated, all under the schema of a futurist poetics. While thinkers such as Deleuze, Marinetti, Khlebnikov and Jakobson come from a variety of conceptual and ideological backgrounds, their versions of the futurist 'shift' converge in terms of finding a problem with the slowness or stasis of a current system, and attempting either to set this system in motion or to accelerate it. As this book demonstrates, the shift is a linguistic operation best encapsulated in the action of *prefixing*. The shift comes before the word and subjects it to a spatiotemporal metamorphosis.

Jakobson's ground-breaking theorization of dynamic linguistic axes carry various different implications for linguistic study. The ones discussed this book can be characterized together as reconfigurations

of linguistic spatiotemporality. For example, Jakobson's distinction between metaphor and metonymy, and the subsequent mapping of these onto the poles of poetry and prose, assigns different spatial and temporal models to each genre. His poetic function uses these same poles – poetry and prose – in order to demonstrate how poetic language operates according to a different temporal logic.

The concept of an alternative linguistic spatiotemporality has been central to this book, although owing to the dynamic nature of this alternative, it is hard to characterize. For example, the celebration of the infinitive verb in both Marinetti and Deleuze was discussed, demonstrating how this grammatical form expresses an entire world view through its refusal of stasis, substantives and the present instant, and its simultaneous affirmation of virtuality, indeterminacy and infinite variations. Marinetti's proposition that verbs should only be used in the infinitive, as discussed, is echoed by Deleuze in *The Logic of Sense*. It is important to state, however, that these two thinkers are not saying exactly the same thing in their celebration of the infinitive. In his descriptions of the way the infinitive should be used, Marinetti still uses terminology drawn from material objects and properties. As discussed in Chapter 3, he describes the infinitive in terms of 'elasticity'.[1] This describes the verb in term of pliability, stretchiness and ease of manipulation: all material qualities. Khlebnikov's famous 'Incantation by Laughter' is a helpful demonstration of a word root being treated precisely like elastic; as we saw in Chapter 3, the Russian root *smek-* is denatured: it is stretched, pulled apart, and fragmented into a series of variations. There is a multiplicity of translations, some by the same author, such as Gary Kern's alternative translations which he suggests: 'Guff it out, you guffsters!', 'Gig it out, you gigglers!', 'Chuck it out, you chucklers!'.[2] These examples demonstrate that the 'problematic' translatability of this poem in fact opens up new variants of expression; it is a 'problem' in the Deleuzian sense, which is that 'true problems are Ideas, and that these Ideas do not disappear with "their" solutions, since they are the indispensable condition without which no solution would ever exist'.[3] Deleuze sees the form of the problem as a celebrated form within itself, in the same way that he sees the infinitive as a celebrated form. This perception of the problem, when understood alongside his later definition of philosophy as the creation of concepts in *What Is Philosophy?*, helps us to comprehend how his philosophy is a kind

of creative conceptual praxis that seeks to build new and complex structures of thought that remain open to further complexification. Concepts are problems for Deleuze, in the sense that they are always complex entities branching out in different directions.

The futurist idealization of the infinitive, therefore, sets the verb in a different type of motion to the ordered succession of syntax. It is splintered and denatured, its meaning destabilized. We can see evidence of this in Deleuze's own celebration of the infinitive; he too is interested in the fragmentation of grammatical forms and the destabilization of meaning. Deleuze describes the infinitive as 'poetry itself'; it is the linguistic expression of his theory of univocity. All possible variations of expression are contained within Deleuze's infinitive; it is a kind of harmonious telos in which all difference is affirmed precisely because it is all said in the same sense. Of course, for a philosopher of the multiplicity such as Deleuze, words such as 'telos', 'harmony' and 'ideal' are precisely the kind of absolutist terms he seeks to escape, which is why the way Deleuze affirms and celebrates univocity is problematic and the concept disappears later in his career.

Reconfiguring: From acceleration to metamorphosis

What we can characterize as one common theme running through these vastly different reconfigurations is the futurist preoccupation with speed: dynamism, urgency, acceleration and immediacy. Again, the brevity required of both language and thought affects both the spatiality and the temporality of language. The acceleration of language and thought described above is one form of reconfiguration; the pre-existing systems of language and thought are considered not fast enough to uphold the radical metamorphoses taking place. Again, this can be viewed in both spatial and temporal terms, but always linguistic; the critique of mediation as a form of representation results in the elimination of mediating terms and the acceleration of conceptual and expressive processes. Another way of presenting the dynamic component is through a critical engagement with the conceptual systems it aims to reconfigure. One such system is that of linguistic mediation. In

figurative language, the equating of one term with another takes up a certain portion of time. The critique of this, as we have seen in the examples from Marinetti and Deleuze, takes the form of an acceleration so intense that it becomes a *fusion* – a blend of two discrete and disparate terms into one. If acceleration is a form of reconfiguration, then neologism is the result.

Shifting: The Cratylic leap of thought

It is not only mimetic or mediating processes subjected to critique by the dynamic shift; systems and schools of thought are also reconfigured. The Cratylic motivated unification of a lexical item with its meaning is a linguistic synecdoche for a conceptual process. For example, Khlebnikov's sound-symbolic creations of meaning around the word root *-um* in the poem *Zangezi*, discussed in Chapter 1, are motivated *lexical* Cratylic leaps. As discussed, however, Deleuze's description of the Stoic tree in Wonderland is a spatiotemporal *conceptual* Cratylic leap. It is a motivated 'discovery' of a Stoic philosophical concept – the 'greening' tree – in a forest whose existence can only be described as a multiplicity of worlds away. Carroll's forest of Wonderland is in effect a forest in nineteenth-century England, although even this is highly problematic (within the conventional realm of logic) because not only does it reside within Carroll's fictive world, it is fantastical even within the realms of this fiction. Important to both Khlebnikov's and Deleuze's examples is the pure 'nonsensical' moment of creativity in which conventional logic is bypassed.

Cratylic thinking is therefore a radical critique of successive thinking, which is in another sense a critique of linear linguistic temporality. A linear succession of instants does not work under this schema for multiple reasons: it does not allow for the cognitive bypasses and leaps performed, and it only upholds the regular syntactic and prosaic line of language. The Cratylic leap of thought functions as a cognitive bypass because it creates its own pathway, rejecting any conceptual preconception or genealogy. The reason why Cratylic thinking rejects prosaic linearity on all levels is because the syntactic line relies on the differentiation and interplay between substantive and infinitive grammatical forms; it relies on

the contiguity of word classes and the arbitrary relations between the lexical items and their referents. Cratylic thinking rather pertains to Jakobson's paronomastic function, in which lexical items are grouped together according to their similarities rather than their differences. This eschews temporal linearity and logic in favour of a common material property selected by the creator, but this property may not be perceptible by anyone else *but* its creator. This is why the systems of Roussel, Wolfson or Artaud are celebrated by Deleuze only from a safe distance.

Enacting: The manifesto

In presenting the futurist manifesto as a genre in its own right, it has been explored as an expression of an alternative temporality, and an actual attempt towards the creation of this temporality. In isolating the manifesto this way, collapsing the distinction between the 'political' and the 'artistic' and focusing on the discontinuities that arise between the nature of the demands expressed and the mode of their expression, I hope to have demonstrated that the avant-garde manifesto is unique in its attempt to sidestep its own temporal restrictions. The element of performativity present throughout the texts under discussion, whether explicitly futurist manifestos or excerpts from Deleuze's texts outlining his linguistic theories, can lead to a multiplicity of ambivalences. If a goal or aim is expressed within the manifesto, but then the fulfilment of this goal is demonstrated to have already been achieved through some textual example, then it appears that the manifesto has already eclipsed the boundaries it seeks to transcend. In this sense it is ahead of its time; it almost short-circuits itself. If a goal is expressed, however, and the terms used to express it perform a simultaneous negation of this goal, this leads us into the territory of the performative contradiction that I discussed earlier. This can occur if the linguistic system used to express a particular practice fails to provide the sufficient means to carry out the demands of this practice. The manifesto is a moment of problematic linguistic temporality, which occupies a pocket of time while proclaiming itself as escaping time altogether. Deleuze's writing is also a moment of problematic linguistic temporality. He presents concepts such as the radical frontier of the Aion

while using language still under the yoke of syntactic succession. He is therefore presenting the possibility of a language that is yet to come rather than expressing this possibility within his prose.

Representing: The linguistic synecdoche

In the introduction to this book I asserted the centrality of the infinitive within futurist poetics. My analysis of the dynamic, bi-directional element in Deleuze's futurist poetics has taken the reader through a series of processes that begin with a linguistic model but encapsulate entire conceptual systems within minute lexical particles or operations. The only way to express this reverse-telescopic representation is by another linguistic model: that of the synecdoche. We have now seen the reliance Deleuze places on the linguistic model and the way in which it functions as a synec-doche in his thought. Of course, synecdoche is so closely linked to metonymy that eighteenth-century rhetorician George Campbell saw them as interchangeable.[4] We could also say that Deleuze's philosophy operates according to a type of radical metonymy, a Cratylic metonymy in which the element that stands in for the original demonstrates a common 'paronomastic' link. How, then, does the linguistic and 'poetic' function of paronomasia work at the level of the concept? If the common properties of a parono-mastic link are usually sound-symbolic, which common properties can be found in thought? Deleuze's logic of and affixes disparate concepts together, but their linkages are not completely arbitrary. Going back to the 'audacious' placing of the Stoic 'greening' tree in Wonderland, this is a creative blend of two disparate objects. They are linked, according to Deleuze's 'trans-reason' here, for multiple reasons. First, the (fictive) Wonderland is a forest, which presumably has trees. So far, there is no evidence of any alternative logic system; shared semantic knowledge allows us to predict that a forest usually contains trees. Secondly, then, the linguistic aspect of Stoicism that Deleuze intends to highlight shares some similarities with a particular linguistic aspect of Lewis Carroll's thought. This is the paronomastic moment of his philosophy. Both the Stoics and Carroll manipulate the boundaries between 'word' and 'thing' and render language a metaphysical surface. Their common conceptual

property is therefore a dynamic and spatiotemporal one; they are linked through a shared characterization of language as a slippery, multidimensional surface in which things are both virtual and actual; both words and bodies; both words and things.

> Why do the same Stoic examples continue to inspire Lewis Carroll? – the tree greens, the scalpel cuts, the battle will or will not take place ... It is in front of the trees that Alice loses her name. It is a tree which Humpty Dumpty addresses without looking at Alice.[5]

While we have ascertained the motivated linking of the Stoic trees in the forest of Wonderland, it is not yet clear why these manoeuvres in Deleuze's thought are described here as synecdochic rather than purely metonymic. In terms of the books analysed here, both *Difference and Repetition* and *The Logic of Sense* make language, an important subsection, stand for a larger encircling of philosophy. In my discussions of nonsense, the infinitive, the Stoic linguistic paradox, the speech act and metaphor, these linguistic elements stand for more than language. They represent the structure of Deleuze's thought. Deleuze cannot elucidate his philosophical premises without recourse to linguistic models, but the implications of this are more significant than a statement expressing an inability to critique language without using it. The specific type of linguistic models Deleuze affirms and uses – combinations of formal and dynamic operations such as the zero phoneme, the phonological opposition, the minimal pair – are not used as tools to critique language but as dynamic forms emblematic of philosophical theories. The zero phoneme characterizes nonsense; the phonological opposition and the minimal pair characterize differen(t/c)iation. This makes their application synecdochic rather than metonymic.

Suffixing: An eternal oscillation

For a book that began with a series of prefixes, it seems fitting to include a discussion of a suffix within the conclusion. The suffix that lends Deleuze's process of pure becoming its continuous or

progressive aspect is '-ing'. This often heralds the grammatical forms of the 'present participle' or the 'gerund', which are linked to but significantly different from the infinitive. This suffix is present in the English translation of Deleuze's description of the 'strafing' and 'stabbing' of the surface of sense, which I have discussed. In terms of the grammatical usage in the English language, the gerund is used when the '-ing' is part of a noun phrase, while the present participle is used when the '-ing' is part of an adjective phrase. In a sense, the gerund form signals a shift from the verbal to the substantive within the structure of a verb, because it makes a verb phrase behave like a noun phrase. We have already ascertained that the infinitive form of the verb is extremely important for the dynamic element under discussion, but what is the significance of the gerund?

Each section of this conclusion is entitled with a verb in the gerund form, because this is an appropriate expression of the spatiotemporal particulars of the linguistic elements under discussion. The gerund expresses the simultaneity of virtual and actual, of 'word' and 'thing', of dynamism and stasis, between noun and verb, in Deleuze's linguistic event.[6] While the infinitive is the celebrated form in Deleuze's poetics, the gerund is emblematic of this celebrated form's actualization in language. The gap between Deleuze's linguistic aims and his own language use can be expressed as the difference between the function of the infinitive and the gerund. Deleuze's texts operate as a gerund. The infinitive is not the entire story, which is why Deleuze's philosophy *itself* is not 'poetry itself'. The 'futurist' line quoted earlier from *The Logic of Sense* – 'A strafing of the surface in order to transmute the stabbing of bodies, oh psychedelia' – contains potential gerund forms with 'strafing' and 'stabbing', but the articles placed in front of these words – 'a' strafing and 'the' stabbing – render them as verbal nouns. The sentence also, of course, contains the infinitive 'to transmute'.[7] This is a complex sentence, and to gain a better understanding of its grammatical and semantic implications a comparison with the original French is required. '*Mitraillage de la surface pour transmuer le poignardement des corps, ô psyché-délie.*'[8] The formations '*mitraillage*' and '*poignardement*' similarly operate as verbal nouns, despite the fact that 'mitraillage' begins the sentence with the definite article omitted. This sentence, however, is further complicated by the fact that the infinitive, '*transmuer*',

is what modifies the succeeding noun phrase, '*le poignardement des corps*'. It is an *action* already in motion that is being transmuted, or undergoing a metamorphosis. The stabbing of bodies undergoes a transmutation that is motivated by the strafing of the surface; again, the matter of language is upheld in order to be bombarded, perforated and denatured. This is the nature of the linguistic metamorphosis Deleuze identifies; its edges solidify and materialize only in order to change state. Functioning as a prefix and actualized by the gerund, Deleuze's thought oscillates between language in its most radically infinitive form, and language at its most radically substantive.

NOTES

Introduction

1 For some useful twenty-first-century compilations of multilingual European articles, both on futurism specifically and the international avant-garde in general, see Sascha Bru, Jan Baetens, Benedikt Hjartarson, Peter Nicholls, Tania Ørum and Hubert van den Berg (eds), *Europa! Europa? The Avant-Garde, Modernism and the Fate of a Continent* (Berlin: De Gruyter, 2009); Günter Berghaus (ed.), *International Yearbook of Futurism Studies Vol. 1: Futurism in Eastern and Central Europe* (Berlin and Boston: De Gruyter, 2011); Scheunemann, Dietrich (ed.), *European Avant-Garde: New Perspectives* (Amsterdam: Rodopi, 2000).

2 'DADA MEANS NOTHING'. Tristan Tzara, 'Dada Manifesto' (1918), Mary Ann Caws (ed.), *Manifesto: A Century of Isms* (Lincoln and London: University of Nebraska Press, 2001), p. 301. See also Elza Adamowicz and Eric Robertson (eds), *Dada and Beyond* (Amsterdam and New York: Rodopi, 2011) for recent essays on dada discourse.

3 'SURREALISM, *n*. Psychic automatism in its pure state, by which one proposes to express – verbally, by means of the written word, or in any other manner – the actual functioning of thought'. Andre Bréton, 'Manifesto of Surrealism' (1924), in *Manifestoes of Surrealism*, trans. Richard Seaver and Helen R. Lane (Ann Arbor: University of Michigan Press, 2010), p. 26.

4 'We stand on the last promontory of the centuries!' F. T. Marinetti, 'The Founding and Manifesto of Futurism' (1909), Lawrence Rainey, Christine Poggi and Laura Whitman (eds), *Futurism: An Anthology* (New Haven and London: Yale University Press, 2009), p. 51.

5 'Presbyopic-Festival Manifesto' (1920), *I am a Beautiful Monster: Poetry, Prose, and Provocation*, trans. Marc Lowenthal (Cambridge, MA and London: MIT Press, 2007), p. 220.

6 'The Avant-Garde represented the most radical and (some might say) the most progressive wing of literary Modernism'. Martin Travers, *An Introduction to Modern European Literature: From Romanticism to Postmodernism* (London: Palgrave, Macmillan, 1998), p. 106. For a more recent conflation of modernism and the avant-garde, see Richard Murphy, 'History, Fiction, and the Avant-Garde: Narrativisation and the Event', *Phrasis* 1 (2007), pp. 83–103.

7 Susan Stanford, 'Definitional Excursions: The Meanings of Modern/ Modernity/Modernism' (2001), *Modernism/Modernity* 8.3 (2001) pp. 493–513, pp. 500–1.

8 See Viktor Shklovsky, 'Art as Technique' (1917), *Russian Formalist Criticism: Four Essays*, ed. and trans. Lee T. Lemon and Marion J. Reis (Lincoln: University of Nebraska Press, 1965), pp. 3–57, p. 13.

 NB: Deleuze demonstrates his sympathy for defamiliarization when he calls literature's effect on language a 'becoming-other' of language. See 'Literature and Life', in *Essays Critical and Clinical* (1993), trans. Daniel W. Smith and Michael A. Greco (London and New York: Verso, 1998), p. 5.

9 The intricate relationship between Russian futurism and formalism is discussed in Chapter 1, 'Poetics of Futurism'.

10 José Ortega y Gasset, *The Dehumanization of Art and Other Essays on Art, Culture and Literature* (Princeton: Princeton University Press, 1968), p. 24.

11 Renato Poggioli, *The Theory of the Avant-Garde* (1962), trans. Gerald Fitzgerald (Cambridge, MA and London: Harvard University Press, 1968).

12 For a slightly earlier monograph which isolates both Russian and Italian futurism and deals with its literary and linguistic elements, see John J. White, *Literary Futurism: Aspects of the First Avant-Garde* (Oxford: Clarendon Press, 1990).

13 This is discussed further in Chapter 1.

14 Dietrich Scheunemann (ed.), *European Avant-Garde: New Perspectives* (Amsterdam: Rodopi, 2000).

15 Velimir Khlebnikov, 'To the Artists of the World' (1919), *The King of Time: Selected Writings of the Russian Futurian*, trans. Paul Schmidt, ed. Charlotte Douglas (Cambridge, MA and London: Harvard University Press, 1985), p. 147.

16 Deleuze has written explicitly about Melville, Whitman and T. E. Lawrence in *Essays Critical and Clinical*; references to writers abound in all of his texts. Significantly, Deleuze does not talk at any

point about *zaum*, apart from a passing mention of Khlebnikov's name at the end of the essay 'He Stuttered': 'Biely, Mandelstam and Khlebnikov: a Russian trinity thrice the stutterer and thrice crucified'. Gilles Deleuze, 'He Stuttered', in *Essays Critical and Clinical*, trans. Daniel W. Smith and Michael A. Greco (London and New York: Verso, 1998), p. 114.

17 Peter Hallward describes Deleuze as a 'theophanic' thinker, concluding that Deleuze is 'essentially indifferent to the politics of this world'. See Peter Hallward, *Out of This World: Deleuze and the Philosophy of Creation* (London and New York, Verso, 2006), p. 162.

18 For a critique of this supposition, see Hallward, *Out of This World*, p. 129.

19 Deleuze, *The Logic of Sense*, p. 80.

20 One notable exception is James Williams, whose published guides to both of these texts are extremely important tools for opening up Deleuze's philosophy using productive, challenging and critical methodologies. These two guides, along with Williams's more recent book *Gilles Deleuze's Philosophy of Time* (2011), have been helpful for this project. See James Williams, *Gilles Deleuze's* Difference and Repetition: *A Critical Introduction and Guide* (Delhi: Motilal Banardsidass Publishers, 2008), *Gilles Deleuze's* Logic of Sense: *A Critical Introduction and Guide* (Edinburgh: Edinburgh University Press, 2008), *Gilles Deleuze's Philosophy of Time: A Critical Introduction and Guide* (Edinburgh: Edinburgh University Press, 2011).

21 Jean-Jacques Lecercle describes Deleuze's aesthetics as 'high modernist or avant-garde' in *Deleuze and Language* (Basingstoke: Palgrave Macmillan, 2002), p. 194.

22 Jacques Rancière, 'Existe-t-il une esthétique deleuzienne?', in *Gilles Deleuze: Une vie philosophique*, ed. Eric Alliez (Paris: Synthélabo, 1998), pp. 525–36.

23 '"Deleuze Fulfils the Destiny of the Aesthetic": an Interview with Jacques Rancière', from *Magazine Littéraire: L'effet Deleuze* (February 2002), http://www.16beavergroup.org/mtarchive/archives/002019.php [accessed 20/05/12]

24 Clément Rosset, 'Sécheresse et Deleuze', *L'Arc* 49, new edition (1980): 89–91, in Ronald Bogue, *Deleuze's Wake: Tributes and Tributaries* (Albany: SUNY Press, 2004), p. 10.

25 Ronald Bogue, *Deleuze and Guattari* (London and New York: Routledge, 1989), p. 122.

26 Ibid., p. 113.

27 Aristotle, *Poetics* [*c*.330 BC], trans. S. H. Butcher, ed. Richard Koss (Mineola: Dover, 1997), p. 53.

28 Deleuze, *The Logic of Sense*, p. 3.

29 Richard Kostelanetz identifies three discriminatory criteria to the avant-garde: 'it transcends current artistic conventions in crucial respects, establishing a discernible distance between itself and the mass of current practices; second, avant-garde work will necessarily take considerable time to find its maximum audience; and, third, it will probably inspire future, comparably enhanced endeavours'. See 'Introduction; What Is Avant-garde?', in *The Avant-Garde Tradition in Literature*, ed. Richard Kostelanetz (Buffalo, NY: Prometheus Books, 1982), p. 3.

30 Perloff, *The Futurist Moment*, p. 115.

31 'para-, prefix 1.' *OED Online*. Oxford University Press. http://www. oed.com [accessed 2/04/12]

32 Roman Jakobson, 'Linguistics and Poetics' [1960], *Selected Writings III: Poetry of Grammar and Grammar of Poetry* (The Hague, Paris, New York: Mouton, 1981), p. 43.

33 'Dostoevskitude', p. 67, Velimir Khlebnikov, *Snake Train: Poetry and Prose*, trans. and ed. Gary Kern (Ann Arbor: Ardis, 1976); 'vyum', p. 76, *Snake Train*; 'shchyl', Alexei Kruchenykh, *Suicide Circus: Selected Poems*, trans. Jack Hirschman, Alexander Kohav and Venyamin Tseytlin (Kobenhavn and Los Angeles: Green Integer, 2001), p. 25; 'ryukpl', *Suicide Circus*, p. 49; 'trollolop', *Suicide Circus*, p. 175; 'zang-tooooomb-toomb-toomb' and 'picpacpam', F. T. Marinetti, 'Bombardment', in *Futurism: An Anthology*, ed. Lawrence Rainey, Christine Poggi and Laura Whitman, p. 436.

34 Gilles Deleuze, *Nietzsche and Philosophy* [1962], trans. Hugh Tomlinson (London: Athlone Press, 1992), p. xiii.

Chapter One

1 Vladimir Markov, *Russian Futurism: A History* (London: Macgibbon and Kee, 1969), p. 44.

2 For an enthusiastic commentary on Khlebnikov's 'utopian' poetics, see Franco 'Bifo' Berardi, 'Zaum and Technomaya'. in *After the Future*, trans. Arianna Bove *et al.*, ed. Gary Genosko and Nicholas

Thoburn (Edinburgh, Oakland, Baltimore: AK Press, 2011), pp. 28–33.

3 A neologism coined by Khlebnikov and Kruchenykh for someone who creates *zaum* words, translated variously as 'speechist' (Gary Kern), 'write-wight' (Paul Schmidt) and 'worder' (Gerald Janacek).

4 Nina Gurianova, *The Aesthetics of Anarchy: Art and Ideology in the Early Russian Avant-Garde* (Berkeley: University of California Press, 2012), p. 7.

5 Ibid., p. 150.

6 David Burliuk, Alexander Kruchenykh, V. Mayakovsky, Victor Khlebnikov, 'A Slap in the Face of Public Taste' (1912), in Anna Lawton and Herbert Eagle (trans. and eds), *Words in Revolution: Russian Futurist Manifestoes 1912–1928* (Washington, DC: New Academia Publishing, 2005), p. 51.

7 Khlebnikov translator Paul Schmidt calls *zaum* 'beyonsense'; Gary Kern calls it 'beyond-the-mind', whereas 'transreason' or 'transrational' has been a more commonly accepted translation.

8 Marjorie Perloff, *21st-Century Modernism: The 'New' Poetics* (Oxford: Blackwell, 2002), p. 126.

9 This is Deleuze's description of the 'paradoxical element' of nonsense, as that which 'says its own sense'. *The Logic of Sense*, p. 79.

10 Gilles Deleuze and Félix Guattari, *What Is Philosophy?* (1991), trans. Graham Burchell and Hugh Tomlinson (London and New York: Verso, 2003), p. 8.

11 François Dosse, *History of Structuralism, Vol 1: The Rising Sign, 1945–1966* (Minneapolis: University of Minnesota Press, 1997), p. 54.

12 Perloff, *The Futurist Moment*, p. 126.

13 Velimir Khlebnikov, *The King of Time,* ed. Charlotte Douglas, back inside cover.

14 'On Poetry' (1919–20), *The King of Time*, p. 152.

15 Viktor Shklovsky, 'Art as Technique', (1917), in *Russian Formalist Criticism: Four Essays*, trans. and ed. Lee T. Lemon and Marion J. Reis (Lincoln: University of Nebraska Press, 1965), p. 18.

16 A. Kruckenykh, 'From *Shiftology of Russian Verse: An Offensive and Educational Treatise*' (1923), in Anna Lawton and Herbert Eagle (trans. and eds), *Words in Revolution: Russian Futurist Manifestoes 1912–1928* (Washington: New Academia Publishing, 2004), p. 185.

17 In this letter, Jakobson describes the temporal theory of
Worldbackwards as 'fully scientific'. See Nikolai Firtich,
'Worldbackwards: Lewis Carroll, Aleksei Kruchenykh and Russian
Alogism', *The Slavic and East European Journal*, Vol. 48 No. 4
(Winter 2004), pp. 593–606, p. 593.

18 Roman Jakobson, 'The Newest Russian Poetry: Velimir Xlebnikov'
[excerpts], in *My Futurist Years*, ed. Bengt Jangfeldt, trans. Stephen
Rudy (New York: Marsilio, 1997), p. 188. NB: the variant spelling
'Xhlebnikov' is due to Stephen Rudy's transliteration from the
Russian. I have adopted the more commonly used 'Khlebnikov' in
my own writing. The same goes for *World in Reverse*, which is more
commonly translated as *Worldbackwards*.

19 A. Kruchenykh, 'From *Shiftology of Russian Verse: An Offensive and
Educational Treatise*' (1923), in Anna Lawton and Herbert Eagle
(trans. and ed.) *Words in Revolution: Russian Futurist Manifestoes
1912–1928* (Washington: New Academia Publishing, 2004), p. 185.

20 Juliette R. Stapanian, '"Universal War" and the Development of
Zaum: Abstraction toward a New Pictorial and Literary Realism',
Slavic and Eastern European Journal, Vol. 29, No. 1 (Spring 1985),
pp. 18–38, p. 20.

21 See Gilles Deleuze, 'He Stuttered' (1993), *Essays Critical and
Clinical*, trans. Daniel W. Smith and Michael A. Greco (London and
New York: Verso, 1998), pp. 107–14.

22 Velimir Khlebnikov, from *Zangezi* (1922), in *Snake Train: Poetry and
Prose*, ed. and trans. Gary Kern (Ann Arbor: Ardis, 1976), p. 77.

23 Ibid.

24 Deleuze, *The Logic of Sense*, p. 79.

25 Ibid.

26 Nikolai Firtich, 'Worldbackwards: Lewis Carroll, Aleksei
Kruchenykh and Russian Alogism', *The Slavic and East European
Journal*, Vol. 48, No. 4 (Winter 2004), pp. 593–606, p. 596.

27 Deleuze, *The Logic of Sense*, p. 105.

28 Victor Shklovsky, *Knight's Move* (1923), trans. Richard Sheldon
(Illinois and London: Dalkey Archive, 2005), p. 70.

29 Deleuze, *The Logic of Sense*, p. 79.

30 For example, in 'New Ways of the Word (the language of the
future, death to Symbolism)' (1913), Kruchenykh claims that they
have 'provided a free language, transrational and universal', and
later in *Kruchenykh the Grandiosaire* (1919) I. Terentyev asserts
that 'Someday in the future a new Dal or Badouin will compose a

universal dictionary of transrational language for all nations'. *Words in Revolution*, pp. 70 and 180.

31 Velimir Khlebnikov, 'The Simple Names of the Language' (1916), *Snake Train*, pp. 201–6.

32 Henryk Baran has discussed Khlebnikov's Zangezi alongside Nietzsche's Zarathustra in terms of 'doubles', in their 'common use of provocation with regard to their audience and themselves, and their readiness to doubt and challenge all doctrine, including their own'. See Henryk Baran, 'Khlebnikov and Nietzsche: pieces of an incomplete mosaic,' in *Nietzsche and Soviet Culture*, ed. Bernice Glatzer Rosenthal (Cambridge: Cambridge University Press, 1994), pp. 58–83, p. 79.

33 Ibid., p. 83 n. 5.

34 Velimir Khlebnikov, 'On Contemporary Poetry' (1920), *Collected Works Vol. I: Letters and Theoretical Writings*, ed. Charlotte Douglas, trans. Paul Schmidt (Cambridge, MA and London: Harvard University Press, 1987). NB: There are two themes here which will be returned to in more detail later. The literalization of metaphor is discussed in Chapter 5, 'Shiftology #2: From Metaphor to Metamorphosis', and the concept of language's 'doubling' is returned to in Chapter 4, 'Shiftology #1: From Performativity to Dramatization'.

35 Velimir Khlebnikov, 'Proposals', *Snake Train*, p. 193.

36 Velimir Khlebnikov, *The King of Time*, ed. Charlotte Douglas, trans. Paul Schimdt (London and Cambridge, MA: Harvard University Press, 1985), p. 199.

37 Velimir Khlebnikov, 'O the racing cloud's Dostoevskitude!' p. 67.

38 David Burliuk, Alexander Kruchenykh, Vladimir Mayakovsky, Velimir Khlebnikov, 'A Slap in the Face of Public Taste', in Anna Lawton and Herbert Eagle (trans. and eds), *Words in Revolution*, p. 51.

39 Plato, *Cratylus*, quoted at the beginning of Gerald Janecek, *The Look of Russian Literature: Avant-Garde Visual Experiments, 1900–1930* (Princeton: Princeton University Press, 1984).

40 Plato, *Cratylus* (380 BC), in *The Dialogues of Plato, Vol.III* (Oxford: Clarendon Press, 1953), p. 42.

41 Gilles Deleuze, 'He Stuttered', *Essays Critical and Clinical* p. 114.

42 Victor Erlich, *Russian Formalism: History – Doctrine* (1965), 3rd edn (New Haven and London: Yale University Press, 1981), p. 50.

43 Marjorie Perloff, *21st-Century Modernism: The 'New' Poetics* (Oxford: Blackwell, 2002), p. 133.

44 A. Kruchenykh and V. Khlebnikov, from 'The Word as Such' (1913), in *Words in Revolution*, p. 57.

45 Perloff, *21st-Century Modernism*, p. 131.

46 Velimir Khlebnikov, 'About Verses' (1919–20), *Snake Train*, p. 229.

47 'Twas brillig, and the slithy toves
Did gyre and gimble in the wabe ...'

Lewis Carroll, 'Jabberwocky', from *Through the Looking-Glass and What Alice Found There* (Ware, Wordsworth: 1993), p. 167.

48 Deleuze, *The Logic of Sense*, p. 73.

49 Victor Erlich, *Russian Formalism: History – Doctrine*, 3rd edn (New Haven and London: Yale University Press, 1981), p. 49.

50 *Transrational Boog* (Zaumnaia gniga), Alexei Kruchenykh and Aliagrov, illustrated by Olga Rozanova (Moscow, 1916).

51 Roman Jakobson, 'The Newest Russian Poetry: Velimir Xlebnikov' (1921), trans. E. J. Brown, in *My Futurist Years*, ed. Bengt Jangfeldt, trans. Stephen Rudy (New York: Marsilio Publishers, 1997), p. 4.

NB: the different English spellings of 'Khlebnikov' and 'Xlebnikov' are due to variants in transliteration from the Russian.

52 Roman Jakobson, 'Linguistics and Poetics' (1960), *Selected Writings III*, p. 25.

53 Ibid., p. 43.

54 Ibid., p. 44.

55 Jakobson, *My Futurist Years*, p. 193.

56 Ibid., p. 198.

57 Jakobson, 'Einstein and the Science of Language', in *Selected Writings VII* (The Hague: Mouton, 1985), p. 261.

58 'Here it is evident that the synchronic viewpoint predominates, for it is the true and only reality to the community of speakers. The same is true of the linguist: if he takes the diachronic perspective, he longer observes language but a series of events that modify it.' Saussure, *Course in General Linguistics*, p. 90.

59 'Everything that relates to the static side of our science is synchronic; everything that has to do with evolution is diachronic. Similarly, *synchrony* and *diachrony* designate respectively a language-state and an evolutionary phase.' Ferdinand de Saussure, *Course in General Linguistics* (1916), trans. Wade Baskin, ed. Perry Meisel and Haun Saussy (Chichester: Columbia University Press, 2011), p. 81.

60 Jakobson 'My Favourite Topics' (1980), in *Selected Writings VII* (The Hague: Mouton, 1985), p. 374.

61 Jakobson 'Linguistics and Poetics' (1960), in *Selected Writings III*, p. 27.

62 Jakobson, 'On Linguistic Aspects of Translation' (1959), in *Selected Writings II*, p. 262.

63 Roman Jakobson, 'On the Translation of Verse' (1930), trans. P. and W. Steiner, in *Selected Writings V*, p. 134.

64 Alexei Kruchenykh, 'New Ways of the Word' (1913), in *Words in Revolution*, p. 68.

65 Jakobson, 'On Linguistic Aspects of Translation' (1959), in *Selected Writings II*, p. 266.

66 Ibid., p. 261.

67 Roger Penrose, 'Escher and the Visual Representation of Mathematical Ideas', in *M. C. Escher: Art and Science* (Amsterdam and New York: Elsevier, 1986), p. 150.

68 Deleuze, *The Logic of Sense*, p. 55.

69 Antonin Artaud, incomplete letter to Henri Parisot (1940), *Selected Writings*, ed. Susan Sontag (Berkeley: University of California Press, 1988), p. 448.

70 Lewis Carroll, *Alice's Adventures in Wonderland & Through the Looking-Glass* [1865; 1871] (Ware: Wordsworth, 2001), p. 167.

71 Antonin Artaud, 'L'Arve, et l'Aume, tentative antigrammaticale contre Lewis Carroll', *L'Arbalète* (1947), no. 2.

72 Deleuze, *The Logic of Sense*, p. 102.

73 Tony Bennett, *Formalism and Marxism* (London and New York: Routledge, 1989), p. 19.

74 'We entered the fight against the Symbolists in order to wrest poetics from their hands – to free it from its ties with their subjective, philosophical and aesthetic theories and to direct it towards the scientific investigation of facts.' Boris Eichenbaum, 'Theory of the Formal Method' (1926), in *Russian Formalist Criticism*, p. 106. The reaction against symbolism is discussed further in Chapter 5.

75 Erlich, *Russian Formalism*, p. 184.

76 Shklovsky, 'Art as Technique', in *Russian Formalist Criticism*, p. 13.

77 Ibid., p. 11.

78 Shklovsky, 'The Resurrection of the Word' (1914), *Russian Formalism*, ed. Stephen Bann and John E. Bowlt (Edinburgh: Scottish Academic Press, 1973), p. 41.

79 Ibid., p. 43.

80 Shklovsky, 'Art as Technique', in *Russian Formalist Criticism*, p. 43.

81 Alexei Kruchenykh and Velimir Khlebnikov, from 'The Word as Such' (1913), in *Words in Revolution*, p. 57.

82 Alexei Kruchenykh, *Shiftology of Russian Verse* (Moscow: MAF, 1923); *Verbal Texture: A Declaration* (Moscow: MAF, 1923); *Apocalypse in Russian Literature* (Moscow: MAF, 1923).

83 Deleuze echoes Shklovsky's critique of recognition as part of his own critique of representation: 'The postulate of recognition was therefore a first step towards a much more general postulate of representation.' *Difference and Repetition* (1968), p. 174.

84 Burliuk et al., 'A Slap in the Face of Public Taste' (1913), in *Words in Revolution*, p. 51.

85 Catherine Gallagher, 'Formalism and Time', *MLQ* 61 (2000), p. 247.

86 F. T. Marinetti, 'The Founding and Manifesto of Futurism' (1909), in *Futurism: an Anthology*, ed. L. Rainey et al., p. 51.

87 Shklovsky, 'Art as Technique', in *Russian Formalist Criticism*, p. 18.

88 'For Adorno, the category of the new in art is a necessary duplication of what dominates the commodity society ... But it must be borne in mind that in the commodity society, the category of the new is not a substantive but merely an apparent one. For far from referring to the nature of the commodities, it is their artificially imposed appearance that is involved here.' Peter Bürger, *Theory of the Avant-Garde* (1974), trans. Michael Shaw (Minneapolis: University of Minnesota Press, 1984), p. 61.

89 Ibid., p. 7.

90 Richard Murphy, *Theorizing the Avant-Garde: Modernism, Expressionism, and the Problem of Postmodernity* (Cambridge: Cambridge University Press, 1999), p. 11.

91 Leon Trotsky, *Literature and Revolution* (1924), ed. William Keach, trans. Rose Strunsky (Chicago: Haymarket Books, 2005), p. 120.

92 Viktor Shklovsky, 'Ullia, Ullia, Marsiane!', in *Knight's Move* (1923), trans. Richard Sheldon (London: Dalkey Archive, 2005), p. 22. NB: Shklovksy's title 'Ullia, Ullia, Marsiane!' is a reference to Khlebnikov's manifesto 'Trumpet of the Martians' (1916), in which he declared that the futurists would be removed from society and be 'martians', therefore highlighting Khlebnikov's shift in position.

93 Viktor Shklovsky, *Knight's Move*, p. 66.

94 Viktor Shklovsky, *Zoo, or Letters Not about Love* (1923), trans. and ed. Richard Sheldon (Ithaca and London: Cornell University Press, 1971), p. 80.

95 See Richard Sheldon, 'Viktor Shklovsky and the Device of Ostensible Surrender', *Slavic Review*, Vol. 34, No. 4 (March 1975), p. 90.

96 Victor Shklovsky, *Knight's Move*, p. 3.

97 Ibid., p. 8.

98 Anatoly Lunacharsky, 'Revolution and Art, 1920–22', in *Russian Art of the Avant-Garde: Theory and Criticism*, ed. and trans. John E. Bowlt (New York: Viking Press, 1976), p. 191.

99 Fredric Jameson, *The Prison-House of Language: A Critical Account of Structuralism and Russian Formalism* (Princeton and Chichester: Princeton University Press, 1972), pp. 69–70.

Chapter Two

1 Gilles Deleuze and Félix Guattari, *What Is Philosophy?* (1991), trans. Graham Burchell and Hugh Tomlinson (London and New York: Verso, 2003), p. 35.

2 Gilles Deleuze, *Negotiations 1972–1990*, trans. Martin Joughin (New York: Columbia University Press, 1995), p. 89.

3 Gilles Deleuze, 'He Stuttered', in *Essays Critical and Clinical* (1993), trans. Daniel W. Smith and Michael A. Greco (London and New York: Verso, 1998), p. 114.

4 Jean-Jacques Lecercle, *Deleuze and Language* (Basingstoke: Palgrave Macmillan, 2002), p. 30.

5 Gregory Flaxman has described Deleuze in terms of a 'philosophy of the future'. See 'Sci Phi: Gilles Deleuze and the Future of Philosophy', in *Deleuze, Guattari and the Production of the New*, ed. Simon O'Sullivan and Stephen Zepke (London and New York: Continuum, 2008), pp. 11–21. Similarly, Ronald Bogue has described Deleuzian 'fabulation' as 'hallucinatory visions of future collectivities, and second, a means toward the invention of a people to come'. See *Deleuzian Fabulation and the Scars of History* (Edinburgh: Edinburgh University Press, 2010), p. 19.

6 Matei Calinescu, *Five Faces of Modernity: Modernism, Avant-Garde, Decadence, Kitsch, Postmodernism* (Durham: Duke University Press, 1987), p. 130.

7 Gilles Deleuze, *Negotiations 1972–1990*, p. 140.

8 Deleuze and Guattari, *A Thousand Plateaus* (1980), trans. Brian Massumi (London: Continuum, 2007), p. 7.

9 Deleuze, *Expressionism in Philosophy: Spinoza* (1968), trans. Martin Joughin (New York: Zone, 1992), p. 311.

10 Gilles Deleuze and Félix Guattari, *A Thousand Plateaus*, p. 4.

11 Samuel Beckett, 'Dante ... Bruno . Vico ... Joyce' (1929), *Disjecta: Miscellaneous Writings and Dramatic Fragment*, ed. Ruby Cohn (London: John Calder, 2001), p. 27.

12 Clément Rosset, 'Sécheresse et Deleuze', *L'Arc* 49, new edition (1980): 89–91, in Bogue, *Deleuze's Wake*, p. 10.

13 Deleuze, *The Logic of Sense*, p. 183.

14 Deleuze's thought has been linked to German Romanticism by John Sellars, citing figures such as Lenz, Hölderlin and Kleist, although he ultimately rejects this model in favour of Deleuze's Stoicism: see 'The Point of View of the Cosmos: Deleuze, Romanticism, Stoicism', *Pli* 8 (1999), pp. 1–24.

15 Gilles Deleuze, *Negotiations 1972–1990*, trans. Martin Joughin (New York: Columbia University Press, 1995), pp. 140–41.

16 Deleuze and Guattari, *What Is Philosophy?*, p. 24.

17 Ibid., p. 64.

18 Ibid., pp. 64–5.

19 *Quand dire c'est faire*, trans. Oswald Ducrot (Paris: Hermann, 1972), Gilles Deleuze, *Essays Critical and Clinical*, trans. Daniel W. Smith and Michael A. Greco (London and New York: Verso, 1998), p. 196 n. 2.

20 Deleuze and Guattari, *Anti-Oedipus*, trans. Robert Hurley, Mark Seem and Helen R. Lane (London and New York: Continuum, 2004), p. 95.

21 Deleuze and Guattari, *A Thousand Plateaus*, p. 42.

22 Gilles Deleuze, *Logique du Sens* (Paris: Editions de Minuit, 1969), p. 219.

 [A strafing of the surface in order to transmute the stabbing of bodies, oh psychedelia.]

23 F. T. Marinetti, 'To my Pegasus' in *Selected Poems and Related Prose*, trans. Elizabeth R. Napier and Barbara R. Studholme (New Haven and London: Yale University Press, 2002), p. 38.

24 Deleuze, *Negotiations*, pp. 140–1.

25 Deleuze, *Difference and Repetition*, p. xix.

26 Deleuze, *The Logic of Sense*, p. x.

27 Ibid., pp. ix–x.

28 Tzvetan Todorov, *Introduction to Poetics* (1968), trans. Richard Howard (Minneapolis: University of Minnesota Press, 1981), p. 54.

29 Deleuze, *The Logic of Sense*, p. 8. NB: Deleuze's Stoicism is discussed later in this chapter.

30 Ibid., p. 12.

31 '... till the poets among us can be
"literalists of
the imagination" – above
insolence and triviality and can present
for inspection, 'imaginary gardens with real toads in them', shall we have
it.' Marianne Moore, 'Poetry' (1935), in *Collected Poems* (New York: Macmillan, 1951), p. 41.

32 The implications of speed in Deleuze and futurism are discussed in Chapter 3, and metaphor's critique through the medium of linguistic acceleration will be discussed fully in Chapter 5.

33 Deleuze, *The Logic of Sense*, p. 3.

34 'A Futurist book became a true paradox: a material form to capture chaotic flux, immediacy, spontaneity – all the immaterial, ephemeral elements of life.' Gurianova, *The Aesthetics of Anarchy*, p. 158.

35 Tristan Tzara, 'Dada Manifesto 1918', in *Dada Almanac*, ed. Richard Huelsenbeck (1920), English edition presented by Malcom Green, 2nd edn (London: Atlas Press, 1998), p. 122.

36 The 'not quite' instantaneity is significant and will be discussed in the following chapter on temporalities.

37 The intensive/extensive distinction, particularly with reference to the Bergsonian opposition differences in degree and differences in kind, will be discussed in Chapter 6.

38 Roman Jakobson, 'Notes on the French Phonemic Pattern', in *Selected Writings I: Phonological Studies*, 3rd edn (Berlin and New York: Mouton de Gruyter, 2002), p. 431.

39 Deleuze, *Difference and Repetition*, p. 150.

40 Ibid., p. 80.

41 François Dosse, *History of Structuralism, Vol. 1: The Rising Sign, 1945–1966* (Minneapolis: University of Minnesota Press, 1997), p. 43.

42 Deleuze, *The Logic of Sense*, p. 82.

43 Gilles Deleuze, 'How Do We Recognize Structuralism?' (1967), in *Desert Islands and Other Texts, 1953–1974*, ed. David Lapoujade, trans. Michael Taormina (New York: Semiotext(e)), 2004), p. 170.

44 Ibid., p. 171.

45 Ibid., p. 173.

46 NB: There is insufficient space in in this book to include a detailed commentary on Deleuze's various discussions of Freud and Lacan.

47 Deleuze, 'How Do We Recognize Structuralism?', in *Desert Islands*, p. 172.

48 This is discussed further in the section below, 'The celebration of univocity'.

49 Deleuze, *The Logic of Sense*, p. 78.

50 Deleuze, 'How Do We Recognize Structuralism?', in *Desert Islands*, p. 176.

51 Deleuze, *Difference and Repetition*, p. 148. This particular minimal pair of Roussel's is discussed further in Chapter 3.

52 Interestingly, Khlebnikov almost uses the model of the minimal pair in an analogous fashion in his manifesto 'Trumpet of the Martians' (1916) when he distinguishes between the 'inventor/explorers' and the 'investor/exploiters'. See *The King of Time,* p. 128.

53 Deleuze, 'How Do We Recognize Structuralism?', in *Desert Islands*, p. 176.

54 Ibid., p. 179.

55 Ibid., p. 184.

56 James Joyce, *Finnegans Wake* (1939), (Harmondsworth: Penguin, 1992), p. 3.

57 Deleuze, *The Logic of Sense*, p. 48.

58 Ibid.

59 Diogenes Laertes, *Lives of Eminent Philosophers*, Vol. II, trans. R. D. Hicks (Cambridge and London: Harvard University Press and Heinemann, 1925), pp. 295–7.

60 John Sellars, *Stoicism* (Chesham: Acumen, 2006), p. 3.

61 Ibid., p. 61.

62 Deleuze, *The Logic of Sense*, p. 49.

63 'Thunderbolts explode between different intensities, but they are preceded by an invisible, imperceptible *dark precursor,*

which determines their path in advance but in reverse, as though intagliated'. Deleuze, *Difference and Repetition*, pp. 145–8.

64 Slavoj Žižek, *Organs without Bodies: On Deleuze and Consequences* (New York and London: Routledge, 2004), p. 34.

65 Ibid., p. 145.

66 Fredric Jameson, *The Prison-House of Language*, p. 89.

67 Ibid, p. 106.

68 Jean-Jacques Lecercle, *The Violence of Language* (London and New York: Routledge, 1990), p. 105.

69 James Williams, *Gilles Deleuze's* Logic of Sense: *A Critical Introduction and Guide* (Edinburgh: Edinburgh University Press, 2008), pp. 24–5.

70 Deleuze and Guattari, *A Thousand Plateaus*, p. 28.

71 Lecercle, *Deleuze and Language*, p. 75.

72 Gilles Deleuze and Claire Parnet, *Dialogues II* (1977), trans. Hugh Tomlinson and Barbara Habberjam (London and New York: Continuum, 2002), pp. 42–3.

73 The conflation of conjunction and copula is important for Deleuze's poetics, and will reappear in Chapters 5 and 6.

74 John Mullarkey, *Post-Continental Philosophy: An Outline* (London: Continuum, 2006), p. 17.

75 Deleuze and Guattari, *Anti-Oedipus* (1972), trans. Robert Hurley, Mark Seem and Helen R. Lane (London and New York: Continuum, 2004), p. 84.

76 Roman Jakobson, 'Linguistics and Poetics', *Selected Writings III*, p. 27.

77 Deleuze and Guattari, *A Thousand Plateaus*, pp. 22–3.

78 'It is not a matter of being which is distributed according to the requirements of representation, but of all things being divided up within being in the univocity of simple presence (the One-All).' Deleuze, *Difference and Repetition*, p. 46.

79 Fredric Jameson, 'Marxism and Dualism in Deleuze', in *A Deleuzian Century?*, ed. Ian Buchanan (Durham and London: Duke University Press, 1999), pp. 31–2.

80 Alain Badiou, *Deleuze: The Clamour of Being*, trans. Louise Burchill (London and Minneapolis: University of Minnesota Press, 2000), p. 10.

81 Peter Hallward, *Out of this World: Deleuze and the Philosophy of Creation* (London and New York, Verso, 2006), p. 156.

82 Slavoj Žižek, *Organs Without Bodies: On Deleuze and Consequences* (New York and London: Routledge, 2004), p. 28.

83 See Jean-Jacques Lecercle and Denise Riley, *The Force of Language*
 (Basingstoke: Palgrave Macmillann, 2005); Lecercle, *Philosophy
 Through the Looking-Glass: Language, Nonsense, Desire* (Chicago:
 Open Court, 1985); Lecercle, *The Violence of Language* (London:
 Routledge, 1990); Lecercle, *Philosophy of Nonsense: The Intuitions
 of Victorian Nonsense Literature* (London: Routledge, 1994).

84 Lecercle, *Deleuze and Language*, p. 16.

85 Ibid.

86 Ibid., p. 17.

87 Jakobson, 'Two Aspects of Language and Two Types of Aphasic
 Disturbances' (1965), in *Language in Literature*, ed. Krystyna
 Pomorska and Stephen Rudy (Cambridge, MA and London:
 Harvard University Press, 1987), pp. 95–120.

88 Lecercle, *Deleuze and Language*, p. 17.

89 See Jean-Jacques Lecercle, 'Lewis Carroll and the Talmud', *SubStance*,
 Vol. 22, No. 2/3, Issue 71/72: Special Issue: Epistémocritique (1993),
 pp. 204–16; and *Philosophy of Nonsense: the Intuitions of Victorian
 Nonsense Literature* (London: Routledge, 1994), p. 3.

90 Deleuze, *Difference and Repetition*, p. 44.

91 'Hence, all to which "being" is not univocal *in quid* are included in
 those to which "being" is univocal in this way … To put it briefly,
 then, "being" is univocal for all'. John Duns Scotus, 'Concerning
 Metaphysics', *Philosophical Writings*, trans. Allan Wolter
 (Indianapolis: Bobbs-Merrill, 1962), pp. 5–8.

92 Deleuze, *Expressionism in Philosophy: Spinoza* (1968), trans.
 Martin Joughin (New York: Zone, 1990), pp. 63–7.

93 Deleuze, *The Logic of Sense*, p. 206.

94 Badiou, *Deleuze: The Clamour of Being*, p. 38.

95 Ray Brassier, 'The Expression of Meaning in Deleuze's Ontological
 Proposition', *Pli* 19 (2008), pp. 1–29.

96 Badiou, *Deleuze: The Clamour of Being*, p. 38.

97 Deleuze, *Difference and Repetition*, p. 44.

98 Ibid., p. 45.

99 Deleuze, *The Logic of Sense*, pp. 211–12.

100 Jameson, *The Prison-House of Language*, p. 158.

Chapter Three

1 Walter Benjamin, 'The Work of Art in the Age of Technical Reproduction' (1936), *Illuminations*, ed. Hannah Arendt (New York: Pantheon Books, 1968), p. 237.

2 Karl Marx and Friedrich Engels, *The Communist Manifesto* (1848) (Harmondsworth: Penguin, 2002).

3 Marshall Berman and Peter Osborne's critiques of the language of the *Manifesto* are discussed in the next paragraph. Also, in *The Futurist Moment* Marjorie Perloff describes the *Manifesto* as having 'curiously mixed rhetoric', even describing its preamble as 'something of a prose poem'. Perloff, *The Futurist Moment*, p. 82.

4 Marshall Berman, *All That Is Solid Melts Into Air: The Experience of Modernity* (London: Verso, 1982), p. 91.

5 D. Burliuk et al., 'A Slap in the Face of Public Taste' (1912), in *Words in Revolution*, pp. 51–2.

6 Peter Osborne, *Philosophy in Cultural Theory* (London and New York: Routledge, 2000), p. 70.

7 Marjorie Perloff argues that the manifesto and the poem are interchangeable in her chapter 'Violence and Precision: The Manifesto as Art Form', in *The Futurist Moment*, pp. 82–115. Ben Hutchinson has also suggested that the two terms 'style' and 'manifesto' are related etymologically: where the former refers implicitly to instruments wielded by the hand (a 'writing-implement' but also a 'weapon of offence'), the latter refers explicitly to the hand ('manus') and to offence ('fendere'). Ben Hutchinson, *Modernism and Style* (Basingstoke: Palgrave Macmillan, 2011), p. 198.

8 Pierre Albert-Birot, 'Nunism' (1916), in Mary Ann Caws (ed.), *Manifesto: A Century of Isms* (Lincoln and London: University of Nebraska Press, 2001), p. 150.

9 As in 'Nowism/Presentism/Simultaneism', chapter 4 of Caws (ed.), *Manifesto*, pp. 141–66.

10 Albert-Birot, 'Nunism', in *Manifesto*, p. 150.

11 F. T. Marinetti, 'Technical Manifesto of Futurist Literature' (1912), in *Futurism: An Anthology*, ed. L. Rainey et al., pp. 119–25; D. Burliuk, E. Guro, N. Burliuk, V. Mayakovsky, K. Nizen, V. Khlebnikov, B. Livshits, A. Kruchenykh, *A Trap for Judges, 2* (St. Petersburg: Zhuravl', 1913), in *Words in Revolution*, trans. and ed. Anna Lawton and Herbert Eagle, pp. 53–4.

12 Andreas Kramer has written about the geographies and cartologies of both Italian and Russian futurism: 'Remapping the World: Geographies of Italian Futurism', paper presented at Futurism: A Conference Day of Aesthetic and Political Reassessment (London, 2009), proceedings forthcoming; 'The Geographies of Peripheral Modernism: The Case of the Russian Avant-Garde', paper presented at Peripheral Modernisms conference (London, 2012).

13 Marinetti, 'Technical Manifesto', in *Futurism: An Anthology*, p. 123; Burliuk et al., *A Trap for Judges, 2*, in *Words in Revolution*, pp. 53–4.

14 Andrey Bely, *'Magiia slov'* (1909), in *Simvolism* (Munich: Wilhelm Fink Verlag, 1969). Quoted in Tim Harte, *Fast Forward: The Aesthetics and Ideology of Speed in Russian Avant-Garde Culture, 1910–1930* (Madison: University of Wisconsin Press, 2009), p. 68 n. 4.

15 All texts are in *Words in Revolution*, pp. 55–83.

16 Marinetti, 'Technical Manifesto', in *Futurism: An Anthology*, p. 122.

17 Ibid., pp. 165–224.

18 Marinetti, 'Destruction of Syntax – Radio Imagination – Words-in-Freedom' (1913), in *Futurism: An Anthology*, pp. 146–7.

19 Benedikt Livshits, 'The Liberation of the Word' (1913), in *Words in Revolution*, p. 81.

20 Deleuze, *The Logic of Sense*, p. 30.

21 Deleuze, *Dialogues II*, p. 47.

22 Ronald Bogue, *Deleuze and Guattari* (London and New York: Routledge, 1989), p. 55.

23 Deleuze, The *Logic of Sense*, p. 79.

24 F. T. Marinetti, 'Technical Manifesto of Futurist Literature' (1912), in *Futurism: An Anthology*, pp. 119–20.

25 In 'A Response to Objections' (1912), Marinetti cites Dante and Poe as his inspiration for the dictum 'to hate intelligence' from the 'Technical Manifesto'. See *Futurism: An Anthology*, p. 125. In *The One and a Half-Eyed Archer*, Livshits recounts a conversation between Nikolai Kulbin and Marinetti in which he vehemently denies any Bergsonian influence. See *The One and a Half-Eyed Archer*, trans. John E. Bowlt (Newtonville, MA: Oriental Research Partners, 1977), p. 153. Bergson's influence on Deleuze will be discussed in Chapter 6.

26 Marinetti, 'A Response to Objections', *Futurism; An Anthology*, p. 128.

27 Deleuze, *Dialogues II*, p. 48.

28 Deleuze, *The Logic of Sense*, pp. 211–12.

29 Žižek, *Organs without Bodies*, p. 55.

30 Manuel DeLanda, *Intensive Science and Virtual Philosophy* (2002) (London and New York: Continuum, 2007), p. 135.

31 Velimir Khlebnikov, 'Incantation by Laughter' (1910), in *Snake Train*, trans. Gary Kern, p. 62.

32 'Khlebnikov's and Kruchenykh's wordforms also lie outside of poetry. They are philology of a doubtful character, poetics in part, but not poetry'. Leon Trotsky, *Literature and Revolution* (1924), trans. Rose Strunsky, ed. William Keach (Chicago: Haymarket Books, 2005), p. 117.

33 Deleuze, *The Logic of Sense*, p. 103.

34 Ibid.

35 Marinetti, 'Technical Manifesto', in *Futurism: An Anthology*, p. 120.

36 Deleuze, *The Logic of Sense*, p. 200.

37 Deleuze, 'Louis Wolfson; or, The Procedure' (1993), trans. Daniel W. Smith and Michael A. Greco, *Essays Critical and Clinical*, pp. 7–20.

38 Raymond Roussel, 'Among the Blacks' (1935), trans. Ron Padgett (Bolinas, CA: Avenue B, 1988), p. 3 and p. 13.

39 Raymond Roussel, *How I Wrote Certain of My Books* (1935), trans. Trevor Winkfield (New York: Sun, 1977), p. 5.

40 Marinetti, 'The Founding and Manifesto of Futurism' (1909), in *Futurism: An Anthology*, p. 51.

41 Ibid., p. 50.

42 Ibid., p. 51.

43 Alexei Kruchenykh, 'Declaration of the Word as Such' (1913), in *Words in Revolution*, p. 67.

44 'The martial arts have always subordinated weapons to speed, and above all to mental (absolute) speed; for this reason, they are also the arts of suspense and immobility'. Deleuze and Guattari, *A Thousand Plateaus*, p. 441. 'From Epicurus to Spinoza (the incredible book 5) and from Spinoza to Michaux the problem of thought is infinite speed. But this speed requires a milieu that moves infinitely in itself – the plane, the void, the horizon'. Deleuze and Guattari, *What Is Philosophy?* p. 36.

45 Deleuze, *The Logic of Sense*, p. 154.

46 This is discussed further in Chapter 4.

47 'The two of us wrote *Anti-Oedipus* together. Since each of us

was several, there was already quite a crowd ... We are no longer ourselves. Each of us will know his own. We have been aided, inspired, multiplied.' Deleuze and Guattari, *A Thousand Plateaus*, pp. 3–4.

48 Deleuze, *The Logic of Sense*, p. 154.

49 Ibid.

50 Ibid.

51 Lewis Carroll, *Alice's Adventures in Wonderland* and *Through the Looking-Glass* [1865; 1871] (Ware: Wordsworth, 2001), pp. 177–8.

52 Burliuk et al., 'A Slap in the Face of Public Taste' (1912), in *Words in Revolution*, pp. 51–2.

53 Markov, *Russian Futurism: A History* (1969), p. 46.

54 F. T. Marinetti, 'The Founding and Manifesto of Futurism' (1909), in *Futurism: An Anthology*, p. 51.

55 Khlebnikov and Kruchenykh, from 'The Word as Such' (1913), in *Words in Revolution*, p. 57.

56 Ibid.

57 Viktor Shklovsky, 'The Resurrection of the Word' (1914), in *Russian Formalism*, p. 47.

58 Deleuze, *Two Regimes of Madness: Texts and Interviews 1975–1995*, ed. David Lapoujade, trans. Ames Hodges and Mike Taormina (Los Angeles and New York: Semiotext(e), 2007), pp. 63–4. The figure of the plane will be returned to in Chapter 6; it is important to Khlebnikov's linguistic spatiality – for example, his long text *Zangezi* (1922), as discussed in Chapter 1, is arranged in twenty 'planes'.

59 '"Found *it*", the Mouse replied rather crossly: "of course you know what "it" means."

"I know what "it" means well enough, when I find a thing", said the Duck; "it's generally a frog or a worm."'

'"I see nobody on the road," said Alice.

"I only wish I had such eyes," the King remarked in a fretful tone. "To be able to see Nobody!"'

Lewis Carroll, *Alice's Adventures in Wonderland* and *Through the Looking-Glass* [1865; 1871] (Ware: Wordsworth, 2001), pp. 53–231.

60 Ibid., p. 96.

61 Deleuze, The *Logic of Sense*, p. 96.

62 Deleuze, 'Louis Wolfson; or, The Procedure' (1970), in *Essays Critical and Clinical*, p. 9.

63 Ibid., p. 8.

64 For a discussion of Wolfson and Brisset's linguistic procedures, see Lecercle, *The Violence of Language*, pp. 64–94.

65 Samuel Beckett, *Disjecta: Miscellaneous Writings and a Dramatic Fragment*, ed. Ruby Cohn (London: John Calder, 2001), p. 172.

66 Deleuze, *Logic of Sense*, p. 12. Deleuze also refers to the surface at many points as a 'metaphysical' surface.

67 Deleuze, 'Louis Wolfson; or, The Procedure' (1970), in *Essays Critical and Clinical*, p. 20.

68 Ibid.

69 'All writing involves an athleticism, but far from reconciling literature with sports or turning writing into an Olympic event, this athleticism is exercised in flight and in the breakdown of the organic body – an athlete in bed, as Michaux puts it'. Deleuze, 'Literature and Life', in *Essays Critical and Clinical*, p. 2.

70 Henri Michaux, 'Athlete in Bed', in *Selected Writings: The Space Within*, trans. Richard Ellmann (London: Routledge and Kegan Paul, 1952), p. 113.

Chapter Four

1 J. L. Austin, *How to Do Things with Words* (1962), 2nd edn (Cambridge, Massachusetts: Harvard University Press, 1975), pp. 98–101.

2 For some important developments of Austin's theories see Pierre Bourdieu, *Language and Symbolic Power*, trans. Gino Raymond and Matthew Adamson, ed. John B. Thompson (Cambridge: Polity Press, 1991), p. 74. Bourdieu rightly identifies the potential of Austin's performative for exploitation by those in power: 'illocutionary acts as described by Austin are acts of institution that cannot be sanctioned unless they have, in some way, the whole social order behind them'. See also Judith Butler's *Excitable Speech: A Politics of the Performative* (London and New York: Routledge, 1997).

3 Jürgen Habermas, *Moral Consciousness and Communicative Action*, trans. Christian Lenhardt and Shierry Weber Nicholsen (Cambridge and Maldon: Polity Press, 1990), p. 80.

4 Martin J. Matustik, 'Habermas on Communicative Reason and Performative Contradiction', *New German Critique*, No. 47 (Spring–Summer, 1989), pp. 143–72, p. 146.

5 The role of metaphor in Deleuze is discussed in the next chapter.

6 Alan Sokal and Jean Bricmont, *Intellectual Impostures: Postmodern Philosophers' Abuse of Science* (London: Profile, 1999), p. 9.

7 Martin Puchner, *Poetry of the Revolution: Marx, Manifestos and the Avant-Garde* (Princeton: Princeton University Press, 2006), p. 25.

8 Puchner, *The Drama of Ideas: Platonic Provocations in Theater and Philosophy* (New York and Oxford: Oxford University Press, 2010), p. 146. For other descriptions of Deleuze's reconfiguration of Platonism, see Foucault, 'Theatricum Philosophicum' for his description of a 'dethroned para-Platonism': *Language, Counter-Memory, Practice: Selected Essays and Interviews*, ed. Donald F. Bouchard, trans. Donald F. Bouchard and Sherry Simon (Oxford: Blackwell, 1977), p. 168; for Badiou's description of Deleuze's 'makeshift Platonism' and 'Platonism of the virtual', see Badiou, *Deleuze: The Clamour of Being*, pp. 44–5.

9 Ibid., p. 170.

10 James Williams, *Gilles Deleuze's Difference and Repetition: A Critical Introduction and Guide* (Delhi: Motilal Banardsidass Publishers, 2008), p. 44.

11 Ibid., p. 45.

12 Roy Sorensen, *A Brief History of the Paradox: Philosophy and the Labyrinths of the Mind* (Oxford: Oxford University Press, 2003), p. 94.

13 Deleuze refers to a 'power of the false' as part of his argument that there is 'anti-Platonism at the heart of Platonism', *Difference and Repetition*, p. 156. For the argument's initial development in Nietzsche's thought, see Friedrich Nietzsche, 'On Truth and Falsity in Their Extramoral Sense' (1873), in *Philosophical Writings*, trans. Maximilian A. Mügge, ed. Reinhold Grimm and Caroline Molina y Vedia (London: Continuum, 1997), pp. 87–99; and 'On the History of the Moral Sensations', in *Human, All Too Human: A Book for Free Spirits*, trans. R. J. Hollingdale (Cambridge: Cambridge University Press, 1991), pp. 31–59. For critical developments of this aspect of Deleuze's work, see Ronald Bogue, *Deleuzian Fabulation and the Scars of History* (Edinburgh: Edinburgh University Press, 2010), and Gregory Flaxman, *Gilles Deleuze and the Fabulation of Philosophy* (Minneapolis and London: University of Minnesota Press, 2012).

14 *Quand dire c'est faire*, trans. Oswald Ducrot (Paris: Hermann, 1972). Gilles Deleuze, *Essays Critical and Clinical*, trans. Daniel W. Smith and Michael A. Greco (London and New York: Verso, 1998), p. 196 n. 2.

15 Deleuze, 'He Stuttered', in *Essays Critical and Clinical*, p. 107.

16 *Quand dire, c'est faire* is an allusion to the title of the French translation of J. L. Austin's *How to Do Things with Words* (New York: Oxford University Press, 1962): *Quand dire c'est faire*, trans. Oswald Ducrot (Paris: Hermann, 1972). See Deleuze, *Essays Critical and Clinical*, p. 196 n. 2.

17 Deleuze, 'He Stuttered', in *Essays Critical and Clinical*, p. 108.

18 Ibid.

19 Ibid., p. 109.

20 The spatiotemporal ramifications of the line are discussed further in Chapter 6.

21 Deleuze, 'He Stuttered', in *Essays Critical and Clinical*, p. 110.

22 Roman Jakobson, 'Linguistics and Poetics', *Language in Literature* (Cambridge, MA and London: Harvard University Press, 1987), p. 71.

23 Jakobson, 'Two Aspects of Language and Two Types of Aphasic Disturbances' (1956), in *Language in Literature*, p. 97.

24 Ibid., p. 109.

25 Jakobson, 'Linguistics and Poetics', in *Language in Literature*, p. 85.

26 Deleuze, 'He Stuttered', in *Essays Critical and Clinical*, p. 110.

27 Ibid., pp. 112–13.

28 Ezra Pound, *ABC of Reading* (1934), (New York: New Directions, 2010), p. 46.

29 'The variety theatre became a giant and expanded metaphor for the Futurist theatre; it was not intended as a representation of it'. Michael Kirkby and Victoria Nes Kirkby (eds), *Futurist Performance* (New York; PAJ Publications, 1986), p. 20.

30 Marinetti, 'The Variety Theater', in *Critical Writings*, ed. Günter Berghaus, trans. Doug Thompson (New York: Farrar, Straus and Giroux, 2006), p. 185.

31 Ibid., p. 187.

32 See Gérard Durozoi, *History of the Surrealist Movement* (1997) (Chicago and London: University of Chicago Press, 2002), pp. 89 and 136; Christopher Ho, 'Antonin Artaud: From Center to Periphery, Periphery to Center', *Performing Arts Journal*,

Vol. 19, No. 2 (May, 1997), Stable URL: http://www.jstor.org/
stable/3245859 p. 15 [accessed 16/05/12]; Vincent Kaufmann and
Caren Litherland, 'Life by the Letter', *October*, Vol. 64 (Spring,
1993), p. 99 [accessed 16/05/12] for varied perspectives on Artaud's
break with surrealism.

33 André Breton, 'Manifesto of Surrealism' (1924), in *Manifestoes of
 Surrealism*, trans. Richard Seaver and Helen R. Lane (Ann Arbor:
 University of Michigan Press, 2010), pp. 1–47.

34 Artaud, 'The Theatre of Cruelty (First Manifesto)' (1932), in
 Selected Writings, p. 242.

35 Artaud's 'gesture' and Brecht's 'gestus' make for an interesting
 comparison, especially in the light of Deleuze's dramatic doubling.
 For a helpful comparison between Artaud and Brecht see Andrew
 J. Webber, *The European Avant-Garde* (Cambridge and Malden:
 Polity, 2004), p. 115.

36 Artaud, 'Production and Metaphysics' (1938), in *The Theatre and
 Its Double*, trans. Victor Corti (Richmond: Oneworld Classics,
 2011), p. 28.

37 The temporal implications of spatially arranged writing, and
 Deleuze's take on this, are discussed in Chapter 6.

38 Artaud, 'An Emotional Athleticism' (1935), in *Selected Writings*, p. 266.

39 Deleuze, *Difference and Repetition*, p. 12.

40 NB: Derrida writes about the significance of Artaud's Theatre of
 Cruelty in *Writing and Difference* (1967): 'The theater of cruelty
 is not a representation. It is life itself, in the extent to which
 life is unrepresentable. Life is the nonrepresentable origin of
 representation'. Jacques Derrida, 'The Theater of Cruelty and the
 Closure of Representation', *Writing and Difference*, trans. Alan Bass
 (London and New York: Routledge, 2007), p. 294.

41 Artaud, 'Manifesto in Clear Language' (1925), in *Selected Writings*,
 p. 109.

42 Artaud, 'The Theater of Cruelty (First Manifesto)', in *Selected
 Writings*, p. 243.

43 Artaud, 'An Emotional Athleticism', in *Selected Writings*, p. 260.

44 Ibid., p. 265.

45 Ibid.

46 Ibid.

47 Henri Bergson, *Time and Free Will: An Essay on the Immediate
 Data of Consciousness* (1889), trans. F. L. Pogson (Mineola, NY:

Dover, 2001), p. 22. NB: Bergson's significant role in the various theoretical threads linking Deleuze to the avant-garde is discussed in Chapter 6.

48 Deleuze, *The Logic of Sense*, p. 154; in Lewis Carroll, *Through the Looking-Glass and What Alice Found There* [1871] (Ware: Wordsworth, 2001), pp. 177–8.

49 Gilles Deleuze, 'Literature and Life', in *Essays Critical and Clinical*, p. 2.

50 See Manuel DeLanda, 'Space: Extensive and Intensive, Actual and Virtual', in *Deleuze and Space*, ed. Ian Buchanan and Gregg Lambert (Edinburgh: Edinburgh University Press, 2005), pp. 80–8 for a clear summary of the relationship between the actual/virtual and the intensive/extensive, and Manuel DeLanda, *Intensive Science and Virtual Philosophy* (2002) (London and New York: Continuum, 2007), for a helpful elucidation of how Deleuze's use of intensity relates to theories of irreversibility and thermodynamics.

51 Deleuze, *Difference and Repetition*, p. 281.

52 Immanuel Kant, *Critique of Pure Reason* (1781), ed. Vasilis Politis, trans. J. M. D. Meiklejohn and Vasilis Politis (London: Everyman, 2002), p. 156.

53 Ibid., p. 158.

54 Deleuze, *Difference and Repetition*, p. 291.

55 Ibid., p. 288.

56 Ibid., pp. 11–12.

57 Ibid., p. 9.

58 Ibid., p. 12.

59 Deleuze, *Nietzsche and Philosophy* (1962), trans. Hugh Tomlinson (London: Athlone Press, 1992), p. xiii.

60 'Walking, like prose, always has a precise object. It is an act directed *toward* some object which we aim to reach ... Dancing is something quite different. It is without doubt a system of acts which are, at the same time, ends in themselves. Dancing goes nowhere ... As different as dance is from utilitarian movement, this essential though infinitely simple observation should be noted: *that it uses the same limbs, the same organs, bones, muscles and nerves as walking itself.*' Paul Valéry, 'Remarks on Poetry' (1927), in *Symbolism: An Anthology*, ed. and trans. T. G. West (London: Methuen, 1980), p. 52.

61 'The set (*Einstellung*) toward the message as such, focus on the

message for its own sake, is the POETIC function of language. This function cannot be productively studied out of touch with the general problems of language, and, on the other hand, the scrutiny of language requires a thorough consideration of its poetic function. Any attempt to reduce the sphere of the poetic function to poetry or to confine poetry to the poetic function would be a delusive oversimplification.' Roman Jakobson, 'Linguistics and Poetics', in (1960), *Language in Literature*, p. 69.

62 A. Kruchenykh and V. Khlebnikov, in *Words in Revolution*, pp. 57 and 63.

63 Deleuze, *Difference and Repetition*, p. 180.

64 Gilles Deleuze, 'Method of Dramatization' (1967), in *Desert Islands and Other Texts 1953–1974* (Los Angles and New York: Semiotext(e), 2004), p. 99.

65 Ibid. p. 98.

66 F. T. Marinetti, Emilio Settimelli, Bruno Corra, 'The Futurist Synthetic Theatre' (1915), in *Theatre of the Avant-Garde 1890–1950: A Critical Anthology*, ed. Bert Cardullo and Robert Knopff (New Haven and London: Yale University Press, 2001), p. 204.

67 Umberto Boccioni, 'Plastic Dynamism' (1913), http://www.391. org/manifestos/19131215umbertoboccioni_plasticdynamism.htm [accessed 02/02/12].

68 Marinetti, 'We Abjure our Symbolist Masters, the Last Lovers of the Moon' (1911), in *Futurism: An Anthology*, p. 93.

69 Deleuze, 'Method of Dramatization', in *Desert Islands*, p. 98.

70 W. B. Yeats, 'Among School Children' (1928), in *The Collected Poems of W. B. Yeats* (Ware: Wordsworth, 2000), p. 185.

71 Marinetti, 'Futurist Dance' (1920), in *Critical Writings*, p. 210.

72 Deleuze, *Nietzsche and Philosophy*, p. 22.

73 Heinrich von Kleist, 'On the Marionette Theatre' (1810), *The Drama Review*, Vol. 16, No. 3, The 'Puppet' Issue (Sep., 1972), pp. 22–6 [accessed 13/03/12].

74 Deleuze, *The Logic of Sense*, p. 294.

75 Deleuze and Guattari, *What Is Philosophy?*, p. 64.

76 Ibid.

77 Ibid., pp. 64–5.

78 Deleuze, *Negotiations*, pp. 140–41.

79 Deleuze, *Difference and Repetition*, p. 108.

Chapter Five

1 Jean Moréas, 'Le Symbolisme' (1886), trans. Mary Ann Caws, *Manifesto*, p. 50.

2 Max Black, *Models and Metaphors* (1962) (Ithaca and London: Cornell University Press, 1976), p. 32.

3 Stéphane Mallarmé, 'Crisis in Poetry' (1886), *Manifesto*, p. 25.

4 Paul de Man, *Allegories of Reading: Figural Language in Rousseau, Nietzsche, Rilke, and Proust* (New Haven and London: Yale University Press, 1979), p. 74.

5 Maurice Blanchot, *The Book to Come* (1959), trans. Charlotte Mendall (Stanford: University Press, 1995), p. 32.

6 Marinetti, 'Technical Manifesto', in *Futurism: An Anthology*, p. 123.

7 Ibid., p. 120.

8 NB: For an interesting later avant-garde inversion of this pattern of word-truncation and blending, see Eric Robertson's article on Hans Arp: 'Everyday Miracles: Arp's Object-Language', *Dada and Beyond*, ed. Elza Adamowicz and Eric Robertson (Amsterdam and New York: Rodopi, 2011), pp. 83–92, p. 87. Robertson discusses Arp's poem *Der Pyramidenrock*, in which a word ('Schnurrbart') is torn apart to create two separate words ('Schnurr und Bart') rather than the other way round.

9 Clearly the 'supposed' transparency of realism is a very contentious claim, but a discussion of this does not fall within the scope of this book.

10 Marinetti, 'Wireless Imagination' (1913), in *Selected Poems and Related Prose* (New Haven and London: Yale University Press, 2002), p. 87; and 'Technical Manifesto', in Futurism: An Anthology, p. 120.

11 'Improper use of words; application of a term to a thing which it does not properly denote; abuse or perversion of a trope or metaphor.' *Oxford English Dictionary Online* http://www.oed.com [accessed 05/06/11].

12 Max Black, *Models and Metaphors* (Ithaca and London: Cornell University Press, 1976), p. 33.

13 Roman Jakobson, 'Linguistics and Poetics' (1960), in *Language in Literature*, p. 86.

14 Paul Ricoeur, *The Rule of Metaphor* (1975), trans. Robert Czerny (London: Routledge, 2003), p. 265.

15 'The old and habitual must be spoken of as if it were new and unusual. One must speak of the ordinary as if it were unfamiliar.' Victor Shklovsky, 'Art as Technique', in *Russian Formalist Criticism: Four Essays*, trans. and ed. Lee T. Lemon and Marion J. Reis (Lincoln: University of Nebraska Press, 1965), p. 85.

16 Black, Models and Metaphors, p. 25.

17 'Whereof one cannot speak, thereof one must be silent.' Ludwig Wittgenstein, *Tractatus Logico-Philosophicus* [1921], *The Wittgenstein Reader* (2nd edn) ed. Anthony Kenny (Oxford: Blackwell, 2006), p. 30.

18 This is later corroborated by important work in linguistics suggesting the operation of metaphor at a cognitive level, the most significant of this being George Lakoff and Mark Johnson's hugely influential *Metaphors We Live By* (1980) (Chicago : University of Chicago Press, 2003).

19 Friedrich Nietzsche, 'On Truth and Falsity in Their Extramoral Sense' (1873), *Philosophical Writings*, trans. Maximilian A. Mügge, ed. Reinhold Grimm and Caroline Molina y Vedia (London: Continuum, 1997), p. 90.

20 Martin Heidegger, *The Principle of Reason* (1955–6), trans. Reginald Lilly (Bloomington: Indiana University Press, 1991), p. 48.

21 Ricoeur, *The Rule of Metaphor*, p. 339.

22 '... the only way to express one's hatred and distrust for language, or one's distrust of it, is through language.' Lecercle, *Deleuze and Language*, p. 1.

23 Deleuze, *Difference and Repetition*, p. 38.

24 Ibid., p. 42.

25 Deleuze, *Expressionism in Philosophy: Spinoza*, p. 31.

26 Ibid., p. 50.

27 Marinetti, 'Technical Manifesto', in *Futurism: An Anthology*, p. 123.

28 Aristotle, *Poetics* (*c.*330 BC), trans. S. H. Butcher, ed. Richard Koss (New York: Dover, 1997), p. 53.

29 I. A. Richards, *The Philosophy of Rhetoric* (Oxford: Oxford University Press, 1936), p. 96.

30 Michael J Reddy, 'The Conduit Metaphor: A Case of Frame Conflict in our Language about Language' (1979); in *Metaphor and Thought*, 2nd edn, ed. Andrew Ortony (Cambridge: Cambridge University Press, 1993), pp. 164–201.

31 Jacques Derrida, 'The Retrait of Metaphor', in *Psyche: Inventions of*

the Other, Vol. 1 (1998), ed. Peggy Kamuf and Elizabeth Rottenberg (Stanford: University Press, 2007), p. 48.

32 Paul de Man, 'The Epistemology of Metaphor', in *Aesthetic Ideology* (1996), ed. Andrzej Warminski (London and Minneapolis: University of Minnesota Press, 2002), p. 38.

33 Deleuze, *The Logic of Sense*, p. 116.

34 Roman Jakobson, 'On Realism in Art' (1921), *Readings in Russian Poetics: Formalist and Structuralist Views*, ed. Ladislav Matejka and Krystyna Pomorska (Cambridge, MA and London: MIT Press, 1971), p. 42.

35 Deleuze, *Difference and Repetition*, p. xix; *The Logic of Sense*, p. x.

36 Bogue, *Deleuze and Guattari*, p. 122.

37 Deleuze and Guattari, *Kafka: Toward a Minor Literature*, p. 22.

38 Deleuze and Guattari, *A Thousand Plateaus*, p. 77.

39 Ibid., p. 302.

40 Marinetti, 'Technical Manifesto', in *Futurism: An Anthology*, pp. 119–29.

41 Of course, Carroll was already exploring this type of accelerative word-blending with the portmanteau word – the word 'frumious' as mentioned in Chapter 1, as a blend of 'furious' and 'fuming'.

42 Mullarkey, *Post-Continental Philosophy*, p. 17.

43 James Williams, *Gilles Deleuze's* Logic of Sense, p. 53.

44 Deleuze, *Difference and Repetition*, p. 51.

45 NB: There is insufficient space here to discuss Nietzsche's eternal return in any detail; it would require a significant divergence from the work on Deleuze's language and the avant-garde. For now, it is enough to acknowledge its significant role in inspiring Deleuze's conception of affirmative difference.

46 Mikhail Bakhtin, *Rabelais and His World* (1965), trans. Hélène Iswolsky (Bloomington and Indianapolis: Indiana University Press, 1984), p. 308.

47 Deleuze, *The Logic of Sense*, p. 3.

48 Bakhtin, *Rabelais and His World*, p. 317.

49 Deleuze, *The Logic of Sense*, p. 154.

50 Ibid., p. 303.

51 Deleuze and Guattari, *Kafka: Toward a Minor Literature*, p. 19.

52 Deleuze and Guattari, *What is Philosophy?*, p. 42.

53 'What, then, is truth? A mobile army of metaphors, metonyms, anthropomorphisms ... truths are illusions of which one has

forgotten that they are illusions; worn-out metaphors which have become powerless to affect the senses; coins with their image effaced and now no longer of account as coins but merely as metal.' Friedrich Nietzsche, 'On Truth and Falsity in their Extra-Moral Sense', *Philosophical Writings*, p. 92.

54 Ibid., p. 91.

55 'Philosphy is becoming, not history; it is the coexistence of planes, not the succession of systems.' Deleuze and Guattari, *What is Philosophy?*, p. 59.

56 Deleuze, *Difference and Repetition*, p. 185.

Chapter Six

1 Deleuze, *The Logic of Sense*, p. 3.

2 Ibid., p. x.

3 Ibid., p. 65.

4 Lewis Carroll, *Mathematical Recreations of Lewis Carroll*: Pillow Problems *and* A Tangled Tale (1885; 1893) (Mineola, NY: Dover, 2003), p. 115.

5 Deleuze, *The Logic of Sense*, p. 3.

6 Ibid., pp. 211–12.

7 See Linda Dalrymple Henderson, *The Fourth Dimension and Non-Euclidean Geometry in Modern Art* (Princeton, NJ: Princeton University Press, 1983); and Mark Antliff, 'The Fourth Dimension and Futurism; A Politicized Space', *The Art Bulletin*, Vol. 82, No. 4 (Dec 2000), pp. 720–33 [accessed 02/06/12].

8 Umberto Boccioni, 'Absolute Motion + Relative Motion = Plastic Dynamism' (1914), in *Futurism: An Anthology*, p. 187.

9 The term 'hyperspace philosophy' was coined by Linda Dalrymple Henderson and applied to a number of thinkers of the 'fourth dimension', including Ouspensky in Russia, Charles Howard Hinton in the UK and Claude Bragdon in the USA. See Linda Dalrymple Henderson, 'Italian Futurism and "The Fourth Dimension"', *Art Journal*, Vol. 41, No. 4, Futurism (Winter, 1981), pp. 317–23 [accessed 02/06/2012], p. 322 n. 3.

10 P. D. Ouspensky *Tertium Organum* (1912), trans. E. Kadloubvsky and the author (Henley and London: Routledge and Kegan Paul, 1981), p. 247.

11 Ibid., p. 26.

12 Henri Bergson, *Matter and Memory* (New York: Zone, 1988), p. 138. Bergson is quoting from these lines:

le Temps fuit, et nous traîne avec soy.
Le moment où je parle est déjà loin de moy.
[Time flies and draws us with it.
The moment in which I am speaking is already far from me.]

Nicolas Boileau-Despréaux, 'Épistre III' (1701), *Œuvres Complètes de Boileau* (Paris: Gallimard, 1966), p. 111.

13 *fugit hora, hoc quod loquor inde est.*
[Time's flying – this that I say subtracts from it.]

Persius, 'Satire 5', in *The Satires*, trans. J. R. Jenkinson (Warminster: Aris and Phillips, 1980).

14 Deleuze, *Difference and Repetition*, p. 100.

15 For important discussions on the relationship between Bergson and Deleuze, see Keith Ansell Pearson, *Germinal Life: The Difference and Repetition of Deleuze* (London and New York: Routledge, 1999); Keith Ansell Pearson, 'The Reality of the Virtual: Bergson and Deleuze', *MLN*, Vol. 120, No. 5, Comparative Literature Issue (Dec., 2005), pp. 1112–27 [accessed 02/06/12]; Michael Hardt, 'Bergsonian Ontology: The Positive Movement of Being', in *Gilles Deleuze: An Apprenticeship in Philosophy* (1993) (Minneapolis and London: University of Minnesota Press, 2002), pp. 1–25; Eric Alliez, *The Signature of the World: What Is Deleuze and Guattari's Philosophy?* (1993), trans. Eliot Ross Albert and Alberto Toscano (London and New York: Continuum, 2004); Alexandre Lefebvre, *The Image of the Law: Deleuze, Bergson, Spinoza* (Stanford: Stanford University Press, 2008).

16 Henri Bergson, *Time and Free Will: An Essay on the Immediate Data of Consciousness* (1889) (Mineola, NY: Dover, 2001), p. 99.

17 Ibid., p. 2.

18 DeLanda, *Intensive Science and Virtual Philosophy*, p. 105.

19 Deleuze and Guattari, *Kafka: Toward a Minor Literature*, p. 22.

20 Deleuze, *Bergsonism* [1966], trans. Hugh Tomlinson and Barbara Habberjam (New York: Zone, 1991), p. 37

21 Bergson, *Time and Free Will*, p. 91.

22 Deleuze, *Bergsonism*, p. 31.

23 Bergson, *Time and Free Will*, pp. 28–9.

24 Carroll, *Through the Looking-Glass*, pp. 177–8.

25 Bergson, *Time and Free Will*, p. 101.

26 Saussure, *Course in General Linguistics*, p. 121.

27 Roman Jakobson and Jurij Tynjanov, 'Problems in the Study of Language and Literature' (1928), trans. Herbert Eagle, in L. Matejka and K. Pomorska (eds), *Readings in Russian Poetics: Formalist and Structuralist Views* (Cambridge, Mass.: MIT Press, 1971), pp. 79–81. This manifesto was originally published in Moscow in the Russian futurist journal '*Novyj LEF*' ['The New LEF'] 1928, No. 12, pp. 36–7.

28 Roman Jakobson, 'My Favourite Topics' (1980), *Selected Writings VII: Comparative Slavic Studies* (The Hague, New York, Paris: Mouton, 1985), p. 374.

29 Bergson, *Key Writings*, ed. Keith Ansell Pearson and John Mullarkey (London and New York: Continuum, 2002), p. 211.

30 Jakobson and Tynjanov, 'Problems in the Study of Literature and Language', *Readings in Russian Poetics*, p. 79.

31 'Time as such was and, I think, still remains a vital theme of our time. In the Moscow newspaper "Art" (Iskusstvo), which appeared for several months in 1919, I wrote in an article on Futurism: "The elimination of statics, expelling the absolute – this is the chief pathos of the new time, the topical theme of the day".' Roman Jakobson and Krystyna Pomorska, 'Dialogue on Time in Language and Literature', *Poetics Today*, Vol. 2, No. 1a (Autumn, 1980), pp. 15–27, p. 15.

32 Alberto Toscano, *The Theatre of Production: Philosophy and Individuation between Kant and Deleuze* (Basingstoke: Palgrave Macmillan, 2006), pp. 168–9.

33 F. T. Marinetti, 'The Founding and Manifesto of Futurism', in *Futurism: An Anthology*, p. 49.

34 Ibid., p. 51.

35 Ibid.

36 Raoul Hausmann, 'Manifesto of PREsentism' (1920), in *Manifesto: A Century of Isms* ed. Mary Ann Caws (Lincoln and London: University of Nebraska Press, 2001), p. 164.

37 Marinetti, 'The Founding and Manifesto of Futurism', in *Futurism: An Anthology*, p. 41.

38 Burliuk et al., 'A Slap in the Fact of Public Taste', in *Words in Revolution*, p. 79.

39 Walter Benjamin, 'Theses for a Philosophy of History' (1940), in

Illuminations, ed. Hannah Arendt, trans. Harry Zorn (London: Pimlico, 1999), pp. 245–55.

40 Khlebnikov, *The Tables of Destiny* (1922), in *The King of Time*, pp. 170–71.

41 Ibid., pp. 180–81.

42 Douglas (ed.), *The King of Time*, p. 167.

43 The contrasting degrees of hostility and/or bonhomie between various Russian and Italian futurists, and accounts of points at which they met, such as Marinetti's 1914 visit to Moscow, are covered in Markov, *Russian Futurism: A History* and Benedikt Livshits, *The One and a Half-Eyed Archer*, trans. John E. Bowlt (Newtonville, MA: Oriental Research Partners, 1977), p. 194.

44 Markov, *Russian Futurism*, p. 158.

45 The Russian futurist book *Worldbackwards* (1912), discussed in Chapter 1. See Susan P. Compton, *The World Backwards: Russian Futurist Books 1912–16* (London: British Library, 1978), p. 73.

46 Markov, *Russian Futurism*, p. 33.

47 'Neo-primitivism arose primarily as an attempt to address the indigenous cultural traditions of Russian art in the face of academic and modernist traditions imported from the west, and Larionov's success was to develop an easel art infused with the style and spirit of the Russian people.' Anthony Parton, *Mikhail Larionov and the Russian Avant-Garde* (London: Thames & Hudson, 1993), p. 50.

48 Mikhail Larionov, 'Luchisty i budushchniki' (1913), in Parton, *Mikhail Larionov and the Russian Avant-Garde*, p. 63.

49 Andrei Bely, 'The Magic of Words' (1909), quoted in Harte, *Fast Forward*, p. 72.

50 Marinetti, 'Destruction of Syntax – Radio Imagination – Words-in-Freedom' (1913), in *Futurism: An Anthology*, pp. 148–9.

51 Khlebnikov, *The King of Time*, p. 205.

52 Deleuze, *The Logic of Sense*, p. 210.

53 Ibid., p. 279.

54 Deleuze and Guattari, *What Is Philosophy?*, p. 58.

55 Ibid.

56 Deleuze, *The Logic of Sense*, p. 72.

57 Ibid., p. 73.

58 Ibid., p. 189.

59 This tradition is described thus because it is a line of descent purely

of Deleuze's own making; it 'does not carry the family name' and covers figures such as Spinoza, Duns Scotus and Bergson. Philip Turetzky, *Time* (London: Routledge, 1998), p. 211.

60 Bergson, 'The Life and Work of Ravaisson', *The Creative Mind: An Introduction to Metaphysics* (1946), trans. Mabelle L. Andison (Westport, CT: Greenwood Press, 1968), p. 272.

61 'So that all life, animal and vegetable, seems in its essence like an effort to accumulate energy and then to let it flow into flexible channels, changeable in shape, at the end of which it will accomplish infinitely varied kinds of work. That is what the *vital impetus*, passing through matter, would fain to do all at once.' Bergson, *Creative Evolution* (1907), trans. Arthur Mitchell (Mineola, NY: Dover, 1998), p. 267.

62 Kleist, 'On the Marionette Theatre' (1810), *The Drama Review*, Vol. 16, No. 3, The 'Puppet' Issue (Sep., 1972), pp. 22–6 [accessed 13/03/12].

63 Deleuze, *The Logic of Sense*, p. 74.

64 Deleuze, *Kant's Critical Philosophy: The Doctrine of the Faculties* (1963), trans. Hugh Tomlinson and Barbara Habberjam (Minneapolis: University of Minnesota Press, 1999), p. vii.

65 Ibid.

66 William Shakespeare, *Hamlet* (1603) (Oxford: Oxford University Press, 2002) Act 1, Scene 5, line 196.

67 Deleuze, *Difference and Repetition*, p. 111.

68 There is not sufficient space in this book to deal with the third synthesis in relation to Nietzsche's eternal return, to which it is linked. For more commentary on this see Deleuze, *Nietzsche and Philosophy*; Keith Ansell Pearson, 'Living the Eternal Return as the Event: Nietzsche with Deleuze', *Journal of Nietzsche Studies*, No. 14, Eternal Recurrence (Autumn 1997), pp. 64–97 [accessed 03/06/12]; Jay Lampert, *Deleuze and Guattari's Philosophy of History* (London and New York: Continuum, 2006); James Williams, *Gilles Deleuze's Philosophy of Time: A Critical Introduction and Guide* (Edinburgh: Edinburgh University Press, 2011), pp. 113–33.

69 The three syntheses of time in *Difference and Repetition* are later developed by Deleuze and Guattari in *Anti-Oedipus* in terms of the connective, conjunctive and disjunctive syntheses. This development, together with the psychoanalytic sections in *The Logic of Sense*, is not relevant enough to the present discussion of the linguistic

temporality to warrant more than a brief reference, although for a psychoanalytic reading of Deleuze's temporalities alongside the syntheses of *Anti-Oedipus* see Keith W. Faulkner, *Deleuze and the Three Syntheses of Time* (New York and Oxford: Peter Lang, 2006).

70 Deleuze's three syntheses in *Difference and Repetition* are linked to a relay of determination and undetermined existence that he believes we can derive from the distinction between the Kantian and Cartesian Cogito. It is ordinal rather than cardinal; it does not contain number or value. For Deleuze, this third synthesis is time itself, as well as being the discovery of difference, constituted as it is for him as transcendental and internal rather than empirical or external. There is not sufficient space in this book to discuss the complex temporal implications of the third synthesis, as this would require a significant deviation from the linguistic focus. The alignment of the caesura with the pure and empty form, however, is just as important as in the description of the Aion; Deleuze defines the third synthesis as a 'purely formal distribution of the unequal in the function of a caesura'. See Deleuze, *Difference and Repetition*, p. 111.

71 Deleuze, *The Logic of Sense*, p. 35.

72 Ibid., p. 190.

73 Ibid., p. 189.

74 Ibid., p. 156.

75 Deleuze, *The Logic of Sense*, p. 39.

76 Stephen Ross, 'Introduction: The Missing Link', in *Modernism and Theory: A Critical Debate*, ed. Stephen Ross (London and New York: Routledge, 2009), p. 8.

77 Peter Osborne, *The Politics of Time: Modernity and Avant-Garde* (London and New York: Verso, 1995), pp. 13–14.

78 Theodor Adorno, *Negative Dialectics* (1966), trans. C. B. Ashton (London and New York: Continuum, 2005), p. 41.

79 For an older, more Carrollian style of geometrical 'characterization', see Edwin J. Abbott's *Flatland: A Romance of Many Dimensions* (1884), (Oxford: Oxford University Press, 2006).

80 Deleuze and Guattari, *What is Philosophy?*, p. 59.

81 Deleuze, *The Logic of Sense*, p. 189.

82 Bertrand Russell, *The Principles of Mathematics* (1903), (London and New York: Routledge, 2009), p. 115.

Chapter Seven

1 'It is imperative to use verbs in the infinitive, so that the verb can be elastically adapted to the noun and not be subordinated to the *I* of the writer who observes or imagines. Only the infinitive can give a sense of the continuity of life and the elasticity of intuition that perceives it.' Marinetti, 'Technical Manifesto', in *Futurism: An Anthology*, pp. 119–20.

2 Khlebnikov, 'Incantation by Laughter', p. 63.

3 Deleuze, *Difference and Repetition*, p. 215. For a detailed discussion of Deleuze's particular problematic, see Daniel W. Smith, 'Axiomatics and problematics as two modes of formalization: Deleuze's epistemology of mathematics', *Virtual Mathematics: The Logic of Difference*, ed. Simon Duffy (London: Clinamen, 2006), pp. 145–68.

4 While Campbell defines metonymy as substituting 'the instrument for the agent', and synecdoche as substituting 'the part for the whole', he nevertheless concludes that they are so closely related at times that they are indistinguishable. See George Campbell, *The Philosophy of Rhetoric* (1776), electronic resource https://archive.org/details/philosophyofrhet00campuoft [accessed 03/06/12], p. 324.

5 Deleuze, *The Logic of Sense*, p. 12.

6 James Williams asserts that the difference between the analytic approach and Deleuze's approach to the 'event' is encapsulated in the distinction between the gerund and the infinitive grammatical forms. See *Gilles Deleuze's* Logic of Sense: *A Critical Introduction and Guide* (Edinburgh: Edinburgh University Press, 2008), p. 34.

7 Deleuze, *The Logic of Sense*, p. 183.

8 Deleuze, *Logique du Sens* (Paris: Éditions de Minuit, 1969), p. 189.

BIBLIOGRAPHY

Abbott, Edwin J. *Flatland: A Romance of Many Dimensions* (1884)
(Oxford: Oxford University Press, 2006)
Adamowicz, Elza and Eric Robertson (eds) *Dada and Beyond*
(Amsterdam and New York: Rodopi, 2011)
Adorno, Theodor *Negative Dialectics* (1966), trans. C. B. Ashton
(London and New York: Continuum, 2005)
—*Aesthetic Theory* (1970), trans, C. Lenhart, ed. Gretel Adorno and
Rolf Teidermann (London: Routledge & Kegan Paul, 1984)
Alliez, Eric *The Signature of the World: What Is Deleuze and Guattari's
Philosophy?* (1993), trans. Eliot Ross Albert and Alberto Toscano
(London and New York: Continuum, 2004)
Alliez, Eric (ed.) *Gilles Deleuze: Une vie philosophique* (Paris:
Synthélabo, 1998)
Antliff, Mark 'The Fourth Dimension and Futurism; A Politicized Space'
The Art Bulletin, Vol. 82, No. 4 (December 2000), pp. 720–33
[accessed 02/06/12]
Aristotle, *Poetics* (c.330 BC), trans. S. H. Butcher, ed. Richard Koss
(Mineola, NY: Dover, 1997)
Artaud, Antonin 'L'Arve, et l'Aume, tentative antigrammaticale contre
Lewis Carroll', *L'Arbalète* (1947), No. 2
—*Selected Writings*, ed. Susan Sontag (Berkeley: University of California
Press, 1988)
—*The Theatre and Its Double* (1938), trans. Victor Corti (Richmond:
Oneworld Classics, 2011)
Austin, J. L. *How to Do Things with Words* (1962), 2nd edn
(Cambridge, MA: Harvard University Press, 1975)
—*Quand dire c'est faire*, trans. Oswald Ducrot (Paris: Hermann, 1972)
Badiou, Alain *Deleuze: The Clamour of Being* (1997), trans. Louise Burchill
(London and Minneapolis: University of Minnesota Press, 2000)
Bakhtin, Mikhail *Rabelais and His World* (1965), trans. Hélène Iswolsky
(Bloomington and Indianapolis: Indiana University Press, 1984)
Bann, Stephen and John E. Bowlt (eds) *Russian Formalism* (Edinburgh:
Scottish Academic Press, 1973)

Baran, Henryk 'Khlebnikov and Nietzsche: pieces of an incomplete mosaic', in *Nietzsche and Soviet Culture*, ed. Bernice Glatzer Rosenthal (Cambridge: Cambridge University Press, 1994), pp. 58–83

Barnes, Jonathan *The Presocratic Philosophers* (London: Routledge, 1982)

Beckett, Samuel *Disjecta: Miscellaneous Writings and a Dramatic Fragment*, ed. Ruby Cohn (London: John Calder, 2001)

Bely, Andrei 'The Magic of Words' (1909), in Time Harte, *Fast Forward: The Aesthetics and Ideology of Speed in Russian Avant-Garde Culture, 1910–1930* (Madison: University of Wisconsin Press, 2009), p. 68 n. 4.

Benjamin, Walter *Illuminations*, ed. Hannah Arendt (New York: Pantheon Books, 1968)

Bennett, Tony *Formalism and Marxism* (1979) (London and New York: Routledge, 1989)

Berardi, Franco 'Bifo' *After the Future*, trans. Arinanna Bove et al., Gary Genosko and Nicholas Thoburn (eds) (Edinburgh, Oakland, Baltimore: AK Press, 2011)

Berghaus Günter (ed.) *International Yearbook of Futurism Studies Vol. 1: Futurism in Eastern and Central Europe* (Berlin and Boston: De Gruyter, 2011).

Bergson, Henri *Time and Free Will: An Essay on the Immediate Data of Consciousness* (1889), trans. F. L. Pogson (Mineola, NY: Dover, 2001)

—*Matter and Memory* (1896), trans. Nancy Margaret Paul and W. Scott Palmer (New York: Zone, 1988)

—*Creative Evolution* (1907), trans. Arthur Mitchell (Mineola, NY: Dover, 1998)

—*The Creative Mind: An Introduction to Metaphysics* (1946), trans. Mabelle L. Andison (Westport, CT: Greenwood Press, 1968)

—*Key Writings*, Keith Ansell Pearson and John Mullarkey (eds) (London and New York: Continuum, 2002)

Berman, Marshall *All That Is Solid Melts Into Air: The Experience of Modernity* (London: Verso, 1982)

Black, Max *Models and Metaphors* (1962) (Ithaca and London: Cornell University Press, 1976)

Blanchot, Maurice *The Book to Come* (1959), trans. Charlotte Mendall (Stanford: University Press, 1995)

Boccioni, Umberto 'Plastic Dynamism' (1913), http://www.391.org/manif estos/19131215umbertoboccioni_plasticdynamism.htm [accessed 02/02/11]

Bogue, Ronald *Deleuze and Guattari* (London and New York: Routledge, 1989)

—*Deleuze on Literature* (London and New York: Routledge, 2003)

—*Deleuze on Music, Painting, and the Arts* (London and New York: Routledge, 2003)

—*Deleuze's Wake: Tributes and Tributaries* (Albany: SUNY Press, 2004)

—*Deleuzian Fabulation and the Scars of History* (Edinburgh: Edinburgh University Press, 2010)

Boileau-Despréaux, Nicolas 'Épistre III' (1701), *Œuvres Complètes de Boileau* (Paris: Gallimard, 1966)

Bourdieu, Pierre *Language and Symbolic Power*, trans. Gino Raymond and Matthew Adamson, ed. John B. Thompson (Cambridge: Polity, 1991)

Bowlt, John E. (ed. and trans.) *Russian Art of the Avant-Garde: Theory and Criticism* (New York: Viking Press, 1976)

Brassier, Ray 'The Expression of Meaning in Deleuze's Ontological Proposition', *Pli* 19 (2008), pp. 1–29

Breton, André *Manifestoes of Surrealism,* trans. Richard Seaver and Helen R. Lane (Ann Arbor: University of Michigan Press, 2010)

Bru, Sascha, Jan Baetens, Benedikt Hjartarson, Peter Nicholls, Tania Ørum and Hubert van den Berg (eds) *Europa! Europa? The Avant-Garde, Modernism and the Fate of a Continent* (Berlin: De Gruyter, 2009)

Bryden, Mary (ed.) *Deleuze and Religion* (London and New York: Routledge, 2001)

Buchanan, Ian (ed.) *A Deleuzian Century?* (Durham and London: Duke University Press, 1999)

—and Gregg Lambert (eds) *Deleuze and Space* (Edinburgh: Edinburgh University Press, 2005)

Bürger, Peter *Theory of the Avant-Garde* (1974), trans. Michael Shaw (Minneapolis: University of Minnesota Press, 1984)

Burliuk, David, Alexander Kruchenykh, Vladimir Mayakovsky, Velimir Khlebnikov, 'A Slap in the Face of Public Taste' (1912), in Anna Lawton and Herbert Eagle (trans. and eds) *Words in Revolution: Russian Futurist Manifestoes 1912–1928* (Washington, DC: New Academia Publishing, 2005) 'a Slap...' is on pp. 51–2.

Butler, Judith *Excitable Speech: A Politics of the Performative* (London and New York: Routledge, 1997)

Calinescu, Matei *Five Faces of Modernity: Modernism, Avant-Garde, Decadence, Kitsch, Postmodernism* (Durham: Duke University Press, 1987)

Campbell, George *The Philosophy of Rhetoric* (1776), electronic resource https://archive.org/details/philosophyofrhet00campuoft [accessed 03/06/12]

Cardullo, Bert and Robert Knopff (eds) *Theatre of the Avant-Garde 1890–1950: A Critical Anthology* (New Haven and London: Yale University Press, 2001)

Carroll, Lewis *Alice's Adventures in Wonderland & Through the Looking-Glass* (1865; 1871), (Ware: Wordsworth, 2001)

—*Mathematical Recreations of Lewis Carroll: Pillow Problems and A Tangled Tale* (1885; 1893), (Mineola: Dover, 2003)

Caws, Mary Ann (ed.) *Manifesto: A Century of Isms* (Lincoln and London: University of Nebraska Press, 2001)

Cicero, M. Tullius *On Stoic Good and Evil: De Finibus 3 and Paradoxa Stoicorum*, ed. and trans. M. R. Wright (Warminster: Aris & Phillips, 1991)

Compagnon, Antoine *The Five Paradoxes of Modernity*, trans. Franklin Philip (New York: Columbia University Press, 1994)

Compton, Susan P. *The World Backwards: Russian Futurist Books, 1912–16* (London: British Library, 1978)

Cooke, Raymond *Velimir Khlebnikov: A Critical Study* (Cambridge: Cambridge University Press, 1987)

Coxeter, H. S. M. et al. (eds) *M. C. Escher, art and science : proceedings of the Interdisciplinary Congress on M. C. Escher, Rome, Italy, 26–28 March 1985* (Amsterdam and New York: Elsevier, 1986)

DeLanda, Manuel *Intensive Science and Virtual Philosophy* (2002), (London and New York: Continuum, 2007)

—'Space: Extensive and Intensive, Actual and Virtual' (2005), in *Deleuze and Space*, Ian Buchanan and Gregg Lambert (eds) (Edinburgh: Edinburgh University Press, 2005), pp. 80–8.

Deleuze, Gilles *Nietzsche and Philosophy* [1962], trans. Hugh Tomlinson (London: Athlone Press, 1992)

—*Kant's Critical Philosophy: The Doctrine of the Faculties* (1963), trans. Hugh Tomlinson and Barbara Habberjam (Minneapolis: University of Minnesota Press, 1999)

—*Bergsonism* [1966], trans. Hugh Tomlinson and Barbara Habberjam (New York: Zone, 1991)

—*Différence et répétition* (Paris: Presses Universitaires de France, 1968)

—*Difference and Repetition* (1968), trans. Paul Patton (London and New York: Continuum, 2004)

—*Expressionism in Philosophy: Spinoza* (1968), trans. Martin Joughin (New York: Zone, 1990)

—*Logique du sens* (Paris: Éditions de Minuit, 1969)

—*The Logic of Sense* (1969), trans. Mark Lester with Charles J. Stivale, ed. Constantin V. Boundas (London and New York: Continuum, 2004)

—with Félix Guattari *Anti-Oedipus* (1972), trans. Robert Hurley, Mark Seem and Helen R. Lane (London and New York: Continuum, 2004)

—with Félix Guattari *Kafka: Toward a Minor Literature* (1975), trans. Dana Polan (Minneapolis: University of Minnesota Press, 1986)

—with Claire Parnet *Dialogues II* (1977), trans. Hugh Tomlinson and Barbara Habberjam (London and New York: Continuum, 2002)

—with Félix Guattari *A Thousand Plateaus* (1980), trans. Brian Massumi (London: Continuum, 2007)

—*Negotiations 1972–1990* (1990), trans. Martin Joughin (New York: Columbia University Press, 1995)

—with Félix Guattari *What Is Philosophy?* (1991), trans. Graham Burchell and Hugh Tomlinson (London and New York: Verso, 2003)

—*Critique et Clinique* (Paris: Les Éditions de Minuit, 1993)

—*Essays Critical and Clinical* (1993), trans. Daniel W. Smith and Michael A. Greco (London and New York: Verso, 1998)

—*Desert Islands and Other Texts, 1953–1974* (2002), ed. David Lapoujade, trans. Michael Taormina (Los Angeles and New York: Semiotext(e), 2004)

—*Two Regimes of Madness: Texts and Interviews 1975–1995* (2003), ed. David Lapoujade, trans. Ames Hodges and Mike Taormina (Los Angeles and New York: Semiotext(e), 2007)

Derrida, Jacques *Writing and Difference* (1967), trans. Alan Bass (London and New York: Routledge, 2007)

—*Psyche: Inventions of the Other Vol. I* (1998), Peggy Kamuf and Elizabeth Rottenberg (eds) (Stanford: University Press, 2007)

Dosse, François *History of Structuralism Vol. 1: The Rising Sign, 1945–1966* (Minneapolis: University of Minnesota Press, 1997)

Duffy, Simon (ed.) *Virtual Mathematics: The Logic of Difference* (London: Clinamen, 2006)

Duns Scotus, John *Philosophical Writings*, trans. Alan Wolter (Indianapolis: Bobbs-Merrill, 1962)

Durozoi, Gérard *History of the Surrealist Movement* (1997) (Chicago and London: University of Chicago Press, 2002)

Eichenbaum, Boris 'Theory of the Formal Method' (1926), in *Russian Formalist Criticism: Four Essays*, trans. Lee T. Lemon and Marian J. Reis (Lincoln: University of Nebraska Press, 1965), pp. 99–139.

Erlich, Victor *Russian Formalism: History – Doctrine*, 3rd edn (New Haven and London: Yale University Press, 1981)

Eysteinsson, Astradur and Vivian Liska (eds) *Modernism Vol. I* (Amsterdam and Philadelphia: John Benjamins Publishing Company, 2007)

Faulkner, Keith W. *Deleuze and the Three Syntheses of Time* (New York and Oxford: Peter Lang, 2006)

Firtich, Nikolai 'Worldbackwards: Lewis Caroll, Aleksei Kruchenykh and
 Russian Alogism', *The Slavic and East European Journal*, Vol. 48,
 No. 4 (Winter 2004), pp. 593–606
Flaxman, Gregory 'Sci Phi: Gilles Deleuze and the Future of Philosophy',
 in *Deleuze, Guattari and the Production of the New*, Simon
 O'Sullivan and Stephen Zepke (eds) (London and New York:
 Continuum, 2008), pp. 11–21
—*Gilles Deleuze and the Fabulation of Philosophy* (Minneapolis and
 London: University of Minnesota Press, 2012)
Foucault, Michel *Language, Counter-Memory, Practice: Selected Essays
 and Interviews*, ed. Donald F. Bouchard, trans. Donald F. Bouchard
 and Sherry Simon (Oxford: Blackwell, 1977)
Gallagher, Catherine 'Formalism and Time', *Modern Language Quarterly*
 61 (2000), pp. 229–51
Gasset, José Ortega y 'The Dehumanization of Art' (1925), in *The
 Dehumanization of Art and Other Essays on Art, Culture and
 Literature* (Princeton: Princeton University Press, 1968), p. 24
Greenberg, Clement 'Avant-Garde and Kitsch' (1939), in *Art and Culture*
 (Boston: Beacon Press, 1961), pp. 3–21
Gurianova, Nina *The Aesthetics of Anarchy: Art and Ideology in the
 Early Russian Avant-Garde* (Berkeley: University of California Press,
 2012)
Hallward, Peter *Out of this World: Deleuze and the Philosophy of
 Creation* (London and New York, Verso, 2006)
Hardt, Michael *Gilles Deleuze: An Apprenticeship in Philosophy*
 (1993) (Minneapolis and London: University of Minnesota Press,
 2002)
Harte, Tim *Fast Forward: The Aesthetics and Ideology of Speed in
 Russian Avant-Garde Culture, 1910–1930* (Madison: University of
 Wisconsin Press, 2009)
Heidegger, Martin *The Principle of Reason* (1955–6), trans. Reginald
 Lilly (Bloomington: Indiana University Press, 1991)
Henderson, Linda Dalrymple 'Italian Futurism and "The Fourth
 Dimension"', *Art Journal*, Vol. 41, No. 4, Futurism (Winter, 1981),
 pp. 317–23
—*The Fourth Dimension and Non-Euclidean Geometry in Modern Art*
 (Princeton, NJ: Princeton University Press, 1983)
Hjelmslev, Louis *Prolegomena to a Theory of Language* (1943), trans.
 Francis J. Whitfield (Madison, Milwaukee and London: University of
 Wisconsin Press, 1969)
Ho, Christopher 'Antonin Artaud: From Center to Periphery, Periphery to
 Center', *Performing Arts Journal*, Vol. 19, No. 2 (May, 1997), pp. 6–22.
 Stable URL: http://www.jstor.org/stable/3245859 [accessed 16/05/12]

Huelsenbeck, Richard (ed.) *Dada Almanac* (1920), English edition
 presented by Malcom Green, 2nd edn (London: Atlas Press, 1998)
Hutchinson, Ben *Modernism and Style* (Basingstoke: Palgrave Macmillan,
 2011)
Jakobson, Roman 'On Realism in Art' (1921), *Readings in Russian
 Poetics: Formalist and Structuralist Views*, Ladislav Matejka and
 Krystyna Pomorska (eds) (Cambridge, MA and London: MIT Press,
 1971), p. 42
—*Selected Writings II: Word and Language* (The Hague and Paris:
 Mouton, 1971)
—*Selected Writings V: On Verse, Its Masters and Explorers*, Stephen Rudy
 and Martha Taylor (eds) (The Hague, Paris, New York: Mouton, 1979)
—*Selected Writings III: Poetry of Grammar and Grammar of Poetry*
 (The Hague, Paris, New York: Mouton, 1981)
—*Selected Writings VII: Comparative Slavic Studies* (The Hague, Paris,
 New York: Mouton, 1985)
—*Verbal Art, Verbal Sign, Verbal Time*, Krystyna Pomorska and Stephen
 Rudy (eds) (Oxford: Blackwell, 1985)
—*Language in Literature,* ed. Krystyna Pomorska and Stephen Rudy
 (Cambridge, MA and London: Harvard University Press, 1987)
—*My Futurist Years,* ed. Bengt Jangfeldt, trans. Stephen Rudy (New
 York: Marsilio, 1997)
—*Selected Writings I: Phonological Studies*, 3rd edn (Berlin and New
 York: Mouton de Gruyter, 2002)
Jameson, Fredric *The Prison-House of Language: A Critical Account
 of Structuralism and Russian Formalism* (Princeton and Chichester:
 Princeton University Press, 1972)
—'Marxism and Dualism in Deleuze', in *A Deleuzian Century?*, ed. Ian
 Buchanan (Durham and London: Duke University Press, 1999), pp.
 31–2
Janecek, Gerald *The Look of Russian Literature: Avant-Garde Visual
 Experiments, 1900–1930* (Princeton: Princeton University Press,
 1984)
Joyce, James *Finnegans Wake* (1939), (Harmondsworth: Penguin, 1992)
Kant, Immanuel *Critique of Pure Reason* (1781), ed. Vasilis Politis, trans.
 J. M. D. Meiklejohn and Vasilis Politis (London: Everyman, 2002)
Kaufmann, Vincent and Caren Litherland, 'Life by the Letter',
 October, Vol. 64 (Spring, 1993), pp. 91–105. www.jstor.org/
 stable/10.2307/778716 [accessed 16/05/12]
Khalfa, Jean (ed.) *An Introduction to the Philosophy of Gilles Deleuze*
 (London and New York: Continuum, 1999)
Khlebnikov, Velimir *Snake Train: Poetry and Prose*, ed. and trans. Gary
 Kern (Ann Arbor: Ardis, 1976)

—*The King of Time: Selected Writings of the Russian Futurian*, trans. Paul Schmidt, ed. Charlotte Douglas (Cambridge, MA and London: Harvard University Press, 1985)

—*Collected Works, Vol. I: Letters and Theoretical Writings*, trans. Paul Schmidt, ed. Charlotte Douglas (Cambridge, MA and London: Harvard University Press, 1987)

—*Collected Works, Vol. II: Prose, Plays and Supersagas*, trans. Paul Schmidt, ed. Ronald Vroon (Cambridge, MA and London: Harvard University Press, 1989)

—*Collected Works, Vol III: Selected Poems*, trans. Paul Schmidt, ed. Ronald Vroon (Cambridge, MA and London: Harvard University Press, 1998)

Kirkby, Michael and Victoria Nes Kirkby (eds) *Futurist Performance* (New York: PAJ Publications, 1986)

Kleist, Heinrich von 'On the Marionette Theatre' (1810), *The Drama Review*, Vol. 16, No. 3, The 'Puppet' Issue (September 1972), pp. 22–6 www.jstor.org/stable/1144768 [accessed 13/03/12]

Kostelanetz, Richard (ed.) *The Avant-Garde Tradition in Literature* (Buffalo, NY: Prometheus Books, 1982)

Kramer, Andreas 'Remapping the World: Geographies of Italian Futurism', paper presented at Futurism: A Conference Day of Aesthetic and Political Reassessment (London, 2009), proceedings forthcoming

—'The Geographies of Peripheral Modernism: The Case of the Russian Avant-Garde', paper presented at Peripheral Modernisms conference (London, 2012)

Kruchenykh, Alexei 'New Ways of the Word' (1913), in Anna Lawton and Herbert Eagle (eds and trans.) *Words in Revolution: Russian Futurist Manifestoes 1912–1928* (Washington: New Academia Publishing, 2004), p. 68

—'From *Shiftology of Russian Verse: An Offensive and Educational Treatise* (1923), in Lawton and Eagle, *Words in Revolution*, pp. 184–6

—*Verbal Texture: A Declaration* (Moscow: MAF, 1923)

—*Apocalypse in Russian Literature* (Moscow: MAF, 1923)

—*Suicide Circus: Selected Poems*, trans. Jack Hirschman, Alexander Kohav and Venyamin Tseytlin (København and Los Angeles: Green Integer, 2001)

Ladislav, Matejka and Krystyna Pomorska (eds) *Readings in Russian Poetics: Formalist and Structuralist Views* (Cambridge and London: MIT Press, 1971)

Laertes, Diogenes *Lives of Eminent Philosophers*, Vol. II, trans. R. D. Hicks (Cambridge and London: Harvard University Press and Heinemann, 1925)

Lambert, Gregg 'Deleuze and the "Dialectic" (a.k.a. Marx and Hegel)', *Strategies*, Vol. 15, No. 1 (2002), p. 74

—*The Non-Philosophy of Gilles Deleuze* (New York: Continuum, 2002)

Lampert, Jay *Deleuze and Guattari's Philosophy of History* (London and New York: Continuum, 2006)

Lawton, Anna and Herbert Eagle (eds and trans.) *Words in Revolution: Russian Futurist Manifestoes 1912–1928* (Washington: New Academia Publishing, 2004)

Lecercle, Jean-Jacques *Philosophy Through the Looking-Glass: Language, Nonsense, Desire* (Chicago: Open Court, 1985)

—*The Violence of Language* (London and New York: Routledge, 1990)

—'Lewis Carroll and the Talmud', *SubStance*, Vol. 22, No. 2/3, Issue 71/72: Special Issue: Epistémocritique (1993), pp. 204–16

—*Philosophy of Nonsense: The Intuitions of Victorian Nonsense Literature* (London: Routledge, 1994)

—*Deleuze and Language* (Basingstoke: Palgrave Macmillan, 2002)

—with Denise Riley *The Force of Language* (Basingstoke: Palgrave Macmillan, 2005)

—*Badiou and Deleuze Read Literature* (Edinburgh: Edinburgh University Press, 2010)

—'In Praise of Misreading', *Atelier*, Vol. 3, No. 1 (2011), pp. 1–15

Lefebvre, Alexandre *The Image of the Law: Deleuze, Bergson, Spinoza* (Stanford: Stanford University Press, 2008)

Lemon, Lee T. and Marion J. Reis (eds and trans.) *Russian Formalist Criticism: Four Essays* (Lincoln: University of Nebraska Press, 1965)

Livshits, Benedickt *The One and a Half-Eyed Archer*, trans. John E. Bowlt (Newtonville, MA: Oriental Research Partners, 1977)

Lopez, Alan 'Deleuze with Carroll: Schizophrenia and Simulacrum and the Philosophy of Lewis Carroll's Nonsense', *Angelaki*, Vol. 9, No. 3 (December 2004), pp. 101–20

Lunacharsky, Anatoly 'Revolution and Art' (1920–22), in *Russian Art of the Avant-Garde: Theory and Criticism*, ed. and trans. John E. Bowlt (New York: Viking Press, 1976), p. 88

Lyotard, Jean-François, 'The Sublime and the Avant-Garde', *The Inhuman: Reflections on Time* (Stanford: Stanford University Press, 2004), pp. 89–107

Malevich, Kazimir *Essays on Art 1915–1933*, Vol. II, trans. Xenia Glowacki-Prus and Arnold McMillin, ed. Troels Andersen (London: Rapp & Whiting, 1968)

Man, Paul de *Allegories of Reading: Figural Language in Rousseau, Nietzsche, Rilke, and Proust* (1979), (New Haven and London: Yale University Press)

—*Aesthetic Ideology* (1996), ed. Andrzej Warminski (London and Minneapolis: University of Minnesota Press, 2002)

Mao, Douglas and Rebecca K. Walkowitz (eds) *Bad Modernisms* (Durham and London: Duke University Press, 2006)

Marinetti, F. T. *Selected Poems and Related Prose*, selected by Luce Marinetti, trans. Elizabeth R. Napier and Barbara R. Studholme (New Haven and London: Yale University Press, 2002)

—*Critical Writings*, ed. Günter Berghaus, trans. Doug Thompson (New York: Farrar, Straus and Giroux, 2006)

Markov, Vladimir 'The Province of Russian Futurism', *The Slavic and East European Journal*, Vol. 8, No. 4 (Winter, 1964), pp. 401–6

—*Russian Futurism: A History* (London: Macgibbon and Kee, 1969)

Marx, Karl and Friedrich Engels *The Communist Manifesto* (1848) (Harmondsworth: Penguin, 2002)

Masschelein, Anneleen 'Rip the veil of the old vision across, and walk through the rent: Reading D. H. Lawrence with Deleuze and Guattari', in *Modernism and Theory: A Critical Debate*, ed. Stephen Ross (London and New York: Routledge, 2009), pp. 23–39

Massumi, Brian *A User's Guide to Capitalism and Schizophrenia* (Cambridge, MA and London: MIT Press, 1992)

Matustik, Martin J. 'Habermas on Communictive Reason and Performative Contradiction', *New German Critique,* No. 47 (Spring–Summer, 1989), pp. 143–72

Meinong, Alexius *On Emotional Presentation* (1917), trans. Marie-Luise Schubert Kalsi (Evanston, IL: Northwestern University Press, 1972)

Michaux, Henri *Selected Writings: The Space Within*, trans. Richard Ellmann (London: Routledge & Kegan Paul, 1952)

Milner, John *A Slap in the Face! Futurists in Russia,* exhibition organized by Esoterick Gallery of Modern Italian Art (London: Philip Wilson, 2007)

Moore, Marianne *Collected Poems* (New York: Macmillan, 1951)

Mullarkey, John *Post-Continental Philosophy: An Outline* (London: Continuum, 2006)

Murphy, Richard *Theorizing the Avant-Garde: Modernism, Expressionism, and the Problem of Postmodernity* (Cambridge: Cambridge University Press, 1999)

—'History, Fiction, and the Avant-Garde: Narrativisation and the Event', *Phrasis* 1 (2007), pp. 83–103

Murray, Timothy (ed.) *Mimesis, Masochism and Mime: The Politics of Theatricality in Contemporary French Thought* (Ann Arbor: University of Michigan Press, 2000)

Nietzsche, Friedrich 'On Truth and Falsity in Their Extramoral Sense' (1873), in *Philosophical Writings*, trans. Maximilian A. Mügge,

Reinhold Grimm and Caroline Molina y Vedia (eds) (London: Continuum, 1997) pp. 87–99

—*Human, All Too Human: A Book for Free Spirits* (1878), trans. R. J. Hollingdale (Cambridge: Cambridge University Press, 1991)

—*Thus Spake Zarathustra* (1883–5), trans. R. J. Hollingdale (Harmondsworth: Penguin, 1961)

—*Beyond Good and Evil: Towards a Philosophy of the Future* (1886), trans. R. J. Hollingdale (Harmondsworth: Penguin, 2003)

Nilsson, Nils Åke (ed.) *Velimir Chlebnikov: A Stockholm Symposium* (Stockholm: Almqvist & Wiksell International, 1985)

O'Sullivan, Simon and Stephen Zepke (eds) *Deleuze, Guattari and the Production of the New* (London and New York: Continuum, 2008)

O'Toole, L. M. and A. Shukman (eds and trans.) *Russian Poetics in Translation, Vol. 4, Formalist Theory* (Oxford: Holdan Books, 1977)

Olkowski, Dorothy *Gilles Deleuze and the Ruin of Representation* (Berkeley, CA and London: University of California Press, 1998)

Osborne, Peter *The Politics of Time: Modernity and Avant-Garde* (London and New York: Verso, 1995)

—*Philosophy in Cultural Theory* (London and New York: Routledge, 2000)

Ouspensky, P. D. *Tertium Organum* (1912), trans. E. Kadloubvsky and the author (Henley and London: Routledge & Kegan Paul, 1981)

Parr, Adrian (ed.) *The Deleuze Dictionary* (Edinburgh: Edinburgh University Press, 2005)

Parton, Anthony *Mikhail Larionov and the Russian Avant-Garde* (London: Thames & Hudson, 1993)

Patton, Paul (ed.) *Deleuze: A Critical Reader* (Oxford: Blackwell, 1996)

—*Between Deleuze and Derrida* (London and New York: Continuum, 2003)

Pearson, Keith Ansell 'Living the Eternal Return as the Event: Nietzsche with Deleuze', *Journal of Nietzsche Studies*, No. 14, Eternal Recurrence (Autumn 1997), pp. 64–97 [accessed 03/06/12]

—'The Reality of the Virtual: Bergson and Deleuze', *MLN*, Vol. 120, No. 5, Comparative Literature Issue (Dec, 2005) www.jstor.org/stable/10.2307/20717678 [accessed 02/06/12]

Penrose, Roger 'Escher and the Visual Representation of Mathematical Ideas', in *M. C. Escher: Art and Science* H. M. S. Coxeter et al. (eds) (Amsterdam and New York: Elsevier, 1986), pp. 143–58

Perloff, Marjorie *Wittgenstein's Ladder: Poetic Language and the Strangeness of the Ordinary* (Chicago: Chicago University Press, 1996)

—*21st-Century Modernism: The 'New' Poetics* (Oxford: Blackwell, 2002)

—*The Futurist Moment: Avant Garde, Avant Guerre and the Language*

of Rupture (1986), (Chicago and London: University of Chicago Press, 2003)

Persius, *The Satires,* trans. J. R. Jenkinson (Warminster: Aris & Phillips, 1980)

Picabia, Francis 'Presbyopic-Festival-Manifesto' (1920), in *I am a Beautiful Monster: Poetry, Prose, and Provocation,* trans. Marc Lowenthal (Cambridge, MA and London: MIT Press, 2007), pp. 219–20.

Pike, Christopher (ed.) *The Futurists, The Formalists, and the Marxist Critique,* trans. Christopher Pike and Joe Andrew (London: Ink Links, 1979)

Plato, 'Cratylus' (380 BC), in *The Dialogues of Plato, Vol. III* (Oxford: Clarendon Press, 1953)

Poggioli, Renato *The Theory of the Avant-Garde* (1962), trans. Gerald Fitzgerald (Cambridge, MA and London: Harvard University Press, 1968)

Pomorska, Krystyna *Russian Formalist Theory and its Poetic Ambiance* (The Hague: Mouton, 1968)

Pound, Ezra *ABC of Reading* (1934) (New York: New Directions, 2010)

Puchner, Martin *Poetry of the Revolution: Marx, Manifestos and the Avant-Garde* (Princeton: Princeton University Press, 2006)

—*The Drama of Ideas: Platonic Provocations in Theater and Philosophy* (New York and Oxford: Oxford University Press, 2010)

Rainey, Lawrence, Christine Poggi and Laura Whitman (eds) *Futurism: An Anthology* (New Haven and London: Yale University Press, 2009)

Rancière, Jacques 'Existe-t-il une esthétique deleuzienne?', in *Gilles Deleuze: Une vie philosophique,* ed. Eric Alliez (Paris: Synthélabo, 1998), pp. 525–36

Reddy, Michael J. 'The Conduit Metaphor: A Case of Frame Conflict in Our Language about Language', in *Metaphor and Thought,* 2nd edn, ed. Andrew Ortony (Cambridge: Cambridge University Press, 1993), pp. 164–201

Richards, I. A. *The Philosophy of Rhetoric* (Oxford: Oxford University Press, 1936)

Ricoeur, Paul *The Rule of Metaphor* (1975), trans. Robert Czerny (London: Routledge, 2003)

Robertson, Eric 'Everyday Miracles: Arp's Object-Language', *Dada and Beyond,* ed. Elza Adamowicz and Eric Robertson (Amsterdam and New York: Rodopi, 2011), pp. 83–92

Rosenthal, Bernice Glatzer (ed.) *Nietzsche and Soviet Culture* (Cambridge: Cambridge University Press, 1994)

Ross, Stephen (ed.) *Modernism and Theory: A Critical Debate* (London and New York: Routledge, 2009)

Rosset, Clément 'Sécheresse et Deleuze', *L'Arc* 49, new edition (1980), pp. 89–91

Roussel, Raymond *How I Wrote Certain of My Books* (1935), trans. Trevor Winkfield (New York: SUNY, 1977)

—and Ron Padgett, 'Among the Blacks' (1935), trans. Ron Padgett (Bolinas, CA: Avenue B, 1988)

Russell, Bertrand *The Principles of Mathematics* (1903), (London and New York: Routledge, 2009)

Saussure, Ferdinand de *Course in General Linguistics* (1916), trans. Wade Baskin, Perry Meisel and Haun Saussy (eds) (Chichester: Columbia University Press, 2011)

Scheunemann, Dietrich (ed.) *European Avant-Garde: New Perspectives* (Amsterdam: Rodolpi, 2000)

Sellars, John 'The Point of View of the Cosmos: Deleuze, Romanticism, Stoicism', *Pli* 8 (1999), pp. 1–24

—*Stoicism* (Chesham: Acumen, 2006)

Shakespeare, William *Hamlet* (1603), (Oxford: Oxford University Press, 2002)

Sheldon, Richard 'Viktor Shklovsky and the Device of Ostensible Surrender', *Slavic Review*, Vol. 34, No. 4 (March 1975), pp. 86–108 www.jstor.org/stable/10.2307/2495875 [accessed 04/05/2012]

Shklovsky, Viktor 'The Resurrection of the Word' (1914), in *Russian Formalism*, Stephen Bann and John E. Bowlt (eds) (Edinburgh: Scottish Academic Press, 1973), pp. 41–7

—*Zoo, or Letters Not about Love* (1923), ed. and trans. Richard Sheldon (Ithaca and London: Cornell University Press, 1971)

—*Knight's Move* (1923), trans. Richard Sheldon (Illinois and London: Dalkey Archive, 2005)

Smith, Daniel W. 'The Concept of the Simulacrum: Deleuze and the Overturning of Platonism', *Continental Philosophy Review*, Vol. 38, No. 1–2 (2005), pp. 89–123 http://www.springerlink.com/content/n2j7662743118768/fulltext.pdf [accessed 23/04/12]

—'Axiomatics and problematics as two modes of formalization: Deleuze's epistemology of mathematics', *Virtual Mathematics: The Logic of Difference*, ed. Simon Duffy (London: Clinamen, 2006), pp. 145–68

Sokal, Alan 'Transgressing the Boundaries: Toward a Transformative Hermeneutics of Quantum Gravity', *Social Text*, No. 46/47, Science Wars (Spring–Summer, 1996), pp. 217–52 http://www.jstor.org/stable/10.2307/466856 [accessed 31/05/12]

—and Jean Bricmont, *Intellectual Impostures: Postmodern Philosophers' Abuse of Science* (London: Profile, 1999)

Spinoza, Benedict de *Ethics* (1677), ed. and trans. Edwin Curley (Harmondsworth: Penguin, 1996)

Stanford, Susan 'Definitional Excursions: The Meanings of Modern/ Modernity/Modernism', *Modernism/Modernity* 8.3 (2001), pp. 493–513

Stapanian, Juliette R. '"Universal War" and the Development of Zaum: Abstraction toward a New Pictorial and Literary Realism', *Slavic and Eastern European Journal*, Vol. 29, No. 1 (Spring 1985), pp. 18–38

Steiner, Peter *Russian Formalism: A Metapoetics* (Ithaca and London: Cornell University Press, 1984)

Stokes, M. C. *One and Many in Presocratic Philosophy* (Cambridge, Massachusetts: Harvard University Press, 1971)

Todorov, Tzvetan *Introduction to Poetics* (1968), trans. Richard Howard (Minneapolis: University of Minnesota Press, 1981)

—*The Poetics of Prose* (1971), trans. Richard Howard (Ithaca, NY: Cornell University Press, 1977)

Toscano, Alberto *The Theatre of Production: Philosophy and Individuation between Kant and Deleuze* (Basingstoke: Palgrave Macmillan, 2006)

Travers, Martin *An Introduction to Modern European Literature: From Romanticism to Postmodernism* (London: Palgrave Macmillan, 1998)

Trotsky, Leon *Literature and Revolution* (1924), trans. Rose Strunsky, ed. William Keach (Chicago: Haymarket Books, 2005)

Turetzky, Philip *Time* (London: Routledge, 1998)

Tzara, Tristan 'Dada Manifesto 1918', in *Dada Almanac*, ed. Richard Huelsenbeck (1920), English edition presented by Malcom Green, 2nd edn (London: Atlas Press, 1998), p. 122

Valéry, Paul 'Remarks on Poetry' (1927), in *Symbolism: An Anthology*, ed. and trans. T. G. West (London: Methuen, 1980), pp. 43–60

Webber, Andrew J. *The European Avant-Garde 1900–1940* (Cambridge and Malden: Polity, 2004)

West, T. G. (ed. and trans.) *Symbolism: An Anthology* (London: Methuen, 1980)

White, John J. *Literary Futurism: Aspects of the First Avant-Garde* (Oxford: Clarendon Press, 1990)

Williams, James *The Transversal Thought of Gilles Deleuze: Encounters and Influences* (Manchester: Clinamen Press, 2005)

—*Gilles Deleuze's* Difference and Repetition: *A Critical Introduction and Guide* (Delhi: Motilal Banarsidass Publishers, 2008)

—*Gilles Deleuze's* Logic of Sense: *A Critical Introduction and Guide* (Edinburgh: Edinburgh University Press, 2008)

—*Gilles Deleuze's Philosophy of Time: A Critical Introduction and Guide* (Edinburgh: Edinburgh University Press, 2011)

Wittgenstein, Ludwig *Tractatus Logico-Philosophicus* [1921], *The Wittgenstein Reader* (2nd edn) ed. Anthony Kenny, (Oxford:

Blackwell, 2006), pp. 1–30, trans. C. K. Ogden (London: Routledge & Kegan Paul, 1955)

Yeats, W. B. *The Collected Poems of W. B. Yeats* (Ware: Wordsworth, 2000)

Žižek, Slavoj *Organs without Bodies: On Deleuze and Consequences* (New York and London: Routledge, 2004)

Websites consulted

http://www.16beavergroup.org/mtarchive/archives/002019.php [accessed 20/05/12]

http://www.391.org/manifestos/19131215umbertoboccioni_ plasticdynamism.htm [accessed 02/02/11]

http://0-www.oed.com.catalogue.ulrls.lon.ac.uk/view/Entry/137251?rskey =5wriaJ&result=10&isAdvanced=false [accessed 2/04/12]

INDEX